Jimi Hendrix

SHARON LAWRENCE left university to become a reporter for United Press International in Los Angeles. Her speciality was film coverage and, eventually, pop music as well. After more than five years with UPI she became a management, marketing and PR consultant for such clients as MCA, Columbia, Apple and Rocket Records as well as for movie studios. Among the artists she worked closely with are Elton John, Kiki Dee, Cliff Richard, Andrew Lloyd Webber, Tim Rice and Lynyrd Skynyrd.

She is the author of *So You Want to Be a Rock and Roll Star* and *Old Carmel in Rare Photographs*. She now writes screenplays and was involved as writer, interviewer and historical expert on Clint Eastwood's two-hour video documentary about Carmel-by-the-Sea.

Sharon Lawrence

Jimi Hendrix

The Man, the Magic, the Truth

PAN BOOKS

First published in Great Britain 2005 by Sidgwick & Jackson
and simultaneously in the USA by HarperEntertainment

First published in paperback 2006 by Pan Books
an imprint of Pan Macmillan Ltd
Pan Macmillan, 20 New Wharf Road, London N1 9RR
Basingstoke and Oxford
Associated companies throughout the world
www.panmacmillan.com

ISBN 978-0-330-43353-2

9 8 7 6 5 4 3 2

A CIP catalogue record for this book is available from
the British Library.

Typeset by SetSystems Ltd, Saffron Walden, Essex
Printed and bound in the UK by
CPI Mackays, Chatham ME5 8TD

Technically, I'm not a guitar player.
All I play is truth and emotion.
—*Jimi Hendrix*

Contents

PART THREE THE REINVENTION OF JIMI HENDRIX

PART FOUR THE TRUE LEGACY

Prologue

I observed the extravagant aureole of carefully teased black hair. The face, with its luminous brown eyes looking directly at me, was gentle. His handshake was firm. He smiled warmly, respectfully even, and said in a low, whispery voice, "Thanks for coming out tonight."

So this was Jimi Hendrix. The exotic photographs I'd seen in the English music papers offered a somewhat terrifying image. On this night, though, I met a shy, polite human being.

"Sharon," Leslie Perrin had said on the telephone, "I've just arrived from London, and I'd like to introduce you to Jimi Hendrix. He's very special. And he's playing near Disneyland tonight!"

For years Leslie Perrin had been a figure in London press and music circles, jovial but shrewd, a stout, chain-smoking, middle-aged public relations expert whose clients ranged from Frank Sinatra to the Rolling Stones. Now he'd added the Jimi Hendrix Experience to his client roster. The motto inscribed on his letterhead read RING ME ANYTIME—DAY OR NIGHT.

"That would be nice, Les, but could we do it another time? I'd love to see you, of course. Maybe for lunch tomorrow? It's been a tremendously busy week, and I'm not at my best, and with all this rain this isn't a good night." I met and interviewed celebrities, particularly major film stars, every day in my job as a fledgling

reporter in the Los Angeles bureau of United Press International, then a powerful news organization. Les sounded disappointed, and I felt ashamed of myself as I caught on—Perrin was on unfamiliar turf in L.A., dismayed by the sudden downpour in sunny California, and he needed a ride. I was also remembering that Les was a great pal of numerous journalist friends of mine in London and that he'd been kind and hospitable to me on a recent visit to England. "Where shall I pick you up, Les?"

This is how I met Hendrix, the hottest new star on the international music scene: because, grudgingly, I was doing a favor.

The tires of my blue Dodge Dart squealed on the slick, slippery freeways as we drove the thirty miles southeast from Los Angeles to Anaheim in a steady, gloomy rain. We smoked cigarettes as Les amusingly related the latest music news from Swinging London. Finally we zigzagged our way off the freeway and slowly turned in to the driveway of the Anaheim Convention Center. It held seventy-eight hundred people, and the parking lot was jammed as we maneuvered into a space near the backstage entrance.

I tentatively followed Perrin into the crowded dressing room, where he introduced me to drummer Mitch Mitchell and bassist Noel Redding, two quite adorable and gracious English boys. We talked about this latest round of the "British Invasion"—the tag given to the increasing number of English bands touring America in the sixties—and the Experience's recent New York press reception on top of a midtown skyscraper. Everything they said made me laugh, down to the corny jokes about "That's what I call getting high!"

Les took my arm and we stepped outside the door, and there was Jimi Hendrix, in a deep purple silk crepe shirt, velvet pants, and a black cut-velvet jacket; I had never before seen a pop musician dressed with such subtle elegance; Hendrix looked as if he should be invited to pose for the cover of *Vogue*. His face and his voice appeared shy. "I've just been tuning my guitar," he said.

Ten minutes later Les Perrin, who'd gone off to chat with other

musicians on the "Invasion" package—which included Eire Appar-
ent, Soft Machine, Eric Burdon and the Animals with the Experi-
ence headlining—returned to smile approvingly as he saw Hendrix
and me in animated conversation. I told Jimi that I had already
seen the Experience soon after the Monterey Pop Festival, when the
trio opened for the Mamas and Papas at the Hollywood Bowl. "I
thought it was fabulous the way you came onto the stage playing
'Sgt. Pepper,'" I said. "The perfect song to grab the crowd."

Jimi's eyes lit up; he liked this compliment, and he seemed to
understand that I was simply saying what I thought. I loved music,
knew music, from Ella Fitzgerald to Tchaikovsky to Ray Charles
and the Beatles; my earliest memories involved a home where the
record player was alive with wondrous voices and captivating
melodies, from Negro spirituals to Gershwin concertos. I had a
boyfriend, Ron, a college student in New York and an avid record
collector, who was crazy about the new pop music. People who
didn't care about music usually didn't interest me.

"My mother thought your group was terrific at the Bowl," I
continued. "She liked your songs and also your clothes. 'That boy
has beautiful taste,' she said. Mother loves fine fabrics."

His eyes opened wide. "You took your mother to hear us?"

"In California," I explained, "the Hollywood Bowl has always
been a family place, where you bring a picnic dinner and hear
music under the stars. It's a summer tradition."

Jimi nodded. "Please tell her I appreciate fabrics, too."

I kept waiting for Hendrix to bring the conversation to a halt,
but he seemed to be enjoying himself. So I went on, "My mother
collects material, edgings, trimmings; she's wonderful at sewing."

Jimi seemed delighted to hear this, saying, "If I had a proper
place, quite naturally, I'd be collecting all that, too."

"I only collect records," I said. "I've got hundreds of albums.
I started buying them when I was ten, and now one of the best
things about my job is that I'm invited to see just about every
movie made, and the record companies send me free records."

"They all must like you a lot!" he said.

"No," I said. "I think it's more about wanting publicity. I quit college and did a bit of finagling to land my job. I was naïve, I suppose, because I hadn't realized until recently that when people give you something free, they just about always want something."

Hendrix gave me a serious look. "Isn't that the truth," he said.

Les rejoined us, glancing at his watch. "James," he said, "I think you're supposed to be onstage."

Hendrix smiled warmly at me. "See you again!"

As he hurried to the dressing room, there was Eric Burdon coming from the other direction. I'd met him a couple of times before. Exuberantly, he grabbed my arm and said, "Come on, let's go out front. It's always so excitin' when Jimi plays."

Eric had just finished "warming up" seven thousand young people for the first of two shows that night. Most of the audience was on their feet eagerly waiting for the Experience. Undoubtedly quite a few of these kids had witnessed the riveting debut of the Jimi Hendrix Experience at Monterey Pop the previous summer.

The minute Hendrix made his entrance, the subdued fellow I'd just met turned into the most lascivious, outrageous, spectacular performer I'd ever seen. His Hollywood Bowl show seemed tame in retrospect. Now he was ravaging the guitar with his teeth, his tongue, playing it behind his back and on the floor, in a brilliant display of showmanship and sound. Although I had seen everyone from the Beatles to the Stones to Bob Dylan, I had never given much consideration to the guitar. Like many other fans at concerts, I tended to concentrate on the lead singer. But tonight a bold, brightly colored world of *fresh* rhythms and sound was emanating from this white Stratocaster that Hendrix played so effortlessly it appeared to be part of his body. Yes, I thought, this is *important*. The mesmerized audience hardly seemed to notice that there were two *other* musicians onstage until an inspired bit of drumming from Mitch Mitchell grabbed them. For all the spotlight on Hendrix, this was a true ensemble; the Experience's playing was both

tight and seemingly spontaneous, a rare and invigorating mix. Noel Redding and Mitch Mitchell were the all-important foundation for Jimi; the three of them together knew how to create magic. Continual ripples of applause now had escalated into exhilarating roars of approval. The crowd hung on every note, on the soulful, whispery singing voice, the quick, shy comments into the microphone. A teenage boy sitting behind me said to his friend, "Hendrix is talking to *us*!"

A year ago I'd assumed that all the excitement about the Experience was purely press agentry and hype. Now I understood why all the major British guitar players couldn't stop talking about Hendrix.

Backstage after his performance, Jimi reverted to the same gentle person I'd met two hours before. He struck me as a *creature*—more of a spirit than a person. Without knowing precisely why, I felt that I was in the presence of someone unique.

Les Perrin murmured something odd as we drove back to Hollywood: "I hope you'll get to know Hendrix. He could use a friend." Meanwhile in the rear seat of the car, big, beefy Chas Chandler, former bassist for the Animals and now Jimi's co-manager, was grinning as he re-counted the thousands of dollars in cash he'd collected for the gig. The rain beat down harder, but I drove faster. I was a nervous wreck until Chandler put all that money in the hotel safe.

I didn't know that Les Perrin had given Jimi my telephone number, so a week later I was surprised to hear from my answering service that "a Mr. Hendrix called to thank you for attending his concert." He'd left the number at his latest hotel, and when I returned the call, he thanked me again. Gee, I thought, Les must have given me quite a buildup as someone worth knowing in L.A. Did Hendrix want to visit a movie studio or *what*? The other musicians I knew from England always urged me to show them where Elvis lived and take them to see the movie-star hand- and footprints at Grauman's Chinese Theater on Hollywood Boulevard.

But as we continued our conversation, Jimi didn't seem to want anything except to talk. When I asked him about life on the road, I was astonished at how openly he spoke of the troubles he was facing as an instant superstar.

His tone was tense, almost desperate. "The group's gotten so big so fast. I'm making everyone unhappy. I don't want to over-shadow anybody."

I didn't know how to respond. The music world had clutched Jimi to its heart. His success appeared unlimited. I would have expected him to say he was on top of the world.

I remembered a Track Records advertisement of congratula-tions in an issue of *Melody Maker* several months back—ALL HAIL KING JIMI. On the cover the self-taught Jimi Hendrix was pictured accepting his trophy as "World's Best Pop Musician," his head bowed, an expression of deep humility on his face. Now I reminded him of this. "What a fabulous honor. It must have made you feel great!"

A smile colored his voice. "Oh, yes!"

We spoke of new records being played on the radio and of films. He told me that he admired Marlon Brando, James Dean, and Sidney Poitier. "I don't have much time to see movies," Jimi said, "but I do love them. The last one I saw was *In the Heat of the Night*. Very cool movie. Did you see it?"

"It was terrific," I said. "Poitier's a great actor! What I want to know, though, is why Brando and Dean? *The Wild One, Rebel Without a Cause*—is this how you see yourself?" I was joking, laughing as I spoke. He laughed, too, briefly and added quite seriously, "Yeah, I relate to those movies. I dig those films a lot. I'd like to get a red jacket in honor of Jimmy Dean, in fact. It's so sad that he died so young, isn't it?"

"Very, very sad," I said.

In mid-March, Hendrix telephoned me from New York, telling me that he'd seen my byline on a UPI feature in the newspaper. I was startled on two counts—hearing from him again and learning

that he read newspapers. Most musicians I knew did not, except for stories about them.

Jimi sounded weary. "We've been touring or recording for almost eighteen months. Since I showed up in London in the fall of '66, I've met hundreds of people besides the fans; that part of it is generally cool. But trying to keep up with radio- and record-business people in each country—promoters, agents, program directors, press, publicity, and blah-blah-blah—it's uh . . . uh—"

"Difficult?" I interrupted.

"Damn right it's *difficult*. I feel like I live on a roller coaster. I don't mean to whine. I'm just tired. Throw in all the little dramas in the band and the management and all the mind-blowing legal bull, and it definitely takes away from the music. I'd like three hours to concentrate only on writing a song." Having gotten it momentarily off his chest, he turned cheerier. "Nothing wrong with me that a solid week of sleep can't cure! I was thinking about that when we talked about movies. Whenever there's time to get rested up, I'd like to go see ten movies in a row!"

"Why don't you arrange for time off to go home and see your family? Tune out for a while," I suggested.

Hendrix's tone completely changed. "There's nothing for me in Seattle," he said flatly. "It's so beautiful, but I couldn't stay there. They didn't understand then. And they don't now."

As he spoke, I could never have known how desperately Jimi needed a confidante, a sounding board, an actual friend who wasn't involved in his career. Nor could I have guessed that in the next years I would see him in a variety of places, situations, and especially moods—ranging from joy to fear.

Jimi held little back in our conversations. It seemed that so many feelings had been bottled up inside him for such a long time, so that when he spoke, he would sometimes rev up into high gear, just pouring stuff out. I was a good listener, often asking questions as he retraced his life, but only occasionally commenting. There were moments when I was startled and dismayed by his candor.

Prologue

He wasn't crying on my shoulder or asking for pity, simply unwinding was how I saw it. I was impressed by the way he spoke with inherent sensitivity of special moments and creative discoveries in his musical life. We shared a few cynical laughs over some of the absurdities and disillusionment in the business side of his career as well as my own. I felt that it was important to remember everything he said about his troubled formative years, his disappointments, his dreams, his goals, and his joy in and passion for music. Still, who could forget such a strong and vibrant mind and how he expressed himself?

Seeing and hearing the pleasure he received from "practicin' up, workin' with words and sneaky riffs," it always made me feel privileged to be present for a few of those creative times.

I deliberately waited years to write this book, not sure that I wanted to revisit the tender and tortured territory of the "Hendrix Years" and also convinced that the perspective of time and added life experience would surely make me see Jimi from a different point of view. But I was *wrong* about that. My intrinsic sense of who Jimi Hendrix was and what he was all about remains the same now as it did then.

Jimi was the greatest musician and the least boring person I have ever known.

<div align="right">

Sharon Lawrence
Los Angeles, November 2004

</div>

Part One

A Boy-Child Comin'

Chapter One

Johnny/Jimmy

SHE LOVED a good time. There were few of them in her short and wretched life.

Lucille Jeter shook off the gloomy blanket of wartime anxieties that troubled all the adults around her, and despite her family's admonitions, she ignored the tedious drip . . . drip . . . drip of the Seattle evening rain to go out and dance every chance she got.

The sweet-natured and naïve "baby" of the Jeter family, Lucille had a brother and three older sisters. Their parents, Preston and Clarice, were typical of many of the black residents of Seattle in the 1940s, men and women who had migrated west, seeking a better life but frequently disappointed. Born in Virginia, Preston Jeter possessed education but few opportunities. He worked, at various times, as a miner and as a longshoreman. His wife, Clarice, a native of Arkansas, brought in much-needed income toiling as cleaning lady and housekeeper. Welfare checks sometimes entered the picture. Mrs. Jeter's Pentecostal religion was both her rock and her social life; she worried and prayed about Lucille and her always fragile health. Lucille was inclined to overdo.

The sight of the pretty, tiny, pale-skinned black girl kicking up her heels and the sound of her giddy laughter as she was tossed into the air captivated Al Hendrix. It seemed that she would never get enough of the bright lights and spirited jitterbug rhythms. Lucille loved her music!

The exhilarating nights on the dance floor didn't last long.

Weeks after the couple's first meeting, Lucille became pregnant and hurriedly married twenty-two-year-old Al, an attractive if not handsome bantam rooster of a man, standing barely five foot two. She told her mother that she liked the way Al smiled at her.

Her young husband was an American citizen raised in Vancouver, British Columbia, who had settled in Seattle several years before to try his luck as a lightweight boxer in the city's Golden Gloves competition. Al's father, Ross Hendrix, was an Ohio native who grew up to become a Chicago policeman and eventually, making an exotic switch, took a job as stagehand for a vaudeville troupe. He married one of the dancers in the company, Nora Moore, the daughter of a full-blooded Cherokee mother and an Irish father. Nora and Ross Hendrix decided to give up the traveling life and make a new start in Vancouver. In quick succession Nora gave birth to two sons, a daughter, and finally to James Allen Hendrix, generally known as Al.

Since his education had ceased in the seventh grade and he was unprepared for any skilled work, Al turned to the love of dancing he'd inherited from his mother to make a few bucks here and there in dance contests. His specialties were tap dancing, jitterbugging, and solo improvisations. Although Al later was to refer to himself as a member of an important show business family, Mama Nora worked long hours in the kitchen of a Vancouver restaurant after she left vaudeville; as a teenager Al was a waiter there.

When he married Lucille, Al had perhaps only three things in common with his sixteen-year-old wife: They both were the youngest children in their respective families, they each loved to dance, and they had a child on the way. Within days after their marriage on March 31, 1942, Al kissed Lucille good-bye. Drafted into the army, he was sent more than fifteen hundred miles away to Oklahoma, and then on to Georgia.

Lucille was barely seventeen when she gave birth to her first son, Johnny, on November 27, 1942. The birth took place at the

home of Dorothy Harding, a good friend to Lucille's sister Dolores. Relatives and friends joked about how strange it was that these two short people had conceived such a graceful, long-limbed baby.

Raising a baby was no joke, and Lucille was unprepared to handle the transition from dropout schoolgirl to mother. Through an army snafu, she was not receiving any of Al's military pay. Not long after Johnny was born, Preston Jeter died of a heart condition. As a result, Clarice was plagued by financial problems. She loved Lucille's baby, but she couldn't take care of him and also work five days a week. Clarice and her daughter Dolores were deeply concerned about Johnny's welfare as he was shuttled around a circle of relatives, friends, and even complete strangers in homes in and near Seattle. Week to week Johnny never was quite sure who was "in charge"—a phrase that stayed with him. He slept on pillows, in baskets, and in other people's beds; a real baby crib was a luxury Johnny seldom knew. Lucille floated in and out of Johnny's life, the "Mama" he adored—even if the young girl couldn't support him or manage to take care of him for more than a few days at a time.

When he was almost two and a half years old, Johnny was taken in by a church acquaintance of his grandmother Clarice. This woman became ill and unexpectedly passed away; her sister journeyed from California to Seattle, where she met and was charmed by little Johnny. It was a fateful meeting, and while he eventually forgot her name, he never forgot her. She volunteered to take care of the boy in her wartime home in Berkeley, California. Lucille had no objections.

Johnny now lived in the finest house yet, a simple bungalow several blocks away from the University of California campus. He felt comfortable and secure, and he blossomed under the warmth and concern of the woman who had rescued him, not to mention the attention of her eldest daughter, who was approximately twenty, and two lively teenage children. He would later recall how he loved being read to, always eager for the next story. Johnny's

5

vocabulary increased dramatically during this happy respite from the insecurities of Seattle. "They called me a little chatterbox," he said to me, smiling at the thought of those long-ago memories.

Al Hendrix had given some second thoughts to his marriage, particularly after he heard that Lucille had been seeing another man; he was considering divorcing his young wife. Weeks after his discharge from the army late in 1945, he traveled down the West Coast to Berkeley to take his first look at his son. Johnny did not quite connect the photograph of his father in uniform, prominently displayed in the living room, with the nonuniformed young man who was inspecting him now. Al stayed with Johnny's guardian angels for a few days, met two of the boy's neighborhood play-mates and when Johnny apparently had become used to him, he packed up the boy's belongings. The two of them embarked on an exhausting, eight-hundred-mile train trip back to Seattle. Years later Johnny remembered how he cried and sobbed when this unfamiliar man he now was to call Daddy disciplined him midway through the journey: " 'I want to get off this train! I want to go *home*. You leave me alone! I want my *family*.'

"I just bawled," he said. "I knew they loved me, that they would *miss* me."

Although the details faded, Johnny never forgot this substitute family. "They, that time has always been like a cozy little dream in my mind," he would say as an adult.

When Johnny was nearly four, his father applied to have his name legally changed to James Marshall Hendrix. It bothered Al that Lucille might have named the baby after a boyfriend. The boy was told that he was now to be called Jimmy. This disturbed and confused Johnny, who'd been learning how to sound out and spell "Johnny" from a child's alphabet book he'd been given in Berkeley. "The kid," as he was often referred to, was now loaded with names. His aunt Dolores, Lucille's concerned and supportive sister, had earlier nicknamed him "Buster."

Later Johnny/Jimmy spoke of the first years of his life as "full

of confusion," and he did not easily discuss his childhood memories. There was a period before he started school when he and his mother and father all lived in Aunt Dolores's small home as part of her own growing family. "My auntie always tried to make things better," he said. The Hendrix marriage was an on-again, off-again union. Occasionally, to remove him from increasing parental tension, Jimmy was sent across the border to Vancouver, British Columbia, for brief stays with Al's mother, Nora Hendrix. In January 1948, when Jimmy was five, his parents produced another son, Leon. Not quite a year later, Lucille gave birth to a third son, Joseph.

Lucille felt trapped. She was too young to be the mother of one child, much less two and then a third; she couldn't handle being tied down. Al was increasingly bossy, short-tempered, and tight with money, always a problem for many residents of Seattle's Central District. There was no more romance—or jitterbugging— for this couple.

Jimmy's father was always telling him, "Don't get in the way" or "Don't make a fuss" or "No sassing from you!"

The boy swiftly learned that being quiet and dutiful occasionally helped to avoid loud, unpleasant volleys of fighting. Al told Jimmy, "That woman's a *mess*." He hated to hear his father talk ugly about his mother as much as he trembled at seeing her intoxicated, stumbling and shaky. Al was no teetotaler himself, and his eldest son often sobbed into an old pillow as he tried to sleep while ugly, noisy battles raged a few feet away from his bed. "Sometimes," Jimmy later told a friend, "I would lay there and ask myself over and over, 'Who am I? Why is this happening? What can I do?'"

One nightmare of an evening, Lucille left, never to return. "Jimmy baby," she told her son, "I have to *escape* this!"

For Jimmy his mother's words, her tears, remained an indelible memory.

The couple divorced in December 1951, with Al asking for and

receiving custody of the children. He wanted and arranged for Joseph to be "fostered out."

Al warned Jimmy and little Leon to stay away from Lucille. "She's a drunk. She's no good!"

"*No good.*" These words, too, haunted the little boy—who became the man Jimi Hendrix—for the rest of his life.

Don't Look Back

SEATTLE DISPLAYED nature's bounty in abundance, but the weather never could be counted on. In a matter of minutes, the breathtakingly lovely, shimmering blue panorama would often morph into gloomy gray, punctuated by intermittent threatening torrents of rain. "Changeable" was a good word to describe young Jimmy's existence; sunny, happy moments were mixed with hunger, abuse, neglect, and the intermittent ugly soundtrack of his parents screaming at each other.

After Lucille Jeter Hendrix left, the pattern that had existed from Jimmy's birth continued; he and his father moved from one low-rent perch, even from one gritty flophouse, to another. Little Leon had been sent to stay with relatives and in several foster homes, returning to Al and Jimmy at intervals. Between the ages of three and sixteen, Jimmy lived in fourteen different places and was pulled in and out of a dozen schools.

"As early as I can remember, I thought about running away," he recalled. "But there was nowhere to go in Seattle, except sometimes to visit at my aunt Dolores's house or to see Aunt Dorothy. She was not really my aunt, but I thought of her that way; she paid a lot of attention to me. I knew I shouldn't really run away, because then I'd be ducking out on my little brother."

The highlight of his early years was taking the ferry to Vancouver to visit his father's relatives. "I always looked forward to seeing Gramma Nora, my dad's mother, in Vancouver, usually in the

summer," he said. "I'd pack some stuff in a brown sack, and then she'd buy me new pants and shirts and underwear. I kept getting taller and growing out of all my clothes, and my shoes were always a falling-apart disgrace. Gramma would tell me little Indian stories that had been told to her when she was my age; I couldn't wait to hear a new story. She had Cherokee blood. So did Gramma Jeter. I was proud that it was in me, too."

He was closer to Clarice, who frequently took him to the small Pentecostal Church of God in Christ on Sunday. "I learned hymns there," Jimmy would recall. "I can't remember all the words now, but I can still hum the music." Clarice Jeter also introduced her grandson to one of his favorite pastimes—"going to the show," as he phrased it. Jimmy was excited to walk into a movie theater then and always thereafter. Early on, in his imagination, he envisioned himself as an actor. He liked it when Clarice would tell him about how she also had taken his mother to church and to the movies "when Lucille was little like you." Jimmy listened eagerly whenever his grandmother shared her memories of her youngest child.

Since Jimmy's birth Lucille had lived a shaky life. She was fragile physically and emotionally, wanting to be "grown-up" like her siblings, but Lucille wasn't cut out for demanding physical work, and jobs in Seattle were in scant supply. Working briefly as a waitress, for example, she showed difficulty lifting and carrying a heavy tray of dishes across the room. Sweet and pretty, Lucille was susceptible to men who complimented her or encouraged her to come out dancing and drinking with them. Taverns and beer joints were never difficult to find in the Central District, and the music was always hot on and around Jackson Street. Lucille made poor choices in men, who came and went or were told to "get lost" by her family. Her mother and her sister Dolores felt increasing anguish over Lucille and helped her in every way they could. "When I went to church with her, my grandmother prayed for everyone she loved, but especially for my mama," Jimmy recalled.

He saw his mother infrequently but often heard reports of her

loose life and her drinking, some of this told to him by his father. He cried in bed and in a closet, where no one would see him, feeling embarrassed and frightened for Lucille. Still, he was always excited about spending time with her, nervously hoping "that my mama would be okay, and that maybe she wouldn't be drinking anymore."

Despite the fact that Jimmy attended ethnically mixed schools and that the Central District was home to Yesler Terrace, one of the first fully integrated public housing projects in America, Seattle as a whole, like most cities in America during the 1940s and '50s, had its ugly pockets of racism. Young Jimmy both heard the word and was referred to as "nigger" countless times. As was his nature, he generally shrugged it off. Although recognized as a "bright child with an interest in art," Jimmy got only mediocre grades, and he often was tardy. Many times he was sent to school with a cup of milk as his only breakfast. Lunch was a hit-or-miss proposition.

"Al neglected the boy," a onetime resident of the projects remembered. "Then we'd notice him paying a little attention, and the next thing you know, the kid was all alone again. Al stepped out to have a few beers, do a little gambling and some flirting. Al liked the ladies."

Another neighbor of the Hendrix family was to say of Al's sons, "Leon was barely walking, and my wife and I would see just one light on in the evening, the two boys all alone. Sometimes we'd take a plate of hot food over on occasion or leave a bottle of milk on the porch. Jimmy never asked for food, but he certainly didn't turn it down. He'd say thank you three or four times; he was very shy. Through the window we'd see Jimmy holding Leon on his lap and feeding him. It was a sad situation. Once in a while, Jimmy and I used to throw a baseball back and forth. I gave him an old mitt I'd had for years, and he got so excited about that. Eventually they moved, a few blocks away, and there were stories that Al was feeding them horse meat. Several neighbors around here made a point of inviting Jimmy in from time to time, after Leon was put in

a foster home. Al Hendrix was not too happy about it; he didn't seem to want Jimmy being friendly with the neighbors."

Jimmy told me that when Al lost his temper or had been drinking, "my father often beat or slapped me. *Hard.* I tried to keep him from doing it to Leon."

For a time Jimmy lived with Al's brother Frank and his wife, Pearl, and their two children, Diane and Bob. "Regular meals," Jimmy remembered. "Diane was a little kid, but smart. We could laugh about things." His personality throughout his childhood veered from happy and bubbly to sad and quiet, depending on how secure he was feeling at the moment. However, with an erratic mother, an erratic father, a life rooted in poverty, and no lasting, stable home base, Hendrix always felt "different." He grew deeply embarrassed as he gradually realized that most of his teachers and some of his friends and their parents were aware that he came from what he later referred to as "a messy background."

Jimmy and Leon also lived with Grace Hatcher, the daughter of Al's sister Pat. The Hatchers had children of their own and little money, but "they were good to us," Jimi remembered. "The adults in our lives went without to be sure us kids got enough food in our stomachs." The adults also included Al's friends Ernestine and Bill Benson. "Ernie," as Jimmy affectionately referred to her, "was very sweet to me and my brother. Very concerned, you know. My dad really just dumped us with people while he was running around drinking, gambling, and showing off to women. He always needed lots of attention."

James Williams and Terry Johnson were Jimmy's closest child-hood friends, and as much as he enjoyed being with them, he said, "I wasn't laying no sob story on them about my mama and my dad and all that mess either." Together they roamed favorite neighborhoods and explored Seattle's verdant parks, running downhill to the water's edge. They talked animatedly of baseball and football, both sports Jimmy loved to play. "We laughed a lot; they were true-blue friends. They helped me in many ways," he

said, which included their giving him some decent clothes from time to time.

As Leon Hendrix's big brother, Jimmy was nurturing and protective whenever they were together. On occasional Sundays he would organize himself and Leon to look as respectable as their scanty wardrobes permitted so they could attend services at Goodwill Missionary Baptist Church. Zina Jordan, a member of that church since 1947, doesn't remember seeing them there, but later she was to say laughingly, "I guess I didn't pay attention to boys then. Jimmy looked better to me when we got to high school. I did recently talk to an older member of the church who said, 'Yes, they lived just a few houses away, and the boys came here. They didn't participate in Sunday school or the choir, though. They sat up in the balcony.' Our church had once been the old Jewish synagogue, and it had a balcony then."

Leon's first memory of his big brother comes from around the age of two. "I was little, and I thought of Jimmy as my father. He was my *protector*. But I did love Al. After all, I'd known him since I was born. He was the one who took me home from the hospital. Remember, he didn't meet my brother until he was three years old; they had a different kind of relationship. I was a happy baby, but when I look at pictures of me then, I think, I'm raggedy-looking! We had no clothes. Jimmy always found a way to feed me, and the neighbors helped. Aunt Dolores did. So I was never in any fear. My brother told me awesome stories. He took care of me and looked out for me."

Leon laughingly recalled, "Me and Jimmy used to get into trouble on purpose so we could go visit our mother. My dad made this our punishment—'You gotta stay the weekend at your mama's if you're bad!' That was what we wanted! Sometimes we'd wake up in the morning and smell pancakes and bacon cookin', and we knew Mama was there. It made us happy."

To his little brother, he was Buster, not Jimmy. "I remember watching Buster play baseball and football," Leon said. "And I

liked it when he drew cartoons for me. Buster was *really* good at art. Wherever we lived, he was always making pictures. He loved those color pencils, and he'd fiddle around trying to choose just the right color. Even though people think of him as left-handed, he could write and draw with his right hand."

When Jimmy visited his mother, they listened to the radio together. "Sometimes she'd sing a little bit to me," he said. "I'd already been messing with trying to learn music. I talked to my mama about it, and she would always smile." Lucille was aware that her son had started out "playing" a broom and that he had progressed to working over a "half-dead ukulele." He didn't tell her that he had begged and pleaded with his father to buy him his first actual guitar, an acoustic model, owned by one of Al's gambling buddies. "He paid him five bucks. Eventually," Jimmy said.

Jimmy was fourteen years old when he saw Elvis Presley perform at Sicks' Stadium in Seattle. Sitting in a cheap seat far from the stage, he was excited and intrigued by Presley's energy and unique body language, but what interested him most was the singer's tight backup band. "Those musicians were really something. Man, they were cool!" he said. "They made playing music seem like the best thing in the world." It wasn't until two years later that Jimmy owned his first electric guitar, a used white Supro Ozark, which Al Hendrix purchased at a downtown music store after much urging from his son. "I put in plenty of gardening time with my dad to get that guitar," he said. "Hours of sweat, lifting, carrying, mowing, trimming, and taking orders."

As her firstborn son was growing into his teens, Lucille's health declined. Jimmy visited his mother in the hospital on two separate occasions, bringing her his drawings and a special card he had designed. In February 1958, Lucille, in severe pain, barely made it inside King County Hospital; she died almost immediately of kidney problems that had resulted in a ruptured spleen. Besides Jimmy and Leon, she left four other children, the fruit of assorted

alliances, who had been adopted or fostered out. She was thirty-two years old.

Al Hendrix did not arrange for Jimmy and Leon to attend her funeral. As much as the fifteen-year-old boy disliked the thought of any funeral, it bothered him deeply for his entire life that he had not been allowed to pay his respects and show his love for his mother one last time.

He poured all his emotions into music. "Words meant nothing to me then," he said. The more the teenager played his guitar, the more his confidence grew. There were moments, Jimmy recalled, when he "felt as if I was flying, *soaring*. I felt *free*, like I could do most anything. I played for *me*."

He told me that during this time he used to play with a kindred spirit named Sammy Drain, whom he knew from Leschi School, the elementary school that both of them had previously attended. Named for a nineteenth-century Indian chief revered as a "courageous leader," the school was three blocks up the hill from Lake Washington.

Sammy Drain's adult memories of Hendrix revolve around his passion for music: "We both had paper routes down around the water. I was thirteen. Jimmy was fifteen. Eventually we started sitting on the porch and jamming together for hours and hours and hours. We would exchange licks and have so much fun in our own little world. We both were self-taught. We used to visualize being stars and playing for the whole world, the kind of stuff that kids fantasize about. His dad didn't want him to play or talk that way. He was kind of mean, you know. Al sometimes called it 'devil music.' Some people around here would shun Jimmy and make fun of him and the way he hung on to that guitar just about everywhere he went. That hurt him inside, but he didn't talk about it."

§

"HE WAS a sweet, polite boy, just crazy about making music," recalled Terry Johnson's mother, Florence, when she was told many years later that Jimmy always remembered her as "a very nice lady, a *real* lady, who was very thoughtful. Mrs. Johnson was a good cook, too. When we'd play at Terry's house, I used to kind of hang around hoping she'd fix me a plate after we were done practicing. And she always did." In her discreet way, Mrs. Johnson steered clear of any discussion of Jimmy's family life. "Those were tough times," she said quietly, "for many people. But I have always thought of Jimmy Hendrix as someone who deserved better than he got."

Over an eighteen-month period, Jimmy played in two bands, the Rocking Kings and the Tomcats, but not exclusively. A man named James Thomas was the guiding force behind both bands; he decided what songs would be played, searched for gigs, and generally acted as manager. Jimmy was, according to a follower of the Seattle club scene in the fifties and early sixties, "a kid who would go anywhere he could find transportation [to get to] and play guitar with any band that would let him sit in. Early on, I remember him playing bass before he was allowed to play lead guitar. Music was all he talked about. Hendrix played at dances, picnics, even in the street. He especially loved to play Ray Charles and Chuck Berry songs." The Rocking Kings and the Tomcats focused on performing cover versions of popular R&B songs. The two bands gigged at Jackson Street venues like the Black and Tan and Washington Hall and several times at a roadhouse near the airport, a jazz joint known as Spanish Castle. (Despite stories to the contrary, this was not the inspiration for a song Hendrix later wrote.) The Rocking Kings and the Tomcats also garnered a mild following at military bases in the state of Washington. "James Thomas grinned ear to ear when the Kings played in the all-state contest," Hendrix remembered, "They gave him a trophy and all."

Jimmy went to pieces when his Supro Ozark guitar was stolen from the stage at Birdland, a club where he often played, usually

with the Rocking Kings. Al was not sympathetic and told his son that it was his own fault for being careless. The loss of the guitar brought on a family argument, and it was his uncle Frank's new wife, Mary, who stepped in and bought, on credit, a white Danelectro for Jimmy. He soon painted it red.

§

CARROLL COLLINS was Jimmy's classmate in the class of 1960 at Garfield High School; she was well known as a member of the popular Hi-Fi's singing group. Now Carroll Brown, an energetic, well-spoken woman who runs two charitable organizations on the East Coast, she has always made a point of attending Garfield High School reunions. In 2000 she was asked to address the alumni gathered for their fortieth reunion. She recalled, "I talked spontaneously from the heart about what Garfield had done for all of us, and if they had not, did not, take advantage of what was given to us as young people, then shame on them. They certainly can't blame the school. The school has made me who I am today. We had teachers who cared, though they didn't look like us. The only black teachers were Mr. Hayes and Mr. Gary."

Ms. Brown continued, "Garfield was neatly manicured. Always! We had rhododendrons growing all in front of the school. We were not allowed to eat on the grass, but we were allowed to sit under the trees. Keeping the school beautified was *taught*. Respect for the school and the property and good values mattered. There was a dress code. Girls could not even wear slacks to football or basketball games; we were expected to act like young ladies and to wear skirts or dresses. We had to respect each other because our neighborhoods were diverse. We didn't need busing in those days. Our neighbors were African-Americans, Jewish, Chinese, Russian; therefore that's what the school looked like. We were taught to respect one another's cultures."

In remembering the Jimmy Hendrix that she knew at Garfield High, she chose her words carefully. "We understood, some of us,

that Jimmy had talent. We didn't think he was going to be college bound, but we knew he would do something with his music. He lived every day with that guitar! I mean, everyone else was in class, and he's outside on the stoop. Alone. He was usually by himself. We weren't allowed to smoke within ten blocks of the school. Smoking was a fad, so we all knew who did and who didn't. He did."

Jerry Carson was another classmate of Hendrix's at Garfield High. Carson, now deceased, went on to college and then became a reporter at the *Seattle Times*. He felt a warm regard for the self-taught guitarist. He remembered Jimmy as "being very excited when he heard a new record he liked. He'd try to learn the song right away. When I think of him, I recall him sitting in the classroom moving his fingers as he played an imaginary guitar."

Al Hendrix never had much communication with the teachers at any of the schools his son attended, and there was a minimum of discussion in in the fall of 1959 when Jimmy decided to drop out of Garfield High. He focused on two priorities—playing guitar and making money. He had been a good worker since the age of seven, when he was often seen helping Al with gardening jobs, sweeping up leaves, and mowing lawns. This work had continued on and off, and now once again he turned to gardening with his father, as well as other odd jobs, to support himself, since the money he made from music was minimal.

As Jimmy became better known around the Seattle club scene, numerous young girls paid attention to him. He definitely enjoyed this. "My special girl was Betty Jean Morgan," he told me. He saved up enough cash from the work he did with his father to buy an inexpensive engagement ring. Realistically, though, he was in no position to get married, particularly since he didn't want to remain in Seattle and Betty Jean was very close to her family there.

In 1961, Jimmy had anxieties that kept him awake at night. He promised himself that he would not be like his father, scrambling for money or echoing the mood swings and the grumbling—

"You don't know how many sacrifices I make." And the thought of his mother's short, misspent existence and miserable demise would always bring tears to his eyes. He was eighteen and eager to move forward. He had no plan, though, and over a period of several months, Jimmy made several foolish choices. "I stole some clothes from a place, and I 'borrowed' a car. I didn't do these things all on my own. But I did get caught and called up before a judge," he told me. A well-meaning counselor sat Jimmy down and strongly suggested that he should start thinking about enlisting in the army if he wasn't going to finish high school. "I got the message," Jimmy said. "If I ended up in jail, I knew I wouldn't be able to play guitar."

He yearned for a future that had nothing to do with his past. Jimmy went downtown to an army recruiting station and signed up; he had hopes of being assigned to the 101st Airborne Division. Hours later he felt shocked by what he'd done; he'd signed up for three years! "I was panicking, so I sat on the bed and had a little talk with myself. It might have been the first time I was thinking as a man, not as a dumb kid. I made myself a kind of promise—Don't look back. If you do, it will hold you back."

Chapter Three

Flying High

JIMMY ARRIVED at Fort Ord in California on May 31, 1961. A major military training post since World War II, Fort Ord covered more than twenty-five thousand acres; it was larger than the city of San Francisco. The appearance of the office buildings, barracks, and mess halls was strictly utilitarian. Most of Jimmy's fellow trainees, some three hundred of them, looked as uneasy as he felt in this strange new world. Being here was not about making friends; it was strictly about learning how to serve and protect America. Like Jimmy, many of the young men had enlisted to move on from impoverished backgrounds.

Jimmy underwent strenuous physical training and learned how to march "properly," sometimes for hours on end. He was taught to shoot, and he was proud of the sharpshooter badge he was eventually awarded. He was instructed in everything from how to wear a uniform to how to conduct himself in field marches and drill and ceremonies, down to how to salute. In the PX store, he and his fellow trainees could buy alluring postcards of nearby towns but they weren't allowed off base to enjoy the wonders of California coastal life for themselves.

The Monterey Peninsula immediately south of Fort Ord was dotted by the recently built coastal town of Seaside, the historic city and harbor of Monterey, and the tranquil villages of Pacific Grove and Carmel-by-the-Sea. Bing Crosby's annual celebrity golf tournament took place on the rolling, velvety golf greens of Pebble

Beach, with its fine mansions looking out to stunning ocean vistas. Down Highway 1, another twenty miles past Pebble Beach and Carmel-by-the Sea, lay the dramatic, mysterious, and awe-inspiring beauty of Big Sur. All his life the beauty of nature had mattered to Hendrix, and now he felt frustrated at accepting the stringent rules that didn't allow him to explore the California coast.

Fourteen miles east of the fort was the rich farmland of the Salinas Valley, a veritable carpet of green in the growing season. Oak trees, a few black walnuts, and tall eucalyptuses with graceful, trailing leaves were to be seen on the road to Salinas, as well as roadside stands selling fresh flowers. This was John Steinbeck country, detailed in the renowned author's novel *East of Eden*. Hendrix was familiar with the story and its setting; while still in high school, he'd seen the film based on *East of Eden*. Jimmy Hendrix admired the picture's star, James Dean, also nicknamed Jimmy, who died tragically in an automobile accident not long after the movie was made. Hendrix was particularly sensitive to Dean's character, Cal, a youth troubled over his unresolved family conflicts.

At Fort Ord there were no trees, no flowers—only bleakness out there on the endless acres of dirt, gravel, floodplains, and beachheads. Being ready to defend your country meant learning to sleep outdoors, no matter how wet, and then thanking God when you finally received the order to return to wooden barracks with rotting floorboards, to lumpy cots that now seemed the ultimate in comfort.

There was a drill instructor at Fort Ord in the late fifties and early sixties who told his men, "If you don't hate my guts by the time you leave here, I haven't done my job right!" Jimmy didn't hate anyone, but he didn't make any close friends either. The loneliness that he'd lived with all his life followed him to California, and he knew in his heart, he said, that no one truly cared about him. "I was worn out by nine o'clock at night. Between all those damn push-ups and potato peeling duty, my body, my

hands, ached so bad I could hardly sleep." Jimmy didn't like holding or using a knife in his long fingers. Early on, as a fledgling guitarist, he had become conscious of the need to always protect his hands.

The army allowed him a brief furlough in September, and Jimmy took the bus to Seattle, where he saw Betty Jean, Leon, assorted musician friends, and his father. When they all asked him what he would be doing next, it bothered him tremendously to admit that he had no idea. He didn't want to admit that he was scared about what future his military career might hold. Being a paratrooper, jumping through the sky, was a source of excitement he'd dreamed about. But what if he ended up being assigned to an office job—or worse? No one at Fort Ord had offered any clues, and even when he returned to the base, his future in the military continued to be a mystery.

In subsequent weeks Jimmy participated in advanced small-unit tactic training and still more rugged physical drills. His days were exhausting. "When my head hit the cot, I was out like a light," he recalled. He began receiving a salary of sixty-five dollars per month, and he was now allowed several four-hour passes to leave the base. On one of those passes, he managed to find a ride to Monterey to attend the annual jazz festival.

Finally Jimmy received the orders he'd longed for. He was to report for duty on November 8, 1961, at Fort Campbell, Kentucky, home of the 101st Airborne. He was jubilant. Now his uniform would soon show to one and all the fabled "Screaming Eagle patch," the proud symbol of the 101st. *And* he would be able to parachute through the sky. He *loved* that idea.

In January, Jimmy wrote to his father and asked him to send his guitar "ASAP." When he opened the bulky package and held the red Danelectro guitar again, checking over the strings, he felt deep happiness. Minus an amp, nevertheless he immediately fingered a bit of an old blues, humming to himself. In this moment Private First Class Hendrix was reminded that all he really wanted

to do was play the guitar. He thought, too, about Betty Jean Morgan in Seattle. He later told me, "She really didn't like to hear it when I talked of going to places like Los Angeles and New York one day. I cared for her, but the longer I was in the army, the more I knew I just *had* to get out into the world. My guitar was what had to come first, no matter what I'd promised anybody about anything."

He took part in a series of jumps at Fort Campbell. "It was scary and exciting when I stood in the jump tower," he said, "moving through the air but keeping my mind on landing just right." Jimmy stayed in touch with his father, asking about Leon and telling of his progress as a paratrooper.

One afternoon, in his off hours, he was deep into playing the guitar at an on-base music facility that provided amplifiers and instruments when another enlisted man, drawn by the music, came up and introduced himself. Billy Cox said in his soft-spoken way to Jimmy Hendrix, "You have real talent."

No one had ever said that before. Jimmy never forgot either these appreciative words or the look of respect on Billy's face.

It was Billy who suggested they put together a five-piece band, known around the service clubs as the King Kasuals. "A bit of the blues, a lot of R&B," Jimmy summed up. Off base the new band occasionally performed in Clarksville, a historic Tennessee town forty miles from Fort Campbell.

On his twenty-sixth parachute jump, Jimmy broke his ankle. Though it was a painful injury, he saw this as a good omen. Jimmy consulted with doctors and spoke at length to two different psychiatrists, explaining how much music meant to his future and asserting that he wasn't really cut out for the military. He was questioned extensively about his background—"They thought I was an oddball," he said with a shrug. The doctor he liked best was the one who reported in writing that the ankle, when healed, would not likely be stable enough for any more jumps.

Hendrix never served in combat, nor is he a part of the proud

history of Unit 187 of the 101st Airborne. During the occupation of Japan after World War II, American paratroopers were given a name that has been in use ever since—*rakkasan.* This is Japanese for "falling-down umbrella." The fancifulness of the term appealed to Hendrix, but ultimately the 101st Airborne gave Jimmy what he wanted even more—a medical discharge.

The Struggle

Loneliness is such a drag.
—*Jimi Hendrix*

JIMMY HENDRIX was a fool. He said so himself. "I was a disgrace to my Screaming Eagle patch the same day I left Fort Campbell." Hendrix squirmed when he recalled his behavior on that long-awaited day; after thirteen months he was finally free of the discipline of military service. "I received my discharge just before the Fourth of July in '62. They gave me all the money I had coming to me, a little over four hundred dollars. It was the most money I'd ever had in my entire life. And do you know the kind of fool you're talking to? That fool blew that money, just frittered it away in a day. I was Mr. Big Shot, buying drinks for people I didn't even know, loaning, giving—because I never saw a dime of it back— almost all of it away."

Jimmy was in a panic for the next few days, trying to survive on the eighteen dollars he had left, and that included all the change. If someone had accidentally dropped a fifty-cent piece on the sidewalk, he couldn't wait to grab it. He was not yet twenty years old, and here he was in Clarksville, Tennessee, faced with the same problems he'd faced when he left Garfield High School. "Working odd jobs again," he said. "I couldn't believe I'd put myself in that situation. I played guitar for a couple of dollars here

and there, just waiting for Billy to finish up in the service so we could get something going."

But life continued to drag, even after Cox was discharged in September. The two musicians tried their luck in Indiana. Luck didn't exist there. They headed back to Tennessee, to Nashville, and performed at the Club Del Morocco. Jimmy and Billy also found brief employment backing up assorted rhythm and blues artists. "I needed money, but I always wanted to learn, along with the dough. The best gig," Hendrix recalled, "was working with Curtis Mayfield and the Impressions. Curtis was a *really* good guitarist, but he was the star, and he thought I was flighty. I learned quite a lot in that short time. He probably influenced me more than anyone I'd ever played with up to that time—that sweet sound of his, you know."

Hendrix met a handsome young rhythm guitar player in Nashville, Larry Lee, who was supportive of his talent and helpful in many ways. Larry was one of the few people, Jimmy said, "that I could *really* talk to."

Fall deepened into winter. "Cold, homesick, and hungry," Jimmy hustled a couple of free rides and took a series of buses more than two thousand miles across America to Vancouver to stay several weeks with Gramma Nora in her apartment. He managed to pick up a few bucks, sitting in with a group called the Vancouvers at a club known as Dante's Inferno, and he refueled his determination to "be recognized in the big world." Once again Jimmy took up his personal battle cry, "Don't look back!"

He didn't bother to hop on the ferry from Vancouver to Seattle to visit his father. Two telephone calls to Al Hendrix had been unsettling and depressing. Al didn't suggest that he come home for a visit, nor did he encourage his son in his music; he made it clear that he wished that Jimmy had stayed in the army. "He made me feel like a failure," Jimmy said. "And of course I was. But I didn't plan to stay one."

He played and bused his way back to Nashville. He and Billy

Cox were always treated well at the Club Del Morocco on Jefferson Street; Hendrix remembered it as their steadiest job. Guitarist James "Nick" Nixon knew Hendrix in those days. "Jimmy's music was almost like Delta blues with a little twist to it," Nixon said. "A little ahead, you know. At the time I didn't understand it. A lot of people didn't understand it. Jimmy thought we didn't appreciate him. But that wasn't right. It was just because we weren't used to it."

Today Nixon is a respected guitar instructor and a member of the long-established New Imperials band. Thinking back on his friendship with Hendrix, he commented, "I didn't necessarily listen to a lot of Jimmy's music. And at that time it would have never occurred to me that he would become famous. What I basically did was run around with Jimmy, you know. We were all very young—Jimmy, Billy Cox, and me—just hanging out, having a good time."

Jimmy's education as an artist and performer continued. Most important to him in this early part of his career was "listening, listening, listening. I learned more hearing blues players at clubs and on the radio in Kentucky and Nashville than I ever did in Seattle," he said. Still, Jimmy couldn't make a living in Nashville. He and Billy had met George Odell there, a man who made his money on the road backing up assorted singers and playing a set or two with his own band. "They called him Gorgeous George," Hendrix said. "He was a character from the get-go. He wore a fancy silver wig and flashy clothes. Billy wasn't too sure about him, but I had nothing to lose. I joined his band for a while in '63."

In the next couple of years, Hendrix crisscrossed America with assorted rhythm and blues bands on what has long been known as the "chitlin circuit," a network of black clubs and theaters in big cities and tiny country towns. (Chitlins, or chitterlings, are pig intestines, considered a delicacy in certain southern and black circles.) He backed up such popular artists as Jackie Wilson, Sam Cooke, King George, and Wilson "Wicked" Pickett and appeared with no-name bands that fizzled out and musicians he soon forgot.

Jimmy finally had to face the fact that there was no future for him on the circuit. "The money was nowhere, and I saw guys getting old just trying to get by, backing up anybody for the bucks whether they liked them or not." Through it all, despite increasing female attention, he felt an intense, abiding loneliness. He sent postcards to his father, trying to create a connection that really wasn't there. He missed Leon and wondered if he was still "fostered out." "If I was gonna be in a city for a few days, I'd put the address where I was," he said. "Sometimes Dad wrote me back. He sent me ten dollars once and five bucks a few months later. But he never offered me a bus ticket to come back to Seattle for a little break. I couldn't bring myself to beg, couldn't bear the idea that he'd make me admit that I just wasn't cutting it. My true—the truest companion I had was my guitar. I would practice until I fell asleep. I slept with it many nights, quite naturally to keep it from being stolen and because it was all I had—until the next time I pawned it for money to eat on." In the army Jimmy had become strong and fit. On the streets he lost weight; he became "too skinny," and his stomach was never full.

Jimmy turned twenty-one on November 27, 1963, and he long remembered how hopeless life seemed to him on that birthday. Five days before, John F. Kennedy had been assassinated in Dallas. "A great man gone just like that. I always admired Kennedy and saw him as special. I cried for him. I was broke. I was no-count. But I cried for him and maybe a little for me. Kennedy was born to accomplish important things. I had accomplished nothing. I *had* to do something about it."

Four months later, with a few dollars saved, Jimmy summoned up his nerve to take on New York City. He didn't know a soul there, and he felt fearful about how he would fare, as he bused his way across the country. When he arrived, he headed straight uptown to Harlem. "It was *awful* when I first laid eyes on Harlem. Huge rats. Freezing-cold tenements. Harsh voices. Scary-looking people screaming in the streets. Drawn knives flashing." He heard about

the famous Wednesday-night amateur contest at the renowned Apollo Theater on 125th Street, where for more than twenty-five years many outstanding entertainers from diverse ethnic backgrounds had gotten their start. "I won first place," Hendrix said. "I was thrilled! That applause was for *me*. They gave me twenty-five bucks. It seemed like a fortune." There is no record of what music he played that night.

The money was soon spent on the necessities of life. A friend of a friend introduced him to the Isley Brothers, and he joined their backup band. They treated him well, and he recorded on several tracks, most notably "Testify." Ed Salamon, later an illustrious figure in radio broadcasting, was about fourteen years old when he attended a white teenage dance club known as Club Giant in Pittsburgh, Pennsylvania, circa 1964. "This was the Brentwood area on Brownsville Road, and there were more than two hundred kids at the club that night dancing to the Isley Brothers band," he recalls. "I was an R&B fan, and I noticed this guitar player who was quite compelling. I'd never seen anyone so *extreme*—he outdid Bo Diddley! It wasn't his band, and he wasn't a star, but Ronnie Isley was allowing him to express himself. This young player, Jimmy Hendrix, made quite an impression on me, and the next day at school, I couldn't stop talking about him."

Jimmy also played on Don Covay's hit "Have Mercy." "I was frustrated all over again," he said, "because it looked like I would never rise above being a member of someone else's band."

He went through a period of deep depression; the idea of ending up a loser was tearing him up. "Some days I felt that I was losing my mind. I'd tried everything I possibly could."

"When I was a teenager," he said, "I *never* would have believed that when I left Seattle and became an adult in the real world, I'd still be praying for the soles of my shoes to last just a little longer." Jimmy had convinced himself that his musicianship would lead to great opportunities soon after he left the military, and he'd been wrong.

Hendrix toured with Little Richard in two separate stretches of time; his memories were less than glowing. There were weeks when he didn't receive a salary, and he still felt bitter about this. "Every dollar counted to me then." While he admired Little Richard's showmanship and his impact on rock and roll, working with him was a disillusioning experience. He said, "When I wore a new shirt with some frills, he had a fit and screamed, 'I'm the *only* one who's allowed to be pretty!'" Jimmy suddenly launched into a scary imitation of an angry Little Richard: "'Hendrix, you be deaf? You git rid o' that shirt, *boy*!' There were always problems," he declared. "I wanted to quit. His brother wanted to fire me."

Musician Ellen McIlwaine recalled, "The first time I ever saw Hendrix was in 1965 in Atlanta at the Royal Peacock, backing up Little Richard. We referred to him as Dylan Black because Bob Dylan was the only person we knew of at that time that had [his] hair puffed out. Hendrix's wasn't natural. It was curled and puffed out."

In many respects 1965 was Hendrix's worst year. One positive aspect, however, was his songwriting. Jimmy had steadily concentrated on teaching himself how to write songs, lyrics as well as music. Unlike many black players, he paid full attention to contemporary white music, and, as he said, he was "digging it," especially another guy with an original sound—Bob Dylan. He felt better the first time he heard Dylan's song "Like a Rolling Stone." Jimmy bought the album and carried it around to play on other people's record players. "It made me feel that I wasn't the only one who'd ever felt so low. I'm talking about the chorus, you know." Slowly, he recited the words to me:

> "How does it feel
> How does it feel
> To be on your own
> With no direction home
> Like a complete unknown
> Like a rolling stone? . . ."

His voice momentarily vibrated with remembered anguish. He *knew* exactly how it felt to be on his own. "It feels so awful that it's beyond words."

Jimmy told me that he'd carried around scribbled lyrics, phrases, and musical themes written down on motel notepads, cheap stationery, and napkins stuffed in a duffel bag. Some of these quick notes would later surface as memorable songs.

For example, in his hardscrabble years going back and forth, up and down, across a country even more vast than it appeared on a map, he'd written on a bus-ticket envelope *"Highway Chile . . . You'd probably call him a tramp. . . ."*

He noticed the way he was observed by "normal people." His odd, worn clothes, the run-down heels and holes in his shoes. "I saw strangers look at me with scorn," he said.

The way he emphasized the word "scorn," his eyes tightening, it was apparent that these moments had been crushing. A *tramp*? No, this was not his dream.

During this year Jimmy met three people who would affect the rest of his life in highly negative ways—Curtis Knight, Edward Chalpin, and Devon Wilson.

Curtis Knight, born Curtis McNear, a small, ambitious young black man with a huge gift of gab, was a good if not great guitar player; he and his band, the Squires, played a motley assortment of gigs around the New York City area. When he ran into Hendrix in the lobby of a cheap hotel and they spoke of guitars and Jimmy's experience on the chitlin circuit, Knight almost immediately decided that he would use him in his group.

A New York drummer active in the 1960s club scene later said about Knight, "Curtis loved music, but he had too many other things going on. It's no secret that Curtis was a pimp, also one helluva high talker, a basic bullshit artist." Several musicians who'd been used and burned by Knight filled Jimmy in on him. Still, Hendrix didn't have a choice. He worked with Curtis on and off, strictly for the money.

"Juggy" Murray, a well-connected figure in R&B music circles, signed Jimmy to a two-year recording contract with Sue Records in July 1965, but nothing came of it. Jimmy's rule of thumb was to check in weekly with anyone likely to help find him work. "I believe he tried, but Juggy didn't come up with anything for me," he said.

In the fall of 1965, Curtis Knight introduced Hendrix to Edward Chalpin, a music entrepreneur with an office and a tiny ten-track recording studio at Broadway and Fifty-first Street in the heart of New York's music-business district. On the evening of October 15, Hendrix affixed his signature to a one-page recording contract with Chalpin, agreeing that he would "produce and play and/or sing exclusively for PPX Enterprises, Inc. for three (3) years." The contract said that Jimmy "shall receive one (1) per cent of retail selling price of all records sold for his production efforts, minimum scale for arrangements he produces." Clause 6 stated, "Jimmy Hendrix shall play instruments for PPX at no cost to PPX Enterprises, Inc." The agreement did not specify anything beyond the "one per cent of selling price" that Chalpin would give to Jimmy. The "one per cent" would bring Hendrix less than a penny for each single sold and perhaps a total of three cents for an album, which then generally sold for approximately three dollars. He saw no money from this agreement in the next year, and his time in the studio with Ed Chalpin was minimal. "The sessions we did do were focused on Curtis," Jimmy said. Curtis spoke often of Ed Chalpin "as my manager and adviser" over a period of years. Hendrix, however, never had a manager-client relationship with Chalpin.

Hendrix played intermittently with Knight at the Cheetah, a spacious discotheque on Broadway and Fifty-third Street, bankrolled by several Frenchmen. He was using the name "Jimmy James" these days, the last name inspired by one of his favorite bluesmen, Elmore James.

Loneliness and lack of money continued to haunt Hendrix. As

he evolved into a tall, slim adult possessed of a charming, shy sex appeal greatly enhanced by his prowess with a guitar, Hendrix's most nurturing moments were those offered by young women who desired to protect and help him in any way they could. Joyce . . . Fay . . . Rosa Lee . . . Kim—these were among the names he mentioned to me as "girls who believed in me, fed me, gave me money." His tone was matter-of-fact, but his eyes were downcast. He was ashamed.

For many months Jimmy dressed in black, "partially because it didn't show dirt." He nightly washed his one and only pair of black pants. There were numerous occasions when he couldn't afford new underpants, he said.

In late 1965 a beautiful girl eyed Jimmy at a New York club, and, as he said, "I eyed her right back." Devon Wilson was a slim, beautiful, and troubled black girl who had left home in her early teens. She was drawn to exciting people in glamorous places, and by age sixteen Devon was supporting a new and expensive lifestyle as a call girl in Las Vegas. After a couple of run-ins with the law, she moved to New York City. Hendrix told me that Devon was the one who had introduced him to LSD, also to a variety of pills. His drug usage until that point had been irregular and minor, and Jimmy, while attracted to Devon, did not encourage a steady relationship.

"Devon had a lot of contacts in high and low places," a member of her inner circle in the late sixties said. "She could score any kind of drug you wanted to buy. She looked like she could easily become a successful model, but Devon never got her act together. She hurt a lot of people, including herself."

§

JIMMY JOINED King Curtis, a divinely talented saxophone player, in early 1966. Curtis was in demand for important record sessions, particularly at Atlantic Records, and he had his own band, the Kingpins. "I had to be quick to pick up what the King wanted,"

Jimmy recalled, "and I think I did a pretty good job. Cornell Dupree, a very pure player, was on lead guitar. Bernard 'Pretty' Purdie and Ray Lucas alternated as drummers. Chuck Rainey played bass, *great* bass. They were the classiest musicians I had ever played with. I did some recording with them, too."

Surely, Hendrix told himself, this association would be his *huge* break. Now he had opportunities to meet respected record producers, who undoubtedly would pay attention to his ability, his special sound. "Not bragging," he said of his high hopes then, "but I was greatly improved from the way I was playin' in 1963. Some nights, I swear to you, I just sizzled!"

Everyone in New York music circles knew that King Curtis worked with only the best, but although successful, respected major record executives and producers listened to Curtis's current lineup onstage and in the recording studio in early 1966, the undeniable fact was these men never considered Jimmy as a potential star; later on, Hendrix was to smile tightly when told, "*I* always knew you'd make it!"

Although this was a period of escalating social change in America, segregation still held its own in many parts of the country. In the recording industry, as in many others, blacks had been frequently taken advantage of, particularly financially, and this would not change overnight. Five years later, leading record labels began to consider grooming Negro performers to appeal to white audiences as well as black. But in early 1966, Hendrix was strictly a backup musician; he lacked standing to attract the attention of experienced managers who could find him deals, give him artistic advice and support. "I remember seeing Hendrix play . . . several times in 1966," a noted white record producer recalled. "No way could I have sold him to my label, but I did recognize his potential as a musician. Still, I never visualized him as a star, nor did I think of him as a guy who could write powerful songs. To me he was just another musically hip Negro who happened to possess a great smile. I'm no racist; I could say I felt the same

way then about plenty of white kids who were after a record deal. For me it's always about coming across a hit song. If Hendrix had been playing a hot tune, you can bet I would have jumped on getting the rights. He'd have been paid fairly, but I would have had to give that song to a white artist to break it big."

Hendrix left the Kingpins after four months. It simply wasn't a situation where he could stand out, and he had come to believe that being "out front" was the only way he'd gain the recognition he was struggling so hard to achieve. "I got to the point where I'd rather make a fool of myself than not try," he said. "It's so risky tryin' to be different, tryin' to chase your dreams." He picked up other gigs with the ever-ingratiating Curtis Knight and also with Carl Holmes, a Philadelphia soul singer. Al Aronowitz, then writing a widely read music column in the *New York Post*, remembers seeing Jimmy play a gig at the Cheetah in April 1966. "I'd never seen anything like him," Aronowitz says. "There was a point where I couldn't take my eyes off him."

As Jimmy became more familiar with Manhattan, as opposed to only Harlem, he decided it was time to cease "just looking in the window" at Manny's Music on West Forty-eighth Street—all those guitars beckoning to him. One day he finally summoned up the nerve to step inside. He carefully inspected both acoustic and electric guitars. Eventually he became a familiar figure in this guitar mecca; the salesmen, several of them fine musicians themselves, liked him and his sounds and allowed him to play assorted guitars. Their encouragement prompted Jimmy to check out Greenwich Village, a two-mile walk down Sixth Avenue from Manny's. It was the bohemian character—and characters—of the Village that offered him renewed hope for a true breakthrough. No one stared at the tall, slim, pale, young black man with his guitar slung over his back. "People treated me good in the Village," he said. Timidly at first, he walked around the narrow streets, peering into the windows of the coffeehouses that served as hangouts for the locals who played chess, read poetry, discussed Beat writers,

gossiped, and listened to the music of the "folkies" who populated the area. "One of the first places I set foot in," Hendrix said, "was the Café Wha? Dylan had played there early on. So of course I hoped they'd let me play there, too. It was a little dream of mine."

Near his latest cheap hotel, he'd met Mike Quashie, a renowned Trinidadian limbo dancer at a spot on West Forty-fourth Street known as the African Room. Quashie was a well-known figure around the New York club scene. "Mike's a colorful guy," Hendrix said in 1969, "in the way he dresses and in his own special way of talking. He was groovy about loaning me money or asking if I had a place to sleep. I was always on the lookout for a floor or a sofa to fall apart on in New York, especially if it was anywhere remotely near the Village." Hendrix added quietly, "The day came when I was able to repay his help and his dollars with interest."

Another "Jimmy believer" was saxophone player Lonnie Youngblood. Hendrix recalled, "I learned a lot about playing guitar from the way Lonnie played tenor sax and the tones he produced. He also was a very good friend to me."

Youngblood remembers Hendrix as "inspiring." "Jimmy was a phenomenal musician," he said. "He had a depth and a deftness that went far beyond an ordinary guy, you know what I'm sayin'? The depth of your structure creates a different thing, and Jimmy happened to have that. I remember one night when we were working at the Lighthouse, the Broadway club in the West Seventies. I wanted to play something different. I wanted to play 'Misty,' and I hoped that was cool with him, because I didn't want to put him in a strange situation, since we'd been playing a lot of straight-out R&B. He said, 'Go ahead, man.' I said to myself, This is gonna be interesting, and sure enough it was interesting, because Jimmy played the hell out of 'Misty'! I felt it was unbelievable that this guy could have such a dedication and love for blues and such an ability that he could go and take his playing into a whole 'nother genre and create such a great rendition that the people there that night loved it!" The sax player treated Jimmy as a

brother. He kept an eye on him, bought him an amplifier, and made sure the perennially late Hendrix got to gigs on time. Lonnie and his wife helped him pay his weekly hotel rent. Youngblood was one of the rare men in Jimmy's life whom he could count on and who wasn't looking for anything from him.

In 1966, shortly before Hendrix broke away from Curtis Knight, he met Regina Jackson (not her real name), a teenage runaway from Minneapolis. Jimmy recognized that the sixteen-year-old Regina, a fledgling prostitute with several arrests on her record, was no match for the dangers of the low-down life in New York City. Just as most of his "chicks" had shown concern for him and his beaten-down dreams and miserable lifestyle, Jimmy attempted to perform his own good deed. Now *he* took on the role of nurturer; if the realities of New York on zero dollars a day had devastated *him*, this big city was absolutely no place for a teenage girl from the Midwest. He told me he repeatedly urged Regina to abandon the streets—"She was headed for terrible trouble." They lived together for a short time in two different inexpensive hotels in the Times Square area. Ignoring Jimmy's heartfelt admonitions, she soon was arrested again, and this time she left New York in a hurry to avoid jail time. The headstrong Regina, who was in the early stages of pregnancy, moved so quickly, in fact, that she couldn't find Jimmy James to say good-bye.

§

FOR SOME time Hendrix had been "fooling with an idea about a band of my own. First I was thinking of calling it the Rainflowers, but I went with Jimmy James and the Blue Flames." That summer he and a changing cast of fledgling musicians played a short string of gigs in the Village. Here he unveiled his own versions of two songs that would serve him well in the future, "Hey Joe" (written by Billy Roberts) and "Wild Thing" (written by Chip Taylor).

Already Jimmy, ever the hapless juggler of female attention, had caught the eye of a young Englishwoman who was to serve as

a vital catalyst in his career. Linda Keith first had been captivated by Hendrix's guitar-playing antics at the Cheetah; now the English model spent her evenings in Greenwich Village watching Jimmy and the various different Blue Flames. Keith was close to beautiful, stylishly dressed, with great legs and shiny, well-cut brown hair. A former coffeehouse waitress in the Village said of Keith, "You knew by looking at her that Linda was a model, and she seemed to know all kinds of important people. We heard that she was Keith Richard's girlfriend, but she definitely was crazy about Jimmy James. Every time she dropped in, she was telling someone about how talented he was, how he was going to be somebody. That British accent of hers jumped out in a small room. She had to be the classiest woman I ever saw around Jimmy."

Linda Keith *knew* music and was convinced, she told Jimmy, that his destiny was to be a great star. She sang his praises relentlessly to every English musician she knew: "You've got to see Jimmy; he's *fabulous!*" She told the husband of her best friend, Sheila, Rolling Stones mentor Andrew Loog Oldham, about Jimmy, believing that this hip "tastemaker" would sign him up, but Oldham didn't react with the fervor she had expected. The Stones themselves turned up on July 2 to see Jimmy perform at Ondine, a popular discotheque on East Fifty-ninth Street. The Stones flipped for Jimmy's guitar sound and his unique onstage persona. Rolling Stone Brian Jones became a major fan from that night on, and in the coming months Jones treated Hendrix better than he did almost anyone else around him. The Stones' approval validated Linda Keith's feelings that Hendrix could be a star.

On July 5, Linda Keith ran into Chas Chandler, bass player for the Animals, one of the first bands to tour America as part of the British Invasion. Chas was well over six feet, big-boned, pudding-faced, with light blue eyes and a sleek short haircut. He was no more than a mediocre bass player; still, he was a founding member of the Animals and had toured extensively and played on all their

hits—including "House of the Rising Sun," "Bring It on Home to Me," and "We Gotta Get Out of This Place."

Word had gotten around that Chas was splitting from the group. He was the first to admit that he wasn't a great bassist. Plus, he'd made little money, due to the skewed business strategies of the Animals' manager, Michael Jeffery, who always looked out for number one. Chas was thinking these days that record production was where the real money was, and here was Linda Keith, whom admittedly he barely knew, raving about Jimmy James.

Chas showed up at the Café Wha? at the corner of MacDougal and Minetta streets just hours after his chat with Linda, to see for himself. Like the Rolling Stones, he, too, immediately recognized Jimmy as "very special," and he was excited that this hot guitarist was playing "Hey Joe," a song he'd heard before and thought was fantastic. Chandler felt so strongly that he saw the combination of Jimmy James and *that* song as a good omen.

Chandler introduced himself as soon as Jimmy finished his set, speaking in a husky Geordie accent, complete with rolling *r*'s, common to the Newcastle-upon-Tyne region in the north of England, where he'd been born. "I tried not to get excited," Hendrix recalled, "but I was thinking about the Animals' hit records, which I liked, and thinking that this *might* be a good connection. I was tryin' to be cool, but Chas laid on the compliments in that thick accent of his. I mean, he *raved* till I was getting embarrassed; he was crazy about the slow version of 'Hey Joe.' He even seemed to like the way I sang it. I'd really never talked that long to anyone quite like him before, being English, hip to the blues and all. He told me that I'd be hearing from him as soon as he finished up with his band. I didn't see him again for six weeks."

In the interval John Hammond was appearing at the Gaslight on MacDougal Street, a Village club where Bob Dylan had introduced his powerful song "Masters of War." Several musicians mentioned Jimmy James in such glowing terms that Hammond

hurried to check him out. Although in his early twenties, Hammond was already an authority on the blues, which he played and sang with passion. Hammond would say, "Jimmy amazed me. Playing left-handed and upside down on a Strat, he was *brilliant*. And offstage he was a sweet and essentially humble guy who took great joy in music. I recognized him as one of a kind." Almost immediately they did some rehearsing, and Hammond invited Hendrix to join him in performance at the Cafe Au Go Go on Bleecker Street.

Hendrix's face lit up when he spoke of Hammond. "He plays and sings with so much feeling," he said. "When I came to know Johnny Hammond, I found out that he was not only handsome but that he owned hands and fingers and a soul just made to play the blues. He is one of the nicest human beings I have ever met. John is a *gentleman*, and he treated me like one, too."

When Chas Chandler, now an ex-Animal, returned to New York in early August, he immediately began searching for Jimmy James. Flustered because Jimmy had moved out of his cheap hotel and the desk clerk there was clueless as to where he'd gone, Chas headed for Greenwich Village, popping in and out of the coffee-houses and clubs. Someone told him that Jimmy might be getting something together with Johnny Hammond. Chas knew that Johnny's father was the renowned Columbia Records producer John Hammond, who had discovered and nurtured, among many others, Bob Dylan. "I was cursin' at the thought that I'd lost Jimmy," Chandler said. Chas headed for the Cafe Au Go Go. "I was worrying it over," he said. "What if Mr. Hammond was on his way to signing up Hendrix?" He breathed a sigh of relief when he spotted Jimmy, who said, "When are we going to get serious?"

The next afternoon Chas, accompanied by a colleague, dropped into the Cafe Au Go Go to talk business. Chandler spied Jimmy sitting against one of the club's redbrick walls, inspecting someone else's acoustic guitar. He introduced Jimmy to Animals manager, and Chas's future business partner, Michael Jeffery,

a brown-haired, "straight"-appearing Englishman of medium height, with keen eyes framed behind the nerdy, businesslike glasses that he always wore. Jeffery had not heard Jimmy James play before, nor did he ask Jimmy to play for him then. Jeffery was there simply to check out "the look" of this unusual character that Chas had praised to the skies. In a matter of minutes, he was whispering to Chas, "*He* could be the black Elvis!"

Ellen McIlwaine, who had moved up to New York from Atlanta and who later would become known for her talent as a slide guitarist, happened to be singing and playing piano at the Cafe Au Go Go, where she'd recently met Jimmy James. Ellen remembers Chas Chandler's visits to the Au Go Go: "When Jimmy was first talking to the English guys, he introduced me. I heard Chandler telling him, 'Come with me to England, and we'll do this and this and that.' Jimmy wanted to know if he could take any of the Blue Flames with him. Chandler said, 'You don't need them. I'll put a band together for you in London. And the name Blue Flames has to go. We have our own Blue Flames in England.'"

Jimmy listened to all that Chandler and Jeffery had to say. There was discussion of his real name and of changing the spelling of his name to the more fanciful, eye-catching J-i-m-i. Hendrix briefly mentioned the recording agreement that he'd signed with Ed Chalpin almost a year earlier, and also the agreement with Sue Records. "Not legal," said Jeffery. "You had no representation of your own. Don't worry. I'll handle it."

Chas didn't especially admire Jeffery as a person; after all, the Animals were perennially grousing that Mike cheated them. But he did appreciate what Jeffery had accomplished with his life—he was a man of wealth and property, and he knew how to talk business with music executives and lawyers. Chas really didn't know any other managers that he felt would take him seriously; he believed that he could learn from Mike, but mainly he felt he needed him as backup to get Hendrix off the ground.

Jimmy signed nothing with Chandler or Jeffery at this time.

However, in mid-August—still never having seen Hendrix play guitar—Michael Jeffery opened an account in the name of "Jimi Hendrix" in the Bahamian tax shelter known as Yameta, that he had established early in 1966. Hendrix was not told of this, nor was he made a signatory on the account.

"In the Village scene at that time," Ellen McIlwaine said, "there was a lot of sitting around and playing together, a certain camaraderie. Jimmy influenced me as far as using the guitar as a voice, and how to make sound effects on a guitar in three easy lessons! He just did it with a guitar and an amp. He really didn't need all those gimmicks that became popular later. I loved to watch him."

As much as she appreciated Jimmy's talent in the summer of 1966, Ellen was startled to observe his competitive side: "He played with Johnny Hammond and really just blew him off the stage on purpose! And then he *still* wanted to play on my sets, and I thought, 'Oooh are you kidding? I'm gonna ask *you* to stab me in the back?' But he didn't do that to me. And in retrospect I realized that John was enough of a friend that he *allowed* Jimmy to express himself. It was an act of generosity."

Chas enjoyed observing the audience at several of the Hendrix-Hammond gigs; the warm, excited response reinforced the new manager's deep belief in the talent of his star-to-be. No matter how late Chas had been up the night before, his days were devoted to taking care of the future. He paid off Sue Records—it required less than one hundred dollars—to be sure the small company would have no further claims on Hendrix as a recording artist. He was delighted that his meager offer was readily accepted. It took Chandler longer to get his way in Seattle. He spoke with the vital-statistics bureau there numerous times in the search for a copy of Jimmy's birth certificate; the fact that Al Hendrix had changed his son's name confused the issue. Chas dealt with lawyers, asking for help in rushing through Hendrix's first passport, and he contended with Jimmy's skittishness about getting the necessary smallpox shot. Chas literally shoved him into kindly Dr. Meyerhoff's office

on West Fifty-seventh Street, where Jimmy closed his eyes while the deed was finally done.

More than four years had dragged by since he'd left Fort Campbell, so confident he'd soon be recognized in "big-time circles" for his musical talent. It didn't occur to Jimmy that he was naïvely setting himself up for disappointment, disillusion, poverty, sleepless nights, and the aching dismay of regularly pawning his guitar to stay alive. Time and time again, he dropped to his knees and prayed to God. He had wept and struggled and picked himself up one more time, still waiting for the day—as bluesman Willie Dixon had written—that *"the world wanna know what this all about."*

Johnny/Jimmy/Jimi was ready.

Part Two

London, Paris, the World!

Chapter Five

Thrilling Times

THE PASSPORT for James Marshall Hendrix came through the morning of September 23 1966. Chas wasted no time; by early evening he and his first discovery/client had arrived at John F. Kennedy Airport on Long Island and were waiting impatiently to board the Pan Am flight. Accompanying them was Terry McVay, road manager for the Animals, a hardworking, no-nonsense Newcastle lad.

Chas felt excited and nervous, and his ideas for launching Hendrix kept his mind racing on the flight over. Chas was sure that every great musician in London would freak out over Jimi the way he had—*that* was the key to making Hendrix happen. Finding a record deal was essential. He knew he had to get down to business straightaway and create instant luck. If things were to drag out, the whole mind-blowing impact of Hendrix and what he was all about might be lost. Chas was obsessed, and his neck was stuck out all the way.

Seated beside him, Chas's discovery had his own thoughts. Jimmy Hendrix and Jimmy James were *gone*. Forevermore, the name would be Jimi! Hendrix amused himself and a smiling Chas by writing the name over and over. "Chas always liked to believe he'd thought of it," Jimi said to me in 1968. "Actually, that spelling had crossed my mind before; I'd even used it a couple of times in New York." On the plane they talked and talked about how important it was to make everything happen fast. Nothing good

had ever happened quickly for Hendrix before. In the back of his mind, he figured that at least he was getting the opportunity to travel in a first-class seat—which was a big deal to him—and a chance to see, maybe even meet, the best English guitar players.

McVay quietly but firmly helped smooth the way with Her Majesty's customs officers, and he carried Hendrix's white Stratocaster through the checkpoint. Jimi, as an American, was cautioned that he could not work on this trip, and his shiny new green passport was stamped accordingly.

As soon as they left Heathrow airport that morning and headed into London, Chas, sensitive to Jimi's concerns about "fitting in with English musicians," decided to put his fears at rest. They dropped in at Zoot Money's house on Gunterstone Road in West London. Zoot (real name George Bruno) was a warmhearted, outgoing, talented organist in the Jimmy Smith tradition, with his own rhythm and blues musical aggregation, the Big Roll Band. Zoot greeted Chas and Hendrix, complimenting Jimi on his hair, which stood out from his head like a full, dark, slightly wiry dandelion, an effect achieved with rollers. Chas proudly explained to Zoot that Jimi had created this style himself, modeling it after a photo of Bob Dylan.

Zoot immediately offered them cups of strong English tea with milk. Hendrix had landed in a welcoming white world where most musicians were "good mates." Zoot was eager to hear Jimi play, declaring that "any mate of Chas's is a mate of mine!" His home was constantly alive with music; he and his wife, Ronnie, rented small flats within the large house to musicians, and by noon that day Jimi was playing a white Telecaster that Zoot had borrowed from Andy Summers, one of his boarders and also the guitar player in the Big Roll Band. (Later Summers was to gain recognition as a member of the Police.)

Chas grinned with pleasure watching Zoot's enthusiastic face while Jimi played a couple of old blues songs, then moved into a Ray Charles tune. Jimi smiled to himself as he got used to the

Telecaster. Zoot was passionate about the blues, and Ray Charles was among his personal heroes. Chas was proud that he'd thought to stop in at Zoot and Ronnie's. Zoot was immensely popular, absolutely the ideal person to help spread the word about his amazing American discovery.

That evening Chas and his Swedish fiancée, Lotta, brought Jimi into the heart of London's West End to one of Chandler's favorite clubs, the Scotch of St. James. Opened a year prior, the Scotch was the most glamorous of the Swinging Sixties clubs and the midnight headquarters for established pop stars, aspiring pop stars, and pretty girls looking to attract status boyfriends. It featured bagpipes on the walls, plaid lampshades, and waiters in tartan waistcoats who served up endless rounds of scotch and Coke, considered to be the Beatles' favorite drink. The "Fab Four," when they dropped by, relaxed in their own reserved booth, complete with a special "Beatles" plaque.

Jimi had never been in such a fine club before. "The Scotch was classy," he recalled, "and comfortable." He was sure, though, that he was the ugliest person ever to walk through the door. He wished that he had some decent clothes, and he was self-conscious about the scattered acne spots and scars on his face, which he religiously washed with a special cleanser. He had felt vaguely better when someone in the Village told him that Bob Dylan had acne, too. Jimi played guitar for a few minutes that night, and everyone stopped talking, joking, and carrying on to listen, to actually *listen*. "They seemed to like me quite a lot. I felt overwhelmed inside that this was really happening," he said. "When I was wallowing in misery in New York, I'd imagined moments like this. But, quite naturally, I never could have dreamed that it all would happen in London, England."

Chas made sure that well-known singer/pianist Georgie Fame—leader of *England's* Blue Flames—was at the club to meet Hendrix. Georgie and Zoot Money, too, were great "mates," known for their appearances together at London's Flamingo Club, where

Fame's ensemble was the house band for several years. The Flamingo was the site of many legendary late-night "rave-ups" in which Georgie and Zoot unleashed their powerful voices, soulful keyboard talent, and blazing energy.

That night Zoot and Ronnie Money brought along nineteen-year-old Kathy Etchingham, one of their tenants in the Gunterstone Road house. "She was good-looking, with lots of hair and big, bold eyes, a very confident chick," Jimi said. They latched on to each other. Kathy also was new to London, but she knew her way around. It was well past midnight when Etchingham found a taxi and accompanied Hendrix to the modestly priced Hyde Park Towers, where Chas had booked a single room for Jimi on a temporary basis. A few days later, she gave up her place at Zoot and Ronnie's house and moved in with Hendrix.

Although Kathy Etchingham was Jimi's first English girlfriend, she certainly was not his last.

On September 29 two significant events occurred in the lightning-quick creation of Jimi Hendrix. Chas and Jimi began holding auditions at Birdland, a trendy basement club in the heart of Piccadilly. A thin, twenty-year-old guitarist from Kent named Noel Redding showed up. He'd recently returned from the Continent, where he was already a veteran of the exhausting German club scene as a member of the Burnettes, later to be known as the Loving Kind. "I thought I was following in the footsteps of the Beatles," Noel recalled, "getting me start in Germany and all that. Pull the chicks, play endless sets, take pills instead of sleep—isn't that how you become a star?"

At Birdland, Noel made it clear that he was a guitar player, and Jimi made it equally clear that he needed a bass player. "James was soft-spoken, all mumbly and whispery, *really* looking me over," Noel said. "He ran down a few chords. We messed with 'Hey Joe' and a couple of soul numbers. I was a quick learner. Hendrix smiled once or twice at the sound we were starting to get, and he looked at me again. 'I like your hair,' he said. 'And your

shoes.' Jimi actually looked like hell, except for his curls. He was wearing this dismal tannish raincoat. Like Bogart gone bad, if you know what I mean. I thought he was a good player. The left-handed thing was quite interesting to me, but I didn't suss out that day just how good he was."

When he left Birdland, Redding wasn't sure if he had the gig or not.

Within half an hour, Jimi knew that Noel would be right and saw it as a plus that Redding was a guitar player. "He paid attention when I showed him the bass sound I needed; it didn't take much explaining," Jimi recalled. "His hair was a little freaky—a light, curly version of mine. This was good, because I believed that it would just be too weird for someone that looked like me to be onstage with English boys with gentlemanly haircuts. Noel was amusing; he made me laugh. His speaking voice was full of interesting little tones. He wore cool-looking square-toed boots that day. I wished that I was wearing them! Always, in fact, Noel wore great boots and shoes that he picked out specially in London. People just do not realize how important the right shoes are onstage. Not only for looks but also for moving easily, comfortably."

That evening at one of the Beatles' favorite clubs, Blaises, located in Queens Gate in the basement of the Imperial Hotel, Jimi sat in with the Brian Auger Trinity. Auger, stirring organist, and his band—including guitarist Vic Briggs whom Hendrix was to remember as "a really kindhearted, supportive cat"—impressed Jimi. Auger was generous, too, telling Chas and Jimi that he was "always welcome to sit in."

European pop idol Johnny Hallyday—the "French Elvis," as he was known in England—was in the audience, considering Auger's group to open for his major concert at the Olympia music hall in Paris. An added musical bonus at Blaises was this American fellow bursting with sound and spirit, even playing guitar with his teeth! When Hallyday left the club, he was quite pleased with himself;

he'd actually picked up two support acts in an hour—the Brian Auger Trinity *and* Jimi Hendrix, a complete unknown with no band.

Pete Townshend and Jeff Beck watched Hendrix show his stuff at Blaises on another night. "These were thrilling times for me," Jimi said, "*thrilling.* Jeff Beck, a truly great guitarist, listening to me. I remember Pete coming to see me play at several clubs in the beginning. I think I was cool with them. But I probably came off like an idiot when I wasn't playing. It was a lot to take in, and getting the right band together was making me nervous. Quite naturally, it had to be tight. We had to agree on songs. Write songs. Learn songs. Rehearse. Rehearse. Rehearse. And at the moment all I had was a maybe-probably bass player. And no drummer."

Jimi and Chas weren't the only ones eager for a band to be assembled. Kit Lambert and Chris Stamp, too, were waiting with great anticipation to become integral parts of the Jimi Hendrix launch. These young Englishmen, co-managers of the Who, were well connected. Lambert's father was the brilliant English composer Constant Lambert. Stamp's brother, Terence, was becoming an important screen actor. Kit and Chris were popular and respected members of the music scene, and their opinions counted a great deal in London. Chris Stamp explained, "Kit and I saw Jimi for the first time just after he'd arrived in London. Chas had brought Jimi 'round to a club, which probably was the Scotch. Hendrix wasn't actually meant to play, but he got up and jammed with the band. He had a special look about him. I loved his face and his hair. It was just the dynamic that got you. A band was playing, and suddenly there was some other enormous thing happening. The whole thing was about ten minutes. *That* night, right, we went up to Chas, knowing him only as a bass player, and said, 'This guy is . . . well, we want to manage him!' Chas said, 'Mike, our manager, is already managing him with me.' So we said, 'Well then, we want to produce his records!' Chas said, '*I* was thinking about

doing that. . . .' We said, 'We're thinkin' of starting a record label.' 'Oh, really,' Chas said. 'Well, I'd love to talk to you about that!' Chas was looking for money, but our label, which we were thinking of naming Track Records, at the moment didn't even exist."

Jimi wanted Al Hendrix to know that it appeared his luck had finally turned. He impulsively managed to locate his father's latest telephone number in Seattle; they hadn't spoken in quite some time. But Al, reacting as many parents might have, was aghast that his son was calling him collect late at night from five thousand miles away. He accused him of stealing the money to fly first class to London. "I suppose to my dad," Jimi said, "England seemed like another planet. He made me feel lousy. I always regretted making that call."

Chas had let it be known that he'd like Hendrix to sit in at Cream's London Polytechnic concert on October 1, a very important show for the newly formed trio made up of the highly respected musicians Jack Bruce on bass, drummer Ginger Baker, and guitarist Eric Clapton. That night, at the university hall in Regent Street, Jimi made his first public appearance in the United Kingdom. Eric, ever sensitive and a gentleman and already aware of Pete Townshend's and Jeff Beck's praise for Hendrix, agreed that he should play a song of his choice even though Ginger and Jack had mixed feelings.

Privately Jimi had dreamed of a dramatic musical showcase in London since the first time he and Chas had talked in New York. Now he took full advantage of the situation and of another band's audience, a crowd who had paid for tickets to see three great English musicians—not some American stranger. Hendrix, playing his white Strat, performed a dazzling, lengthy version of legendary bluesman Howlin' Wolf's "Killin' Floor" while a coolly triumphant Chas stood off to the side of the stage with Clapton. "Eric actually turned pale, he was so overwhelmed by Jimi's talent," Chas said. "He could hardly talk." For Clapton, acknowledged as the finest guitar player in England since his previous work with the Yardbirds

and John Mayall's Bluesbreakers, hearing Hendrix stretch out this way was a startling, threatening moment in time.

Hendrix said, "When I think back, it seems *so* pushy that I would have barged into someone else's show that way. I can hardly believe I treated Clapton—a hero of mine—with so little respect. I can still remember seeing out of the corner of my eye, a glimpse of him watching me that night. I knew I was being *rude*. But at the time I *had* to get moving. So I did." His eyes sparkled at the memory as he spoke, and he added, "You know that I love Eric Clapton. My idea of happiness would be for the two of us to play together for hours one day, one night, one week! Just grooving away on every song that comes into our minds, our fingers . . ."

Within days after the Cream gig, Hendrix began rehearsing with Noel Redding while Chas hunted for drummers. Aynsley Dunbar was very much in the running; still, when Chas heard that his pal Georgie Fame was making changes and that John Mitchell was out as the drummer for the Blue Flames, he got in touch with Mitch, as he was known in musical circles. Mitchell—thin, blond, with a special charm about him—was just nineteen. He was poised, a show business veteran. As a child he had attended drama school, acted on television, and was even a talented tap dancer. Now music was his great passion.

Chas and Jimi went back and forth, back and forth between Aynsley Dunbar and Mitch. They *had* to make a decision; the Hallyday tour was starting the next week. Chas was frantic about rehearsals; there could be no screwups. He said, "We all thought Aynsley was great. Mitch, too. We actually flipped a coin to decide. It came up Mitch."

"Chas knew that Georgie Fame would never have put up with anything less than a good drummer, but I was not at all sure about Mitch," Jimi recalled to me. "He had played with Noel and me several times, but I felt like something was missing. I was dead wrong about him, because it turned out that Mitch was a little monster on drums. He really put out onstage in our first gigs. I'd

be up front, and suddenly my ears would practically stand to attention. Mitch was all energy and precision.

"Another thing about Mitch," Jimi said, "is that he was the one who introduced me to Jim Marshall, who was not only an expert on drums but the guy who was making the best guitar amps anywhere. Meeting Jim was beyond groovy for me. It was such a relief to talk to someone who knows and cares about sound. Jim really listened to me that day and answered a lot of questions. I love my Marshall amps; I am nothing without them!"

The Soho area in London's West End was the heart of the music business. A variety of restaurants, strip clubs, private gambling rooms, record shops, and pubs catered to a diverse clientele in this old bohemian quarter. Michael Jeffery's office on Gerrard Street was identified as ANIM LTD. on the door, since it was the official London headquarters of the Animals. There, on October 11, 1966, Jimi, Noel, and Mitch sat down for a special meeting with Jeffery and Chandler.

At the age of thirty-three, Michael Frank Jeffery, a native of South London, had built himself a successful business career. He owned clubs in Newcastle and Spain, a fair amount of real estate, including a house in London; as the manager of the Animals, he'd made hundreds of thousands of dollars. He knew how to be charming, when to be intimidating, and his timing was dead on for moments that required an air of absolute authority. At various times he would imply that he had been or even still was part of British Intelligence. There were those who would tell you, in hushed voices, "He's a spy, you know." Of course, these people were mostly easily impressed musicians and hangers-on. Other hushed voices then and later spoke of Jeffery's mysterious "gangster connections." Jeffery did do his National Service. He spent time in Egypt, and he was said to speak fluent Russian but the details of how and why were never fully explained to the musicians he managed. One didn't just suddenly start up nightclubs on a shoestring, and Mike was ever evasive, refusing to be pinned down to the specifics of

how he became an entrepreneur. Later it turned out that Mike Jeffery's greatest talent was in knowing how to strike when his clients were most vulnerable.

But today, as Jimi, Noel, and Mitch sat listening to the agreement being read aloud, Mike didn't have to work at his victory. The new band was desperately eager to record, to tour, to make money and have a good life, the quicker the better. The seven-year contract gave Michael Jeffery and Bryan James "Chas" Chandler complete control of the trio's future recordings, and their songwriting and publishing. The wording of this agreement was heavily weighted regarding records as opposed to career management. The musicians would split approximately 2.5 percent record royalties; the vast majority of the profits, *if* the group was successful, would belong to Chas and Mike. Little thought or discussion was given to the possibility of the new band's becoming a big-grossing touring act internationally. The meeting and the signatures took only a few minutes. In time there would be other legal agreements.

Eyes rolled that evening as word circulated in a music-biz pub in Soho that it was official; Chas was actually partnered with Jeffery in managing the new group. "Bloody hell!" exclaimed the barman, a crony of the Animals, well acquainted with their complaints about Jeffery. Off the record, a former associate of Jeffery's in his club business told a reporter for one of the music weeklies, "Jeffery's just signed up more lambs to the slaughter. And Chas, of all the lads, knows what Jeffery's like; he's made a terrible decision to let Mike in on the group. He *will* be sorry." Cold words, yes, but no one ever disputed that Michael Jeffery did do one great thing for the band—he dreamed up the name the Jimi Hendrix Experience.

Music entrepreneur Don Arden, who created great success in England for such American artists as Gene Vincent, Jerry Lee Lewis, Little Richard, and Sam Cooke, knew Michael Jeffery only too well. His son David Arden summed up his father's opinion of Jeffery succinctly: "Michael Jeffery was an arsehole!"

Other lawyers and managers associated with pop talent had mixed feelings as to whether Hendrix and his "instant group" really could get off the ground in the international market. When Jeffery was overheard comparing himself to Brian Epstein, the devoted manager of the Beatles, the knives came out. "Brian is honest and decent," said an EMI Records executive, "two words that could never be associated with Michael Jeffery."

Jimi himself recalled later that Jeffery had told him, "I have more experience than Epstein. You'll see." Hendrix said, "All I knew was that these were businessmen, and you had to have representation. Chas introduced me to Jeffery, and that was that."

Despite all their assurances to Jimi, Chandler and Jeffery were striking out in their efforts to secure a major record deal. They went first to Decca, who turned down Hendrix as "lacking in long-term potential." Meanwhile, Chris Stamp and Kit Lambert were moving ahead with their plan for Track Records. "What clinched it," Stamp remembers, "was Chas and Mike insisting, 'You *have* to give us some sort of money.' No one was getting the sort of money that bands got later on. We didn't want to lose Hendrix, so we eventually came up with a thousand pounds, and we promised that Track would get Hendrix on *Ready, Steady, Go!*" This tremendously influential Friday-night television program showcased English and American pop music talent—and other interesting young people "on the scene," with guests ranging from boxer Muhammad Ali to record producer Phil Spector. The innovative show was assembled in a hip, visual way by Stamp and Lambert's good friends Vicki Wickham and Michael Lindsay-Hogg.

"We also said to Chas and Mike," Stamp continued, "and they already knew this, 'Look, we're the best sort of concept promotion going at the moment. In an overall management, conceptual way.'" Lambert and Stamp were already well recognized for their abilities and distinct flair, qualities that Jeffery and Chandler did not possess. "Chas had only just stopped being a bass player, and Mike, though he had been very lucky and was a shrewd operator,

was not operating on the sort of level that Kit and I worked on. Jeffery was not the most imaginative fellow, but he was certainly ambitious and held out for the best deal. Probably business-wise he made Kit and me look stupid, because we weren't that fabulous at business, so to speak."

In actuality Stamp and Lambert were far from stupid. It was only a matter of weeks before they gained the interest of the giant Polydor Records in financially subsidizing the launch of Track.

The new band started its career at the Novelty in Evreux, France, then playing in Nancy. The French, according to the custom, sat and watched, seldom applauding until the finale. For the most part, they liked this unusual trio. And Hallyday's band gradually bonded with the Experience, in part, as Mitch Mitchell was to remember, "through a puff or three on a marijuana cigarette." These generally consisted of hashish mixed with tobacco.

The two bands traveled together in a bus; Hallyday, a great star in France then and now, was driven separately in a sleek Aston-Martin.

"Johnny was very professional, one of the best-rehearsed entertainers I had ever seen. Chas and I watched every move he made, all his stage tricks. When and why he slowed the pace down. How and why he moved closer to the audience," Jimi recalled. "He was never sloppy. Ever. Johnny was very alert to the audience and to his band. You could tell how determined he must have been from the beginning to become this big French star. So much thinking. So much rehearsal."

The Experience appeared with Hallyday in Villerupt, then drove to Paris the next morning. They needed time to rehearse for the "big show" at the Olympia on the evening of October 18. Jimi said that he walked every inch of the stage and through the rows of seats in the intimate hall, getting a sense of what was in store, thinking out the dramatic opening he and Chas had discussed. After several hours he quietly left the theater. His nerves were

acting up, he wanted to be alone for a few minutes and get a sense of the city.

He began to stroll down the boulevard des Capucines, making a point of noticing the names on street signs so he could retrace his steps; as his landmark he just focused on the impressive Paris Opéra. "I wanted so badly to sneak inside that building that looks like the tallest, most elegant birthday cake anyone ever created, all gold on top. I wondered if they ever allowed guitar players on the stage."

This was what he had yearned for—the Big Time. Lucille's baby boy Johnny in Paris, France, of all places. Unlike his mother, he had pulled off his escape from a life that offered little. Hendrix said of this day in October 1966, of his excitement and his terror, "Even me, with my big imagination, had never imagined any place so beautiful—a city with so much history that I wanted to know every single thing about what had happened there, the kings and queens and rebellions and how they built the city and what kind of people had lived there in the past. I wished that I could stop time and explore all those fantastic buildings for weeks."

It was cold and overcast; Jimi shivered in his cheap jacket. He kept walking. "For just a tiny minute, the gray disappeared as though I'd snapped my fingers. The next time I looked up, there was a graceful tower rising into a heaven-blue sky. I'll never forget that. It had to be magic, it happened so quickly. I'd seen pictures of the Eiffel Tower before, but I didn't understand that it was *art*."

He saw and was impressed by tall, ancient lampposts "decorated with a touch of gold. I wanted to get closer, so I walked right across the river on this old bridge, just grooving away. And then, when I turned around to head back, in the distance were crystal fountains filled with light. I loved every single thing about this city. The hustle and bustle. The traffic and all those horns squawking and squealing. The smell of fresh roses in the air . . . that slightly funky fragrance that turned out to be chestnuts roasting in

cauldrons right there on the street corners . . . tobacco and taxi fumes. What I thought then, what I told myself, was, *Finally*, something's the way it's supposed to be."

Jimi was keyed up in anticipation for the fifteen-minute slot when he, Mitch Mitchell, and Noel Redding would perform as the least-known opening act on the Olympia bill. He was quite prepared for the reality that the French would be saving all their cheers for "John-nee!" "Would they dig the Experience at least a little bit?" Jimi wondered. "Would we be too loud? Could we hear each other onstage?" At rehearsal a stagehand who spoke halting English tried to tell him about all the stars that had played the Olympia. Jimi had never heard of the French singers the man mentioned, but knew they were special from the excitement in his voice. "He sang me bits of their songs with all those French words, figuring I'd catch on. It was sweet how he tried. I told him I wanted to say thank you onstage, and I practiced my *'merci beaucoup'* on him. What was really amazing to me was that he told me that Bob Dylan had played the Olympia only a few months before. Quite naturally, *this* seemed like such a good omen. I just *knew* that I would play in Paris again . . . that they would *want* me to come back."

Jean-Pierre Leloir watched Hendrix play that first time on the stage of the Olympia. Leloir, a young photographer who was to become renowned for his images of such legends as Ray Charles, Miles Davis, and Charles Mingus, was allowed full access—in the wings, on the stage, and in the dressing room— to candidly capture the new band's nerves, their focus, and their personal excitement at performing in such a prestigious venue.

Leloir later spoke of that October night. "I was shocked by Jimi's way of playing, of behaving, onstage. It was rather like what had happened to me when I saw Coltrane, when he came with Miles Davis in 1961 for the first time. Hendrix's music was *disturbing*. Different. He didn't pay attention at all to the camera. I immediately felt that he was going to be important."

Leloir said that as Hendrix made his entrance, there was a subtle intake of breath from the audience. What was this? They looked him over, listened to that "disturbing" music, murmuring to themselves, "Ah, what have we here?"

Mitch and Noel were already in place onstage. An announcer said, "Ladies and gentlemen. . . ." The audience heard a flurry of musical notes coming from the wings. Then again the emcee: "From Seattle, Washington . . ." Hendrix appears, wearing the blue mohair suit and white shirt that Chas had insisted upon, his left arm dramatically raised. The audience reacts in astonishment, because his guitar continues to make music, but it appears that he's not playing it. This was one of Hendrix's early "tricks." The set began. The songs were "Killing Floor," "Wild Thing," and "Hey Joe."

Leloir remembered, "He was like a *butterfly* on that stage. All movement. *Natural*. Completely *natural*."

§

DE LANE Lea Studios in Kingsway, London, is the studio where Jimi Hendrix, Mitch Mitchell, and Noel Redding recorded together for the first time, on October 23, 1966. Having worked there frequently with the Animals, Chas was able to cut a good deal for the recording of the demo version of what would be the first single, "Hey Joe" with "Stone Free" on the flip side. For the next six months, the group recorded—in between every gig they could get to stay alive—at Regent Sound and Olympic Studios, with return visits to De Lane Lea.

When Hendrix had an hour to himself and if it wasn't too cold, he enjoyed strolling the streets of London. Paris had been beautiful, dramatic, and sophisticated. "London felt like a storybook," he said. He loved the parks and especially the old churches with angels of stained glass. He gravitated to statues, taking the time to inspect them carefully. When he came upon a bookstall on the street, he inspected the books, too. They didn't have much in the

way of science fiction, which he was always hoping to find. Still, for as little as a shilling, there were books of poetry, some Dickens. He bought a worn copy of *David Copperfield*. Jimi said, "I read it on a plane one time and started crying, it was so sad in parts. One of the things I liked most about London was seeing window boxes filled with pretty little flowers, even in winter. I really enjoyed being alone and getting in touch with my imagination, my actual thoughts. Music can be such a nighttime thing, and the way I grew up, I was used to being part of nature. It's that kid thing where you want to run around and explore the outdoors. Or need to."

Hendrix's innate interest in words and sounds was enriched by his London life. "Words paint pictures in my mind. Now I see that I knew next to nothing about songwriting until I got to London. I had ideas and phrases, but I was uneasy about how to make the words all hold together for an entire song," he said. "In England I learned dozens of new words and expressions every single day, which opened up my writing. Chas was supportive, even when he didn't know what I was rambling on about. He gave me confidence in getting my writing going."

Hendrix found inspiration even in the BBC newscasts. "I heard big, impressive words spoken so properly on the telly. I'll never forget watching the news and a reporter speaking of 'uncharted waters.' Ever since, I have wanted to use 'uncharted waters' in a song. That's life in a nutshell! Hearing English spoken in England was like opening a door. . . ." Jimi picked up numerous English accents, from Mayfair to Cockney to Geordie, and he was delighted by such expressions as "taking the mickey," or "are you daft?" and even "bugger off!" His lifelong love of the radio now encompassed the silly, stupid, and wonderful *Goon Show*. "I think that Spike Milligan must be some kind of genius," Hendrix said.

§

WHILE NOEL, Mitch, and Jimi constantly complained about tiny weekly salaries that simply couldn't be stretched any further, Mike

was his usual evasive self on the subject, and although he could well afford to gamble on their future prospects, he didn't.

Chas came up with a gig in Germany. The Experience spent several days in Munich, playing mainly for American military men, along with a couple of soul bands. Noel spoke a fair amount of German and knew how to order food for the three of them. Jimi liked Munich but wondered what the hell he was doing back in the same kind of situation he'd left in the States. Around this time another of Noel's ideas came in the form of Gerry Stickells, "me drinking mate from Kent." Noel said that Stickells "was a mechanic, and he had a van the band could use. Jeffery's office hired him to drive us, lug the amps around, and generally learn how to be a road manager." Noel added, "Gerry really didn't care much for our music."

A tremendously exciting idea had been burning in Chas Chandler's brain since shortly after he first met the former Jimmy James. He dreamed of presenting a small, intimate event that no one in the London music scene would ever forget, the official launch of Mr. Jimi Hendrix and his new band. Lunchtime "receptions" for pop recording groups were starting to become a London tradition, and Chandler scrambled up the pound notes to pay for what the press jocularly referred to as a "booze-up" at the Bag O'Nails on November 25. No one understood better than Chas that the quality of the guest list was the key to revving up press coverage and attracting serious interest from booking agents.

It was a risky dream, he knew, because what if he spent the dough and the music stars he was counting on—used to late hours and sleeping until afternoon—didn't show up in time? Worse yet, what if they didn't show at all? What if they forgot the date? "I faked confidence with Jimi, Noel, and Mitch," he recalled, "and worried meself sick." The transition from bass player to co-manager, impresario, and record producer was loaded with responsibility for Chas. He was determined to do right by Jimi, to gain status and success by making events happen in the biggest

and best way, and to avoid the mistakes he now even more clearly remembered seeing Michael Jeffery make in his management of the Animals.

This winter day turned out to be unusually beautiful. The air was crisp, but nature had provided one of England's famous "sunny intervals," complete with blue skies. Gradually, the charming young princes of London's rock scene trooped into the Bag, on Kingly Street a few yards from Carnaby Street. It was unlikely that any of them had ever set foot in the place during daylight hours before. Chandler needn't have worried. Eric Clapton. The Beatles. The Rolling Stones. Pete Townshend. Jimmy Page. And more. Tall Chas, towering over them all, was ecstatic as he noticed members of the press nodding, smiling, and scribbling down the high-powered names—"the lads," as Chas thought of them. It was a good press assembly, by his assessment. Not great. A couple of reporters for the "nationals," as the daily newspapers were familiarly known, and writers from the all-important weekly music papers—*New Musical Express, Melody Maker, Disc and Music Echo* and *Record Mirror*.

There were two other "lads" there that day: fifteen-year-old Dan Kessel and his twelve-year-old brother, David. They were bright, musically sophisticated boys, the sons of American guitarist Barney Kessel, who had been influenced by Charlie Christian and was a superb player revered in jazz circles as well as pop music, where he'd worked with everyone from Phil Spector to Ricky Nelson. The Kessel boys had heard about this special reception at the Bag O'Nails, and they persuaded their father to use his influence with a friend at Polydor to get them into the club. They were self-conscious about their youth, but they knew how to radiate a certain cool; the boys had been around fine musicians throughout their young lives. "It was the most exciting day that ever happened!" Dan Kessel recalled. "To be sitting inches away from all the greatest players in London. Our heroes. And to see Jimi Hendrix

for the first time was unbelievable. He was fantastic! The English players went nuts—they cheered, clapped, hooted, and hollered!"

The forty-minute performance was ear-blastingly loud in the small club; there was no doubt that *this* was definitely a *power* trio, and Jimi's flashy showmanship overwhelmed the audience. The set included "Like a Rolling Stone," "Everybody Needs Somebody to Love," and "Johnny B. Goode." The guitar players in the audience went nuts over that last one. Wasn't Jimi Hendrix the very personification of Chuck Berry's lyric? And then there was "Wild Thing." "Amazingly cool," John Lennon was to say. However, it was probably Jimi's version of "Hey Joe" that made the afternoon a lovefest. All the musicians present *knew* that this would be a huge hit one day soon. After their set Noel and Mitch wore expressions of disbelief when John Lennon was the first star to appear in the band's dressing room. "Grand!" he said. Paul McCartney was right behind him: "James, you're a wonder!" Jimi grinned, listening attentively to each word of praise spoken by the rest of Chas's "lads."

Of course, the Kessel boys *had* to meet Hendrix, and their father's helpful Polydor friend arranged that, too. "He was very nice to us," Dan said. "All these guitar stars dying to talk to him, and Jimi gave us his time and interest." Their paths would cross again, and Jimi always remembered them.

At the end of the afternoon, Hendrix was relaxed and happy in a way he'd never been before, he said. He radiated joy. "Jimi, you are a very attractive lad when you smile," Chas said, turning on the full Geordie accent, r's rolling.

§

ON NOVEMBER 27, 1966, Jimi's twenty-fourth birthday, he had no reason to feel anything but optimistic about his future. He now possessed an English work permit, he had acquitted himself well in Paris, his English musical peers worshipped him, and he was

in the process of making his own first album. No longer was he considered "just a backup musician." The life of Jimi Hendrix had dramatically changed within the space of a mere two months.

The week after the Experience had wowed the starry crowd at the Bag O'Nails Mike escorted Hendrix to the Mayfair office of solicter John Hillman, the architect of Jeffery's Bahamian tax shelter, Yameta Company Limited. "Jeffery had already mentioned to me that he was putting together New York headquarters," Jimi recalled. "He talked about a Rolls-Royce, too. I was impressed. He and Chas made me feel those offices would belong to me, to the group, too. After we played Paris, Mike got excited about the good reports he heard. He said he was inspired with several new ideas about what he could do for me in Los Angeles, including films. But mainly, to begin with, he was working on a big American record contract." This afternoon Hillman and Jeffery presented Jimi with another legal agreement, this one exclusively to do with him as a performer in all mediums; it called for Jeffery to receive a whopping 40 percent of Jimi's gross performance earnings, an extraordinary figure by any show business standard. Jeffery explained that a part of that percentage could pay for possible tour expenses. Hillman told Hendrix that these "tax deductions could work well for Yameta," and he mentioned the name of Sir Guy Henderson. "He was a very important person in the Bahamas," Hendrix said, "and Mike told me that Sir Guy had helped start Yameta. . . . They also talked about how, if I did good in America, that various Bahamas accounts would save me paying too many taxes and eventually support me for the rest of my life." In these early weeks of being the leader of the Jimi Hendrix Experience, he was grateful for the ideas presented to him that day. To hear Hillman and Jeffery speak of "success" and "earnings" made him extremely happy. "It all sounded first class!" he said.

Jimi remembered that Chas was not present at this meeting. Even though he and Jeffery were Jimi's comanagers, Jeffery still

held management papers on Chas from his days as bass player for the Animals; that contract had not yet expired. Before Chas left the group, Jeffery had presented a similar glowing scenario to Eric Burdon and the band. Like Jimi, the Animals, too, had been excited to believe they would save on taxes by virtue of the Yameta "shelter," and could be assured that money was tucked away for the future.

Jeffery did not offer Hendrix the opportunity to seek outside legal counsel or to discuss the meeting and contract with Chas. Hendrix raised the subject of Ed Chalpin, and Mike once again assured him that the paper he'd signed with Chalpin "could be handled." This day's agreement would seriously affect Hendrix in the years to come.

In this same week, a tangible reward of the admiration felt for Jimi was Ringo Starr's offer to loan Hendrix and Chandler his flat in Montagu Square. "It was roomy, with two bedrooms and good light. I was pretty sick of the Hyde Park Towers, and Kathy was very excited about moving to such a classy neighborhood," Jimi said. He felt that Lotta, Chas's devoted girlfriend, was not necessarily pleased about living with another couple, and he didn't blame her. Lotta was kind to Jimi, even though she had to put up with endless hours of discussion about his career. "Lotta is a very sweet, quiet Swedish girl, as you know," Jimi said. "She is a lady. And I think that not having much privacy was rough on Lotta."

At the urging of his girlfriend, and against his own better judgment, Hendrix visited his ex-employer Little Richard, who was in London to perform at the Saville Theatre. Kathy was pushing to meet him. "Little Richard's always been a big deal in England, you know," Jimi said.

The Experience's first single, "Hey Joe," written by Billy Roberts, was released on December 16. That night, thanks to Stamp and Lambert and their television pals Vicki Wickham and Michael Lindsay-Hogg, the Experience was seen performing the song on

Ready, Steady, Go! The first notes of the song grabbed many a viewer. So did the musical atmosphere of building menace, plus the top-notch playing of the brand-new band.

The unique look and attitude of Hendrix, Redding, and Mitchell made them a talking point among *RSG!* fans throughout England. "What was that line about *'gonna shoot my old lady'*?" people everywhere were asking.

As much as "the lads" admired "Hey Joe," Jimi's own song, "Stone Free," was the B side of the single, and this quintessential rock and roll sound was well appreciated by every guitar player in London. One could say that it convincingly staked out Hendrix's claim to rock greatness and bore out the tongue-in-cheek phrase that came to be identified with him—"Let Jimi take over!"

In a story detailing the current record charts *Melody Maker* soon declared:

Hendrix Leads Stones in Pop Song Race

On December 26, Jimi, stting in a dressing room before showtime at the Upper Cut Club in London, finished writing a new song entitled "Purple Haze." He said, "It had been in my head for a while. I wasn't at all sure that it would amount to anything, but Chas liked the opening riff."

The Experience ventured down to the coast to Noel's hometown of Folkestone on the last day of the year. A modest little venue, but a gig at Stan's Hillside Club, after much hustling from Noel, brought in fifty pounds. "It seemed like a fortune to Jimi and Mitch and me," Noel said, "and I was really buzzed to show the locals that it was all happening for me." Late that night Jimi met Noel's grandmother and his adoring, outgoing mother, Margaret, who served up an impromptu hot supper. A blazing fire had been lit on this cold New Year's Eve, and Jimi always remembered the evening as "cozy and happy." He enjoyed feeling welcome in what he termed "a real family home" and was immediately comfortable with Margaret Redding. She treated Jimi with warmth and humor,

as though they'd known each other for ages. "Mum thanked him for putting me in the group. She told him how pleased she was that they were spending New Year's together," Noel recalled. "Our James was at his best that night, very sweet and mannerly to my mum. I can still picture them standing by the fire laughing together. It's one of Mum's favorite memories."

Chas was full of high spirits this night. "Folkestone, London, Paris, the world!" he declared, raising a glass to Jimi. "You've got a hit record blooming and more on the way! I've kept my promise, mate!" In a private moment together, Chas appreciated it when Hendrix surprised him with a rare hug. "Thank you, Chas," he said. "One other thing, Chas," Jimi declared. "No more mohair suits!" he said, smiling that charismatic smile.

"Our" and "we" is how it was as they entered a glorious 1967.

Chapter Six

"The Best Year of My Life"

"HENDRIX IS the most exciting, sexual, and sensual performer I have ever seen," Mick Jagger of the Rolling Stones told the British press. He spoke for all Jimi's musical peers in early 1967, who, openmouthed, watched the Experience in action at small, packed London venues, among them the Marquee, the Speakeasy, the Upper Cut, the 7½, and return appearances at the Bag O'Nails. Jimi Hendrix was on his way to achieving a most elite acknowledgment of fame—the status of being known by a single name. In London, when one spoke of "going to see Jimi," nobody needed to ask precisely who that might be. At the clubs the Beatles, the Stones, and the rest of "the lads" felt honored when Jimi accepted an invitation to join them at their tables. They were besotted with this fascinating figure. They admired his hair, his cheekbones, his smile, his cheap but imaginative clothes, his whispery voice and the way his eyes shone when he laughed at their "Britishisms."

Penny Valentine was England's most influential reviewer of new pop singles. Her writing in *Disc and Music Echo* was specific and powerfully evocative. As Richard Williams was later to write in the *Guardian*, "She was the first woman to write about pop music as though it really mattered." Valentine, a lovely young human being with a sparkling personality, was seen regularly across England on the *Jukebox Jury* television show. The Beatles and the Stones topped the list of her fans, ever appreciative of her reviews.

In an unpublished excerpt from her journal, Valentine noted

early in 1967 that "Hendrix appears at the Bag O'Nails in Kingly Street. We go along. Pete Townshend is there and Eric Clapton is almost unrecognizable. Just back from Paris, he looks like a slender French mod with a cropped haircut and tight-fitting pastel cashmere sweater. By the time Hendrix comes on stage, this club is so hot and full that condensation is running down the walls. Sweat is running down my back as Hendrix starts the stamping, heaving introduction to 'Purple Haze'. 'I can't see him,' I wail. I am beginning to feel faint in the crush and wish that I had not had three virulently colored tequila sunrises. Someone lifts me up onto their shoulders so I can see the stage. Young, skinny, black with a halo of curls, Hendrix holds his guitar slung low and slightly away from his body but makes it roar defiantly, even though it doesn't look like his fingers are moving. He finishes by getting on his knees and playing with his teeth. We are stunned. I have a momentary panic that Hendrix will electrocute himself. Pete and Eric have their mouths open but say nothing and Hendrix finishes with a flourish of feedback and wailing anger. When he comes off stage to talk to Townshend and Clapton he is so shy and deferential we all feel bewildered."

Chris Stamp and Kit Lambert came through with an offer for the ten-week-old Experience to appear at Brian Epstein's Saville Theatre in London, where the Who topped the bill. The Koobas and Thoughts were two other supporting acts; thus Jimi, Noel, and Mitch played a short set and dreamed of headlining the bill "next time." This gig kicked off a mostly friendly rivalry with the Who.

Still, the appreciation of a core group of renowned musicians or a top-ten hit record in "Hey Joe" didn't necessarily translate into an instant love affair when the Experience ventured outside London. Still struggling to exist on their meager salaries, they accepted virtually any gig Chas could find in England while they waited for Jeffery to deliver on his earlier promise: "You'll have money in the bank!"

The Experience puzzled many provincial audiences. What on

71

earth were these English lads, Redding and Mitchell, doing on a stage with this exotic creature in the strange clothes? What was wrong with a suit? Why velvet pants and flowery, feminine shirts? Several members of the press had already dubbed Hendrix "the Wild Man of Borneo." And how could this disturbing, flamboyant music with weird lyrics be considered pop? Whatever happened to "Love Me Do"?

Jimi once described an Experience show at a working-men's club: "We were playing in this club in the north of England, completely different from London. When they got a look at Noel, Mitch, and especially me, they didn't know what the hell we were all about. You would have thought we were from Jupiter or Saturn. Some of the men were whispering about 'the nigger' and making really rude comments about Noel and Mitch. We kept at it, and these guys eventually seemed to relax and pay some attention to the music. They really perked up for 'Hey Joe.' After we finished, this red-faced, big bruiser type came over to me and said, 'Nigger-boy, you have magic fingers.'"

After Jimi recounted this story, he took one look at me and laughed. "You ought to see the look on your face," he said. "He meant no harm calling me that. And he gave me a groovy compliment." He looked down at his hands. He was very proud of those magic fingers.

Hendrix possessed an elevated attitude toward racial prejudice. "I'm against labels of any kind except on pickle jars," he said. "I know that people are just people, whether they're green, yellow, black, or white. I *am* colored, and I'm Indian, and I'm this, and I'm that. If someone says 'nigger' to me, as long as they mean it out of ignorance and not from cruelty, I generally don't think much about it."

One of the main labels attached to Hendrix in his growing popularity was "sex symbol." He grew sick of hearing it, but in the beginning he was flattered. Sexy, intriguing photos created atten-

tion, and Hendrix was definitely in on Chas Chandler's ongoing plan to attract press coverage. Onstage Hendrix delivered plenty of body movement, tongue action, and meaningful glances. Not only was he that rarity of the time, a left-handed guitar player, but his performance in the early days included playing with his teeth, with one hand, behind his back, and occasionally rolling around on the floor midsong. He saw it all as "putting on a show." "That's what the audience pays for," he'd been told by Little Richard and the leaders of other bands in his chitlin-circuit years. They had kept Hendrix in the background; now *he* was the leader. "I play for the crowd most of the time, but I like to throw in something for me, too, and that's about challenging myself with music and forgetting the circus."

"Purple Haze" was released in England on March 17. This song, with its memorable introduction and Jimi's distinctive voice, was instant magic for pop fans. From schoolkids and their parents to factory workers and the debutante set, "Purple Haze" created a host of new fans for the Experience and further documented the view of his peers that Hendrix was truly one of a kind. This single opened a new door in English pop music.

The month of March marked the beginning of constant travel; the band played club dates and appeared on radio and television in England, Holland, France, Belgium, and even a couple of nights at the Beatles'—and Noel's—former haunt, the Star Club in Hamburg, before returning to England to embark on their first official UK tour.

In 1967, when he was asked by a newspaper reporter, "Do *you* think you're sexy?" Jimi quipped, "Shoot, I'm no Engelbert Humperdinck!" The Experience and Humperdinck, an unlikely combination, had performed on the same tour package after Chas had pulled strings to make it happen. The wildly popular Walker Brothers headlined the tour, which also featured singer/songwriter Cat Stevens. Keith Altham of the *New Musical Express* amusingly

wrote of the March 31 London show at the Finsbury Park Astoria, "Engelbert Humperdinck was smooth, suave and sophisticated and followed Hendrix rather like Dr. Jekyll following Mr. Hyde."

Altham went on to note, "The Jimi Hendrix Experience are a musical labyrinth—you either find your way into the solid wall of incredible sound or you sit back and gasp at Hendrix's guitar antics and showmanship, wondering what it's all about. . . . The finale to Hendrix's set came about when his guitar burst into flames, 'by accident,' we are assured."

Chas was elated with this and other press coverage regarding the "accident," and he chuckled to himself and his mates at the fury shown by the Walker Brothers camp over all the attention that Hendrix was getting on *their* tour. On a personal level, Jimi, though, got along well enough with everyone on the tour. One night on the road when Humperdinck's guitar player didn't make it to the show, Hendrix volunteered to help out the singer. He stood backstage and played the guitar parts with appropriate style and volume.

When Jimi wasn't playing, he was listening. Two elements always mattered to him in London—hearing diverse musicians he'd never been exposed to before and jamming with them. English blues masters John Mayall and Alexis Korner sang his praises, and Hendrix felt unusually complimented by their interest. "They know much more than I will probably ever know about playin' the blues," he said.

The blues were one thing. Roland Kirk, the "multi-instrumentalist," was another. Hendrix heard Kirk at Ronnie Scott's club, and he saw this brilliant, blind artist as a revelation. "Roland can play every possible kind of sax," Jimi explained. "He is able to sing while he plays flute at the same time. I keep tellin' you there's no best, but I must also say that Roland is a special messenger. I've never said that before about anyone!" He took a deep breath, his eyes sparkling as he added, "*And* he is completely unique. *And* we jammed together. *And* he liked my stuff!"

After the two couples—Chas and Lotta and Jimi and Kathy—

had begun to think of Ringo Starr's flat as home, Chas got the word that it was time to move on; the neighbors were fed up with too much noise, especially late at night. It was a busy time for Chas and Jimi, whose minds were always on gigs and recording schedules. Chas scurried to find another place nearby. They all moved to a flat in Upper Berkeley Street. Chas asked Jimi to stop playing his record collection at top volume and to keep Kathy's voice to a calmer pitch. Jimi apologized, telling Chas, "She just likes to scream; she doesn't need a reason." he said, "I'll tell her to do her yelling in the park."

Chris Stamp recalled "a favorite Jimi moment" that took place at the Upper Berkeley Street flat: "We'd already recorded four or six tracks for *Are You Experienced?* Chas and Lotta, Jimi, Kit, and I were at the Marble Arch apartment; I don't remember anyone else being there. We were talking, just hanging out, probably rolling some spliffs, having a drink, whatever. The apartment was quite small, on the corner of Edgware Road. The TV is on. The record player is on. Jimi and I are sitting playing Monopoly, of all things.

"Everyone's talking. The music is playing. There's traffic noise from Edgware Road. *Everything* is noisy. Loud! As I'm sitting there, every minute Jimi looks up and says something about a *sound.* Like the *sound* on the record . . . the *sound* of the TV . . . the *sound* of a taxi outside. Always something to do with *sound.* After ten minutes I start to realize this guy is hearing sounds like no one else hears them. He was extracting things from the air in this great big pitcher of sound. He would make a note of it and then go back to playing Monopoly. He listened like we don't listen." For Jimi, always, sound was tied in with discovery.

§

JACK NITZSCHE, one of the truly innovative arrangers, composers, and producers of the Los Angeles music scene, was probably the hippest music man known to Mo Ostin, president of Reprise Records, Frank Sinatra's small new label at Warner Bros. in Burbank.

Jack had worked with Phil Spector among others, and he *knew* sound. When Ostin, whose experience was in accounting, not music, needed a solid opinion on the worth of a musical artist, he frequently picked up the phone and called Jack. In the early spring of 1967, he told Nitzsche, "I'm hearing nothing but raves about someone in England called Jimi Hendrix. You know everybody. Could you call Mick Jagger and ask him what he knows or thinks about this guy?"

Los Angeles producer Denny Bruce, a close friend of Nitzsche's, recalled Jack telling him, "Mick says, 'Hendrix is the most exciting performer in the rock thing to hit London or anywhere.' So Jack passed this on to Ostin. He was very helpful to Mo in the sixties as Reprise was getting off the ground."

A New York lawyer, Johanan Vigoda, was instrumental in guiding Mike Jeffery to strike a very rich deal for the time, an approximate $125,000 advance plus a sizable promotion budget to market the Experience in America. The agreement was made between Reprise and Jeffery's Yameta company.

Reprise put out "Hey Joe" as a single in the United States while on May 12, in England, Track Records released Jimi, Noel, and Mitch's first album, *Are You Experienced?* Provocative and sensual both musically and lyrically, the album certainly fulfilled Chas Chandler, Chris Stamp, and Kit Lambert's strong feelings about Hendrix's long-term potential. Critics raved and predicted a fabulous future for the Experience.

The Experience played the Saville Theatre again on May 7 after the release of the single "The Wind Cries Mary." In *Disc and Music Echo*, Penny Valentine wrote,

If you could see electricity, it would look like Jimi Hendrix. . . . Hendrix proved, if proof were needed, that there is no other explosive force on the British pop scene today to match him.

He is a resplendent figure. Tall, snakelike in scarlet velvet suit and frilled shirt. His hair like a black halo round his head,

his guitar like another limb to be used with his body. . . . On Sunday he topped the bill for the first time to an audience wholly receptive, filled with Hendrix devotees, many of them looking more like Jimi than Jimi.

And they were given what they asked for. The man has changed—he is now confident and entirely at ease. . . . [H]e showed that he is now feeling much more at home with his success. Cracking jokes, talking to the audience, treating the majority like long lost blood brothers, knowing they knew what it was all about . . .

Jimi and the Experience went through "Hey Joe," "Stone Free," "Purple Haze," "Wind Cries Mary," "Wild Thing," "Like a Rolling Stone" with almost indecent ease . . .

Brian Epstein didn't wait long to book the Experience again. Sunday, June 4, was a stellar evening, with crowds being turned away from the sold-out performance; the variety of support acts included Stormsville Shakers, the new and hot Procol Harum, the Chiffons, and Denny Laine and his Electric String Band. The star-studded audience included members of the Beatles, who just two days before had released their groundbreaking album *Sgt. Pepper's Lonely Hearts Club Band.* Epstein and his Beatles were over the moon when Jimi Hendrix walked out onstage playing the title track as a surprise tribute to the "Fab Four." This was the Swinging Sixties at its most superb.

After the show Brian Epstein hosted a supper party at his home; when the Experience arrived, Paul McCartney himself was at the door to welcome them in. The group had been in existence for only six and a half months, but already an aura of excitement clung to everything Jimi, Noel, and Mitch participated in—every record, every performance, every late-night jam. Epstein considered his party to be a kind of "farewell . . . good luck!" event for the Experience, soon to venture into uncharted territory.

§

THE PRODUCERS of an innovative California music festival courted both the Beatles and the Rolling Stones to headline a weekend of music on June 16, 17, and 18. Each group declined. However, it was Paul McCartney who made the call to suggest that the Experience be part of the bill and Mick Jagger also urged that Jimi be invited to Monterey. "The lads" felt that this could be the perfect time and place for "their" Jimi to return to America and cause a commotion!

The festival, despite local controversy, was set for a fairground area, accommodating only three thousand people, in the historic town of Monterey, just ten miles south of Fort Ord, where Hendrix had been stationed for his first months in the military in 1961.

Jimi, Mitch, and Noel would join an exciting range of artists, including Otis Redding, Simon & Garfunkel, Ravi Shankar, Eric Burdon, the Jefferson Airplane, the Grateful Dead, the Who, the Mamas and Papas, and a new girl singer named Janis Joplin.

As the Experience prepared to fly to New York and then to Monterey, they received joyous news from Chas, who told them that *Are You Experienced?* had climbed to the number-two spot in the English album charts. Jimi would return to his native land in a new incarnation—as a man of accomplishment. If his luck continued to hold, he would reinforce his star status at the small but mighty California festival. And lucky Reprise Records would really have something to "promote."

The festival directors—Derek Taylor, John Phillips, Lou Adler, Donovan, Mick Jagger, Andrew Loog Oldham, Paul Simon, Smokey Robinson, Jim McGuinn (later Roger), Brian Wilson, and Paul McCartney—created a festival theme, borne out in the stage banner that read LOVE, FLOWERS AND MUSIC, and they hired D. A. Pennebaker to film the entire weekend. This foresight proved a masterstroke. Pennebaker's 1965 documentary on Bob Dylan, *Don't Look Back*, was admired by the directors, who visualized *Monterey Pop* as a small cinematic chronicle. Who could have

guessed at the time that the movie would become a worldwide sensation and a valuable historical document?

Pennebaker knew little about Jimi Hendrix except for what John Phillips had told him. "John said there was a guy he'd seen in England who plays blues and sets fire to himself!" Pennebaker recalls. He told his crew to shoot just one song for each performer in order to save on film costs. A small red light was positioned on the side of the stage. "We had these cameramen all around the place, and they could see the red light was on, and they all knew that if they shot, then there'd be something to edit." During the Experience's performance, the director said, "We all realized that Hendrix was so amazing that we just kept on shooting everything he did."

The light never went off.

Michael Lydon is one of the definitive authorities on the music explosion of the sixties. A founding editor at *Rolling Stone* and a passionate, perceptive writer, Lydon is the author of numerous books that focus on music, including *Flashbacks: Eyewitness Accounts of the Rock Revolution* and a superb biography of Ray Charles. He came to know virtually every square inch of the Monterey Fairgrounds during his days and nights covering the festival. This is what Lydon wrote about Jimi Hendrix:

He is both curiously beautiful and as wildly grotesque as the proverbial Wild Man of Borneo. He wore scarlet pants and a scarlet boa, a pink jacket over a yellow and black vest over a white ruffled shirt. . . . Dressed as he was and playing with a savage wildness . . . the act became more than an extension of Elvis's gyrations. It became an extension of that to infinity, an orgy of noise so wound up that I feared that the dynamo who powered it would fail and fission into its primordial atomic state. Hendrix did not only pick the strings, he bashed them with the flat of his hand, he ripped at them, rubbed them against the mike, and pushed them with his groin into his amplifier. And when he knelt before the guitar

as if it were a victim to be sacrificed, sprayed it with lighter fluid and ignited it, it was exactly a sacrifice: the offering of the perfect, most beloved thing, so its destruction could ennoble him further.

"The audience was completely overwhelmed by Hendrix," said Joel Selvin of the *San Francisco Chronicle*, long a respected writer and pop music critic and a walking encyclopedia of Bay Area music memories. "It was an epic, historic performance."

For Jimi, Monterey was "just wonderful! *Wonderful!* Our band was great! Noel and Mitch were as excited as I ever saw them; afterward they couldn't stop talking about it. It was like the birthday you always dream of and it never happens. We'd had a few blah-blah moments before the show with Pete Townshend about who was going on last, but it all worked out for everybody." What he meant was that the Who played before the Grateful Dead, and the Experience followed the Dead—just the way Chas and Jimi had hoped it would be. "I knew and the Who knew," Chas said, "that they'd be crazy to try and come onstage after Jimi."

Tom Donahue, a disc jockey at the San Francisco FM radio station KMPX, deserves credit for his role in revolutionizing American radio at this time. By playing album cuts, producing live radio broadcasts, and utilizing the airwaves as a true public service to listeners, Donahue founded "underground" radio. His hipness was an instrumental factor in helping the career of Jimi Hendrix take off *before* as well as after the Monterey Pop Festival. Donahue had been playing Experience tracks for several months prior to the band's appearance onstage at Monterey. San Francisco area fans hip to the "new music" couldn't wait to attend the festival, and one of the must-see names on their collective list was Jimi Hendrix. However, there were others in the audience who knew nothing of Hendrix and were restless. At first.

"The Experience arrived in San Francisco a day after their

appearance in Monterey," Joel Selvin explained. "Jimi was to be the opening act on the show with Jefferson Airplane and Gabor Szabo. Concert promoter, Bill Graham at that time had no idea of what was going on.

"He booked acts in a combination of blind luck, speculation, and other people's advice. Bands played two sets a night and they did them '3 . . . 2 . . . 1 and 3 . . . 2 . . . 1' so that the opening act followed the headliner once. This led to some pretty interesting match-ups. So then Hendrix showed up and so wiped the Airplane off the map the first night that they did not come back! They had six nights booked at the Fillmore June 20 to 25, and Tuesday night Hendrix opened. He'd been all over the radio in San Francisco, even before the Monterey festival, so nobody gave a fuck that the Airplane was there. *Everybody* was there to see *Hendrix*, which came as a surprise to the Airplane and Bill Graham.

"At that time there's this vector going on and you see people raising the bar on almost a weekly basis. And that's what the first Hendrix album did. Immediately, everybody recognized that this was something new, that *this* had raised the bar and that we were now dealing with a whole new world. Hendrix was an exciting and radical new high. We all saw that . . . we'd all been listening to everything that was going on. Bluesbreakers with Clapton. The Butterfield band. Every new record was *scrutinized.* The Hendrix record had been brought in here as an import. It wasn't even released in this country until August. It was such a *focused* thing in San Francisco, this burgeoning musical culture.

"So Hendrix blows the Airplane off the stage. Janis Joplin and Big Brother and the Holding Company were brought in to fill out the rest of the engagement. The Airplane suddenly remembered they had to leave town to . . . uh . . . work on their record! So that Sunday there was a free concert in the Panhandle, which was a little bit of Golden Gate Park that sticks out from the main park, a block wide, three or four blocks from Haight–Ashbury. There's a generator and a flatbed truck. The Airplane loans the

truck and some equipment and Mitch, Noel, and Jimi play that Sunday. Fifteen hundred people showed up!"

Soon Jimi was invited to make an in-store appearance in Los Angeles, his first, at the Groove Company, the Sunset Strip's first hip music store, located at Sunset and Crescent Heights boulevards, across from an in-crowd club known as Pandora's Box. The appearance was engineered by Michael Villella, a bright and knowledgeable fellow, who had recently become a record buyer for the shop. Villella had first heard the Experience's records on a visit to London, and he traveled to Monterey to see Hendrix onstage— "Jimi was magical. His aura took over the entire festival." The Groove Company soon sported a painted façade of Noel and Mitch on either side of Jimi. To enter the store, customers walked inside Jimi's mouth. When the avant-garde radio station KPPC alerted listeners as to the day and time they could see Jimi Hendrix in person at the Groove Company, fans filled the store, its spacious parking lot, and the surrounding sidewalks; the buzz after Monterey, 350 miles up the coast, was that strong. Villella had scored yet another coup by arranging to sell the first *Are You Experienced?* albums before the official American release date weeks later.

Hendrix was also seen during these glory days riding in a limousine along Hollywood Boulevard with twin blonde *Playboy* Playmates on either side of him. Jimi and his chicks dropped by a party honoring the Who, hosted by Rodney Bingenheimer and Frank Zinn at Zinn's Hollywood home.

Frank was a friend and fan of the Who. Diminutive Rodney, with his Buster Brown bob, was to become known as the stand-in for Davy Jones on the Monkees' television series. Rodney enjoyed knowing the "right" people and Hendrix was always kind to him, a year later even taking him cruising in his new Corvette on the Sunset Strip.

At the Who gathering, Hendrix sat down on a couch flanked by his blondes, and the guests were "flipping out," as they said, to see Hendrix up close. A sudden line materialized of both male and

female wannabe groupies begging for his autograph. Jimi didn't wish to disrupt the party or offend his friends in the Who, so he and the blondes soon split.

Life was *not* just about fun and pop frolics, however. Ever since the assassination of John F. Kennedy, political turmoil had blanketed the "land of the free and the home of the brave." The words of "Blowin' in the Wind" by Bob Dylan and of Sam Cooke's song "A Change Is Gonna Come" resonated in these troubled times. People of conscience, horrified by the unspeakable daily acts of cruelty and violence against black citizens, debated how integration could and must be peacefully accomplished. Numerous whites of all ages made their way to southern states, most notably Alabama, to take part in freedom marches and support the leadership of Dr. Martin Luther King Jr. And Americans in all regions of the country felt an increasing concern over the military action in Vietnam in the summer of 1967; this was a real issue for many young people, as well as for parents who didn't want to see their sons go to war in a place they'd never heard of. *Why* are we there? Images of huge protest marches throughout the country filled television screens and the front pages of newspapers.

Then, too, a major new element was infiltrating the lives of America's youth—drugs. Two slogans became part of the lexicon of the young—"Peace and love" and "Turn on, tune in, drop out," the motto of LSD guru Timothy Leary. The sweet, acrid smell of marijuana filled the air. "Acid" became a new word in the hipster vocabulary—slang for LSD. Three years later Jimi Hendrix would say, "They called it the Summer of Love. Summer of Acid is more like it! The LSD passed around in San Francisco was a fabulous discovery to me. I'd taken LSD in London, but *this* acid was advanced, a whole other thing. I wanted more; it became the great escape. There were nights when it seemed like anyone who came near me was handing me LSD. I overdid it. I know that now. Almost every musician I knew was an acid freak. Quite naturally, there were also people who couldn't handle it; they had to find out

the hard way. I actually thought that I was one of the special ones meant for LSD. I don't believe that anymore."

§

MICHAEL GOLDSTEIN, a New York publicist, flew to California specifically to attend the Monterey Pop Festival, where he hoped to pick up music clients. One of the stories that circulated around the festival concerned "this New York guy who rushed over to Hendrix and said, 'Hello, Otis! I'm a big fan of yours!'" Despite the gaffe of confusing Hendrix with Otis Redding, "the New York guy" and the Experience's manager, Michael Jeffery, hit it off. Michael Goldstein returned to New York with the title of "American press representative" for Jimi, Noel, and Mitch.

That summer Patricia Costello, who worked for Goldstein, was instrumental in putting together a far-ranging American publicity campaign. "The first time I met Jimi Hendrix was, as I recall, in July of 1967," Pat Costello said. "I hadn't yet heard the music. I met Jimi the person in New York after the Monterey festival, and I understood there was something different there. I just got this feeling that he was unique, not just another run-of-the-mill guy coming in from England soon to be forgotten. There was a special spark in Jimi and about him. He was quiet and shy, soft-spoken, well mannered, quite unlike the image that Michael Jeffery wanted to present to the world."

Jimi felt comfortable with her. "Pat is such a pleasant person; she has that wonderful, gentle voice," he said. Jimi always noticed speech patterns and tones of voice. He was uncomfortable, though, with the often aggressive sound of her boss's voice. Jimi preferred to deal with Costello rather than Michael Goldstein. The press, too, responded to her "gentle voice," and Jimi, Noel, and Mitch's music, backed up by Pat's telephone calls, created a demand for interviews in a wide range of newspapers and magazines. Pat lived with a telephone in her ear as she scheduled interviews around their performing and recording commitments, and she was ever vigilant

in seeking record and concert reviews. Costello was one of the trustworthy few who truly worked long and hard for Jimi Hendrix and didn't gouge him for money.

How did the media react to this unique new presence in the mostly white world of pop music? "I never really thought about his color," Costello said. "I don't think most press people did when they met him. He was simply Jimi."

She paused reflectively and then continued, "Maybe a few of them were scared to meet him not because of color but more because of the bold image on record sleeves and in publicity photographs. I remember when the Experience was to be on *The Ed Sullivan Show*, someone from the Sullivan office called to ask, 'Now, what is this guy all about?' I said the truth—'He's great to work with.' The show was all set, but at the last minute, as I recall, Jeffery's office called with a change of plans. So, unfortunately, the Experience never appeared on *Sullivan*. I can't think of anyone in the press who was afraid of Jimi when they actually met him. Just surprised at how nice he was, and perhaps in a couple of cases, writers were embarrassed to have had preconceived ideas."

§

ERIC CLAPTON could be shy and less than forthcoming with the press. In early July 1967, he opened up to Penny Valentine in *Disc and Music Echo*. She was easy to talk to, and Clapton respected her. "At present, the Cream are enjoying great popularity," Valentine wrote. "Eric, modestly, puts this down to the fact that Jimi Hendrix is out of the country." Clapton told Valentine, *"That's our real competition. We're always getting compared and when he's around we knuckle under!"* He also declared of playing guitar, "For me it's my life. I am wholly concerned with and completely wrapped up in music twenty-four hours a day and when I'm working nothing else matters in life." In the photograph accompanying the article, Clapton was sporting a handsome and full white-boy version of the familiar Jimi Hendrix hairstyle.

Hendrix, when he was told of Eric's interview, was delighted with all that Clapton had said, also amused and flattered that the always fashion-conscious guitarist had posed for a picture that showed indisputably he was taking lessons from Hendrix in the "looks" department, from his shirt to his recent "English Afro."

On July 8, Jimi, Noel, and Mitch began the first of eight nights on tour as the support act for the Monkees. Chas was said to be angry that Mike Jeffery had agreed to this unlikely tour combination. Others in the inner circle believed that Chas, from the first, saw the publicity value of the idea and went along with Jeffery and Michael Goldstein in plotting out a letter-writing campaign, signed mostly by fictitious names, complaining to the media that "The Jimi Hendrix Experience doesn't belong on a show for innocent children!"

Mickey Dolenz of the Monkees said, "We were so close to that uproar when the Experience toured with us. Jimi really was one of the nicest people I've ever known. We all had a lot of fun in the hotels. The Monkees were into chicks and being drunk and stoned and stuff, and so was Jimi's band. But the difference was when the Monkees were onstage, we had to do 'Last Train to Clarksville.' Not that we minded, because the kids dug it, but we really had a good time back at the hotel jamming together, Peter Tork and Mike Nesmith especially, because they were primarily musicians all the time. It was a fantastic tour from our point of view. When the Experience left us, they'd had a real good offer in New York City. We didn't want to hold on to them, because the audience we were playing to wasn't the audience that really appreciated Hendrix. It was driving the Experience crazy to play for kids as young as eight and ten after their incredible reception from teenagers and adults at Monterey. The little kids didn't understand their music. But we all had such a good time offstage!"

Now away from the Monkees, Hendrix caught up with Eric Clapton in New York for two nights at the end of July; they rushed out to see John Hammond at the Gaslight on MacDougal Street,

one of Bob Dylan's early haunts. The small stage sizzled as Hendrix, Hammond, and Clapton played the blues in free-flowing jams. These exciting musical hours with special men who continued to show him respect and friendship meant the world to Jimi Hendrix; it was his definition of true happiness.

With success comes envy. In Los Angeles, producer Jack Nitzsche praised Hendrix to the skies, calling *Are You Experienced?* "utterly brilliant," according to Denny Bruce. "Jack played the album constantly," Bruce recalls of his friend. "Neil Young got sick and tired of hearing about Hendrix from Jack. Neil was jealous."

Two men in New York were more than jealous—Curtis Knight and Ed Chalpin. They wanted a part of Jimi Hendrix's newfound success. Curtis dropped in on Hendrix at his New York hotel that summer and pressured him. Hendrix agreed to accompany him to Chalpin's studio and do a little recording "for old times' sake." "Curtis was on my case about going 'big time' at Monterey," Jimi said, "and I'd already heard that Chalpin was causing problems at Track. I just wanted to cool everybody out. I said I'd play on some tracks for Curtis but that they couldn't use my name. Curtis agreed."

§

GREETED LIKE conquering heroes when they returned to London at the end of the summer, the Experience was deemed a "supergroup" after less than a year of existence by the press and the band's powerful English fan base. On September 16, *Melody Maker* held its annual awards party at the Hotel Europa in London. The highlight of the festivities was the moment when Jimi Hendrix was named "World's Best Pop Musician." His face was a study in humility as he accepted a large trophy to a roomful of cheers and applause from the movers and shakers of the English music industry. Days later, Track Records took out an ad bannered: ALL HAIL KING JIMI!

Barrie Wentzell, a talented photographer covering the greats

of the London music scene, snapped many pictures of Hendrix, including the special occasion at the Hotel Europa as he accepted his trophy. "We loved him at *Melody Maker*," Wentzell said cheerily. "Chris Welch, who first saw Jimi down at the Bag O'Nails, and all of us. We were completely into his music, his *art*, really. We always looked forward to wonderful conversations with Jimi, the best guy on the planet!"

Jimi discussed his *Melody Maker* award with me a couple of years later. "Nineteen sixty-seven was such a busy, busy, busy year," he said. "I almost never got more than five hours of sleep a night. When I had three minutes to breathe a couple of days after the *Melody Maker* party, we were off somewhere on the road, and I was brushing my teeth, thinking about it. I started to cry because it meant so much, and I ended up washing my face three times to get off this mess of tears and toothpaste."

He had come to England not knowing what to expect, wondering if the pop greats would accept him, and so much had happened so quickly. "Nineteen sixty-seven was the best year of my life," he said.

"We went over to Paris in October, and they *still* loved us," Hendrix said proudly. "Standing onstage looking into the first few rows, I felt so close to the audience. I could see into their eyes; it was like we had a little understanding. Those are the times when I just want to play and play." He smiled dreamily and added, "If I ever have a place of my own, I want it to be in one of those historic old buildings looking out at the Seine. I'd like a little home to hide away from the rest of my life. Somewhere I can play all my tapes and think and imagine and plan. I'd like to take drawing lessons in Paris, too."

Chas Chandler, Michael Jeffery, Mitch Mitchell, and Noel Redding—the four men whose lives were then intertwined with Jimi's—had little knowledge of his deepest dreams. With them, with the press, and with Noel's mother and Mitch's parents, when he was asked about growing up in America, Hendrix kept it light, offering

only the occasional amusing comment or memory about Seattle, family, the military, or the chitlin circuit. Few clues circulated as to childhood betrayals and poverty, fear, loss, and loneliness. The "bad stuff," as he referred to certain parts of his previous life, was hidden away in a corner cupboard of his brain. The good days were in the here and now.

While Jimi was waving his "freak flag" high, Michael Jeffery and Steve Weiss, the attorney Jimi and Mike now shared, told their star that Chalpin could conceivably keep him from further recording for anyone other than Chalpin until October 1968 as Jimi had signed an exclusive agreement. Not since his mother had left him and his brother Leon had anything shaken him so badly. He felt that all he had worked to attain was now in total jeopardy.

The Hendrix–Chalpin issues would never go away.

§

CHAS PRIZED publicity. He was quite sure that the Experience was just getting started to show the world what Jimi Hendrix and his band were all about. As a former member of the Animals, he knew firsthand what a valuable tool the right kind of press could be, particularly in the national daily papers and in color magazine spreads. He cherished his own assortment of clippings, ranging from tiny ads about gigs the Animals had played in the Newcastle area to reviews and interviews in London music weeklies to photos in American teen magazines. He was intent on capturing the interest of Leslie Perrin, a clever, amiable, middle-aged man who was Swinging London's most revered music press agent. Perrin knew virtually every journalist worth his typewriter in the whole of the United Kingdom. London's top editors and reporters were his friends; they met frequently, most usually at the Wig and Pen on Fleet Street, for plenty of booze and even more gossip.

"He knows *everyone*, and he has agreed to represent the group," Chas told Jimi, Noel, and Mitch. "Les will be our good-luck charm."

Their other good-luck charm was Dick Katz, a fine agent with

Harold Davison, Ltd. Katz was a deluxe wheeler and dealer with the clout to secure important concert dates; he had impressive experience in career building. The Davison agency represented a range of world-renowned singers and musicians, including jazz legends, who'd been with them for years. Jimi respected Perrin and Katz and enjoyed hearing their lively stories about musicians he admired. They were perhaps the only men in his business life who possessed the sensitivity and the knowledge of the music business to understand his past. In their company he didn't have to pretend to be anything he wasn't or answer painful questions. Dick Katz kept a careful eye on Hendrix. "I knew early on that he was one of the greatest players I would ever hear," he said. "It is deeply gratifying for me to work with someone so young who has unlimited potential."

Success brought a dazzling escalation in the attention offered by the female sex. In America, California blondes, hippie chicks, and sexy models panted after Hendrix, and, time permitting, he was more than agreeable in accommodating them. For the Experience and most other popular English and American groups, sex was like fast food—quick and readily available. Names were often forgotten; descriptions would suffice: "the red-haired scrubber," "the kinky New Jersey model," "big tits from Detroit." Jimi was high on the "score list" of numerous English beauties, a few of them the girlfriends of his musical peers. Tall or petite, curvy or thin, these often braless, miniskirted "dollybirds," as they were described in the British press, with their thickly lined eyes, gleaming pale lips, and long, shiny, straight hair, went crazy for the sexy Jimi Hendrix. "Half the time I didn't even know the girl's name, and there we were in bed," he was to tell me. He wasn't bragging, just stating the facts. He made it clear that Kathy Etchingham was well aware of it all and that theirs was an "open" relationship—on both sides.

His fellow musicians privately acknowledged Jimi as a fantasy figure. "We all were sure that his sexual . . . uh . . . equipment was

as astounding as his musical technique," a noted British guitar player said. "We all wanted to be him. What could be more cool than to be a sexy black man, playing the blues and pulling any chick you fancied?"

That fall the Experience made a quick trip to Holland for television filming and a concert, immediately returning to England for their second and more extensive tour of the country. Kicking it off at the Royal Albert Hall in London, they gave thirty perform-ances in three weeks. Jimi, Mitch, and Noel wound up exhausted in Glasgow and got very drunk after the final show.

As he headed into a new year, Jimi Hendrix was grateful for the huge progress he had made in his career, deeply proud of the Experience's hit records and also of the bags of fan mail that were arriving daily at the Jeffery-Chandler and Track Records offices. These letters *mattered* to Jimi; they were tangible proof of his success, of the fans' respect, and he made an effort to personally answer as many of them as time permitted.

Also, the letters bolstered Hendrix in the increased pressure and insecurity he was feeling as Ed Chalpin turned up the heat on his legal actions. "I was very scared," Jimi told me a year later. "I remember going off to jam at the Speakeasy one night, so full of frustration that I wanted to play until my fingers were bleeding, do anything that would blot out all the legal blah-blah-blah. I knew it wasn't going to be settled easily, no matter what crazy routine Jeffery was laying on me. So much had been accomplished in 1967. So *very* much! To me the whole point of success is to control my own musical thoughts and how each song is recorded, mixed, and produced. *Every* song! All these damned threats of lawsuits have nothing to do with music. *Nothing!* It's all about greed."

On December 1, the second Experience album, *Axis: Bold as Love*, was released in the UK. Jimi felt that *Axis* represented a giant step in the progress of his recording and songwriting; the rave reactions from fans and critics alike to this new Experience record filled him with a sense of accomplishment. For all his success, his

insecurities were ever present. "The way *Axis* turned out gave me faith that I could keep moving forward," he said to me, "and that the audience would come with us."

Jimi's pride in his work was soon diluted, however. He became agitated and physically ill when Mike Jeffery informed him that the American release of *Axis*, which was due the same month, was to be delayed until January 1968. Meanwhile Chalpin had negotiated a handsome deal for himself with Capitol Records, which meant that *Get That Feeling*, a concoction of old tracks with Curtis Knight on vocals and Jimi backing him up, was now to be released in advanced of his own new carefully crafted album.

Capitol was the Beatles' label in America and generally distributed quality new music. John Lennon took umbrage at the proposed release of *Get That Feeling*, and he told Jimi that he was "being punished for your talent and success." Lennon felt frustrated that the seeming power of the Beatles didn't work at Capitol. He had personally spoken to the American record executives about Hendrix's situation but ultimately he was unable to help and protect this musician he admired.

Experienced

ON THAT rainy evening of February 9, 1968, backstage at Anaheim Convention Center when Les Perrin introduced me to Mitch and Noel and then to Jimi, there was little doubt in my mind that these three musicians possessed personal flair and charm. But music was what it was really all about. Like most of the seven-thousand-plus members of the audience, I heard and felt the birth of greatness that night. This music was indeed *different*, and the wide-eyed, openmouthed crowd soaked up every note and each exciting, swooping Hendrix stage move. "I've never seen anyone like *him*!" said the teenage boy sitting directly behind me. "This band is *incredible*!" He and his friends cheered every song. They leaped to their feet to applaud. I followed suit. Everyone was grooving to "Wild Thing." I turned and smiled at the boys behind me, seeing their joy-filled faces. They were so caught up in their elation that they didn't seem to notice Eric Burdon standing along-side me. Eric, a star in his own right who'd already seen Hendrix perform many times, appeared as joyful as these kids, his eyes fastened on the stage. I've always enjoyed observing audiences, and I sensed in that moment that the boys behind me would treasure this night for a very long time.

In my car with Les, Chas, and Lotta, on the freeway back to Hollywood, Chas talked about the Experience's demanding schedule of the past ten days. "You ought to have seen him in Paris last week," Chas said. "Jimi's a huge star there now; he loves playing

in France, and they love him. We sold out two shows with Eric as our support act." Chas and Eric Burdon, both Newcastle lads, knew each other well, of course, from their years together as members of the Animals. "Immediately after the Paris show, the Experience flew to New York," he added.

Their plane, caught in heavy air traffic, circled New York for almost an hour. Finally Jimi, Noel, and Mitch landed at John F. Kennedy International Airport, enduring a strip search before they made their jaunty entrance at the "The British Are Coming" press reception plotted out by Michael Jeffery and his press aide Michael Goldstein. As they stepped inside the Copter Club on top of the Pan Am building, crowded with reporters and photographers, they were almost blinded by a flood of flashbulbs.

"Paris and New York. Sounds like an exhausting two days and nights," I remarked to Chas.

"Only the beginning of a long haul," he said. "New York was purely about publicity. No gig." Hours later the Experience boarded another jet, this time flying across America to San Francisco.

The Bay Area was "Hendrix territory." "We love to hear *you* scream!" Jimi boyishly commented to an audience in the city that had been a stronghold for the Experience since the Monterey festival. The screams echoed over a long San Francisco weekend—two performances at the Fillmore and six more at Winterland, all with Albert King, a guitar player Jimi admired; he bought every King record he could find. His pals from London, John Mayall and the Bluesbreakers, provided even more guitar power to the shows. For the last night at Winterland, Janis Joplin with Big Brother and the Holding Company were added to the bill.

Hendrix told Joplin that he knew this part of town before he became famous. "I backed up Ike and Tina Turner," he said, "but not for very long." Joplin's eyes got big as she listened. "That Tina Turner is damned fine," she said, "but I hear the husband's bad news."

Day in, day out, Jimi, Noel, and Mitch were on the move. "So

many airports, so many hotels, so many gigs," Noel said. "It becomes a blur." Eventually he developed a fear of flying, needing Valium and a strong push to get him up the boarding steps. Occasionally the musicians managed to squeeze in as much as six hours of sleep. In lieu of adequate sleep, artificial stimulation in the form of pills, marijuana, and hashish became as essential to the band as amps and microphones. No major group of this era—including the Beatles, Stones, Cream and Who—endured such a punishing schedule.

To American fans the Experience's life looked like a spectacular party, fueled by thunderous applause and hourly offers of drugs and sex. "You guys are so *great!*" was the chorus that constantly rang in the musicians' ears. Onstage the band represented a range of fulfillment for the audience—powerful music, sex appeal, fun, intimacy. As big and bold as Hendrix appeared, his most ardent fans nevertheless picked up on his shyness and vulnerability when he spoke to them briefly as he introduced a song or made a comment or two between numbers; they *loved* to hear him talk, to feel a personal "just between you and me" connection, and they delighted in intermittently singing along to Hendrix's tongue-in-cheek version of "Wild Thing," giddy as Jimi declared, *"Wild Thing, I think I love you. . . . Sock it to me one more time."*

Guitar sales were skyrocketing in an America where hundreds of thousands of young people were thinking less about their education and more passionately about learning to play an instrument, most especially one of those shiny Stratocasters. This was great news for Fender Guitars, the California-based company that was seriously considering ceasing production on the "Strat" until Hendrix came along. The impact and style of his music quickly quadrupled sales; urban young men and country boys alike all wanted a guitar "just like Jimi's," whether they knew how to play it or not. The new American Dream was now about being in a band, or at the very least working for one.

Chas Chandler had been a mere musician as opposed to a

star, and now he was a hit record producer and a co-manager. He enjoyed these titles and savored his growing prestige and power. Chas was generally pleasant and polite and knew the value of saying thank you. Still, he came on as strong as he dared with Reprise Records in California. Chandler's goal was to make lots of money—the faster the better. To this end he was on the telephone or in meetings with record executives and promotion and publicity people on an hourly basis. Chas's favorite word was "strategy," and Reprise listened closely to his ideas. In both America and England, Chas made it a point to acquaint himself with key "opinion makers" who could be helpful to the Experience.

One of them was Tony Palmer, who came to know Chas and Hendrix in large part due to John Lennon. In 1964, Palmer was studying at Cambridge, where he attended the film premiere of *A Hard Day's Night.* "Lennon was there," Palmer recalls. "We struck up a conversation and got on extremely well. John said, 'Next time you're in London, why don't you ring me?' He gave me a number where I could reach him." Two and a half years later, Palmer went to London. "By then the Beatles were extremely famous," he said, "but I did try the number. To my absolute astonishment, John did call me back, and we became good friends."

Palmer was one of two music critics of the *Observer* from 1967 to 1974. His special responsibility was jazz and rock and roll. He recalls, "I reviewed *Are You Experienced?*, which I didn't like. I wrote a rather bad review of it, which I almost immediately regretted. I wrote a letter to Chas Chandler saying, 'The next opportunity I have, I will re-review this record because I've changed my mind and actually think that it's marvelous!' So I was not in their good books, to put it mildly. I am so ashamed of that first review.

"At this time I had gotten a job at the BBC in the films and arts department, the cultural department, as a filmmaker. John Lennon said to me that I really ought to use my influence to make a film about what was happening in rock and roll in early '67 and '68. I said, 'Fine, will you help me?' He gave me a list of people I

must film in this wonderful flowering time for music. I wanted to call the film *All My Loving*, and John gave me permission to use the title. Of the musicians in it, not a single one had actually appeared on British television, other than in little promos, and had never been seen talking seriously about what it was they wanted to do. They were the Cream, the Who, the Beatles, of course. John said, 'Whatever you do, you've got to film Jimi Hendrix.'

"Jimi was doing a North American tour, and I rang Chas and said, 'Don't slam the phone down—this is what I'm doing. My sponsor as it were is John Lennon. Would you allow me to film Jimi at his next gig?' And he said, 'No!' I said. 'All right, would you have a think about it? I'll call you back in an hour's time.' So I did, and Chas said, 'I've spoken to Jimi, and he's so angry he wants to punch you. So therefore you'd better show up, and if he doesn't kill you, then you can film.' I showed up in Worcester, Massachusetts, on a very cold, snowy night in February 1968. Chas wasn't there, but I was introduced to Jimi by one of his road managers, and the thing that saved it was we discovered that we had a very close mutual friend, Mark Boyle. Jimi said, 'Well, I can't punch you, because if I do, Mark won't speak to me again. And I like Mark.' I filmed Jimi nonstop for about two and a half hours; only about five minutes survived, because the BBC junked it all."

Eventually Palmer bought a big house in Ladbroke Square in the middle of Notting Hill. "It was great fun to be there at that time," he recalled. "Jimi came 'round quite a lot. He was shy and insecure, like a few other creative people I've known; he often sat in the corner at parties. He was almost always the only black person in the room."

Palmer's friend, Glasgow-born Mark Boyle, who was later to become an internationally acclaimed artist, was an innovator with regard to the "light shows" of the late sixties. He and Jimi became mutual admirers when Boyle and his wife, Joan Hills, produced a fabulous light show for the Soft Machine on a 1968 tour called "The British Are Coming." The Machine toured America with the

Experience on a grueling route that spanned twenty-five cities, performing at some fifty venues, often playing two shows a night.

Boyle remembers an extraordinary time on his first and last pop tour. "On an April afternoon, we were in this bar in Virginia Beach, Virginia, sitting around quietly. Jimi, my wife, Joan, and I were there, and Mike Rattledge from Soft Machine, who was then the greatest keyboard player in the world, also Robert Wyatt, who was their thrilling drummer, and Mitch and Noel. Suddenly there were these men crowded 'round the bar who began to shout and laugh. And they started opening bottles of wine and drinking to the health of someone's assassin. The waitress told us that it had just come over the radio that Martin Luther King Jr. had been shot. My Glasgow instinct was to grab a bottle and attack, and I looked 'round at the others and saw Jimi staring away into space. I matured twenty years in two minutes, and we got up and left the bar in silence. We all flew back to New York immediately. There was rioting in the streets; cars were turned over and set on fire. We were due to play in Newark that night, and no one wanted to go. Jimi said the last time he had been in Newark, there were tanks on the street and the city was on fire. We all milled about in the foyer of the hotel, waiting for the decision to cancel. Then the police came on the phone from Newark to say that there was a vast crowd waiting for us, and if we didn't show up, they were sure they'd burn the city. The first limo driver took a long, thin cheroot out of his mouth and said, 'Jimi sits up front with me, or I don't go.' So Jimi sat up front, and all of us white people slumped down in our seats, and we set off. The streets of Newark were silent and deserted when we arrived, except that there seemed to be an enormous black man on each corner as though he was a sentry or policing the block or something. There was an immense crowd at the auditorium, and I was terrified that Jimi was going to be killed. At the time everyone thought there was an insane conspiracy to eliminate anyone who was seen as a threat to the extreme right in America, and who was next on the list? We were out in the

auditorium with the projectors for the light show, and what would we do if someone suddenly stood up with a gun?

"Jimi came on very quietly to enormous applause. Then he said softly into the microphone, 'This number is for a friend of mine.' He then began an improvisation that had a beauty that was simply appalling. Immediately everyone knew that the friend was Martin Luther King Jr., and this music somehow seemed to convey all the agony of the black people. The whole audience was weeping. Even the stagehands just stood there with tears streaming down their faces. It was a lament for a great man, but it was the most harrowing lament, beyond anyone's imagining. When he finished there was no applause. Everyone in this vast crowd just sat or stood sobbing, and Jimi laid his guitar down and walked quietly off the stage."

§

"JIMI DROPPED by my editing room in New York several times in 1968," *Monterey Pop* director D. A. Pennebaker remembered. "Jimi was a pleasure to have around; he was a very gentle person. I'm sure the only reason he ever spent any time with me was because of Dylan." Hendrix was impressed that Pennebaker personally knew Bob Dylan and had directed a film about him. Pennebaker didn't fully understand that Jimi had been interested in movies since his boyhood and that he was a veritable human sponge when in the company of other creative people he respected, soaking up knowledge and new insights.

Most of Jimi's thoughts in April, May, and June 1968 were focused on recording *Electric Ladyland*, although it was being done in fits and starts due to touring. At the beginning of May, the band was in the studio, soon fitting in a Fillmore East gig with Sly and the Family Stone and headlining the Miami Pop Festival. They flew to Europe for a short tour of Italy and Switzerland. Michael Jeffery insisted Hendrix fly back to New York for two days of legal meetings about "the Chalpin situation" and then return to meet

Noel and Mitch in Switzerland. In June, Hendrix was allowed a few more days to work on *Electric Ladyland.*

Mitch Mitchell said in his book on Jimi and the Experience, "After we finished *Axis* and before we left for the second U.S. tour, some recording was done at Olympic in London including the original four-track versions of 'Crosstown Traffic' and 'All Along the Watchtower,' which were transferred to sixteen track in New York later on." Mitch makes a very important point in the book in saying, "By that time the pressure was off of us to record hit singles, which was great. The market had changed and you could become to all intents and purposes an album band, which is what we'd always wanted. For us, recording was a completely separate thing from playing live, and I'm very proud of the fact that we were able to deliver the goods on both fronts in very different ways." However, this kind of thinking was more true of Hendrix and Mitchell than it was of Noel Redding.

When Jimi was productive in the studio, he was happy. But it sometimes took a while to get to the "productive" stage. The others, particularly Chas and Noel, who bitched together about this on a regular basis, were weary and bored by what Mitch calls "Jimi's self-indulgence of rerecording endless basic takes." *Electric Ladyland* is a superb album. Could recording have been cheaper and easier without the indulgences? Undoubtedly so. But the fact remains that, as Jimi said, "Sometimes it takes the messing around to get to the good stuff. You cannot walk into a recording studio, push a button, and say, 'I'll be great tonight!' Sound is in my head, but it's not always in my fingers." Most of *Electric Ladyland* was recorded at the Record Plant, because Jimi, Noel, and Mitch liked the engineer and co-owner, Gary Kellgren. The band and the growing entourage partied incessantly, often hanging out at Steve Paul's club, the Scene, a couple of blocks away. This was where Jimi loved to jam. Teddy Slatus, who managed the Scene, refers to Hendrix as "one of the few gentlemen that came down to the club. He was very polite and nice to everyone, especially to me; he was

a great guy to have around." The basement club was small and intimate, a hangout where a variety of musicians would drop by in hopes that Hendrix was in town and ready to jam.

"Each time Jimi arrived back in New York from the road," Pat Costello recalled, "the first thing he would ask is, 'Who's playing in town?' There was one occasion when I casually mentioned, 'Oh, just Jeff Beck.' As I knew he would, Jimi got so excited! 'Jeff Beckson! Jeff Beckson (his affectionate nickname for the guitar player). Great, great, great! I'll call him right away and set up a jam.'"

As much as Jimi liked to jam with his English friends, he was not an elitist. One night at the Greenwich Village Club then known as Generation (later to become the site of Electric Lady Studios), when Mitch was nowhere to be found, Jimi brought up a New York college kid, Woody Lewis, to sit in on drums, providing Lewis with the thrill of his life.

In 1968 the magazine division of the Hearst Corporation launched *Eye*, a totally hip publication, aimed at young people and music lovers. Journalist Michael Thomas wrote the finest feature piece on Jimi Hendrix that had been published in America until that time.

"Hendrix is a master of ceremonies," Thomas said. "He saunters on stage, looking like a buccaneer Othello come to Camelot, in velvet and lace and boots of Spanish leather, a Mexican bandit's hat on his head with a feather in the gold chain-band, his silk blouse open to the navel, a shiny gold medallion sparkling on his chest. . . . He is, after all, the Great Pretender of rock 'n' roll burlesque. He is, unchallenged, the Cassius Clay of pop."

Thomas went on to write, "At a college concert on Long Island, I saw kids mob the stage at the end in the kind of frenzy I've only seen before at a Stones concert, and they were college kids, not teenies. At a concert at UCLA, grown men cried; the audience crawled onto the stage and tried to kiss his boots."

That spring Hendrix telephoned me several times. He knew that my friends and I were regulars on the Whisky–Troubadour–

Ash Grove club circuit, and he liked to hear updates on the L.A. music scene. Also, he got a kick out of some of my cruel but true comments—"So-and-so was *completely* pathetic at the Troub, the dullest act in the history of folk music" or "I was invited to the Doors' office the other day; Morrison insisted on reading me his poetry. It was eighty-five degrees, but he was wearing those leather pants. They were so shiny I think they actually may be vinyl." Hendrix burst out laughing at this—"Vinyl!" He was not a Morrison fan.

When I heard from Jimi, I wasn't sure if he was bored, lonely, or feeling momentarily hemmed in or isolated by his regular "record, tour, jam, party" routine. In one of these calls, he told me that he was "coming down from a trip." I listened, saying little. "I don't know why I phoned you," he concluded. "I'm embarrassing myself. You must think I'm a fool."

I heard from Chas Chandler, too, and the picture he candidly painted was one of unbearable disappointment. Chas's Geordie accent ran rampant as he spoke. "Jimi is now completely surrounded by hangers-on, particularly when we're in New York. I can't stand 'em! I'm not puttin' up with this! It's hell! Jimi doesn't listen to me or anyone else." Chas had fought for Jimi's stardom, forgetting that stars attract all kinds of people, users as well as devoted fans. Chas missed the "mateyness" and the sense of teamwork of the early days. A stronger, more experienced manager might have sat Hendrix, Noel, and Mitch down together and individually, talking straight and nipping emerging problems in the bud. Easier to say than do, and Chas waited too long.

"Please be honest with me," he said. "Is there a lot of chat in L.A. about things goin' wrong with Jimi and me?"

"No," I said. "I haven't heard anything. I will let you know if I do."

"The thing is," Chas blurted out, "I'm getting ready to pull away. I don't believe I'll be producin' Jimi anymore. This is not the life I want."

I had to hold back a gasp. I was simply amazed by Chas's words. He spoke of his marriage to Lotta and eventually being a "family man." He made it clear that he was already on the lookout for other talent. "I'll be in the business for a long time!" he said confidently. "I've shown now that I've got it in me to be a successful producer and manager."

On June 28, Jimi, Mitch, and Noel signed several far-reaching agreements that affected them jointly and individually. Jeffery presented these ideas as a sort of "Chas is leaving, so I'll take better care of you" package: Warner Bros./Reprise had agreed to pay Ed Chalpin a handsome percentage on the Experience albums, and thus he would no longer be a problem. Jeffery-Chandler had agreed to allow Warner Bros./Reprise to essentially "purchase" Jimi from them; the original Reprise deal from March 1967 was superseded by a new agreement in which Jimi was signed directly to the company for production and recording. In this arrangement a clause stated that Hendrix would be responsible for all royalty payments to any and all subproducers, vocalists, and musicians. Still other contracts were voided or rewritten to include Noel and Mitch in the Yameta "tax shelter."

After several days of recording at the Record Plant, the Experience returned to England in early July to perform at the Woburn Music Festival. A joyful crowd welcomed them home after a six-month absence. One fan summed up the show this way: "Jimi was inexpressibly wonderful!" Mike Jeffery made no plans for other English concerts that year; far more money was to be made in the vastness of America.

Before Jimi arrived in London, Chas already had made it clear to Kathy Etchingham that he and Lotta would not be living again under the same roof as she and Jimi or any other of his growing string of girlfriends. Jimi had told him he would be quite content to live on his own "in a nice hotel near the clubs."

Well aware of Jimi's other female interests and unwilling to lose him, Etchingham found and took out a lease on a small third-

floor flat in Brook Street, a superb London location a few yards from Claridge's Hotel and near the Speakeasy, where Hendrix loved to jam. In the eighteenth century, Georg Friedrich Handel had lived next door; Jimi was impressed by this fact, despite knowing little more about Handel than that he'd been a respected musical figure. Jimi agreed to move into Kathy's "find," and they immediately embarked on a one-day shopping spree along Oxford Street. Since, as always, he paid for everything, Hendrix supervised the speedy decoration of the flat, which was soon put to use for a flurry of press interviews and photo shoots. Jimi also took the time to purchase recordings of Handel's organ concertos. Over the next six months, he spent only scattered days at Brook Street; for quite some time, he and Kathy had been leading separate lives. Hendrix said that they had eventually "mutually disappointed each other."

A month after the Woburn Abbey gig, the Experience returned to America for another lengthy tour, striking, as Jeffery had told Jimi, "while the iron is hot." The band members' life as newly anointed rock stars wasn't completely sweet. Noel and Mitch, both thin, pale-complexioned, curly-headed English boys, were horrified to discover—in assorted towns in America's South and Midwest—that Jimi was not welcome to eat in the same restaurants with them or enter a bathroom meant for white males. Their mouths dropped open when their attention was called to the COLORED ONLY signs. Hendrix himself took it in his stride; this treatment was nothing new to him. Onstage there were times when Jimi spontaneously created musical moments that were so powerful, unexpected, and exciting that even Noel and Mitch sometimes viewed him as godlike. Encounters with racism threw them for a loop—how dare anyone treat their Jimi in such a demeaning way? "It made my blood run cold when some old scrubber of a waitress said once, 'The nigger can't be served here.' Ignorant cow!" Noel said. Occasionally, when they all were high, Hendrix, a dandy mimic and born character actor, would entertain the boys with wild

impersonations and bawdy racist stories from the chitlin circuit until everyone exploded in helpless laughter.

§

ON SEPTEMBER 14, 1968, the Experience played the Hollywood Bowl, where, little over a year ago, they had been the opening act for the Mamas and Papas. Now it was Jimi who headlined, and thousands of fans sitting under the stars felt spellbound in his presence. "My friends Richard and Bill Tuskewiscz and I thought of nothing else for days," recalled Kirk Silsbee, today a Los Angeles writer, who was barely into his teens in 1968. "We plotted and planned on how to get as close to that stage as possible." Stealthily they moved downward, a few inches at a time, from their seats high up in the amphitheater. Sneaking past ushers and random security guards, finally—delightedly, triumphantly—they claimed a vantage point a few feet from the stage. *Now* they could fix their eyes on Jimi's every move. These were innocent and happy times for young people like Silsbee and his friends, the days when Jimi was king.

A couple of days after that show, I returned to Los Angeles from a vacation in England and Europe. Chas and Lotta Chandler were in town and invited me to dine with them at a much-loved Hollywood hangout, a Japanese restaurant called the Imperial Gardens. Chas told me, "Noel wants to work with some of his mates in a band called Fat Mattress every now and again when the Experience isn't gigging." We casually talked of record advances, and Chas felt he could come up with a major deal, including publishing money for Redding. Chas was excited, Lotta was supportive, and I was dubious, thinking that though a lucrative deal might be procured off Noel's connection to the Experience, delivering a great record might not be such a sure thing. I said little, though, since it was Chas who was the music-business professional.

Gradually disengaging from his relationship with Jimi and with Jeffery, he was still in the process of working out the financial details of that separation. I sensed that Chas harbored hopes that Jimi would beg him not to leave.

Now spending substantial time in New York, Mike had relaxed his dull English wardrobe. Sporty jackets and open shirts gradually replaced his "serious businessman" look. He was to be seen in hipster sunglasses. Jeffery had also taken up LSD on a regular basis; Chas Chandler had not expected this, and it worried him. He said of the relationship between Jimi and Jeffery, "One day they're acid buddies. The next day Jimi is moody and cursing him, though not to his face, because Mike has a second sense about avoiding bad scenes with Hendrix."

Chas told me that the Experience was living for a few weeks in a contemporary house off the curving Benedict Canyon Road—Beverly Hills movie-star territory. He declared the home to be a veritable zoo, and that was why he and Lotta didn't wish to stay there. "That dangerous road winds up and up, and all sorts of people are finding their way." The way he said "people" resonated with distaste. My impression was that the record company was paying for a pricey rental that had turned into a twenty-four-hour-a-day party house. Well, that was rock and roll, wasn't it? "I wish you'd call Jimi," he said, "and go up there and have dinner." I wasn't quite sure what this was all about. His eyes twinkled momentarily as he said, "You can be a good influence. Jimi likes you."

"My schedule's pretty hectic. I doubt that I can get up there, especially with the hours musicians keep," I said, "but I will call Jimi in the next day or two if you want me to."

He wrote down the telephone number on a napkin.

I hadn't talked to Hendrix since July, and I was surprised when he answered the phone himself. When I thought of expensive houses in the canyons of Beverly Hills at that time, it brought images of butlers and "staff" to mind. I heard music, laughter, and

the voices of squealing girls in the background. Jimi said, "Let me change phones and rooms, okay?"

"Hi," he said after several minutes. "I'm glad you called. I'd heard you were in London for a while."

"And I hear you're living big time in Beverly Hills!"

"It sounded so groovy when Chas first told us we'd be in a house instead of a hotel," Jimi said, "but now too many characters know where we are." He told me he'd been surprised that I wasn't at the Hollywood Bowl show. I explained about deadlines and mean bosses. I congratulated him on how well the band was doing. I thought I'd heard wrong when he said, "Noel Redding's driving me crazy." He muttered into the phone, "Just a stuck-on-himself English guitar player." Then, quickly, he attempted to reverse himself. "I don't mean that. I don't want to overshadow anybody." *Overshadow?* Funny, I thought, he used that same word to me earlier this year. Bands have leaders. Leaders get attention. Hendrix was a rock god now. Wasn't this what he wanted? I'd been around Noel Redding briefly. He was amusing and a good player; that was all I knew. So he was *jealous*, too. And maybe Hendrix was over-sensitive? But Jimi's tone was *tense*.

"Groups have these kind of problems," I said finally, "and then it all sort of works out, doesn't it? I think fame takes some getting used to, at least from what I've seen in Hollywood."

"It takes a *lot* of getting used to!" Jimi said.

§

CHAS HAD told me that one reason the band was staying in ritzy, rustic Benedict Canyon was so that radio and press movers and shakers could meet and become friends with the Experience "at home."

One fellow invited to dinner was a major West Coast rock critic, a friend who telephoned me the next morning to admit ashamedly, "Well, I blew it! Jimi, Noel, and Mitch couldn't have been nicer. But I was overwhelmed when I sat across from

Hendrix at dinner. My knees started to shake, I began to sweat, and my voice cracked. I guess I acted like a real jerk."

Sepp Donahower, a fledgling concert promoter in the late 1960s, also visited the Benedict Canyon house. "I ran into Jimi at the Whisky one night," he recalls, "and he asked me if I could give him a ride home. I took him up to the house, and neither of us could believe our eyes. It was noisy as hell, and the house was crawling with creepy people. Jimi was at least a little stoned, and I could tell he just wanted some peace and quiet, and here was this bunch of people partying and making themselves at home in a house he was paying for. He was the hottest star in the business, and no one even asked him if he was hungry or if they were getting in his way. Finally he just burst loose. He yelled and cursed and told them all to get the hell out. It seemed sad and surprising to me that he was treated so disrespectfully."

On October 19, I sat with another friend in the audience at the Forum in Inglewood, California, to catch Eric Clapton, Ginger Baker, and Jack Bruce on the Cream farewell tour. A major buzz of excitement tickled my ears. I looked around, and a few rows to my right I observed Jimi Hendrix, Mitch Mitchell, and George Harrison sitting out front with the fans. As many in the crowd of eighteen thousand came to realize this, the excitement in the arena built to fever pitch. This was a fantastic night to be at a rock concert! Jimi! Mitch! A Beatle! *And* Cream! *Too* much!

Clapton was incredibly handsome, and Jack Bruce the essence of macho. Red-haired, wild-eyed Ginger Baker was a demon on drums. Although rumor had it that they were sick of one another, Cream performed as a brilliant cohesive unit, and their hypnotic songs, such as "Sunshine of Your Love" and "White Room," brought fans to their feet again and again.

Russ Shaw, an effervescent young promotion man from Jimi's record label, approached me. "Sharon, do you see how they're reacting to Hendrix? Even when he's just *sitting*. Isn't this fabulous!" We grinned in fellowship, because seeing stars "happen"

was one of the things that was so wonderful about living in L.A. in the late sixties; we were still kids, not long out of school, and definitely grateful for the opportunities and special perks our jobs brought us. "I want you to come backstage after Cream's last encore," he said. "I believe you already know Jimi." I smiled but didn't comment. "I'll take good care of you," Russ promised.

Jim Rissmiller, one of the concert promoters, a tall, fair-haired, young California guy who was soon to became a major force in bringing leading English and American rock groups to Los Angeles, handed me a tiny slip of paper, the kind you would find in a fortune cookie. It read THE CREAM BACKSTAGE. It was the first backstage pass I'd ever seen.

After the climax of the high-octane concert, which left Hendrix, Mitch, and Harrison clapping and cheering like enraptured teeny-boppers, I shyly stepped through the VIP entrance, an opening in a curtained-off section near the arena stage. A long hall led to a spacious, well-furnished reception room adjacent to the locker room of the Lakers basketball team.

Here the top figures in the L.A. record hierarchy, drinks and cigarettes in hand, were mixing and mingling with one another, gawking at Cream, and trying to figure out ways to meet Jimi Hendrix and George Harrison, both garbed in trendy Kings Road finery and sitting casually on a basketball-player-size sofa. I moved through the room, nodding and saying quick hellos to record executives and local musicians I knew, sipping from a glass of champagne handed to me the moment I entered the room.

"Hey!" Jimi said in that familiar whispery voice, gently pulling at my blue velvet jacket. "Come sit down." I soon found myself in spirited conversation with Hendrix, Clapton, and Harrison. We compared notes about our favorite soul singers and bands; "the boys" were surprised that I was aware of the songs and styles of Jackie Wilson, Bobby "Blue" Bland, Sam Cooke, and all the others I'd listened to on KGFJ in Los Angeles since I was ten years old.

"Sharon's very hip," declared Jimi.

They couldn't believe it when I said I must leave because I was due at work at seven in the morning.

"*Every* day, love?" Harrison was aghast at the thought.

"Just about," I said, embarrassed because it sounded so geeky.

Hendrix had mentioned that he would be doing some recording in Los Angeles over the coming weeks, getting a start on the next album. "Will you come and tell me what you think?" he asked. Watch and listen to Jimi creating original music? I was surprised by the invitation—and honored.

At 8:30 P.M. the following Tuesday, I dropped by TTG Studios, a compact facility on a quiet side street in the long-established industrial area south of Hollywood and Sunset boulevards, where film labs and equipment companies abounded. TTG concentrated on sound and was minus any rock star décor or perks such as hot tubs. Nearby was the old studio where Ricky Nelson's family had filmed *The Adventures of Ozzie and Harriet* television show.

One of the band's roadies greeted me cheerily and directed me through a narrow door into the control room. Expecting an aura of serious concentration, I stepped tentatively, quietly, so I wouldn't disturb the proceedings, taking a seat on a comfortable bench below the recording console that looked directly into the window of the room where the Experience's equipment was set up. Soon a young black man sat down, grinned in a friendly way, and muttered into my ear, "Are you holding?" I *wasn't* as hip as Jimi thought and I hadn't a clue then that this meant did I have any drugs to share?

Jimi, looking stressed, appeared. He smiled at me. "Oh!" he said. He nodded to the young man next to me, and then Hendrix strode into the recording studio behind the glass to check the tuning on his guitar.

A small wave of young women attempted to parade into the tight space of the control room. Two sleek and gorgeous girls of color, each with an air of wondrous confidence, casually looked over a bevy of long-haired white chicks in miniskirts and tight tops

minus bras. Thick lashings of mascara and pale, glossy lips were the makeup du jour.

"Those black girls are Emeretta and Winona," one of the blondes whispered to her friends. "They're from New York!" Then she said in a tone close to awe, "*They* know Jimi!" As the evening progressed, his music was of scant interest to most of the white girls, who were busy comparing notes on musicians they'd slept with or wanted to sleep with. "I can't wait for the Stones to come to town! Look out, Keith!" one of them exclaimed. Then Noel and Mitch bopped in, evoking excited giggling from the groupies; meaningful eye contact was exchanged.

After almost two hours had elapsed, I was bored with this scene, and since I had yet to hear any music recorded, I quietly slipped out into the night air.

§

WRITING ON a deadline in the UPI office late in the afternoon, I was deep in concentration when the intercom rang. "Lawrence!" the bureau manager barked in my ear. "Some guy named Hendrix is on the phone."

"I just got up," Jimi said. "And I'm sorry I wasted your time last night. We're gonna be at TTG for a few nights. I hope you'll come back."

"I'd like to," I told him. "Maybe tomorrow night."

When I got there, Hendrix was working on vocals in a narrow, closetlike booth. Through the small window in the closed door, his face looked tense. I kept moving and took a seat on the same bench as before. It was just Angel the engineer and me in the room, both waiting for greatness.

Five minutes later a stream of girls dressed in their best mod finery trooped in, filling the room. They happily eyed one another, at intervals touching up their hair and their makeup, delighting in inspecting themselves in pretty little hand mirrors. They behaved like chirping sparrows intent on capturing the same juicy worm.

When Jimi walked in, they practically hissed with excitement. Hendrix only half smiled, completely focused on the lyrics he wanted to get on tape that night; he spoke briefly to Angel and then loped away. Noel and Mitch wandered in to chat with the chicks.

The session didn't go well. Jimi, still nervous about his singing, literally hid in the tiny vocal booth, making agonized attempts to sound strong and assured, redoing the lyrics over and over. Chas had told me Hendrix lacked confidence in his vocal talent.

The girls continued to preen themselves, by now bored and furiously looking at their watches. Jimi left the booth, heading to the board to speak to Angel. "Let's go to the Whisky!" one of the girls begged, slithering her fingers down Jimi's chest. Noel and Mitch appeared pallid alongside their magnetic leader, and now they were grinning at this little moment. These days it was *always* like this.

The Whisky was *the* rock club on the Sunset Strip, and its late-night menu paid tribute to Hendrix this way—"JIMI'S FAVORITE: Super-Sausage on a Wah-Wah Bun."

Finally the party dolls were politely urged by a roadie to disappear. Noel and Mitch also split, while Jimi stayed to listen to the playback. He didn't like what he heard, and, obviously annoyed with himself, he searched for his green jacket, putting it on as he wandered out to the small hallway. He returned almost immediately, took off the jacket, and walked into the studio, standing there alone near a pile of tangled electrical cords. Angel and I glanced at each other—what now? Hendrix picked up a guitar, checked the tuning, glanced at us through the window, and launched into one of his classic blues numbers—"*There's a red house over yonder. . . .*" It was a long song, and he played and sang with so much feeling that Angel could barely speak. "Man, that was magnificent," he said when Jimi joined us. The song was a brilliant and unexpected gift.

Jimi smiled, with his eyes as well as his lips. His performance

was a form of apology. "Sorry I put you through all that cater-wauling before," he said to me.

"Thank you, Jimi," I said, grabbing my bright blue cardigan and handbag from the bench.

"I'll walk you to your car," he said.

It was past midnight, and we stood at the curb looking up into a dark, misty sky. "You and the blues are a magic combination," I said. It was a comment as opposed to a compliment.

"When I was a little kid," he said, "I heard a record playing at a neighbor's house turned way up. That song called to me, and now I don't even remember which one it was. I left my yard, went down the street, and when the song was over, I knocked on the door and said, 'Who was that playing?' 'Muddy Waters,' the guy said. I didn't quite understand. He repeated it and spelled it out—M-u-d-d-y. I heard more blues, of course, along the line when I was in school, and I fooled around trying to write the blues, but it wasn't until I was workin' the chitlin circuit that I heard a whole mess of blues, usually on southern radio stations. When I was alone, I'd play every riff, every change I could remember from the radio. I saw it as holy music."

We sat for a while in the car as Hendrix talked about recording versus playing live. "It's all about tones," he said. "This is very important to remember: It's *all* about tones." I asked him to explain. Softly, he said, "You hear the sound in your head or your heart, and you send a message to your fingers. That's my technique." He smiled at me. "On a good night, it works."

When he finally got out of the car, he said, "Now don't forget! It's all about *tones*."

§

HENDRIX HAD told me that I was welcome at the studio "whenever you have time." When I did return to TTG, I brought all the English music papers—*New Musical Express, Melody Maker* and *Disc and Music Echo*—sent regularly to me by the UPI London

bureau, with the hope that the Los Angeles bureau would catch on that pop music was increasingly important and worth covering. I knew that Jimi, Noel, Mitch, and Eric Barrett, their devoted young guitar technician, were homesick for news of the London scene.

I handed Jimi a page from *Melody Maker.* It featured a review of his new single, "All Along the Watchtower," written, of course, by his great inspiration, Bob Dylan. His eyes focused on paragraphs of high praise for his work; it appeared as though he didn't ever want to put down that page. When, Jimi finally looked up, he concentrated on me with equal intensity—brown eyes glowing—and said, "Thank you for making me so happy."

This was a startling and unforgettable moment for me; Hendrix's reaction, his emotion, was extremely touching. That he cared so much about his music, that this critical validation was so meaningful, was a powerful revelation. Later I was to realize that Jimi, perhaps more than any one of the hundreds of celebrities I've encountered, understood how very fleeting success and public approval can be.

§

STANLEY BOOTH, the brilliant American writer, best known for his chronicles of the Rolling Stones, recalls that in October 1968 he had gotten hold of the *Electric Ladyland* album before its official release in the UK. It was his first visit to London at the peak of its grooviness, and Booth was looking forward to meeting Brian Jones, who had suggested lunch at the Casserole on King's Road. The fair-haired, trendily dressed Jones and his girlfriend, Suki, were charmed by Booth's southern accent, and the Rolling Stone was thrilled when Stanley told him he had the new Experience album. Brian wanted details—"What's it like?"

Stanley laughingly declared, "More psychedelic bullshit."

Brian sighed: "I *told* him to stick to the blues!"

Electric Ladyland, the Experience's third album, was far more experimental than the previous two, featuring imaginative musical collaborations with diverse musicians ranging from Stevie Winwood of Traffic to the Jefferson Airplane's bass player, Jack Cassady. Fans and music critics alike were dazzled by Jimi's powerhouse version of "All Along the Watchtower." In other words, the two-record set offered more than a hint that Jimi Hendrix was looking to go in a new direction and that the trio format might be wearing thin for him.

Track Records' owners Chris Stamp and Kit Lambert were proud of what Hendrix had accomplished thus far in his career; his relationship with them continued to be one of mutual admiration. "We, the world, had two brilliant records in *Electric Ladyland*," Chris Stamp remembered. "We were very impressed with Jimi's progress. He was the first musician to use the studio as another instrument, which Chas didn't get at all. Either Chas was going to go totally off the wall with Jimi or Jimi was going to have to do it on his own. That was inevitable; it could have been even better if Chas had somehow stayed in there."

While their relationship with Jimi was strong, it was quite different with Noel and Mitch. Stamp said, "I did something that was politically incorrect in a sense, which set me apart from Noel and Mitch, revolving around the *Electric Ladyland* album. This was Jimi's first major work, the next step up. I put together that album sleeve with the naked women. There was all the talk that Jimi didn't like the sleeve, but this wasn't true. Inside of that album sleeve, I had the beautiful photograph of Jimi, and I took the liberty of putting the whole of it inside the double sleeve." In the left- and right-hand corners, Stamp placed two small photographs of Noel and Mitch. The photograph of Hendrix worked magnificently in the artistic context of the sleeve, although it also visually overshadowed the image of the Experience. "Noel and Mitch took umbrage at that," Stamp said, "which I sort of understand. Still,

they were already feeling this draft between themselves. I didn't do it in any kind of deliberate way."

§

WE STOOD outside TTG on an October night, smoking cigarettes. Hendrix said, "You and Chas and Lotta are friendly, aren't you?"

"Chas has been very open with me," I said, "and I'm sorry you're not working together."

Jimi listened as though my opinion really mattered. "I hear sounds and tones, have ideas, that Chas doesn't," he said. "Why don't we go get something to eat? I need a break."

It was late, and the only place I could think of that would be open and not a greasy dive was Nickodell, a long-established restaurant a few blocks away. As we drove down to Melrose Avenue, Jimi said, "You probably know that Chas can't stand most of the people that come around the band, around me. I've got a whole lot of so-called friends these days."

So-called friends. What an interesting phrase, I thought. "Why don't you tell them to buzz off?" is what I said.

"Hard to do," Jimi said. He sighed.

"Who are they?" I asked.

Jimi shrugged and didn't want to talk about it. I waited him out. Finally he offered a verbal list. "Producers. Would-be producers. Musicians. Guys that want to be musicians or work for the band. Girls that want to be singers. Dope addicts. Drug dealers. About a hundred million chicks that like to be around the scene. Designers. Models. A lot of guys who want or need money. A few thieves . . ." I wondered how I'd feel in his position and knew I couldn't imagine screaming, *Get the hell out!* Movie stars had secretaries or chauffeurs or occasional bodyguards to deal with extraneous people so they could keep their glossy images. It seemed odd to me that his manager hadn't hired a bodyguard for Jimi.

Nickodell got the studio crowd—working people from the adja-

116

cent Paramount and Columbia movie lots, aging bit-part actors, local characters. Here they could sit in comfortable booths and relax after a hard day, receive a welcoming smile from the long-time waitresses, and, in some cases, feel like "somebody," right here in Hollywood, California. This restaurant was not glamorous; big-name stars seldom dropped in, unless they needed a cocktail fast. Nickodell was cozy; the food and the booze were priced right.

As we walked down an aisle to an empty booth, several of the customers looked Jimi over. He noticed, he smiled politely, and they smiled back. I doubted that anyone in the restaurant would be familiar with his music, but there was a sense that some of these men and women understood that he really was *somebody*.

Jimi ordered a bowl of soup, a hamburger, and a Coca-Cola. I went for the soup. We talked about hit records on the radio; he had noticed that KHJ, a major AM station, was close to the restaurant. He brought up writing—curious as to how long it took me to write a 350-word feature or a 2,000-word article. I wanted to know what inspired him to start writing a song.

Jimi's best ideas for songs often came, he said, "when I first wake up and my head is buzzing with words and phrases . . . ideas, and I'm running around the hotel room searching for stationery. The first flash of an idea or line is always the best, if you can just capture it right away. I'm trying to train my brain so that if I've had some solid sleep, I can wake up with a song strong in my head; I don't want to think about anything else. Other times we're rushing to get to the airport and the next gig; I might write a few lines on the plane, especially if I had a melody going while I was brushing my teeth."

He took a bite of his thick hamburger and then another. "I'm starving!" he said. "I need to eat more. When you travel all the time, it can be difficult finding a decent meal."

"Don't you ever visit your family and have a home-cooked dinner or two?" I asked.

"After six years I finally went back to Seattle this year," he told

me. "It went better than I thought it might." He considered this for a minute. "Actually, it was two or three days after Les Perrin introduced you to me, I believe." He laughed at the surprise on my face. "I have a sharp memory!" Jimi said. "Not bragging, just warning you!"

The elderly waitress brought him a refill on his Coca-Cola without being asked, and he smiled at her. Jimi took a few sips and declared casually, "My dad never thought I'd amount to a hill of beans, and now he kept wanting to have his picture taken with me. There was way too much posing for photographs; it was embarrassing and weird, with various people lining up in front of me to sit down for two minutes. Click, click. And next person sits down. Click, click. My father was as bossy as ever. He always had various girlfriends, but it seems he married this one. She's Asian, with a mess of kids. June—that's her name—is nice but starstruck, you know. Like *really* starstruck. They want me to call her 'Mom.' I did a couple of times, but it stuck in my throat. Because in my heart I have just one mother, you know. They all kept asking me what it felt like to be a millionaire. Quite naturally, I did the right thing, gave them some money, bought what they wanted."

A bittersweet mood hung in the air. I attempted to break it by teasing him, really piling it on. "A millionaire? Far out, man, you never told me! You're *too* groovy."

Jimi chuckled "And don't you forget it!" he said. Then he added, "I'll probably never be a millionaire if all these damned lawyers have anything to say about it."

"I read in the paper that you received some honor at your high school."

"Yeah, a welcome-back thing, at eight in the morning after we did a show the night before. Jeffery's publicity guy concocted it, I believe. It felt really strange to be at Garfield again, especially since I never graduated and they were glad to get rid of me," Hendrix said. "We went back to play in Seattle for the second time a few weeks ago."

Jimi wrinkled up his face as though he were reflecting on his relationship with his hometown. "Our records are doing good there. Not great but good. The best thing has been seeing my grandmother, my aunts and cousins, and a few of the guys I used to be in bands with."

He took a last bite and pushed his plate away. "The main thing that concerns me about the family stuff is my brother. I don't think he really remembers our mama. He was such a sweet little kid, and he's still got all that sweetness floating around inside, but he could be heading for trouble. Being related to me only makes it worse for him. Don't you think?"

I nodded.

He paid the check and placed a fifty-dollar bill on the table for the waitress.

I drove him back to TTG. "This was fun," Jimi said warmly. *Fun?* I found much of what he told me surprising and sad. I tried to suppress a yawn, as I realized that I was due at work in five hours.

Several weeks later I asked Jimi if he'd heard from Bob Dylan about his version of "Watchtower." He shook his head, seemingly unbothered by what others would construe as a slight. "Bob Dylan is a *very* busy person," he said.

§

JIMI'S INFLUENCE was being felt culturally across America, not only in music but also in fashion. The changing Hendrix "look" was so intriguing and innovative that in 1968 *Eye* magazine asked to interview him a second time for a splashy feature titled "Private Wardrobes of the Stars," along with such diverse celebrities as Peter Fonda, Liza Minnelli, and Buffy Sainte-Marie. "They wanted Jimi very much," Pat Costello remembers, "and he was flattered, but he insisted that Noel and Mitch should be part of the piece." Fashion editor Donna Lawson wrote, "Not since the Beatles have any pop star's clothes and hair been as emulated as Jimi's. He wears chain

belts, silver Indian belts, scarves around his waist, paisley shawls, antique brooches, flowered chiffon blouses and three rings at one time."

Lawson went on to say of Hendrix, "On a chain around his neck he wears an oriental green jade medallion, a gold three-leaf clover, an elephant-hair ring, a centaur archer Sagittarian symbol—Jimi's birth-sign—and sometimes a surfer's cross. Girls give them to him and the memorabilia grows all the time.

"Jimi, Mitch Mitchell and Noel Redding usually shop in the same places in London and the States. They once bought gear at Dandy Fashions in King's Road before designer John Krittle went to the Beatles' boutique, the Apple. Now they stock up at Granny Takes a Trip and Chris Jagger and Jay, boutiques in London. . . . [In] New York they shop at Stone the Crow, the shop over Salvation discotheque. In Los Angeles they shop at DeVoss."

Chris Jagger is the talented singer/songwriter and younger brother of Mick. Before Chris began making some fine records of his own, he and his friend Jay put together a London shop where many a trendy found something special to wear. "We knew a girl named Julia who had done some silk ties using inks, something not much done then," Chris said. "Jay, my partner, and I had the idea that she should make something bigger, like a jacket, which she did. It was Julia's own design, with eyes on the front. Jimi came to mind for this, as we had sold him clothes earlier, colored jackets and shirts. The jacket was sixty pounds. He was a gentleman, and he always paid for everything, but we didn't hustle him either! We shared a love for blues music, and that was important to him. There is no picture of us together, and of course we never asked for an autograph. That would have been too crass! Hey, we were hip then!"

The legendary silk "eye" jacket was purchased at auction years later by the Hard Rock Café for twelve thousand dollars.

Blair Sabol, *the* American columnist on hip fashion, was a "must-read" in New York's *Village Voice* newspaper in the late

sixties and early seventies. She remembers, "First of all, Hendrix had *incredible* taste. Jimi was *it*! His beautiful headbands. His vests. His pants. In the early days, he wore a lot of Oriental fabric that men never wore and open silk shirts and gorgeous kimonos. He was an absolute trendsetter. Other guys were walking around in bell-bottoms, and Jimi wore cut velvet and the fabulous Moroccan stuff. Even his guitar strap was a work of art. Stella and Colette had that funny little shop in the East Village, and they really decked him out."

In 1968, as in the year prior, days off for the Experience were as rare as perfect pearls. Pat Costello recalls, "Even with his crazy schedule, Jimi was almost always cooperative about doing press interviews and photo sessions. He is one of a very few people I've met in the music business who didn't go through a prima donna phase. I remember picking him up in midtown in a taxi on a bitter cold winter's day and going all the way down to the East Village. It looked like snow when we got there, and for some reason Jimi didn't have a coat, probably so he wouldn't mess up his shirt for this photography session. When we were finished, I knew he must really be cold, because when we got downstairs, he hurried to huddle in a doorway, and said, 'Please, Pat, could you be the one to find a taxi? If *I* stand out in the street, you know they aren't going to want to stop for *me*.'" Despite all the attention and acclaim, Jimi understood from experience that success didn't open every door.

Chapter Eight

All Along the Watchtower

"There must be some way out of here,"
said the joker to the thief.
"There's too much confusion,
I can't get no relief."
—*Bob Dylan*

"LULU'S TELEVISION program has been very successful," Marian Massey said, "and quite delightful to do, with the exception of that dreadful boy Jimi Hendrix." I raised an eyebrow at this unexpected comment, and she was eager to explain. "He and his group were our guests on the show in January. They did a song, and then he was supposed to do another one. He launched into it, changed his mind, and proceeded to start babbling about Cream and Eric Clapton. Then they began to play a Cream song. It just spoiled everything. We were short of time. Jimi Hendrix is a *terrible* person."

Massey was the dedicated manager of energetic, big-voiced young Lulu, the Glasgow-born pop songstress, whose songs "Shout" and "To Sir with Love" had been huge hits around the world. I was interviewing Lulu about her career when her manager moved away to take a telephone call. Lulu smiled at me and declared, "It was really great when the Experience were on the show. "I'm a big fan! Jimi performed 'Voodoo Chile' and started

into 'Hey Joe,' but his guitar went out of tune so he, Noel, and Mitch really worked over 'Sunshine of Your Love.' It was fab! Absolutely fab!"

After the departure of Chas Chandler, the Experience took on the dynamics of an airplane that was seriously veering off course. Mike Jeffery, as ever, concentrated on his own interests while the band continued its intense touring schedule. Whenever possible, Jimi was eager to lose himself in the recording studio. This cramped Noel and Mitch's style; they grew bored with long nights of waiting while Hendrix, often surrounded by a phalanx of the so-called friends, took his time deciding what sounds he wanted or engaging in take after take of a new song. While a recording studio might have been one of Jimi's favorite worlds, this was not true for Noel and Mitch. Young and eager to party, Redding and Mitchell savored their status as American pop stars. On days off in Los Angeles, after sleeping into the afternoon whenever possible, they preferred a leisurely evening schedule, taking their time to select and adorn themselves in the latest smart clothes before they went clubbing. Mario Maglieri, the majordomo of the Whisky A Go-Go, found Jimi to be "quiet and gentlemanly; he never wanted a fuss to be made over him."

Noel and Mitch, however, boyishly enjoyed being catered to and greeted like royalty in the nightspots. A typical example was Redding phoning Thee Experience, Marshall Brevitz's new club on the Sunset Strip named after the trio, to inquire when Rick Derringer's band was going on. When told, Noel sighed in disappointment, realizing that he couldn't get there that soon. "Not to worry," assured Brevitz. "Would ten be better than nine-fifteen for you?" On occasions when Jimi himself showed up, word spread like wildfire and the venue was suddenly packed with customers. "Just to *see* him close up was mind-blowing," recalls a former Sunset Strip habitué, "and if he jammed, we lost our minds!"

An added bonus in the growth of the club scene included increasingly blatant displays of drugs offered for sale, usually in

the parking lot and the men's room, as well as free "samples" for VIP customers. Drug dealers from throughout California converged on Sunset with their portable candy stores of new pills, "dynamite Colombian," and San Francisco's finest acid. A radio disc jockey who frequented Thee Experience used to lovingly refer to Noel and Mitch as "the junior chemists." "They will swallow anything," he chuckled. "And everyone knows that Hendrix is a drug freak."

This was a typical comment uttered about Hendrix, most often by those who had never met him. Wild music, wild sex, wild drugging—wasn't that what Jimi Hendrix was all about? What a lucky guy; he could do as he damned pleased! Just waving his "freak flag" high, minus any worldly cares.

Hendrix didn't see it that way. Michael Jeffery, plus assorted lawyers and accountants, called him all too frequently to speak of financial concerns. When the Experience took even a short break, cash flow and the rapidly improving lifestyles of all the band's "support team" were affected—"Gotta keep those monkeys working," was the way Jimi once expressed his cynical view of the never-ending financial pressure. He didn't live in a daydream; Hendrix was the first to recognize that he required money to cover touring and recording expenses and salaries, legal bills and management commissions. "I just wish," he told me, "that when I get all those phone calls with the money blah-blah talk, someone could ask, 'How are you, Jimi?' before they start in." As he spoke, I thought about the ironic fact that Hendrix's public image was of a powerful "cool cat," who had achieved a level of success that gave him the freedom to do everything *his* way. The world didn't know that Jimi had long ago been brainwashed by the admonitions he'd heard over and over in childhood—"*Don't* get in the way. *Don't* make a fuss." As an adult he was willing to put up with whatever he must in order to keep playing his guitar.

In February 1969 the Experience had played two shows in the splendor of the Victorian-designed Royal Albert Hall in London, with The Soft Machine and Traffic as support acts. Despite deep

misgivings, Jimi agreed that his performances could be filmed for a movie project with the working title of *The Last Experience* – as a favor to his friend Eric Burden. Now free of Michael Jeffery, Burdon had become a management client of Steve Gold and Jerry Goldstein; these two had endlessly hustled Hendrix to allow them to film the concert for their aptly named company, Far-Out Productions.

Weeks after the Royal Albert Hall filming, Jeffery telephoned from New York, interrupting a late morning of Hendrix's songwriting in Los Angeles, to savagely tear into Eric Burdon's new management and predict what a disastrous mess the film of *The Last Experience* would be. Recounting it all to me, Jimi said, "The story is always the same. 'We love you! We'll all get rich together.' Gold and Goldstein get high and dress their pathetic version of cool, but they've got adding machines for minds; they're loaded with bad vibes. I see them as weekend hippies, just playing the role. And what's wrong with Eric Burdon? He should know better! After finally getting loose from Jeffery, how could he fall in with those two? And *why* does Mike bother me with this stuff? *He's* supposed to be the brilliant manager. Did I tell you that Jeffery's bought himself a house up in Woodstock? Speaking of another weekend hippie . . ."

It was a beautiful spring day; I had put in so much unpaid overtime that I was taking a day off from work. Hendrix had phoned earlier, as he ate a room-service breakfast, to ask if I wanted to go record shopping with him. He would send a limousine, he said. I had laughed at him—"L.A. is my turf. I'll do the driving." Now I sat silently in the living room of his hotel suite as he muttered and cursed; I had never heard Jimi carry on like this before. I watched as he organized a sheaf of lyrics and carefully hid them under the sofa cushions. Hendrix had unhappily come to the conclusion that someone who worked for the band was "nosing around," he said, and regularly removing assorted personal items from his hotel room. He patted down the cushions. "I am waking up to business," he said. "I am sick of being walked

on." Finally he smiled, and switched gears. "Let's go up to the funky part of Hollywood and see if we can find that old record shop that has the blues albums."

The store was closed. I turned the car around and drove slowly down the once glamorous, now crumbling boulevard. As we approached the exotically designed Grauman's Chinese Theater, Jimi said, "One day let's come back here and look at all the movie-star foot- and handprints, okay? When I was starving in the scuzzy part of Hollywood, I always wanted to explore that courtyard and take a peek in the theater. There might be a whole other world in there." I maneuvered into a no-parking zone in front of Grauman's, as close as possible to the section where a few famous hand- and footprints could partially be viewed from the street. Jimi, with his less-than-perfect eyesight, peered out the open car window for a couple of minutes. Then he placed his own hands on the car dashboard, inspecting them with a subtle sense of pride. "I get my hands from my mother," he said. "She was tiny, but she had very long fingers."

From comments he'd made in the past months, I knew that Jimi possessed a deep yearning that his mother somehow could know he'd done her proud, that he'd found his way out into the big world and his musical talent counted for something. He had told me, "I would give anything if my mother could see me play the guitar." He always spoke warmly of Noel's mother and of Mitch's parents, who welcomed him into their homes and treated him with sincere interest and kindness. Jimi was effusive in his thanks when my own mother sent him a homemade strawberry shortcake, after he'd mentioned to her on the telephone that he loved strawberries. He so needed to be treated as a human being and not a *star*.

When I dropped Jimi off at the hotel, Noel was standing in the small parking lot. He called out, "Sharon, I must buy you a drink!"

"Have fun!" said Jimi in my ear. "There's nothing more exciting than getting to hear about Fat Mattress!"

Over his vodka and my scotch, Noel happily reeled off the dates that Fat Mattress was playing as a support act on the Experience tour, including Seattle. "I thought Hendrix didn't want to play there for a while," I said. "I wouldn't know, lovie," Noel said. "Come to think of it, he almost never talks about home. Maybe he got sick of all that rain up there." He chuckled as he spoke. "You must know that our James is very much a lad of the present."

Noel, well mannered and amusing, was wrapped up in Noel. He enjoyed telling me about his plans; always the emphasis was on making a lot of money. He spent freely, writing down each expenditure in a little notebook. "You don't write down your drug bills, do you?" I joked. "In code, love," he said with a wink.

The camaraderie that Noel, Mitch, and Jimi had shared definitely appeared to be in jeopardy. Whenever Hendrix mentioned his concerns about the Experience, I came up with Girl Scout rhetoric like, "Have you talked it out with Noel and Mitch?" or "You guys need to sit down and make a plan." Jimi would sigh, making comments such as, "I'm nothing without Mitch" or "I wish Noel wasn't on Planet Redding."

Jimi gave handwritten letters—respectful and from the heart—to Noel and Mitch as an attempt, he said, "to keep things together," and although he didn't think much of Fat Mattress's music and wished that Noel had not pushed for his new group to open for the Experience, Hendrix had agreed in order to "keep it all cool," he said.

§

I WAS DROPPING off a record album he'd asked to borrow. The door to his suite was ajar, and Jimi sat on the living-room sofa, sorting through three stacks of legal and financial documents. "Hi," I said.

He looked up, unsmiling. "So who's going to be the new me?" he asked. "James Taylor?"

127

Wow! I thought. I understood that his insecurities were part of what drove his talent, but these words in this grim tone hit hard. Jimi made room for me on the sofa. "We should warn him!" he said.

A strong buzz circulated in the record business these days about the potential of singer songwriter James Taylor. Hendrix admired Taylor; he'd heard about him early on from the Beatles, who had signed him to their Apple label. "I was just thinking as I read all this stuff how one minute you can be so up, so positive, and the next minute you feel like nothing at all," he said.

"But you'll always be one of a kind," I told him, "and that's the only compliment you get from me." I pulled the Stevie Wonder album out of my tote bag. Jimi's face lit up. "I met Stevie in London a while back," he said. "We didn't get a chance to talk, but we did do a tiny bit of jamming. He played drums! And, of course, the way he plays that harmonica is pure *genius*."

This was a word that many of Hendrix's peers applied to him. Carefully I asked, "Do you think that *you* are a genius?"

He swatted my shoulder. "Don't say *that*. No, no. Technically, I'm not even a guitar player. All I play is truth and emotion."

Anywhere a guitar was within reach, Jimi Hendrix was home.

His eyes, his ears were constantly drawn to this instrument that he truly lived for. It could be a cheapie played on a street corner, a fine old Gibson brought to interest him in buying, or a hotel lounge musician's early Stratocaster. If a fan carrying a guitar ran into Hendrix and summoned up the courage to ask a question, Jimi treated the person and the question with genuine interest, making suggestions; if he had time, he was quick to demonstrate. It wasn't a matter of "being nice to a record buyer"—these encounters brought him personal pleasure. "Quite naturally, I learn about guitars every single day," he told me. "I've got a lot to learn. I'll always be learning; *that's* what makes music so enjoyable to me. Without a guitar I'd be a squawking old hen!"

If the Experience were staying in the same hotel for several

nights, Jimi liked to keep a Strat, a small amp, and an acoustic guitar with him. On several occasions he played bits of new songs he was working on for me, or he'd launch unexpectedly into a classical riff or his version of a Beatles song. He smiled in contentment as he played. I always felt privileged to listen.

When I think of the "real Jimi," it is moments like this that come to mind. He would play his guitar for perhaps two or three minutes, then pause to comment, "Now, I've told you it's all about tones. But remember, when you're writing a song, musically or in the words, it's also about colors. Thinking about a specific shade of a color paints pictures in my mind that I want in the song. For instance, orange is a very insecure color; it hasn't yet decided if it will be red or yellow." He told me that when he was working on a song, he often remembered parts of his life that he wanted to forget. "If I put these feelings in the lyrics, in the music, sometimes I feel cleansed. Words can be—" He stopped, searching for the precise thought, his eyes tight in concentration.

"Like volcanoes of emotion," I said quietly.

"Yes! Yes. Yes." Jimi seemed thrilled with this phrase that had come to me out of the blue.

"Words can be lovely or fragile or ugly or breathtaking," I offered.

"Oh, yes!" he agreed. He was a high school dropout; I hadn't lasted long in college, but we both thrived on these conversations.

Often the lyrics I'd seen on a page of hotel stationery came to life in a way I never could have imagined when he added music. "Machine Gun," "Izabella," and "Belly Button Window" were among the songs I saw in several different drafts. Emotional power soared from his guitar, punctuating his themes, his feelings, when he put the songs down on tape. Jimi would watch me as I read his words. He grinned when I laughed at the "chocolates" in "Belly Button Window," but I also interpreted serious personal issues in that song; we briefly discussed those concerns. Of course I realized that *he* was the unwanted baby in the song and that the words

were different, a bit funny, and a whole lot poignant, and I said pretty much that to him. I also said that it was a darned unusual song for a big-deal performer to do. Jimi took this as a compliment.

Impressed by the care Jimi took in his lyric polishes, I saw the work of a dedicated lyricist who corrected misspellings and, sometimes but not always, grammar. He went for sound in words as well as music.

It was never all about *him*, which was unusual in Starland. Jimi liked to hear tales of my job, from grumpy bosses to my interviews on movie sets and locations, in studio commissaries, and in fancy restaurants like the Brown Derby and Scandia. He sipped herb tea or orange juice and devoured strawberries by the dozen, smiling contentedly as he quizzed me on the latest movie actor or director I'd written about. First I interviewed the celebs; then Hendrix interviewed me. I could be outspoken and sarcastic, and Jimi would laugh and laugh in reaction to my smart-ass asides.

He *really* wanted to know about other creative people—how they lived, how they worked. What kind of goals had they set for themselves? Who assisted or advised them? Were they happy? For me one of Jimi's most appealing characteristics was his eagerness to learn.

I described strolling with Oscar-winning director George Stevens at sunrise in the Nevada desert as he explained how he was going to set up the shots for the day's work. I told Jimi about Fritz Lang, the revered director of such classic films as *Metropolis* and *M*: "Fritz is in his late seventies, wears a black eye patch, and after he escaped from the Nazis and came to America, the first thing he did was drive hundreds of miles to see the Indians of the Southwest." Lang was also well versed in science fiction, another subject that deeply interested Hendrix. Stevens and Lang were highly respected film directors throughout the world. It was meaningful to Hendrix to hear that men of such lofty standing had endured their own

struggles with the creative life and had felt as frustrated as he did over a love-hate relationship with fame.

I mentioned a special trip to Henri Matisse's studio in Nice, France, and being the only person there looking out the window at the same scene the artist had viewed fifty years prior—shimmering sea, trees, roses—and what it had meant to me. "I *have* to go there!" he said.

It was obvious that Jimi's primary interest was that these men of unique vision continued creating and/or using their powerful imaginations all their lives. This was what he wanted for himself. "I want to play my guitar forever. *Forever*," he emphasized.

One afternoon I told him I felt that at some point in time—in this world or the next—if he were to enter a room of great musicians and composers, among them Beethoven and Mozart, they would recognize and welcome him. A naïve thought, perhaps, but I believed it then as I do now. Jimi didn't take this as flattery. As he and his music evolved, he believed absolutely in the *continuity*, the *kinship*, of inspired music makers through the ages. As much as Jimi Hendrix often lived in the moment, his sense of the meaning of music went far beyond a rock festival or a hit single. When he was deep into an elevated thought, his spirituality, his message, burned as an incandescent flame. Onstage and off.

§

ON APRIL 26 the Experience played one of its most important California concerts since hitting the big time, at the Forum. Among the eighteen thousand fans attending were hip young men sporting tie-dyed T-shirts and blue jeans and fashion-conscious girls in gauzy peasant blouses and miniskirts. But no matter how much time they'd spent getting ready for the show, when Jimi, Noel, and Mitch took the stage, their admirers forgot about looking trendy; their eyes were glued to the band. The music built to a fever pitch, and Hendrix was more exciting this night than his rapidly growing

Los Angeles fan base could handle. Hundreds of devotees pushed past more than a measly dozen security guards fronting the stage, hurling themselves as close to Jimi as they could get. Girls and guys alike risked bodily harm in the crush, desperate to catch Jimi's eye, touch his boots, *scream* that they loved him, that yes, they were *experienced*!

The Experience was one of the first bands in these early days of the rock explosion to draw this *sudden*, emotional, and dramatic reaction at the Forum. Half sitting in my third-row seat in the perfect spot to view the entire stage, I found this pandemonium breathtaking and *thrilling*! I loved watching the crowd as well as the performers, and tonight was an ecstatic eyeful. Jumping to my feet to see more of the lovefest taking place at Jimi's feet, I suddenly felt someone take hold of my arm and pull me forward, away from the growing rush to the stage. I was furious as this . . . this person pulled me gently but firmly toward the orange curtains at the side of the stage. "I don't want you to get hurt!" said Russ Shaw, the nice young guy from Reprise Records. "It's rough out there!" He meant well, but now, to my great disappointment, I could view only part of the electrically charged melee instead of all. I smiled as I observed Jimi, Noel, and Mitch grinning and laughing at one another, soaking up their popularity. It made me tremendously happy to see that it was all going to work between them.

The next day the bureau manager at UPI called me in and told me he wanted me to interview Jimi Hendrix "immediately." Frowning as if I'd been remiss, he said, "I can't understand why you haven't written a feature on him already. He's the black guy that calls here, right? He's becoming very popular." I nodded, unable to tell him that I knew far too much about Hendrix, most of which would not fit into some easygoing feature style. "Find out," my boss said, "what it's like to travel on the road making all that money. Get some stories about the fans. Who are they? New York wants your story this week."

I telephoned Hendrix, and we set it up for the afternoon of

May 1 at the Beverly Rodeo Hotel. Jimi sounded excited about the interview: "This will be *fun*! We're flying to Detroit later. I gotta get my clothes from the dry cleaner. We can talk while I pack, okay?"

It didn't turn out to be fun at all. His suite was like Grand Central Station, full of confusion and interruptions. I ended up with nothing that would lend itself to the type of lighthearted feature beloved by UPI's New York bureau. That afternoon stuck in my mind because it was one of the few times I had ever returned to my office to admit, embarrassed, "The interview didn't happen."

§

ON MAY 3, 1969, the Royal Canadian Mounties swooped down on Jimi Hendrix as he, Noel, and Mitch were going through customs in Toronto, after flying across the border from Detroit. A piece of Jimi's hand luggage was inspected and taken away for further examination, and ultimately he was charged with possession of heroin.

According to bystanders, Jimi's face expressed genuine shock when the word "heroin" was used. He was released on bail, and a very shaken band went on to perform a strong concert that night at Maple Leaf Gardens.

Several days later at the Los Angeles news bureau where I worked, my attention was called to a brief wire story out of Canada. "Hey SL, don't you know this guy that got busted for heroin?" someone called to me.

I scanned the brief report.

"You hangin' out with a junkie?" my colleague inquired.

"No, I don't have any reason to think Hendrix is a junkie," I said, "but if this is true, I wouldn't be doing any hanging out either." I was matter-of-fact, assuming that a mistake had been made; from time to time, we received wire stories that were inaccurate and were soon corrected.

I was completely opposed to hard drugs. Most of my friends who did dope on a regular basis felt that heroin was the line that

could not be crossed; it was a word, a drug, that they didn't joke about. Less than two months before, I had endured a devastating interview with a popular entertainer who was so high on "smack"—as his manager later admitted to me—that he smoked one cigarette after another, putting out the end of each still-fiery butt with his fingertips. Disillusioned, not to mention horrified, I couldn't wait to leave his office, shakily muttering, "Thanks for your time!"

There was nothing about the Hendrix arrest in the Los Angeles papers, but I soon received an interoffice message from a reporter in the UPI London bureau who mentioned the arrest and said that the word around London was that someone had arranged to plant the heroin on Hendrix. Precisely why and who was the mystery.

I considered Jimi Hendrix a great talent and a fine human being who had overcome great odds in his troubled life. Almost every musician I knew did some sort of drugs, but there wasn't a one of them that I would continue to associate with, if he was playing with hard drugs, and that included Hendrix.

Two weeks later, on a weekend trip with my family, we drove a hundred miles down the coast from Los Angeles to the exquisite seaside resort of La Jolla, a village we visited several times a year. The disc jockey on the local radio station was revved up with excitement over the fact that the Jimi Hendrix Experience would be playing at the San Diego Sports Arena this very night. I knew that they were still on tour, but I'd assumed they were in some other part of the country.

Later that glorious, sunny Saturday with its near-perfect temperatures, I cruised twenty minutes farther down the coast. I figured the Experience hadn't arrived yet, so I would find my way to the arena and see if tickets were still available. As luck would have it, the first sight I saw as I came off the narrow exit was a large, brightly colored equipment truck parked in a hotel lot with a cheery driver waving at me. "Hello, love. Good to see you!" It

turned out to be one of the Experience's roadies. A few feet away stood Noel and Mitch, smiling in my direction.

§

JIMI HAD the drapes drawn against the afternoon sun, and he was standing at an ironing board in his hotel room, wearing jeans and a peach-colored flowered silk kimono. He looked *serious* and not in the mood for conversation. "I'm tired," he said. "Too much travel."

"You need some rest," I replied, taking the hint. "I'm going on back to La Jolla for dinner." I rose from my chair. "I'll see you at the show."

"I'm sorry I'm grumpy," he said. "Sit back down. Please." He attempted a smile, but his face was tight, his brow furrowed, and the smile disintegrated. I sat there watching how carefully he pressed the ruffles on a satin shirt he planned to wear onstage that night.

"A while ago," I said, "I heard something quite surprising, and then I got very busy and put it out of my mind. Is it true that the band was arrested in Canada?"

Jimi glared at me. "It wasn't the band," he said. "*I* was arrested." His voice shook with humiliation and fear. "Whatever I have done," he said, "getting hooked on heroin is not one of them. I'm afraid of needles. I always have been. Drugs are supposed to be fun. I've seen real junkies. Nodding out in the gutters of New York. *That's* not fun. Yeah, I know people who do heroin."

Miserably, he inspected the shirt, gave it a couple more deft touches with the hissing iron. Then he adjusted the shirt neatly on a hanger in the closet, unplugged the iron, and declared defiantly, "I'm willing to stand naked in that courtroom. They won't find any needle marks!"

Defiance quickly turned to tears. "Damn!" Hendrix headed to the bathroom and came out mopping his face with a towel.

As he pulled himself together, I was remembering *something* . . . almost. Weeks earlier, when we had attempted to do the

135

interview, there was the sound of a too-eager voice that had stuck in my head. Someone holding something, waving it around. *Who? What?* By their training, reporters remembered conversations and noted settings. Plus, I had inherited a good memory; it came in handy in my job.

"I want to ask you a question about what was found at customs—"

He moved away and sharply cut me off. "I'm not supposed to talk about this."

"Was a bottle with a yellow top involved?" I was remembering more, and I attempted to press him on this.

He whirled around. "How could you know *that*?" He sounded suspicious, even paranoid.

I shrugged and left the room.

That night the Experience delivered a great performance, with Noel's band Fat Mattress as one of the opening acts. I believe this was the first time I'd ever heard Jimi play "Litle Wing" live; it was one of the highlights of the evening.

Backstage after the show, Noel was sweet and charming. "How did you feel about the Mattress, love?" he asked.

"It's a good group, Noel."

"But . . .?" he pressed, picking up on my lack of wild enthusiasm.

"You need a couple of *big* songs," I said quietly. Out of the corner of my eye, I watched Hendrix conversing with three record-company promotion men and a handful of local music writers. I kissed Noel on the cheek and walked over to Jimi.

"When you have a moment . . ." I said.

He finished with the men, and we moved to a corridor outside the dressing room. I got straight to the point: "When we were trying to have that interview in Los Angeles and you were packing to leave, there was someone outside the door who pushed her way in and had a bottle with a yellow top."

"You saw this?" Jimi was astonished.

"A hippie chick—" I said

"At the door?" he asked.

"Yes! Do you know her name?"

He shook his head. "I didn't know most of the people in and out of the room. It was hot that afternoon. I wanted to get a breeze going, so I had the door open."

"She was wearing long love beads; they swayed as she leaned into the room," I said. "I believe it's in my notes, because it was pretty obvious that we were never going to get the interview done, so I scribbled a few notes about fans and constant interruptions. As I was watching Noel's band tonight, I was thinking about that afternoon, trying to remember what it was about the flash of that yellow top. I may even have it all on a cassette. That girl was so pushy, the way she spoke."

"That's right, you'd brought that big old Sony recorder!" His face was a study in relief. "It's the weekend. I'll call my lawyer Monday. Can you tell him what you remember? And play the tape?" The words virtually flew out of his mouth.

§

STEVE PARKER was a young college student when Jimi, Noel, and Mitch appeared at the Santa Clara Fairgrounds on May 25, 1969. He recalled that the audience, photographers, and even the security guards were mesmerized as they watched Jimi's intense physical and emotional concentration on his music. Like a sleek racehorse, sweat glistening off his face under the heat of the afternoon sun, he was a champion, *their* champion. "We understood that he was giving us *everything*," Parker said more than thirty years after the concert, still vividly remembering that California day. "Jimi was *magnificent* beyond all belief."

Parker remembered, too, "the amazing sense of freedom we all felt that day. Sitting in the sun . . . some of the girls taking off their tops, which was a fairly bold move for college girls at that time . . . guys paying more attention to Hendrix than to the girls."

Seth Winston, today an Oscar-winning filmmaker for the short *Session Man*, also attended the Santa Clara show. "I was going to school at the University of California at Berkeley," he said. "I drove down to Santa Clara specifically to see Hendrix. I had fourth-row-center seats, and I was tripping on mescaline. I was amazed by Hendrix. It was like watching a magician play, his hands coming from all over the place. I saw him just the one time, and I'm *still* recovering from the gig!"

§

HENRY W. STEINGARTEN, the New York lawyer who months back Chas Chandler had suggested should represent Jimi within the Steingarten, Wedeen and Weiss firm, telephoned me several days after I'd seen Hendrix in San Diego. For a long time, Jimi, as well as Mike Jeffery, had been counseled by Stevens Weiss in a cozy situation that I thought could be seen to have benefited management, not their "artist." I read Mr. Steingarten the notes I'd scribbled down in Hendrix's hotel suite the afternoon of May 1; he asked me to mail the entire notepad, including interviews with two film stars I'd also seen that week, to him immediately. I mentioned that I also had a cassette of my attempts to conduct an interview; Jimi's voice and that of the determined if uninvited hippie girl were clearly heard on the tape, as were my earlier attempts to launch the interview. Mr. Steingarten asked me to describe and name everyone who'd been in the room; I knew only a couple of Hendrix's visitors, and only by their first names, a young musician and a petite, dark-haired girl.

June 20 was a day filled with sunshine and blue skies, and it was my day off work. Jimi had asked me to attend a late-morning meeting with Henry Steingarten, who was in Los Angeles on business. The conversation ranged from the lawyer's thoughts about Jimi's drug arrest in Toronto to upcoming business decisions Jimi needed to make. Hendrix kept turning to me as though seeking my approval, which made me uncomfortable. I said, "Jimi,

why don't you just explain what you really feel?" I remember thinking at the time that he didn't seem to be used to being listened to. He gradually became very verbal and direct with Mr. Steingarten; they both were clicking and on the same track. Jimi was in a great mood when we came away from the lawyer's Wilshire Boulevard hotel. "I accomplished things!" he said. We were being driven around Los Angeles in a limousine, as Jimi ran his errands, purchasing "normal" things like three pairs of socks, a newspaper, chewing gum, and several writing pads. We ate a leisurely late lunch on the patio of a health food restaurant. He was in a wonderful mood. Tonight was a *big* gig, the kickoff to a three-day rock festival titled Newport '69, held on a college campus fifteen miles over the canyons at a place deep in the San Fernando Valley known as Devonshire Downs. Creedence Clearwater Revival, Steppenwolf, Eric Burdon, and Three Dog Night were among the performers. "They're paying us a hundred thousand dollars tonight. More than even Elvis got," Hendrix said reverently. It was the only time Jimi ever mentioned to me the financial guarantee for a gig. "It's the most we've ever made." "We," not "I." He was proud that day, and excited about the evening to come.

Jack Meehan had arrived in Los Angeles that weekend. He was another great friend of the Experience's London PR man, Les Perrin. Meehan, a distinguished veteran reporter in the London UPI bureau, was a colleague of mine. Although "straight-looking" and middle-aged, Meehan was one of the most perceptive men I'd ever met. After lunch I asked Jimi whether he'd mind if we picked up Jack at his hotel; Meehan planned to attend the Devonshire Downs concert with me and some other friends, and I would be driving them all to the show.

Jack and Jimi hit it off immediately, and Hendrix was impressed that Jack would be willing to make the effort to go all the way out to the Valley. "It'll be outdoors and uncomfortable," Jimi said. "A lot of hippies!" They started talking music; Jimi

was impressed by intelligent people, and he liked the way Jack analyzed the work of everyone from the Jefferson Airplane to Stravinsky. He was intrigued that Jack had seen the Stones, the Doors, and the Nice, among others. "Are you *sure* you want to see the show tonight?" Jimi was all consideration. Didn't think I should drive. Why didn't he get us our own limousine? Reminded Jack there'd be lots of pot smokers in the crowd. Jack shrugged. In his cool way, he told Jimi, "I've heard you play in Swinging London. I want to hear you in mellow California." Jimi laughed and patted Jack on the shoulder.

It had been a great day, and Meehan, a couple of my friends, and I drove deep into the Valley through the traffic, then trekked for a long distance to get out to the field where the stage was located. We were revved for the show of the year. A half hour later, we felt like we'd been served a fallen soufflé. Hendrix was *awful*. His back was to the audience for most of the very brief set. This could not be the person I'd spent four hours with earlier in the day. I was dumbfounded, and I was angry. Fighting all that traffic all that way for nothing! I spoke to him later that night. "*What* happened?" I asked. "Bad-news people backstage," Jimi said without elaboration. One of his roadies told me the next day that "a mess of heavy-duty black guys laid a political rap on Hendrix. No one knew how to get rid of them. It was, um . . . dicey. Someone else spiked the plastic cup Jimi was drinking from." Jimi returned to the festival on Sunday afternoon. From all reports, some lengthy and exciting jamming took place, and the audience rock and rolled all over that dusty field.

I saw him soon after, but we did not discuss the debacle at Devonshire Downs further. While Jimi was straightening up the living room of his suite, his eye went to the headline on an English music weekly atop a pile of newspapers and magazines on the coffee table. He picked it up, looked at it, showed it to me. The headline read **Band Breaks Up**.

The story was about a minor English group that had called it quits. "It's all so sad," he said. "Some bands are just born to die."

As I observed Hendrix in both happy times and miserable moments, what I admired about him most, his music aside, was his complete lack of pretense or self-importance. He was a genuinely kind human being, and in the world of show business, where phonies hang from every tree, Jimi was very much for real.

As obsessed as he was with music, Hendrix paid attention to what was going on in the world. I remember him staring at a photo of Richard Nixon on a magazine cover, muttering indignantly, "Nixon. Well, we all know where he's at! This article is sickening. Just read this! And he thinks he's fooling everyone."

Most rock stars kept the TV on twenty-four hours a day, relishing background noise. If Jimi watched cartoons on television, it wasn't for long, and he generally sketched or drew when the TV was on. A good cartoon never failed to make him laugh, and Jimi enjoyed the *sounds* as much as the animation techniques. He generally preferred the daily papers to viewing a news broadcast. Newspapers meant song ideas and interesting, fresh words and concepts to Hendrix. Once he showed me a story concerning water pollution. "They can dump all they want in that ocean," he declared, "but one day Neptune will just slap it all back in their faces."

He was bigger than life onstage, but at home in the latest hotel suite, the adjective that fit him best, strangely enough, was "cozy." He was a basic Mr. Clean both personally and in his surroundings. Jimi could barely contain a sigh when some of the so-called friends would carelessly splash ketchup on the rug while munching a burger he had taken it upon himself to order from room service. Once I heard him say in annoyance, "Please. *This* is my *home*." Observing a visitor grind out a cigarette in a half-finished piece of pie had him gritting his teeth.

When his pals departed, Hendrix often tidied up rather than

leaving the mess for the middle-aged French maid who cleaned his suite at the Beverly Rodeo. "Monsieur Jimi, I will do this—"

"No, no," he cut her off as he continued clearing the remnants of a room-service lunch devoured by one of the so-calleds, as I came to think of them. "I'm just about finished." She scurried to bring in fresh towels for the bathroom; Jimi rushed to help her. Smiling sweetly, he said, "*Merci beaucoup,*" a lilt in his voice. She adored him.

Jimi emptied ashtrays, sorted piles of magazines into music and news, dampened a tissue to remove sticky spots from a table where his Coca-Cola bottle had rested. Watching him putter around definitely added a dimension to how I thought of Hendrix; it was particularly fascinating to see him organizing his amazing wardrobe for the dry cleaners, laying his clothes in categories across the king-size bed: "special care" and "needs mending." He *enjoyed* his silk shirts, velvet and suede pants, and his array of scarves, placed by length in a plastic bag.

His "looks," like his music, were ever evolving—the silk scarf tied jauntily around a velvet-panted thigh (for day only) or his upper arm, the leopardskin band wound around his wrist, the famous wide-brimmed black hat. At home—wherever that happened to be at the moment—there was always an inventive touch, a bracelet or a brooch or an exotic shirt, boldly proclaiming that this was *not* the boy next door. Yet for all his wonderful finery, I remember the day I first saw him barefoot, dressed only in blue jeans and a black T-shirt. I said what I thought: "Jimi, you look great!" He was pleased and smiled shyly, his long, thick eyelashes lowering as he accepted the compliment. "This is my new day-gig look," he said. "I've been working on a song." He told me matter-of-factly that he'd never had more than two changes of clothes when he was a child. He was making up for it now.

Hendrix noticed any mood that invited guests might display. "Everything okay with you?" he'd ask with genuine interest. And at some point *your* wardrobe would be pleasantly inspected. He

responded to color and detail as a great painter might. A delicate periwinkle blue or a sharp, clear coral or an engraved piece of old silver would catch his eye. He seemed to applaud the touches that said that this man or woman had *tried*, and he was free with his compliments, nodding approvingly or saying, "You're *very* together today."

As I marveled at how respectfully he treated the French housekeeper, I thought about the dynamics Jimi offered in conversation. Depending on whom he was relating to or with, he was a chameleon.

Days before, I had observed Jimi and a particular musician who often dropped by to ask for "a loan." Jimi listened quietly. " 'Bro'," this guy said, "you know the struggle we share." It was all a bit jivey sounding and Jimi obligingly turned quietly "bro-like." When his "pal" took the five hundred-dollar bills Jimi pulled out of a pillowcase, one of the current hiding places, he slapped Jimi's hand hard, and Hendrix halfheartedly slapped it back. When the musician left, Jimi reverted to being relaxed and enthusiastic as he offered a flowery description of the room-service dinner he planned to order. "You've been working all day. You're probably hungry," he said to me. "I think you'd like a small filet mignon? Medium-well, right? I'll have one, too. A *big* salad. Baked potato or fries? Dessert is a must. Maybe they'll have butterscotch pie!"

He could be quite the actor in these relaxed moods, gesturing amusingly, rolling his dark eyes, and striking silly poses. I asked him if his friend who'd come for money ever paid back his loans. "Hell no!" Jimi said, and he grinned at me. "How'd you like that riff about 'the struggle we share'? This is a guy who once called a limousine to bring him over here to borrow money, and then had the nerve to charge the limo to me!"

With older people or someone well spoken, Jimi pulled out his best grammar, and his impressive vocabulary came into play. Around Noel and Mitch, there were moments when Hendrix became more English, dishing out amusing expressions he'd

143

learned in London. If he felt shy, his voice became whispery. When he was actually enjoying a conversation with anyone who took him seriously and treated him as a human being instead of an "image," his eyes sparkled and his confidence asserted itself. During his years of fame, Jimi became worldly and sophisticated in positive ways. From constant travel and exposure to different cultures, attitudes, and languages, he soaked up knowledge and made a conscious effort to improve his grammar. He almost always tried to put others at ease. His myriad interests included science fiction, art, history, politics, football, chess, and any board game that called for quick thinking. A lot went on in his head.

§

TO VISIT Jimi at hotels in Los Angeles or New York was to run the gauntlet of fan worship. Male wannabes of diverse ethnic origins hung around hoping to strike up a conversation as Jimi made his way in or out of his hotel. Shiny-faced white college girls who shyly admitted they had huge posters of Jimi in their dorm rooms sometimes sat primly in the lobby, adjusting their miniskirts, thrilled when Hendrix walked by and offered them a pleasant smile. "I had a big crush on Jimi," recalls Ellen Berman. "Seeing him perform at the first rock concert I ever went to was fantastic! I cherished the black-and-white poster of him in my bedroom. Our family's cleaning lady was very upset. She went to my mother and said, 'Do you know that your daughter has a big picture of a black man in her bedroom?!'"

Berman was such a "nice girl" that she never dared set foot in a Los Angeles hotel seeking Jimi; she worshipped strictly from afar.

"Bold girls" didn't settle for anything less than stealthily camping out in hotel *corridors*—forget about the lobby! They would wait for hours, or until they were firmly asked to leave by hotel staff. At the very least, these girls sought a smile from Hendrix or an autograph. The ultimate score was a sexual rendezvous. Their

giggles and the vibe of their high anticipation filtered through to the suite. They had become a fact of his life. When it became ridiculously noisy, he would grin in embarrassment and call the front desk to have a bellman escort them downstairs and lie: "Mr. Hendrix has checked out." One day he had just made such a request, and he turned to me self-consciously. "Ah, my little distractions," he said lightly.

"Little *distractions*?" I echoed, "That's how you really think of these girls? Honestly, Jimi!" I was half laughing at him. "Well, there are certainly plenty of sluts and scrubbers running around here when you, Noel, and Mitch come to town," I said, "but I also notice some very nice girls who really like you." I mentioned two or three that floated around his axis.

He nodded. "*They* are decent, and they're sweet, but I am in no way interested in settling down anytime soon. And I've never pretended otherwise. I tried to make that clear to someone in England, and she didn't like hearing it. Now she's living her life and I'm living mine. I wish I had a home of my own, but until I have some time to sort my life out, the only place I live is on a roller coaster."

This was not the Jimi Hendrix many of his "chicks" wanted to know—or listen to. They craved sex and excitement, the divine recognition of being the female on Jimi's arm out in public. To say you'd done it with Hendrix had become the ultimate rock status symbol. So many women. And always they came to him. I was intrigued, amused, and, in the end, saddened to realize that for all his mighty reputation, the one thrill Jimi had missed was the pleasure of pursuit.

"Once in a while I might say 'love' to a girl, but I don't mean it," he admitted quite straightforwardly. "I'm not in one place long enough to fall in love with anyone. I've never truly been in love, the kind of love that lasts. The only person who ever really led me was my mother. And she's long dead.

"Love doesn't love anybody these days." As if to highlight his words, he reached for his guitar and strummed a discordant riff.

§

ONE TIME I noticed on the coffee table a collection of offerings left at his door by strangers who managed to get past the reception desk and upstairs. I picked up a large pink seashell. Taped inside were a marijuana joint and a tab of LSD, plus a small note with a name and phone number. I stared at the shell and then at him. "So you *are* a drug fiend!" I was joking and also curious to see his reaction.

"I've got things to accomplish today," he said, and briskly strode into the bathroom to flush his presents down the toilet. As soon as he returned, Jimi reached for a green-and-white package of Kools. He lit a cigarette, took a puff, and dryly commented, "Of course, I shouldn't be doing this either." He turned on his tape recorder.

Earnestly he said, "Everything can be used properly as long as it's not used as a crutch, as long as it doesn't take command of you. I was thinking about this after we played the San Jose Festival [actually the Santa Clara gig so well remembered by Steve Parker and Seth Winston]. I was on such a very natural high. It was such a beautiful feeling. I could see better. I could breathe better. Sometimes I could almost see behind me. I'd been making contact with the right people as we were riding along to the gig. There were certain smiles that were directing me in such a good way. That's why words sometimes get in the way; they have a tendency to draw away from the real power, the first flashing I get about something holy or something real. What I have found out is that when I get around people or listen to people too much, they have a tendency to pull me away from these feelings. But that one temporary thing is enough to help me learn a lesson not to be pulled as much. Again. Actually not to be pulled at all."

This was an important thought to Jimi, and he continued, "Like I said before, I was on a natural high. I was playin' the guitar, practicin' up. I never played that good before in the dressing room. And all of a sudden there were a lot of people milling around before we went on, and then a person, in a token of love, in a token of friendship, gave me a joint. Love doesn't love anybody right now. So forget about love and think about truth and understanding. And the idea of me turning on before going onstage wasn't actually me being truthful to accept a joint then. I shouldn't have accepted it. Maybe if I'd already played and was going back home to listen to music and relax, I might have accepted it then. That's where that is and nowhere else but that."

Jimi admitted he couldn't handle hard liquor, which set off a bottled-up anger, a destructive fury he almost never displayed otherwise. He regularly smoked marijuana and hashish, and he told me that he'd been introduced to LSD by one of the Rolling Stones. I looked skeptical. "You've always been so open with me," I said.

"Because I trust you. You're smart," he said. "Because you understand. Because we care about a lot of the same things."

I brushed it off. He talks to me, I thought, because he's *got* to tell someone.

"Okay, okay," Jimi said, "I got turned on to LSD in New York before I ever went to London, courtesy of Devon Wilson."

"Don't you ever try to avoid temptation?" I asked him.

"Hell, yes!" he flared up. "I have common sense!" Then he apologized and simmered down. With quiet pride Jimi said, "*I have Indian blood*; both my grandmothers were part Cherokee. Gramma Nora told me stories about Indian laws. I remember every word she said: If you don't keep your balance, nature will make you pay. You can't defy nature. You can only respect it and work with it."

§

MIKE JEFFERY continued to describe his client as the "black Elvis," even though he was aware that Hendrix wished he wouldn't do so. "I'm not Elvis, and he's not me," he said, "and I've come to realize that Mike doesn't actually know anything about music. I've seen the way he's screwed up my life with the Chalpin thing, and I don't want his advice on race and politics. He doesn't know what he's fooling with." Jimi was leery when pushed to comment at length on racial matters. "I'm only a musician," he would say. He did not see himself as a leader or celebrity spokesman for "the cause."

When black-militant leaders from New York and California sought him out, they were the ones who did all the talking. Jimi listened politely, and several times he quietly affirmed to these passionate young black men that he believed in the nonviolence stand taken by Dr. Martin Luther King Jr. It was not what they wanted to hear. He discussed their conversations with me, and he once told me, "I don't *feel* black. It's the Indian part that I mostly pay attention to. Anyway, I'm just me. . . ."

However, he said, he did have an idea of how to help the black community. "When I have some actual big money, I'm gonna buy one of those awful, beat old buildings in Harlem and fix it up. That will call attention to that mess and get other people to do the same thing. Together we could clean up the ghetto. You can't even imagine how bad some of those streets are!"

"What I'm wondering, Jimi, is where are all the people going to live while you're fixing up buildings?" I asked. "Where will the children sleep?"

He explained firmly, "They will all camp out on Fifth Avenue until they can go back to their new homes. *That* will get the attention of the rich—if the poor are right out there in front of their noses."

§

148

HENDRIX ENGAGED in a quest for self-knowledge and reassurance, looking for answers his music could not supply. He always enjoyed a good discussion on fate and destiny versus free will. A few of his female "distractions" regularly gifted him with jewelry featuring his astrological sign, Sagittarius. He read his horoscope for a time and found nothing compelling enough to make him a believer. A specialist in tarot cards wrote him kooky letters offering to give him a free reading. What did seem to consistently resonate for him was numerology.

"I've been searching for this book," he said to me on a summer afternoon. "It finally turned up in a guitar case. I bought it in London, and I want you to read it." Jimi held up a slightly tattered, faded book published at the turn of the century, a classic reference work on numerology. "This is important. I've read it dozens of times. *You* should read it. I think that you're a five.

"I'm a nine," Jimi said softly, as though he were confiding a rare and special secret. "It's a powerful number, and it can be very good or very bad. Nines are meant to accomplish things in this world."

"Did you always think you would accomplish something?"

He nodded, his face very serious. "Even when it was *very* bad, I felt sure that I would. In New York, of course, but also as a kid. I had to believe in *something*."

He lit a cigarette. So did I. The room was silent except for the swift striking of the matches. For a moment, I found myself thinking about the poor and hopeless unfortunates I saw every day in downtown Los Angeles, other young men and women, dragging small kids around, unable to find their futures. "What was the worst time?" I asked him.

"Probably when I'd hear that my mother was in the hospital," he said into the air, not looking at me. "She had tuberculosis and other stuff wrong with her. Like her life. If it wasn't for getting into music, I would have gone out of my mind."

"You must have felt very alone," I said.

After a long pause, he said, "I had my imagination."

I asked Jimi if he had visited his mother's grave.

"No," he said sharply. "It breaks my heart to think of her in that awful place. I know her soul can't be *there*. And the soul is what matters."

I asked him if he believed in God. He looked at me as if I'd lost my mind. "Of course."

Jimi appeared to be making a supreme effort to move ahead with his life and career. He called me at my office one day, saying, "I'm back at the Beverly Rodeo. Can you come over? I've got something really important to tell you!"

"Not until I get off work."

"It's *really* important!"

Shortly after four in the afternoon, I drove through the heart of the Beverly Hills shopping district to his hotel. As I parked the car, I heard one of the bellhops talking about drummer Buddy Miles. "He had this big drum kit sent up to Hendrix's penthouse, and he played so loud you could hear those drums pounding all the way down to Wilshire Boulevard! One of Hendrix's roadies says Buddy comes around to borrow money."

As Jimi had become a regular guest at the Beverly Rodeo, almost everyone who worked or shopped on world-renowned Rodeo Drive knew who he was. The comings and goings of Hendrix and his friends were viewed with interest, and the betting was that Beverly Hills' vigilant police chief wouldn't allow much more of Buddy Miles's drumming.

Inside the hotel's small lobby, as I waited for the elevator, I heard the telephone operator complain to the manager. "All these calls for Hendrix have the switchboard completely tied up. He's apologized and says he doesn't know most of them." She brandished a thick handful of pink message slips.

Jimi greeted me at the door to the penthouse; his face was *joyous*, his eyes shining with excitement. He escorted me to a chair

and sat down on the end of the bed, brandishing a white legal pad. "I've been thinking about it all morning. How to make life better. How to move ahead. I'm going to put together Skychurch. I'll buy some property in the country, maybe in those hills near the ocean. Up high above Malibu, maybe ... not Topanga Canyon, too many people nestled in there. We'll work on new music. Anyone who's good, who truly cares about music, can be part of it. It will be a family."

"A family?"

"A home. Away from everything, with a musical family," he said. "A place to concentrate on music all the time. We'll experiment. Take the music forward. *Progress*, that's what I want. It's going to be great!"

"Who are you thinking of inviting to be part of this?"

"Eric C., of course. Stevie Winwood. Mayall. Beck!" He paused and added, "If I can get Jeff to leave all his cars. Vic Briggs— I learned from him. Roger Mayer—he might have some new sound ideas." Jimi sat smiling as I took this all in. I'd never seen him so happy.

Then he jumped up, moving around the room, muttering to himself, sat back down, grabbed his pen, and began writing in big letters, then making small sketches, talking as he drew. "Definitely, definitely, *definitely* Roland Kirk. I can see us all listening to him blow our minds. Like a private concert kind of thing. You must realize that the entire world is an orchestra. At first I'm thinking about guitar players, because that's what I know. But there are great musicians who play other instruments. I need to get to know them and prove myself so they might want to join in."

He arose from the bed and handed me the legal pad with his sketches, standing over my shoulder, pointing out details. "Two stages, I think. The main one not too large. Outside, near groves of trees. And a small one inside, for when it rains." I could practically see Jimi rushing out to buy a hammer and nails, he was so excited and and eager to make it happen.

I asked him, "Where will you all sleep? Go back into town?"

"No, no, not at all." He raised an eyebrow at me as if to say, *Don't you get it?*

Laughingly I wondered, "Will there be a bunkhouse?"

"Why not? Designed in a U shape, you know. With really comfortable beds."

"You'll have a kitchen?"

"A big one with someone to come in and cook. A nice older lady, maybe a widow who likes music. We'll build a cozy dining room."

So Jimi Hendrix, whose family life had been sketchy at best, and who had never lived in anything resembling a genuine home for more than a few months at a time, made his plans. "All my childhood dreams are coming true!" he declared. Pen in hand, he began making a list. *Skychurch*, he wrote with a flourish. *Find property* was item one. "And there'll be an office in town! We can all do our business from there. Get some honest management."

Jimi never spoke of owning a fancy estate or a mansion à la Elvis's Graceland; Skychurch was *his* dream.

Two days later Hendrix asked me to drive him to the Sunset Strip. He was recognized virtually every foot of the way. He smiled and smiled, waving tiny, self-conscious waves back to the hippies and the fans in other cars. I giggled and teased him, "Now I know what Queen Elizabeth's chauffeur must feel like."

"Oh . . ." he said, waving a long finger, chiding me. "Now, don't be disrespectful to the queen." Then he giggled, too.

We sat waiting for a long red light to change. I snapped on the car radio; KHJ was playing a preview of Elvis Presley singing a new song called "Suspicious Minds"; he hadn't had a hit in a while, but this sounded like one. Jimi turned up the volume and began singing along. "Great song!" we both said at the same time as Elvis faded out. He turned the volume down and said, "My mama always liked to listen to music. Sometimes, when the Experience visits radio stations, I think how pleased she'd be that her little

babydoll is talking on the radio. I always hope she's listening. Do you think she can hear me?"

"Of course!" What else could I say?

Jimi just beamed. In this sunny, relaxed mood, he seemed to be completely magical. When he spoke of his mother and music, it reminded me of a line from an old blues song. Lightly, I spoke the words. *"You got a boy-child comin', gonna be a son of a gun."*

"You are *too* much!" Hendrix just gasped at these words from "Hoochie Coochie Man," grinning from ear to ear. "Willie Dixon! I *love* Willie Dixon!" He began to sing in an unusually robust voice:

> "Gypsy woman told my mother 'fore I was born,
> You got a boy-child comin', gonna be a son of a gun,
> Gonna make pretty womens jump and shout,
> And then the world wanna know what this all about."

"I wish, I wish, I wish," he said, "that I had my guitar with me right now! I'm in the mood to play *so* good!"

§

ON THE southeast corner of Sunset Boulevard and Carol Street stood the large building owned by Phil Spector, the eccentric producer/songwriter with the visionary ears. There was a possibility that Spector might consider renting out a limited amount of space to the right person; his assistant had arranged for Hendrix to take a look, graciously allowing him to wander at will. Jimi nervously fingered his tight green velvet pants as though he were being presumptuous to explore someone else's turf. But soon he couldn't wait to tour all three spacious floors, even peeking into a kitchen. "I'll have a refrigerator like that someday," he said softly, his eyes fixed on this bland-appearing appliance as though it were unbelievably rare and special. In retrospect this remark was to haunt me, conveying so much about where he'd been and where he wanted to go.

Jimi gazed out a window that looked onto Sunset Boulevard.

"Wow!" he said. "It's so clear that you can see to the very top of the hills. California is so beautiful today, isn't it? Like a very sunny kingdom." Carefully surveying several rooms that flowed into one another, Hendrix's brown eyes took on a dreamy quality: "I can just see how it could be. A big desk and a telephone here. Maybe that larger space over there for a lounge, a living room, you know, for all the musicians to relax . . . talk a little business . . . play new tapes from the studio. Our own place. For Eric C. and Stevie Winwood—all our English friends when they're in town." Jimi's eyes sparkled just thinking about his potential "kingdom." He kept moving, padding around in that gentle way of his. "I could build shelves across most of that long wall to hold records and tapes, and do some drawings to be hung near the door. Do you think Phil Spector would let us rent that much space?"

He marveled at Spector's procession of hit singles, the gold records attached to another wall, pausing in front of "To Know Him Is to Love Him." "He was only sixteen when he wrote that, you know," Jimi said reverently. "And look at what he's accomplished."

"He even has his own building," he added. "Just like Mike Jeffery."

Jimi was so excited about his visit to the Spector building that he mentioned it to Jeffery, who immediately squashed his dreams. "He reminded me that the management contract calls for him to make those kinds of decisions," Jimi said, imitating Mike's British accent. "He told me to concentrate on my priority. He got kind of strong about it." We were sitting in Du-Par's restaurant at the Farmers Market, and although his seafood salad had just arrived, Jimi lit a cigarette; he was increasingly nervous as he thought about his latest dilemma.

The priority Jeffery had reminded him of was the ongoing design and building of Electric Lady Studios in New York. "A place where I can play and record anything I want to," Hendrix said. "Free. A good investment. Like a pension, you know. I was so

excited in the beginning." Now he expressed his concerns over the way Jeffery had gone about setting up the plan for Electric Lady recording studios on West Eighth Street in Greenwich Village. "Mike used me and my music as collateral for a big loan from Reprise. We're partners in the studio—I hate this! Then there's all the money that it's costing for an architect to build the studio on property that's owned by someone else. It seems as if I'm supposed to put in hundreds of thousands in money that hasn't been made yet into a place that will be leased from a stranger," he said and then he blurted out, "He knows bad people with bad connections. Everyone's telling me, whispering to me, about the mafia and all that." He grimaced and shut his eyes for a moment, as if to say, *I'm willing this horrendous thought to disappear.* "I can't go along with that." He opened his eyes and stared at me: "Damn! Can't anything ever go right?"

"Have you mentioned any of this to Jeffery?" I asked.

"I have to protect myself, but I can never get him on the phone when I've got my nerve together to pin him down."

He added abruptly, "I just don't want to end up like Joe Louis."

"Joe Louis?" I couldn't see what the former boxer had to do with it. Oh! Right. A pathetic ex-champion bled dry by his entourage.

§

JUNE 29 WAS miserably hot at the Mile High Stadium in Denver, Colorado, where the Experience headlined the Denver Pop Festival. The audience, twenty-five thousand strong, screamed and cheered for Jimi, Noel, and Mitch. They screamed so loud that many of the fans didn't hear what Jimi said into the microphone just before the band left the stage: "This is the last gig we'll ever be playing together." Noel Redding was now out of the Experience, free to play with Fat Mattress at any time he chose.

For months Noel and Jimi had been unhappy with each other, and Jimi had been in communication with Billy Cox, his pal from

the army and his early, struggling days. It wasn't a secret to anyone in the inner circle but there was never an official "this is serious" discussion among the band members; Michael Jeffery had never sat the three of them down together and tried to work it all out. "Billy is a solid bass player," Jimi had told me weeks back, "and he *listens*." It was wrenching to accept that the early camaraderie and kinship between the members of the Experience were now indisputably in the past. Jimi's desire for *progress* was quite different from Noel's.

§

LONDON WAS in the midst of a suffocating heatwave in early July. I flew in from Los Angeles for a lengthy vacation, thanks to all the overtime hours I'd accumulated. Two hours after my plane landed at Heathrow, I walked slowly through a crowd of two hundred thousand people, with thousands more still arriving, at Hyde Park, the vast green space in the center of London. The Rolling Stones were "ready to rock" at their long-awaited free concert. It should have been a joyous occasion, but only three days previous one of the founding members of the Stones, Brian Jones, a strong swimmer, had died in mysterious circumstances—drowning in his own swimming pool late at night. Weeks before, the troubled Jones had been thrown out of the band, drugs being only one of his problems. His was the first major rock death, and music fans around the world continued to feel deep shock; heroes weren't supposed to die.

A personal invitation had been sent to me in California, and now I was given a special badge and offered luscious English strawberries from the big bowl on a table in the Stones' trailer behind the stage.

The heat was overwhelming as the band took the stage. Mick Jagger wore a long cotton tunic over his pants; the newspaper headlines soon would blare: **Jagger Wears Dress!**

He nervously stood facing the vast crowd and made clear that

the concert was dedicated to the late Brian Jones. He recited Percy Bysshe Shelley's poem "Adonais" for Brian as tiny white butterflies were released into the air; most of them, too, felt the heat and flutteringly fell into the crowd. Newspapers loved this irony: **Jagger Quotes Shelley As Moths Die**.

Young, angelic-appearing Mick Taylor, who'd been rehearsing with the Stones, on this day officially replaced Brian Jones on guitar.

In the next two weeks, I spent hours with another musician who had left his band—Noel Redding. He and Chas solicited my thoughts about what Fat Mattress could further accomplish in America, and I obligingly watched the band several times in London at clubs such as the legendary Marquee on Wardour Street. I was young and truly no expert on what any band should do. But since I was from the land of the Sunset Strip, this appeared to be enough "expertise" for them.

Chas was deeply interested in anything I would tell him about producers that Hendrix was considering working with. Foolishly, I mentioned that I'd suggested to Jimi that Glyn Johns was someone he should get to know. I had met Johns only once, casually, but I was familiar with his work for the Beatles and the Stones and his solid reputation as an engineer who knew and loved sound. So was Jimi. He'd pricked up his ears. "Ohhh!" he said as his eyes lit up, too.

As I recounted this, Chas flushed and angrily said to me, "That would *never* work! Glyn Johns would be in total awe of Jimi!" I wished that I'd held my tongue; I hadn't meant to hurt Chas. In any case, Johns and Jimi never connected.

§

THE TELEPHONE began ringing the moment I walked into my Los Angeles apartment after my English holiday. It was Jimi's attorney in New York. Henry Steingarten was loaded with bad news. Regarding Hendrix's drug situation in Toronto, there would definitely be

a trial, and I would be called as a witness; a deposition wouldn't suffice.

He told me that Jimi had taken a brief vacation to Morocco with some of the so-called friends. "His pals can really pick the spots," Steingarten sighed. "Nothing like a trip to a major drug capital when he's in trouble already. Now he's back at the rented house in Shokan, allegedly rehearsing."

"What's Shokan?" I wondered.

Mike Jeffery had found a rustic, spacious old home for rent in the small town of Shokan near Woodstock in upstate New York, Steingarten said, and Jimi and Mitch were living and working with perhaps eight or ten of Jimi's musician friends, including his army buddy Billy Cox and his supportive friend from Tennessee Larry Lee, the rhythm guitar player. Apparently, this was Mike Jeffery's version of Skychurch. The new band was to be known as Gypsy Sun and Rainbows.

Everything Steingarten said had me gritting my teeth. Jeffery was now dismayed that there were several black men in the band. All sorts of lowlifes were dropping by at odd hours, disturbing the peace of the countryside and living high on the hog, charging, among other items, new television sets to Jimi, and then jauntily shoving them out the window. Jimi wasn't returning important telephone calls. "It's just Jimi and his parasites," Steingarten said. He was mightily disappointed in Jimi.

"It's difficult for a star to run interference for himself, Mr. Steingarten," I said. "If Michael Jeffery wants to keep the gravy train rolling, if he gives a damn about Jimi, then maybe he'll allow you to hire a genuine security guard with brains and loyalty." I knew it would never happen. Most famous pop stars of the time had begun to hire one or more trustworthy men whose main job was to stand around looking cool and trying to fit in while keeping a sharp eye out for potential trouble—or troublemakers.

Hendrix phoned after midnight to ask about my vacation, and

he wanted to know if the Rolling Stones had treated the memory of Brian Jones with respect at Hyde Park. I felt like sniping at him, *At least they didn't run off to Morocco to get high in Brian's honor.* I held my tongue. It seemed that Steingarten wasn't the only one feeling disappointed. Jimi's nerves were on edge about his new group. "It's no Skychurch," he admitted. "I was thinking being out in nature would make it all come together."

"But?"

He hesitated, not wanting to put down his musicians. "The house is nice, and the food is good," he said, "and that little Woodstock festival is coming up soon, and I don't know what this group will sound like with a crowd." It was four o'clock in the morning in Shokan; he was depressed and floundering.

Ellen McIlwaine, Jimi's old friend from the Cafe Au Go-Go, recalls seeing Jimi during this time. "I was living in Woodstock," she said. "He walked into one of the hangouts there. I hadn't seen him since our Village days. I smiled and said, quite happily, as I would have then, 'Oh, it's *great* to see you. Want to jam?' But he didn't respond. He just kept walking, and he didn't make eye contact with anyone. Everybody knew everyone else at this place, and eventually both Jimi and I ended up at the same table. He just sat there, not saying a word. He didn't seem high. My instincts told me he was upset. Very upset."

Ellen was upset, too, and sad. This was not the Jimmy she had known, forever filled with enthusiasm for music—*never* refusing an opportunity to jam.

A few days of my vacation remained before I returned to work, and my on-again, off-again boyfriend, Ron, had sent me a round-trip ticket to New York for the weekend. He'd made dinner reservations at a fancy French restaurant and bought tickets to a Broadway play. This was a big deal to me: I had never before set foot in a New York theater. Ron and I had met in a writing class at UCLA; now he majored in journalism at Columbia University and

had managed to land a summer intern spot at *Newsweek*. I telephoned Steingarten to say that I would briefly be visiting New York, and he suggested that I drop in and say hello after I arrived.

Steingarten's business card was in my wallet. I headed off to the law firm of Steingarten, Wedeen and Weiss at 444 Madison Avenue. What I didn't know until I arrived there by taxi was that this address was the Newsweek Building, where numerous legal partnerships had offices. In one of life's fluky coincidences, Ron was working a few floors below Henry Steingarten. Jimi's attorney showed me around the large suite of offices and introduced me to one of his partners, Stevens Weiss. So *this* was Michael Jeffery's "personal lawyer," I thought. This renowned music-business wheeler-dealer was friendly to me, radiating confidence. For years after, I was to meet New York music people who had tales to relate regarding Weiss.

As we walked down a hallway, Steingarten gestured to a room on my right, perhaps ten by eight feet, painted an aging yellowish cream color. "Those are three years of Jimi's legal files," he said.

"My God!" I said, staggered at the sight. Was this what success was all about? Box upon box, folder after folder, ceiling-high stacks of lawsuits, contracts, and "ownership" papers crammed this space. Thick files brimming over the top of a deep box near the door bore the green label *Ed Chalpin and PPX*. I wanted to squeeze my eyes shut against the reality of what it meant to be Jimi Hendrix.

I was soon ready to leave this depressing citadel of lawyers. No wonder Jimi wanted to tune it all out. My escape would be shopping; I was enough of a California innocent that it was quite exciting for me to pass through the revolving doors of the Newsweek Building, ready to stroll up world-famous Madison Avenue. But I managed only five steps, because suddenly a uniformed man said, "You're Sharon?" I hesitated, noticed his cap, and realized that he was a limousine driver. He smilingly announced, "Michael Jeffery wants to see you." I hesitated some more, because although

I'd heard this name hundreds of times from Hendrix, from Chas, from Eric Burdon and others, I hadn't actually met many rotten people then. When Chas and Eric were telling Jeffery stories, they got really wound up, and their faces showed anger and contempt. I had never laid eyes on Jeffery, nor did I wish to. The driver assisted me into the plush rear seat; I was afraid to argue or cause a scene in broad daylight on Madison Avenue.

When he parked the Cadillac in front of a brownstone on East Thirty-seventh Street, I hesitated once again, observing the JEFFERY-CHANDLER plaque near the door. I wondered what Jeffery's inner sanctum would be like; I knew there was a basement, because Jimi told me he'd slept there on occasion. The interior seemed as dull and brown as the exterior. I don't remember any colorful posters or beautiful touches. Mike sat at his low desk, a nerdy intimidator staring at me behind lightly tinted aviator glasses.

"You're a reporter," he said. "Are you thinking about going into management?" One of his minions was skulking around, listening hard.

"That's something that has never occurred to me," I said. "I'm doing quite well as it is. I care about writing."

"You seem to have an influence on Hendrix," Jeffery said in his cool British tones. I let it pass. I was not particularly sure that this was true.

When he was midway through asking if romance was involved, trying to put his words together very carefully, I just laughed.

"I understand that you may be a witness in his Canadian problem," he continued.

"I was there that afternoon when the girl . . ." My voice faded away. I didn't have the guts to ask him if it was true that the heroin had been a plant. He didn't press me for details. This struck a warning note for me. If I were the manager of someone who was in trouble, I'd be concerned. I'd want to get to the bottom of the problem. I'd want to know about the hippie chick. *Maybe* he knew

a lot more than I did. I wasn't precisely uneasy in Jeffery's lair, but the atmosphere was not warm and cozy, and I understood he was a dangerous fellow. My brain was asking what advice Les Perrin or Jack Meehan would have for me in this situation. I decided that it was to leave as quickly and coolly as possible.

Before I could get out of there, Jeffery launched into an amazing riff on how he visualized Jimi as the leader of hundreds of millions of people around the world. He actually made a comparison to the Reverend Billy Graham and, for good measure, Gandhi. "I have great plans for Hendrix," he said. "He could use his power in so many ways." An image of Michael Jeffery as puppetmaster came to my mind. Chas had told me that Mike had done and continued to do a fair amount of LSD. I didn't think he was tripping at the moment, but he definitely was spinning a nutty fantasy. It annoyed me to think he believed that I would be impressed with this baloney. Especially because the reality was that it was more likely Jimi Hendrix was going to prison than turn into Billy Graham.

"You know, Mr. Jeffery," I said, "I'm just in New York for a short time. Ron, my boyfriend, and I are going to dinner and the theater tomorrow night, and I need to do some shopping." I stood up while he chewed on these words. He sat like a lump, not rising from his chair or walking me to the door. What a twerp, I thought. A twerp minus manners. Where was that famous Michael Jeffery charm anyway?

Years later someone mentioned Jeffery's name to me, and I actually felt faint. I remembered how cool I thought I'd appeared at our little meeting. Looking back, I knew that underneath my cool I'd been scared to death of the man. He was a power freak, and he hurt many people beyond Hendrix.

§

FEW COULD have imagined in the summer of 1969 that an event held on the bucolic pastureland of Max Yasgur's farm in the town

of Bethel in upstate New York would go down in the annals of music as a momentous weekend in time. Promoters of the Woodstock Music and Art Fair, held August 15, 16, and 17, had booked a fabulous list of performers for "Three Days of Peace and Music" —Janis Joplin; Joe Cocker; the Who; Sly and the Family Stone; Ten Years After; Ravi Shankar; Crosby, Stills, Nash & Young; the Jefferson Airplane; and the Jeff Beck Group to name but a few. Ten thousand to twenty thousand music fans were expected to journey to the farm. Shock and dismay were felt in the nearby villages when more than four hundred thousand people showed up.

Most of the sleepless and, after a siege of rain, dirty and muddy audience had departed when Jimi and Gypsy Sun and Rainbows took the stage as the closing act. There were perhaps thirty thousand die-hard devotees waiting for Hendrix. A respected middle-aged cinematographer named Dave Myers was there. Michael Wadleigh, the director of the film that came out of the Woodstock festival, was proud to have Myers among his hardworking crew. During the exhausting weekend, Myers's bed was directly underneath the trailer that served as Jimi's dressing room. While Myers shot many important sequences that weekend, including the famous "garbage pickup" footage, he got a break when Jimi and his band took the stage. "I was onstage, a few feet from Jimi," he remembers, "crouched down and purely an enthralled listener. Sunrise went on for a long time. The sun came up directly in front of Jimi as he played 'The Star-Spangled Banner.' This was an extraordinary culmination to the festival, and I felt very privileged to see and hear Hendrix."

"Was he playing to the cameras?" I asked.

"Oh, no," Myers said. "He was playing for himself. Concentrating like I'd never seen anyone concentrate before. It was all in his fingers. His beautiful magic fingers."

Chapter Nine

The Trial

"I'D LIKE to talk to you privately," Mick Jagger said to Jimi Hendrix. It was late the evening of Hendrix's twenty-seventh birthday, November 27, 1969. Earlier that night a devoted New York audience had screamed and cheered throughout the Rolling Stones' tumultuous performance at Madison Square Garden. Jimi dropped by to say hello to his old friends in their dressing room, surrounded by a zoo of hip dressers going for that "cool Stones look," including ebullient record-company executives, disc jockeys, photographers, gorgeous girls, and anyone else who had managed to talk his or her way into a backstage pass. As this privileged crowd multiplied, there were so many people milling around the stars and their guitars, neatly set out on stands, that the Stones had had to retreat to a tiny room to do their tuning. Hendrix talked guitars with "new" Stone Mick Taylor, and they jammed briefly in the small space. When the Stones let loose onstage, Hendrix and the Stones' pal, writer Stanley Booth, stood unobtrusively onstage behind Keith Richard's amp, digging the show and the audience's exuberant reaction.

After their gig the Stones rolled into the party that Devon Wilson had spent days planning, both to celebrate Jimi's birthday and further her own desire to start an affair with Mick Jagger. She'd persuaded a friend to turn over his spacious two-story Manhattan apartment for the event, and it was well after midnight as the seductive Devon strolled through the large duplex, smiling,

laughing, and gossiping with her mixed bag of pals. The party really took off when Jagger arrived. Devon's girlfriends grinned knowingly as the hostess kept one eye on Jagger and another on Hendrix. Mick was wearing a natty suit of his own design, and Jimi was all in black, to match his birthday mood. In nine days he was due in Toronto to meet with Canadian attorneys he hardly knew, then go on trial two days after that.

I was told later by one of my New York acquaintances who fed on gossip that "Jagger and Hendrix went off that night to fight it out over Devon." But that wasn't true.

Mick suggested to Jimi that they find a place to speak in confidence. "Let's go downstairs," Hendrix said. Impressed by Hendrix since the first time he saw him play in 1966, Jagger's admiration grew as Jimi's career took off in London. Now, three years later, Hendrix was a huge international star, and while Jagger continued to sing his praises, on this particular night his feelings were ones of sympathy, concern, and support.

§

MY FLIGHT from Los Angeles to Toronto on Saturday, December 6, was uneventful. I hadn't spoken with Jimi in weeks, and tonight we would be dining with Henry Steingarten in the heart of downtown Toronto.

In the taxi that afternoon, I speculated on what the proceedings would be like. For the past six weeks, I had received a series of odd phone calls from both acquaintances and total strangers in New York. The gist of their seemingly well-meaning comments was, "You'd better look out for yourself. Be careful! Pull back from Hendrix and his people; he's mixed up with bad company." I was told that I might well be followed. Since I'd never experienced anything remotely comparable before, I didn't know what to think or who to tell. So I started walking fast to my car, keeping it and my apartment locked at all times—and guess what? I was still breathing. The scariest thing about these calls was that I hadn't

discussed Hendrix and the trial with hardly a soul. So *who* was putting out the news that I was going to be one of the witnesses?

The most upsetting phone call came from a well-placed friend of an important friend at a New York record company, who said strongly, "Look, Sharon, there are people associated with Mike Jeffery who could hurt you. He doesn't want you or any other witness at that trial in Canada. Michael Jeffery is a control freak; he has problems with Hendrix. He wants to teach him a lesson. I'm going to tell you the name of a man that Jeffery knows. . . ." And she did, and I never forgot it. I checked out that name with a friend at the *New York Times.* It was one of the aliases of a major Manhattan crime boss. Jesus! It made no sense to me as to where Jimi Hendrix and his drug bust figured in all this.

I thought about a conversation with a trusted source inside Reprise Records in Burbank, California. "What I'm hearing," he said, "is that Mike Jeffery's long-term plans depend on keeping Jimi as a management client. Mike's nobody without Hendrix, and it's no secret that Jimi wants out. Maybe Jeffery's been cruel enough to set him up so no other manager will touch him. . . . And if Jimi goes to prison, Mike controls unreleased Hendrix tapes plus that New York recording studio they're building. Mike has always been lucky. Lucky and crafty."

I looked out the window on the left side of the taxi—blue sky and traffic.

The taxi driver irritably honked his horn. "D'ya see that?" he said. "Tried to cut me right out. The nigger bastard! So many of them moving across the border from Detroit. Damn niggers . . ."

I'd been told that the prevailing political attitude in Canada regarding Hendrix was "We have to make an example of the fuzzy-haired black weirdo; there's no welcome for drugged-out rock-and-rollers here." I couldn't wait until this transplanted red-neck dropped me off at the hotel.

My thoughts became grimmer: Life was so unexpected. Me being *here*. And *everything* in Jimi's life seemed uncertain. From

what he'd told me, instability was a way of life during his child-hood and when he played the chitlin circuit. Against the odds he had achieved fame, and now his success was generating more fear than protection. Would he go to prison? Would he be allowed to keep recording? Would he even want to? Who would he play with? The band that had brought him stardom had fallen apart. How long would the audiences really remember Jimi Hendrix? Did Mike Jeffery have some awful surprise waiting in Toronto?

This was a real "take-it-one-day-at-a-time" situation. And how I wished, as the taxi drove me closer to downtown Toronto, that a deposition would have been enough to save me from making this trip. I'd never respected people who complained that they "didn't want to be put in the middle." It was so wimpy. I knew that if I didn't tell what I'd observed that afternoon at the Beverly Rodeo, I would hate myself. Of course, it might not make any difference at all.

§

LATE SATURDAY afternoon Jimi's New York attorney, Henry W. Steingarten, waited by the telephone in his room at the Royal York Hotel in Toronto. His client's trial would commence in less than forty-eight hours, and Steingarten was worried. The two high-powered Canadian attorneys who'd been retained to defend Hendrix had told him they were less than confident about the out-come of the trial. They were also expensive, and Jimi's personal cash flow was down to a few thousand dollars.

An hour after checking into the Royal York, I sat in a chair by a window as Steingarten removed a silver cocktail shaker from a bulging briefcase. "My wife generally makes a shaker of manhat-tans for me to take along when I travel, in case, at the end of a long day, a drink is in order," he explained. He was a considerate man, very close to the "teddy bear" Jimi had described to me. A teddy bear with keen eyes, a fine legal background, and adorned in conservative suits. He commanded respect.

He offered to pour me a cocktail from the shaker. "No thank you," I said. "I've always thought manhattans and martinis taste like gasoline."

I had mentioned to Steingarten some time back that it seemed strange to me that Jimi never seemed to be invited to genuinely social occasions by his business associates or even his so-called friends. When I occasionally traveled to New York, I was treated very well, but Jimi spoke as though he were unfamiliar with good Village and midtown restaurants. He might have been a star, but he was not a part of the upscale lifestyle of successful New Yorkers. In Britain his English friends had offered hospitality and friendship that were dazzling to him. In New York, to some, Jimi was more of an *object*.

In the fall of 1969, as a result of our conversation, Steingarten arranged a lovely dinner at his home and was shocked and humiliated, particularly in front of his wife, to have Jimi turn up not alone or with a date but rather accompanied by several of his so-called friends. They were high when they walked in the door and became even higher through the evening. They'd brought cocaine into the home, and there was much running back and forth to the bathroom to snort it. Steingarten didn't quite realize precisely what was going on, blaming the "intruders" more than he did Hendrix. Still, he said, "Jimi was a complete ass that night."

However, here in Toronto, Steingarten was willing to give it another try, and he had planned a small, relaxed dinner for this evening at a nearby steakhouse for Jimi, Chas Chandler—who was making a special trip from London to testify—and me. It was a night designed to bolster Jimi before he went into the courtroom.

The busy attorney led a demanding business life and preferred to spend his weekends with his family. He couldn't believe that he was sitting here now waiting for the phone to ring to signal Jimi's arrival from New York. He waited and waited, looked at his watch, and observed the overcast weather outside the hotel window. He

This is Jimi's favorite photograph of
his mother, Lucille Jeter Hendrix.
(Courtesy Dolores Jeter Hall Hamm)

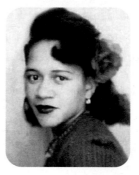

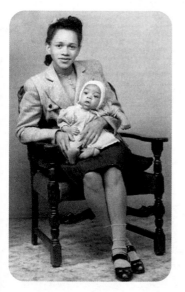

Baby Johnny in his mother's arms.
(Courtesy Dolores Jeter Hall Hamm)

Jimi and his brother, Leon,
circa 1950. When Johnny was
nearly four, his father applied to
have his name legally changed
to James Marshall Hendrix. Later,
Johnny/Jimmy spoke of the first years
of his life as "full of confusion."
He did not easily discuss his
childhood memories.
(Courtesy Dolores Jeter Hall Hamm)

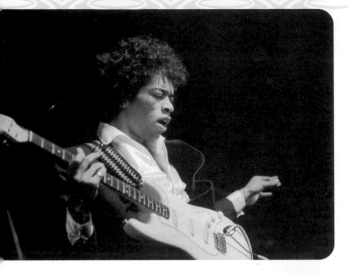

Jimi onstage at
the Olympia in Paris,
October 18, 1966.
"Imagine," he said
he thought then,
"Lucille's little boy in
Paris, France!"
(Photograph by
Jean-Pierre Leloir)

October 18, 1966.
This shot, one of the
first ever taken of
Jimi Hendrix and his
band, is also from the
Paris show that was
a vital part of getting
the Experience off the
ground. A particularly
young-looking
Noel Redding is on
Jimi's left. "Jimi was
so *natural*," said
photographer
Jean-Pierre Leloir,
who became his
friend and went on to
capture many great
images of Hendrix,
including this one.
(Photograph by
Jean-Pierre Leloir)

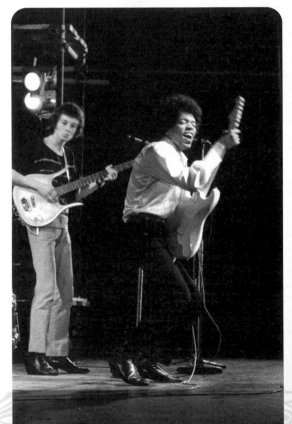

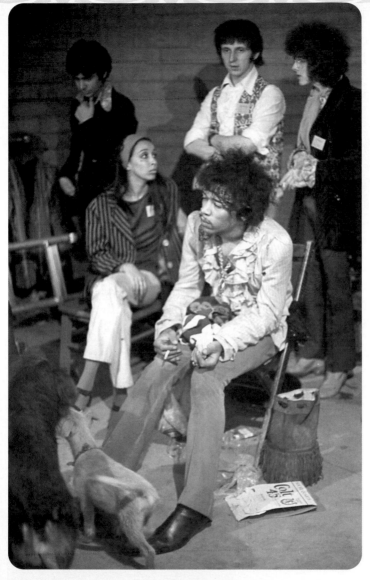

This sixties "tableau" was taken just hours before Jimi took the stage
at the Monterey Pop Festival, June 1967. Here, he was thinking about
"how to blow the audience's mind." He wore the same shirt onstage that night.
Notice John Entwistle of the Who and Noel Redding behind him.

(Photograph by Henry Diltz)

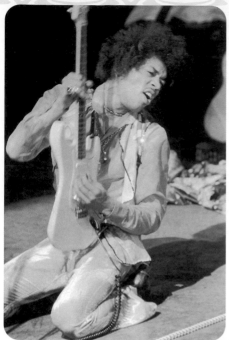

Paris, October 9, 1967. "Yeah!"

(Photograph by Jean-Pierre Leloir)

Paris, October 9, 1967.
He wasn't always the "wild
man." Even standing still,
Hendrix radiated artistry.

(Photograph by Jean-Pierre Leloir)

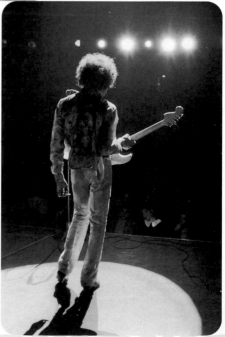

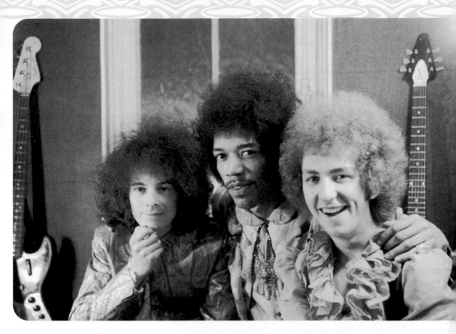

Noel, Jimi, and Mitch in their dressing room at the Olympia in Paris, October 9, 1967. Freaky hair, freaky clothes, trailblazing music. One year after the formation of the Experience, they were gaining a worldwide reputation as life equaled a nonstop tour.

(Photograph by Jean-Pierre Leloir)

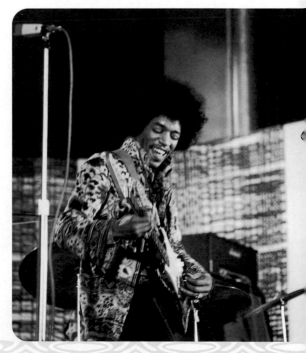

Jimi Hendrix, in this "fab" jacket, loved clothes and was his own stylist. He became a fashion icon for his generation and those that followed.

(Photograph by Jean-Pierre Leloir)

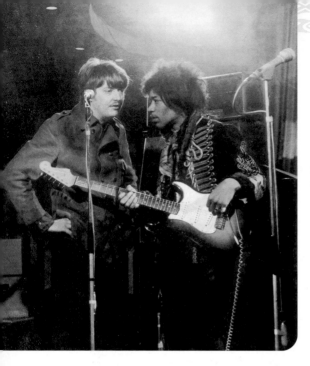

Jimi with Chas Chandler, former bassist of the Animals, at the Marquee Club in London, circa 1967. They had met in 1966 in New York City.

(Photograph by Jan Olofsson / Redferns)

Jimi, with Mitch, Noel, and Chas, in Germany, 1967. The previous year, soon after they first got together, the band had done a few random gigs for American military men in Germany.

(K&K ULF Kruger OHG / Redferns)

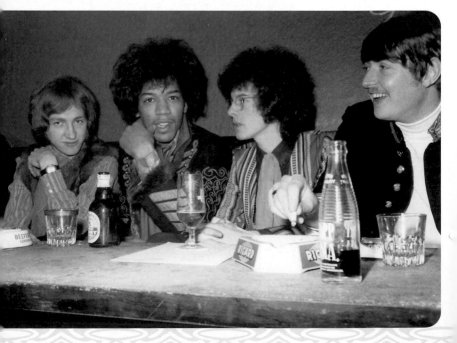

A humble Hendrix being presented by DJ Jimmy Saville with the *Melody Maker* Award for World's Best Pop Musician, 1967. This was one of the happiest days of Jimi's life. The year before he'd been starving in the streets.

(Photograph by Barrie Wentzell)

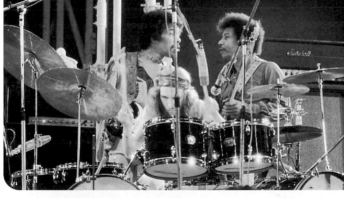

A rare tight shot of Jimi, Billy Cox and Mitch. Frustrated by sound problems, Jimi had moved back to the drum kit at the huge Isle of Wight festival in August 1970. This image was taken three weeks before his death.

(Photograph by Jean-Pierre Leloir)

Jimi's father and his brother, Leon, receive Jimi's star on the Hollywood Walk of Fame, November 12, 1991.

(Courtesy of the Hollywood Chamber of Commerce)

Jimi hand-painted this 1965 Stratocaster, which he "sacrificed" at the Saville Theater in London on June 4, 1967. He added special words to the back before he threw it into the audience—"My darling guitar . . . please rest in peace. Amen."

(Photograph courtesy of Cité de la Musique, Paris)

The guitar ultimately broke into several pieces after the "sacrifice" and was later restored.

(Photograph courtesy of Cité de la Musique, Paris)

sighed several times. "Jimi can be such a sweet kid, but his life is a mess," he said.

Finally the shrill ring of the phone pierced the silence. "Hi, Jimi!" he said, and then tightened his lips. The voice on the other end belonged to one of Mike Jeffery's people. Steingarten turned the phone at a slant so I could hear as I rose from my chair.

The voice vibrating out of the receiver was saying, "Um, well you see . . . Jimi's *not* at the hotel. He's still at the airport. They busted him for drug possession coming through customs."

"Busted? *Again?*" The expression on Steingarten's face said he couldn't believe he'd heard correctly. My God, I thought. My God!

Steingarten was furious. "We may as well pack our bags and leave," he barked. He moved purposefully toward his suitcase.

"No!" I said. "You can't abandon him now. What's this all about? We need to know. Is this one of Jeffery's games? Is Jimi a lunatic? And Chas will be expecting to have dinner with you."

After Steingarten settled down, the three of us drank red wine and ate our steaks at Barberian's in between bouts of anxiety, and minus any of the London and Los Angeles record gossip that Chas and I had always enjoyed. Steingarten was now waiting for another call to say that Jimi had been sprung from customs. Or taken to a cell.

Shortly after 9:00 P.M., we heard that the substance found in an acoustic guitar was "tiny" and not readily identifiable, and that Hendrix had been released to check in at the Four Seasons Hotel until lab work could be done and a decision made.

I told Steingarten that I was going to the Four Seasons "carefully and quietly" in half an hour. He was adamant that I would not. Surprisingly, Chas spoke up and said, "We have business relationships with Jimi, Henry. He's more likely to tell Sharon what's going on because he trusts her."

"I don't *really* want to go there," I said. "And I'm not sure that Jimi trusts anyone, including himself. But I can't possibly sit down

with the lawyers tomorrow and go into a courtroom if there's some odd game being played. We need to know what Jimi is thinking. Is he going to self-destruct?"

§

I SAID my name, and Jimi opened the door barely wide enough for me to enter. The room was dimly lit, with just one lamp burning. There was no "hello" or "how are you?" I started to sit down in a wooden chair next to the latched door of an adjoining room. Hendrix pointed, directing me to the foot of the bed less than a yard away, and he whispered, "There are two guys listening on the other side of that door." I looked questioning. He muttered their names; one fellow worked for the band, and the other in the New York office. Both of them, Jimi indicated, would be reporting back to Jeffery.

We sat there on the edge of the bed. "What did you put in your guitar?" I whispered.

"Something to blot it all out for a while if I get sent away."

"I know you're not stupid, Jimi." My voice was so low that I could hardly hear my own words. "You *have* to think positive to get through this."

His eyes turned fierce. "Do you have any idea of what men in prison could do to someone like me? I couldn't bear it! I'd be dead in a week. One way or another."

"You have Mr. Steingarten and the two lawyers here. Chas is here, too. And Les Perrin is on his way from London."

"Let's go in the bathroom," he whispered, pointing to his right, then grimaced at the latched door across from the bed.

We leaned against the tiled wall, and, finally in a normal voice, Hendrix began telling me about his conversation with Mick Jagger on his not-so-celebratory birthday.

"We went downstairs and talked quietly," Jimi said. "I was embarrassed because he was really nice to me. He *cared.* Mick

always has liked my playing, but this was a whole other thing. Embarrassing. I was squirming inside. You can dig that."

"You felt humiliated," I said.

"Damn right, that's what I felt. What I feel now. When he was telling me about him and Keith being sent to prison, it was very real. And Mick was very real. He told me how Les Perrin helped them . . . about what the *London Times* wrote that got them out of prison."

In February 1967, Sussex police had raided Keith Richard's home and found, according to their report, "various substances of a suspicious nature." Mick Jagger was charged with possession of four "pep pills," found in a jacket pocket and actually belonging to his girlfriend, Marianne Faithfull. Keith faced charges that he had allowed guests to smoke cannabis resin in his home. They were brought to trial at the end of June. The judge gave Jagger a year's imprisonment and fined him five hundred pounds. Richard's sentence was three months in prison and one hundred pounds. Mick was handcuffed and transported to Lewes Prison. Keith, also handcuffed, was taken away to Wormwood Scrubs, a 150-year-old prison. "They were set up and persecuted," declared Les Perrin. The severity of the sentences for such minor offenses caused a stir across Britain, and led William Rees-Mogg of *The Times* to write the now legendary editorial "Who Breaks a Butterfly on a Wheel?" The situation, he said, was "as mild a drug case as can ever have been brought before the courts," and he asserted, "There must remain a suspicion in this case that Mr. Jagger received a more severe sentence than would have been thought proper for any purely anonymous young man." Both Rolling Stones were soon let out on seven thousand pounds' bail. Jagger ultimately received a one-year conditional discharge, and Richard was set free.

"Mick told me he cried in the courtroom when he was sentenced," Jimi said. "He and Keith were terribly frightened. But it all worked out, because it was an injustice." Jimi sighed, looking

gloomier by the minute. "*They* were English and in England. In Canada I'm the *enemy*. I can't take . . ." Jimi's voice trailed off. He turned his head away from me; he was crying now. "Might as well get the tears over with," he said as he pulled himself together. "I cannot let myself cry in a courtroom. *I* will not do that!"

We moved out of the bathroom, away from the glare of the overhead light, into the tiny entry space near the door. "I'd better get out of here," I said.

"Be careful," he told me. "Be very careful going back." On this dark, cold, difficult December night, Jimi Hendrix was somber and a complete realist. Illusions and talent had built three years of fame, but there were no illusions left for him this night. "If anything happens to me, the lawyers will be fighting it out for the next twenty years," he said. Even in the dimness, his eyes appeared intense, but his tone was matter-of-fact. Jimi was speaking of much more than the trial at hand. He was referring to his very life.

"You know what I'm about. You know what it's been like," he said. "When the time comes, tell it straight. I don't want people to think badly of me." No words can explain how wretched I felt hearing this.

I reached for the doorknob and finally, briefly, turned to half face Jimi. "I'll see you in the morning."

Jimi grabbed my hand. "Be very careful," he said once more.

§

JIMI, CHAS, Henry Steingarten, and I arrived at the law offices of John O'Driscoll at 10:30 A.M.. on a chilly Sunday morning. We were a quiet, outwardly calm group, sitting in upholstered contemporary chairs in a dully decorated oblong room. O'Driscoll was fortyish, attractive, and a former district attorney. He and a colleague were Hendrix's defense team, and we waited for them to present their plan of action for the trial, which they presumably had been working on for several months.

The two attorneys spoke knowledgeably, but their lack of

confidence in Jimi's chances for acquittal hovered in the air. No clear-cut strategy was offered. They saw Chas, Jimi, and me as strange birds, and in all fairness this was an unusual case for these respected Toronto gentlemen to tackle. Steingarten was okay, though; he was a lawyer. The conversation moved in stops and starts. As time ticked by, the three of us waited for the dynamics of this meeting to change.

Pulling my hefty Sony recorder out of a tote bag and placing it on a low table, I asked O'Driscoll if he'd like to hear the cassette of my attempts to interview Hendrix in Beverly Hills on May 1. I reminded the room at large that Jimi's voice and that of the girl who had stepped through the door were clearly audible. The lawyers weren't interested in hearing the cassette. "We won't be able to use it in court," Mr. O'Driscoll said.

"I guess I thought you'd want to hear it for yourself just to get a sense of what happened," I said.

The two Toronto lawyers looked Jimi over. Finally one of them said, "You'll say you don't take drugs in testimony."

Jimi quietly replied, "But I do. Just about everyone I know takes drugs."

Mr. O'Driscoll was dismayed by his answer. "Do you buy them?" he asked.

Jimi and Chas exchanged a look. "People bring drugs around everywhere we . . . I go," Jimi answered. "Sometimes I take them, sometimes I don't."

Chas valiantly tried to explain life on the road, the lack of privacy, the "gifts" brought around in every city from complete strangers. Both Jimi and Steingarten were amazed by Chas's passion as he struggled to make the lawyers understand how hard Hendrix worked, that he was an intelligent person whose sudden and immense fame had not turned him into a capricious monster with no respect for the law. Chas locked eyes with the lawyers as he concluded, "Jimi, Noel, and Mitch have been strip-searched many times in traveling around the world. I've gone through it,

too! *You'd* be furious to be treated in this manner. Musicians all know that valises and carry-on bags will be searched crossing borders. Jimi is not a fool!"

To be fair, these attorneys were not used to dealing with rock stars, their images, and the huge influence their music had on young people. Still, we all wondered why they hadn't done some homework about the lifestyle. Hendrix continued alert and cooperative during that very long day, but when Steingarten, Chas, and the Canadian attorneys left the room, his face showed a terrible anxiety. He sat in a large green chair against the wall. I sat in my green chair a few feet away. Eventually Jimi stood up, and walked over to the window, sighing deeply.

I thought about the last time I'd spoken with him. Weeks back he had rented a modest two-bedroom apartment on West Twelfth Street in Greenwich Village. One day he called me at work. "I know we're not supposed to talk until the Toronto thing is over. But I had to tell you this!" His voice sparkled as he announced, "Guess what? I saw Bob Dylan on the street!" *Dylan*—his absolute idol. "I saw him driving his car. His little feet hardly reached the pedals."

"How could you know that?"

"I just *know*." Whimsy and a captivating sense of humor were as much a part of Jimi as his guitar.

Humor and whimsy were absent today; only apprehensive silence filled the room. He padded softly back to his chair.

To Jimi's right the door to an outer office was ajar. As the minutes ticked on, we heard Mr. O'Driscoll's associate enter the outer office with a young man, whose voice was instantly recognizable as a key employee of the Jimi Hendrix Experience on and off the road. He had flown to Toronto from New York under instructions from Mike Jeffery. The attorney declared that if Hendrix were to be convicted, the prosecutor would ask that he be imprisoned for as long as twenty years. He added, "The attitude in political circles is that we will not tolerate drug use in our young people.

The black idol of white teenagers will not set our standards." He added, "Obviously, we would have the opportunity to appeal. It could drag out for quite some time."

Jimi's employee asked, "No touring?"

"I shouldn't think so," the Canadian attorney replied. He asked the Englishman if he would take the witness stand and testify in court that he had known Hendrix for three years and give a description of life on the road as the band traveled the world. "No! I won't do that!" he said in a harsh squawk. "I'm not going to prison for the likes of him!"

I saw Jimi's eyes flicker, and his face transformed into an impassive mask.

§

AT THE Toronto Courthouse on University Avenue, it was Action Central early Monday morning, December 8, 1969. Press and photographers eagerly awaited the arrival of Hendrix's limousine, and the fans, out in full force on the sidewalk and in the street, waved and cheered at the sight of their star stepping out of it. Jimi forced a smile and a wave or two. He was wearing a blue blazer, bell-bottomed gray flannel pants, an open shirt filled in with an ascot instead of a tie, and a turquoise ring and bracelet.

As he walked into Courtroom 15, someone caught his eye. "Oh, Hi! How are you?" Hendrix said pleasantly to the gentleman, who engaged him in brief conversation. One would never have guessed that in the limousine a few minutes earlier, he'd been grim and quiet. "Who was that, Jimi?" Steingarten asked with concern. "He's one of the customs officers who went through my bags," Jimi explained. "He was asking for an autograph for his children. He was nice to me when I was arrested."

In the courtroom Hendrix was escorted to a three-sided wire cage—referred to by one of the attorneys as "the box"—to the right of Judge Joseph Kelly. Jimi was clearly visible to the jury and all spectators in the room, which held approximately two hundred

people, most of them fans, some in colorful hippie attire, come to view this "happening." Despite the humiliating situation, Hendrix was attentive and dignified. He showed respect for the court but also for himself. It was nearly impossible to believe that this young man could be a dangerous drug addict out to corrupt young people.

As his Paris friend, photographer Jean-Pierre Leloir, had observed in their first meeting, three years later Jimi Hendrix was still "natural" despite the fact that now this beautiful butterfly was virtually trapped and quite still. Steingarten whispered to me, "I'm impressed with the way he's handling himself. He has the demeanor of a true gentleman."

Prosecutions in Canadian courtrooms are carried out in the name of the queen of England. Counsel for the Crown, John Malone, questioned Jimi intensely and interminably, zeroing in several times on the issue of whether Hendrix had *knowingly* brought heroin into Canada. He was also asked more than once about a small aluminum tube containing a trace of hashish residue found in his flight bag. Finally Jimi lightly replied, "Maybe it's a peashooter." The Crown prosecutor verbally poked and prodded for information on Hendrix's career, his travel and touring schedule, and his fans, whenever possible focusing on drug usage. Jimi was attentive to each question, no matter how many times it was asked.

At the lunch recess, Hendrix's lawyers took us to a nearby restaurant frequented by legal circles. We were ushered to chairs at a long table where, to our surprise, we were seated close to the prosecuting attorneys. The Canadian lawyers from both sides were friends, and they chatted affably and joked throughout the meal. Mention was made of a recent copy of *Life*, America's most widely read magazine, in which Jimi had been featured in a lavish photo layout. The lawyers all grinned at him. I wondered if they, too, would ask for autographs.

The best thing about the first day in court was when it was over and we had a chance to sit down with Leslie Perrin, who'd just arrived from London. As always, Les was warm and supportive. He was like a favorite uncle for everyone who knew him; today Les was more serious than we'd ever seen him before. "Stars are targets for all sorts of people," Jimi, Chas, and I heard him explain to Steingarten. "Whenever Frank Sinatra is in London, we always take precautions to keep strangers away from his hotel suite. But our young pop lads, like Jimi here, don't want to be rude to the fans; they're more accessible."

"This is just the kind of testimony we need from you tomorrow," Steingarten said happily. "And, Sharon, you will probably take the stand tomorrow, too."

Shortly after, I excused myself; I wanted to get some sleep so that on Tuesday I would appear more rested and calm than I felt.

The next morning Chas came to my room and told me that Jimi had been ill during the night. "The strain is getting to him," he said. Chas handed me a newspaper account of the first day of the trial. The headline in the *Telegram* read **I've Used Drugs But Not Heroin—Hendrix**.

"This all seems like a bad dream to me," Chas said, adding, "Can you believe Jeffery not being here for the trial? If there's a conviction, I expect Mike doesn't want to be around to take the blame or the heat of explaining to the record companies and the press. Or to be questioned by the press as to whether he had the smack planted on Jimi—and *that* rumor is getting around."

"Maybe he's afraid of an all-out confrontation with Jimi," I said.

"Jeffery would be terrified of that," he agreed. "*Terrified*," he repeated in his rolling northern accent.

"One more thing, Chas," I said. "Doesn't it seem strange to you that Jeffery hasn't offered to chip in on Jimi's legal bills?"

"He's a right bastard," Chas said. "Mike's a very tricky man."

I saw in his pale blue eyes that he was afraid of what he clearly feared Jeffery had set in motion.

§

THE JURY, twelve white men, mostly middle-aged, wore good suits and ties. I was sworn in, my hand on the Bible, surprised to find myself feeling relatively comfortable as the questioning got under way. In large part this was due to the fact that the gentlemen of the jury were listening closely, and they struck me as decent human beings who wanted to be fair. The honorable Judge Kelly, a respected Canadian, paid close attention to the proceedings. I answered questions for what seemed like at least two hours. Interrogated by Jimi's lawyer John O'Driscoll about the afternoon of May 1, I testified regarding the people in and out of Hendrix's room as I'd tried to conduct an interview, detailing the constant interruptions, the open door, the hippie girl, and Hendrix's demeanor. The Crown prosecutor John Malone bore down on my background, my job, and my familiarity with drugs and music fans. The judge asked briefly about my writing job, and finally I was allowed to step down. "No more questions."

When court took a recess, I hurried up the aisle and out the courtroom door, moving as quickly as possible through a corridor swarming with fans, reporters, and photographers. Behind me I heard, "Here's Hendrix! Get him! Get the picture!" While they all turned to catch Jimi, I was out of there.

I rushed around the corner to find a taxi and asked the driver to take me to the Royal York and wait while I checked out and retrieved my suitcase. As the taxi driver drove to the airport, I wondered about how much more testimony there would be and how long it would take for the jury to arrive at a verdict. I had a sense that most of these men were sympathetic to Jimi's situation, from what I could observe of the way they looked at him, listened to his words. My fingers were crossed. He was hopeful, Jimi had told Chas, that he would be vindicated and "have a chance at a new begin-

ning." I was so relieved to be away from the stress and uncertainty that I couldn't wait to get back to work. Jimi described his world as "life on a roller coaster." That was not what I wanted for myself.

Late the next afternoon, I received a message from Steingarten's New York office telling me they'd waited all day for a verdict.

"Pop singer Jimi Hendrix was acquitted here Wednesday night on two charges of drug possession," read the United Press International story from Toronto that went out on the wire to newspapers around the world.

A 12-man jury deliberated eight and a half hours before setting the 27-year-old singer free. He had been charged with two counts under the Canadian Narcotics Control Act—one dealing with possession of heroin and the other with hashish. Hendrix thanked his young fans for sticking by him. Some remained in the courtroom for nearly 12 hours Wednesday— the time taken for the final summations, the charging of the jury and the long deliberation. The trial lasted three days.

"When the verdict was read, Jimi's face just glowed," Henry Steingarten told me on the phone. "I wanted to hug him; he was a man all the way through it. Of course, the chicks and the creeps were surrounding him soon enough. What a life he leads!"

"Were the photographers still screaming *'Get him'*?" I asked.

"Horrible phrase," Steingarten said, agreeing with the disdain in my tone. "Well, they got him! There were photographers all over the place, TV cameras, reporters coming out of the woodwork. Jimi was very cooperative; he must have given the V-for-victory sign a hundred times after the verdict. All kinds of people literally followed him down the street until we could get him in the car. Jimi was their Pied Piper in that handsome brown suede cape of his. He cut quite a dashing figure."

I asked Steingarten if Michael Jeffery had surfaced and whether he'd offered to pay a portion of the legal expenses. "Not that I've heard of," he said, adding, "I find Jeffery a troubling subject."

I heard from Jimi in New York the day after Christmas. As usual, he had not returned to Seattle for the holidays. He told me about rehearsals with the Band of Gypsies, his latest musical concept. Mitch was taking time off in England. Drummer Buddy Miles had long been pushing to work with Hendrix, so Jimi, as he said, "got myself talked into agreeing" that Buddy would be part of the trio. Billy Cox would continue as Jimi's bass player. As he gave me the details, Jimi sounded unsure of himself; there was none of the usual sparkle and enthusiasm he usually displayed in speaking of his new music.

Neither of us brought up Toronto.

Drifting

THE BAND of Gypsies played four shows for concert promoter Bill Graham at the Fillmore East in New York on New Year's Eve and New Year's Day. The first performance was showy, sloppy, and lacking in substance. Graham jabbed at Jimi during the intermission, "You're all jive tonight. Can't you do better than this?" Jimi was taken aback and angry. His personal pride was on the line when he walked onstage for the second show. He offered up a highly focused virtuoso performance that held the crowd spellbound.

Jimi agreed to play at A Winter Festival for Peace, on January 28, 1970, at Madison Square Garden, which benefited and was organized by the Vietnam Moratorium Committee. The Band of Gypsies didn't appear until after three in the morning. The excited crowd, who had waited for him for hours, soon realized that Jimi was in no shape to play. He spoke offensively to members of the audience, became sick with cramps, and finally he walked offstage. It was an embarrassing disaster for Hendrix.

When I heard from Jimi in early February, he told me, "Devon hit me with some bad acid. I was out of my mind at the Garden." Personally and musically, he had nothing but cold words for Buddy Miles. I asked what had gone wrong with the Band of Gypsies. He said sarcastically, "*Mr.* Miles didn't hear the songs the way I did. It was all recorded at the Fillmore shows; you can hear for yourself if you want to buy a copy from *Mr.* Chalpin. He'll be releasing it for himself on Capitol, not Reprise, thanks to *Mr.* Jeffery."

Jimi was not usually a sarcastic person. He made an effort to cool down. He spoke of new song ideas. I usually enjoyed hearing about the songs he was working on, but tonight I didn't pay close attention. I was thinking about Chalpin and Jeffery.

Thus far Ed Chalpin had made far more money on Hendrix Records than Jimi had. Chalpin was shrewd; he'd made monkeys of Jeffery and all the lawyers involved. "Ed Chalpin," recalled a source involved in the negotiations, "was astute and tenacious. He was a master at wearing people down. Chalpin reminded me of a squirrel surrounded by acorns. When he found the one he wanted, he grabbed it and wouldn't let go." In two and a half years, Chalpin's actions had delayed some of the Experience's record releases, he'd received a handsome sum of money from Warner Bros. (ultimately charged to Jimi), released two substandard albums on Capitol, and now he'd struck gold. It was Jeffery's idea to give him the Band of Gypsies' live album. Then *maybe* he'd go away.

For years Chalpin had made a prosperous living releasing poor-sound-quality recordings, in cheap sleeves, often by unknown performers—cover versions of songs established artists had made famous. "He made deals around the world for you might call 'bargain-basement music,'" a New York distributor said. "The kind you find at truckstops, drugstores, little mom-and-pop stores, and the like."

Now on the latest *authorized*, however reluctantly, Hendrix album, Chalpin's name and his company, PPX Enterprises, would be emblazoned for the world to see, and he would collect the lion's share of the profits. It should have been a proud step up for Chalpin, scoring in the big leagues. But *still* he grumbled. Why did it have to be a live album? Why couldn't he get his hands on one of those big, splashy studio albums the critics raved about?

Jimi Hendrix and Ed Chalpin never appeared together in a courtroom in front of a judge and/or jury. Amongst others, Mike Jeffery did not want to take that risk. Jeffery preferred to keep his

client traveling, performing and recording so that he'd be able to pay hefty commissions and legal fees "off the top." Emotionally and intellectually, Jimi chafed at this disillusioning reality of his existence.

Jimi phoned me again in February. As before, there was *too* much on his mind this day. "*Two* children now," he said abruptly. He told me that he'd recently been given the news that he was the father of a son born several months ago in Sweden. I said nothing. What was there to say? I found it all terribly sad and screwed up, as I reflected on the small photo of a baby girl he'd shown me in 1969. She was, he said, the child of Regina Jackson, the young prostitute he'd tried to reform, to help, in the summer of 1966. "The little girl looks like me," he had said. "The eyes . . ." I had nodded. Whenever Jimi had brought up assorted personal issues, I usually just listened.

"Two girls . . . women I hardly know anymore," he went on. "But I *do* know them."

§

FOR MONTHS several well-known figures in the music business had been courting Hendrix to take over his management as soon as his contract with Jeffery ran out, in about eighteen months' time. One of them was the powerful promoter Bill Graham. Mike Jeffery became increasingly uneasy as Devon Wilson, on Jeffery's payroll as Jimi's "assistant" and Mike's informant, tauntingly told him about Hendrix's conversations with potential new managers. Jeffery had long put the pressure on Jimi; now he was feeling it himself. Music producer Alan Douglas, who was ambitious and knowledgeable about a variety of styles of music and musicians, was yet another thorn in Jeffery's side. Douglas had introduced Hendrix to, among others, John McLaughlin, a guitarist Jimi admired; lately they had jammed and recorded together. Douglas, according to Jimi, was "always full of plans and ideas for me; he's a big talker." He was a white man who affected the look of a black

man, complete with Afro hairstyle, goatee, and, often, deep tan. Mike felt threatened by what he perceived to be Douglas's influence on Jimi. Did Douglas want to be Jimi's manager? His producer? Or both? The usually cool Jeffery was heard screaming outside a New York club, "Alan Douglas is scum! I will *never* let him get his hands on Hendrix!" This in response to a surprised record-company promotion man who'd asked if Hendrix was hooking up with Douglas.

Douglas lived near Hendrix in the Village; his wife and her sister, talented in fashion design, had been involved with elements of Jimi's wardrobe for quite some time, as well as personally involved with Jimi. "Lately I've been thinking that I'm circled by wolves," Hendrix told me on the phone one afternoon, in reference to "Douglas and that whole little scene." He sounded somewhat disenchanted with the lot of them.

Jimi felt "brutalized," he said, by the tug-of-war over him as a business entity. Mike Jeffery had never made it a secret that he didn't want Hendrix playing with black musicians. Jimi was eager to play with Mitch again, and Jeffery was pushing to reassemble the Experience. Jimi told me that both he and Mitch had strong misgivings about working with Noel anytime soon. Redding's personal, financial, and musical lives were in chaos; as a result of his erratic behavior, he'd been kicked out of his own band, Fat Mattress. Chas Chandler had no further bright ideas for him, and he forthrightly said to Noel, "You need to get fit, man. The pills are affecting your mind. And lay off the booze."

Jimi soon told Jeffery that he wanted Mitch on drums, that Billy Cox would be playing bass, and that was that. Hendrix said he would not use the Experience name. "We'll call ourselves Gypsy Sun and Rainbows again." This was the band name he'd first used at the Woodstock festival. Jimi had worked with engineer Eddie Kramer for most of his recording career, since they met in London in 1967, but he indicated to me that he'd been increasingly feeling that Kramer was not on the same creative wavelength with him.

"With the new studio, I'd like to try out other engineers," he said. "Fresh thoughts. Fresh tones." Hendrix had studied recent expense sheets; the cost of being on the road was huge, with salaries and bonuses to pay for musicians and crew plus hotels, airfare, and transporting the stage equipment. Now Jimi was taking on new overheads with Electric Lady Studios, and it made him uncomfortable that so many livelihoods depended on *him*.

§

IT HAD been a hard, cold, dangerous winter for Jimi Hendrix, and the spring of 1970 proved little better. Jimi's first and only true home, the Greenwich Village apartment leased in the fall of 1969, was a vision to behold, for the most part personally decorated by him in an imaginative, tasteful Arabian Nights / Moroccan theme. Unfortunately, many of his guests were not as attractive as the décor. A growing stream of droppers-by, hangers-on, so-called friends, and Hendrix wannabes cluttered the sidewalk of West Twelfth Street, the genteel lobby, and the elevator at all hours of the day and night. Hendrix—like many new rock stars— often felt he was obligated to share his success, his private time, with his admirers. "Once you let 'em in, how do you get rid of them?" he desperately asked a New York police officer who showed up once to help throw out visitors who had overstayed their welcome.

There were also the drug dealers and drug "gifters," some of them members of New York high society, eager to feel hip and trendy by association. And there was Devon, hanging on as tight to Jimi as was possible. She was by turns beguiling and brazen, as well as a serious drug user and supplier and possibly a "narc," according to New York rock-scene insiders; when in a tight spot, she informed on others to avoid her own problems with the law. Jimi was drawn to her, but he had learned never to trust her for long. He had brought her name up to me on several occasions and admitted that it was a destructive relationship—"She has always

brought me trouble." He understood that to clean up his own act, he had to stay away from a list of people he had identified as "bad news." He made this clear to Devon when she dropped in unexpectedly, bringing two of the "bad news" crowd with her. Jimi'd just gotten home from the studio, and Devon and her friends were stoned; one of them fell heavily on a chair Hendrix prized and broke it.

Being in Hendrix's orbit was vital to Devon's sense of self-esteem. She cared about Jimi, but more than this she *needed* him. *Everyone* in New York whose opinion mattered to her *knew* she was one of Jimi's girls. She couldn't allow him to dump her. She decided to show Jimi she *could* get her act together.

The respected stage director Carmen Capalbo was rehearsing his concept of the renowned lyric opera *Mahagonny*, originally created by Bertolt Brecht and Kurt Weill in the late 1920s. It was to be staged at New York's Anderson Theater on Second Avenue, especially renovated for Capalbo's theatrical event. Devon excitedly told Hendrix that she'd won a small role in *Mahagonny*.

She counted the days until Jimi could see her onstage. Hendrix told me of what he viewed as a major creative revelation. "I've seen something so mind-blowing I feel like it could change my life! Incredible music! With sets and costumes! Can you imagine me creating something for theater?" he asked. "I mean, on Broadway and all?"

"Absolutely, Jimi. Absolutely!" It was fantastic for me to hear the old enthusiasm back in his tone.

He said that he'd met the director. "Mr. Capalbo told me he'd enjoy hearing any of my ideas. And I don't believe he thinks I'm an oddball or a drugged-out hippie," Hendrix said.

Jimi never mentioned Devon's stage appearance in this conversation; it was all about new creative vistas for himself.

Jimmy Justice—pianist, writer, composer, singer, and actor—was in the cast of *Mahagonny*. "We started rehearsing in February, and the show opened and closed in April after only eight perform-

ances," he said. "It was a shame, but that's the way the theater can be. Devon Wilson was among the beautiful girls who appeared as hookers in the show. She didn't sing or act; the hookers were part of the ambience, the setting. I was known for cooking up soul food and bringing it to the show. She said, 'Oh, my boyfriend would just love this food!' She asked for recipes and instructions. I don't think she'd ever done much cooking, but she was very proud of knowing Jimi Hendrix. 'I want *you* to cook for him,' she said. I gathered from what she said that he was disappointed in how she fixed the beans."

Jimmy Justice never did have the opportunity to cook for Hendrix; they would have hit it off, for the multitalented Justice was a graduate of Juilliard, the music school Jimi dreamed of attending. "Maybe he didn't really need school," Justice said. "I always thought of him as one of God's special children."

Hendrix told Mike Jeffery of his interest in creating a full-length musical play for the theater. "He listened, but then he changed the subject," Jimi said. Mike's interest was in keeping the reins tight on Jimi. His big lure—and he counted heavily on this—was Electric Lady Studios. Jeffery knew that Hendrix would give his time and interest to details of everything from microphone placement to sound baffles. The million dollars plus that poured into the studio were covered by large advances against Jimi's future royalties from Reprise Records. No lariat could be tighter than the one Jeffery had long spun around his once idealistic star. Mike called the shots, and Jimi's grand plans, visualized months ago in Los Angeles— all those "childhood dreams"—were vanishing like beautiful but fragile bubbles in the air.

Jimi appeared in Los Angeles in concert on April 25, 1970, again for a sold-out show at the Forum. This night several hundred young black men and women were on hand to check him out. I observed their curiosity and, gradually, their pride. This white folks' black rock star was something else! They cheered and jumped to their feet, joining the entire rocking arena, and they applauded

the musician whose records seldom received airplay on black radio stations. "He's somethin'," I heard a thirtyish black man tell his wife. "We'll buy an album or two tomorrow."

Where Jimi really didn't cut it was often with older, respected black guitar players. They found him "too flashy," and they weren't sure exactly what it was he was trying to say with his guitar or in his songs. Los Angeles record producer Denny Bruce worked with numerous talented black musicians; he heard their comments about Hendrix. "There was *resentment*," he said. "Jimi was one of a kind, making money from the white audience. Some of the guys felt he was an overnight success, that he hadn't paid his dues, and here he was making a bunch of money, riding in a limousine and all that."

"Your own can be so cruel," Jimi had earlier said to me about his struggling days and the jealousy and lack of encouragement he felt from many other black players. B. B. King was a notable exception. "I knew him just a tiny bit before I went to London," Jimi told me. "When our paths crossed again, and I was doing good, B. B. gave me a guitar. That meant something to me."

§

HENDRIX CALLED me several times when I was out on interviews; we played phone tag in vain. "He wants to know what you think of the Crosby, Stills, Nash & Young album," my answering service informed me in one of the messages. "He's crazy about it. He said to tell you, he's looking for a good tape recorder for you."

Jimi, Mitch, and Billy played two shows at the Berkeley Community Theater near the end of May. Berkeley was directly adjacent to San Francisco, Jimi's turf since 1967. Between the early Bay Area fans and the college kids at the University of California at Berkeley, "Hendrixmania" was in full throttle for these gigs that were recorded and also filmed. In the course of the evening, Regina Jackson turned up to speak to Jimi about financial support for their daughter; they ended up having a serious conversation in a rest-

room away from the curious and baleful gaze of Devon, who'd begged Jimi to let her come along on this California run. Regina would never forget "how handsome Jimi was in his black leather suit."

On June 20, I went to see Jimi at the Beverly Rodeo Hotel. I'd been hearing stories about Jimi and drugs that made me sick at heart; they revolved around his snorting cocaine and heroin with Devon and her pals. On this occasion Hendrix was staying in a small suite, not his usual penthouse accommodations, and he, Mitch, and Billy had arrived only minutes before.

I tapped lightly at the door and said my name. Jimi opened the door for me to enter but said nothing at all. Ignoring the fact that he looked exhausted and had probably gotten little if any sleep before they left New Mexico early that morning. I stood there and just sailed into him, loaded with righteousness. "It kills me to have half of New York City calling me about the kind of dope you and your so-called friends are into. Snorting away and then talking about how *spiritual* you are. What a load of bull!"

Jimi's eyes went from tired and dull to angry. He backed toward a sliding glass window, placing his hand on a wooden chair, and he looked as though he was contemplating flinging it at me. Jimi was one step away from raising his fist. "Don't make me act like a fool. I have to get some sleep," he said. As I moved away from him, I asked him if he'd read the letter I'd sent to him in New York—a letter of encouragement, expressing faith that he could and would turn his life around. He looked at me like he didn't know what I was talking about and said again, "*Don't* make me be a fool!" I'd never heard this semithreatening tone of voice from him, and it angered me. *He* angered me.

"You *are* a fool," I snapped, "Whatever happened to that common sense you supposedly believe in?" He had never experienced cruelty or contempt from me before.

Jimi moved closer, looked me straight in the eye, and said, "Fuck you! Get out of here!"

I headed for the door, his words ringing in my head. This was not the Jimi I knew. I did not want to know this person.

§

HENRY STEINGARTEN phoned me to say hello when he traveled to Los Angeles on business. "I suppose you've been talking with Jimi," he said dourly. He was down on Hendrix, telling me that Jimi didn't show up for serious meetings that were important to his best interests, or else when he did, he soon left the meeting or closed his eyes and said nothing.

"No, not lately," I lied. I didn't want to admit to our ugly confrontation.

"He is simply not acting like a responsible adult," the attorney told me. There had been times when Steingarten would affectionately say, "Jimi's on the ball this week." Now his lawyer seemed to have lost just about all respect for Hendrix. If he walked—and I figured it wouldn't be long before Steingarten did just that—Jimi would be more vulnerable and troubled than ever.

I poured all this out in the regular airmail letters Jack Meehan at the UPI London bureau and I exchanged. Jimi and Meehan also communicated from time to time. Jack may have been fifty, which seemed ancient to me and everyone I knew, but he was intelligent, kind, and insightful. We discussed everyone from Marianne Faithfull to Jim Morrison to the Stones and the Jefferson Airplane. Jack sent me a telegram urging me to "be patient with Jimi. Don't walk away from him." I felt that I already had.

Little more than a week after our confrontation at the Beverly Rodeo Hotel, I received a late-night phone call from Jimi. At the sound of his voice, I wanted to hang up on him, but he sounded earnest and clearheaded, so I listened. The words "I apologize . . . Please forgive me" were repeated many times. He was trying so hard, but it was torturous for me to hear him actually plead. He told me that he had returned to his New York apartment, "and I dug through all the stuff that was piling up. I found your letter!"

Jimi said, "It means so much to me. I read it carefully, and I will keep reading it." He sounded truly contrite and sincere. "I'm not stoned, in case you're wondering," he said. I asked him why he was on his own this night. "Because I *want* to be," he said. "I'm trying to make changes. Can't you tell? I am *really* trying. . . ." His voice trailed off.

I waited for more, but he said nothing. I was very quiet against this . . . this background of his constant internal chaos. All the juggling of his problems. I felt how desperate Jimi was, trying to hold on to himself. Finally I said, so quietly that I could hardly hear my own voice, "*Your* life is very serious now. You can't let all the losers in your life bring you down." We were both crying. "So much light would go out of the world if something happened to you," I said. I could barely speak the words.

"I know. I *know*," he said.

§

WHAT I THOUGHT about when Jimi and I hung up was . . . money. I knew that he was concerned and embarrassed about the lack of financial support he could provide for the two children he believed to be his. His "personal" money in the last three years had been spent on clothes (onstage and off), loans to virtually anyone who asked, generous tips, and the funds his father asked for. He had bought, at different times, two or three Corvettes. He didn't own a home or property. Occasionally his limousine bill was out of whack, but a car and driver were also a form of security. Drugs were generally free, but not always. The bulk of his income went two places: into Electric Lady Studios and to pay thousands upon thousands of dollars in legal bills. With competent, honest management, most of those legal fees would not have been necessary.

In certain ways, no matter how talented or famous he was, Jimi Hendrix was a "black curiosity." The record industry in 1970 had a long and shabby history of treating black musicians dishonestly. It wasn't just white record labels that played it this way, but

also some black companies. It seemed to me that often black performers who were joyful in their music were punished and easily taken for granted—"Oh, he [or she] will go along with it. He's just glad to be working!" And here was Hendrix breaking ground as a one-of-a-kind artist, a *star* in the eyes of the white audience. Two different record executives in Los Angeles, one of them at Jimi's own label, had asked me at a party, "Do you think Jimi Hendrix knows how *lucky* he is?" I didn't know how to reply.

It was not much more than a year earlier that Jimi had been fun, whimsical, still idealistic, and full of ideas for his music and his life. I wondered when it would be like that for him again.

§

ON JULY 4, 1970, Jimi, Billy, and Mitch played the Atlanta Pop Festival, held down the road from Atlanta proper, in Byron, Georgia, during weather so sticky and sweltering that their show was moved from afternoon to midnight. One teenage fan, who had "camped out in the mud" at the Woodstock festival the previous summer and who'd hitchhiked hundreds of miles from Washington, D.C., to Georgia specifically to hear Hendrix, described the Atlanta performance as being "Jimi at his best. He was classy and focused. It was beyond thrilling to hear Hendrix play 'The Star-Spangled Banner' on the Fourth of July." Young people from throughout the south attended this three-day festival, which drew a total of about half a million people; along with Woodstock, it was the most impressive turnout of the "hippie nation" ever. Duane Allman, the inspiring and influential king of southern music, and the Allman Brothers Band played on both July 3 and 5. Hendrix regretted that the time frame did not permit a Duane-Jimi jam.

Seeing hundreds of thousands of people on their feet cheering Jimi as a great star that hot night offered a mighty redemption for the boy who had first played Atlanta as an unknown backup musician, sleeping in the cheapest motel and dutifully obeying the Colored Only signs.

All that summer in sporadic chunks of time whenever his gig schedule permitted, Jimi spent long hours in Electric Lady Studios. Working on new material and testing the studio sound, Hendrix unleashed his guitars in a hellacious frenzy, exploring the diverse rhythms and tones he heard in his imagination. As word spread about Hendrix's new hangout, admirers gathered outside 52 West Eighth Street hoping for a glimpse of their man.

Few of them had any reason to know that almost fifty years prior, down the street at 18 West Eighth, a comfortable, multistory, historic home, another graceful young man about New York had spent Saturday evenings playing his new compositions on the piano for an array of spellbound luminaries. His name was George Gershwin.

§

WHEN HENDRIX discovered Dylan, he made a point of learning about Dylan's own inspiration, Woody Guthrie. "He was a man who knew about suffering," Hendrix told me in 1969. "He had a rough life, in the Depression and all. Woody wrote hundreds of songs, and he sketched and drew cartoons. He died a couple of years ago. It all came from deep inside; I think he must have been a *genius*." It was one of the few times I ever heard Jimi use that word. In July 1970, unexpectedly Jimi sent me a copy of some words by Woody Guthrie:

> I am out to sing songs that will prove to you
> that this is your world
> and that if it has hit you pretty hard
> and knocked you for a dozen loops,
> no matter how hard it's run you down,
> and rolled over you,
> no matter what color, what size you are,
> how you are built; I am out to sing the songs
> that will make you take pride in yourself
> and in your work.

In the same envelope, Jimi had included copies of several business contracts and pertinent documents. No note was attached. I figured he saw this assortment as representing warring factions in his life—pride versus business.

That summer Lonnie Youngblood met up with his old friend from the early days in New York. Lonnie remembers that Jimi wore a serious expression on his face. "He was famous; he had some money and a bunch of worries. Jimi told me, 'Man, I have got to make some changes. The music isn't going where I want it to go.'"

Chapter Eleven

Purple Haze

"Is it tomorrow, or just the end of time?"
—*Jimi Hendrix*

IT HAD been sunny and warm in San Diego, where he, Mitch, and Billy had enjoyed their concert, almost as much as the fans, but when Jimi flew into Seattle the next day, on July 26, he felt shivery and cold as a strong breeze kicked up. Well aware of how changeable the Seattle weather could be, he had misgivings about playing in the outdoor Sicks' Stadium. Jimi felt certain it would rain. Slowly the sky turned gray, and so did his mood.

Sammy Drain, his boyhood friend and fellow guitar freak, recalls, "It rained that night at the show, and there were electrical problems. It was dangerous. I saw Jimi at his dad's house after the concert. He kept saying, 'Sammy, it was a bummer . . . a *bummer.*' I told him, 'You played your ass off!' Jimi was the kind of guy who, no matter how well he played, he always felt it could have been better. I showed him my new car, and he said, 'Man, that's a nice car!' He told me about his white Corvette. . . . He was restless, though. I got the feeling then that something else besides the gig was bothering him."

§

JIMI CALLED me a few days after the Seattle show, from Hawaii. We spoke briefly of the film interviews that had taken me out of

town on location. "You've been busy," he said. "Me, too. We did a show in Honolulu, and before that I was playing my guitar between two craters—old extinct volcanoes, you know—in Maui," he said. "We did two shows there, and now there's all this commotion and blah-blah-blah about this *Rainbow Bridge* movie Jeffery's suckered me into." We had talked before about Michael Jeffery's desire to become a film producer and how Jeffery was pulling strings at Warner Bros., using the Hendrix connection to float the financing. "I have mixed feelings about this movie," Jimi said. "It's kinda weird, to say the least. Hippie-dippy and blah-blah-blah. It's not like a *real* movie. Mike's pouring on the charm and acting super palsy-walsy. He rented me a nice house here, and it's a beautiful area. They're filming away, and I'm in bed recuperating, and I wanted to catch up with you."

"Recuperating from *what*?" I asked.

"Well, I was out in the ocean, and I cut my feet on jagged coral. Man, it hurt! Stings like you wouldn't believe. I finally had to go to a hospital and get treatment. They brought out one of those big needles that has always scared me to death since I was a kid to clear up any infection. The doctor told me, 'Go to bed and stay there.' I'm feeling pretty wobbly. But I've been thinking a lot. Been reevaluating, as you always say."

Hmmm, I thought. "That's good, isn't it?"

"Reevaluating is painful!" he said. "I've been taking a hard look at Jeffery, at some of the hustlers that come 'round, at my father, even at myself."

His tone indicated that this was to be a serious conversation, and I wondered what exactly had triggered it.

"You know those two little children I told you about? I showed you that picture of the baby girl. I'm going to have to do something about them—do right, get involved, you know. I *can't* have babies growing up the way I did. Quite naturally, I need to meet them, support them."

"I understand."

"This has been in my mind a while, and when I was in Seattle last month, things happened, things were said. . . ." He was suddenly silent. At first I thought the telephone connection had been broken. But he plunged in again, his voice low and troubled. "There was a lot of food at my dad's house, a lot of people, old friends, relatives, people I'd never heard of come to look me over. Dad and his wife, the Japanese woman, had pictures of me on display, a poster and all that. They were just groovin' away on the fame riff. Then, at this certain point, my father got on me about money and was wanting to know about my business situations. The only thing he knew about Mike Jeffery was that the office was where he called when he wanted money. Quite naturally, I can assure you if I can't make sense of all these damn messes, how the hell could he? It would take a thousand years to go over all that."

"So much for rest and relaxation at home," I interjected.

"Exactly," Jimi said. "*Exactly!* Do you know that he came right out and asked me what I was doing about a will and about him being the beneficiary? How old am I? Twenty-seven, right? He's twice my age, and he wants to be the beneficiary?" He stopped, sighed a long sigh, and got to the point: "I guess they all want me to die."

These words stunned me. "No, Jimi, no! He just got a little carried away. He didn't mean it like that." I found myself actually defending his father, whom I didn't know at all, and trying to smooth over this painful family situation.

"No!" he said. "You're *wrong*. This was *serious*. My father meant every word, and he even had someone else work me over, ask about my assets and all that bull. Giving me the old routine about how much my dad had done for me. Hah! It was a bad, bad scene, I'm telling you. I couldn't wait to get out of there!"

It wasn't the first time he'd told me his father equated his music with money and lots of it. So *this* was what was bugging

him. He felt disrespected, but I didn't want to hear any more, because there was nothing I could do about it. "Jimi, as you like to say, it's all hogwash!"

"Hogwash!" he echoed. "Yeah, that's what it is. . . ." He laughed, but it had a bitter ring.

§

HENDRIX LEFT Hawaii for the steamy heat of a New York August. He called to tell me that Electric Lady Studios was shaping up, offering details of new microphones and technical ideas he was excited about.

"You must be just about the only rock . . . uh . . . star that I can think of who has his own studio," I said, immediately feeling awkward because I seldom used the word "star" to Jimi, who never referred to himself like that.

"If Ed Chalpin has his way, I won't have it for long. He's filed *another* lawsuit against me. There are times when I feel really great about the studio. Other times it scares me. I can't really afford it, and being tied to the studio, quite naturally, means being tied to Jeffery. We're going to England for the Isle of Wight, and you know it'll be a drag. Festivals," he said disgustedly, "they're a joke." Once Hendrix had deeply believed in the "peace, love, and music" slogans of these mass rituals; now he was disillusioned, viewing them as "money trips" that rewarded the promoters more than the audience. At the same time, he ruefully admitted, "I have to be on my own money trip. To pay salaries and a million other things and blah-blah-blah. Am I boring you? I'm boring me!"

I told him that I would be taking my usual vacation in England and France. "I was thinking about going to the Isle of Wight, but, Jimi, you don't make it sound worth the effort."

He debated this momentarily. "You'd probably have a better time if you were in London. Maybe we could just send the band to the gig and we could go to the movies and eat popcorn!"

I giggled at the thought and said, "Only if you do the gig first, so you have enough money to pay for the tickets."

"I'm going to be on the spot at the Isle of Wight." His tone made it sound like a true dilemma. "I wish I had something more special to play. They're expecting a hot new band; it's just not *there* yet. I *can't* say that in an interview. I just read a letter from Les Perrin about all the publicity the promoters want me to do. I don't like sounding—*being*—phony in publicity."

"Stop whining, Hendrix!" I said, trying to cheer him up. "The English press has always loved you; they've been the best friends you could ask for. They aren't going to tear you into pieces. You're *good*! Have you forgotten that?"

We agreed that we'd each give Les Perrin our various phone numbers in London. "Get Les to tell you where I am, and call me as soon as you get there, okay?" Jimi said. "You won't forget?"

"I won't forget."

On August 26, 1970, Hendrix attended the party to celebrate the official opening of Electric Lady; the guest list was a melange of press, musicians, friends, and so-called friends. "Eddie Kramer had suggested that we serve sushi," Pat Costello remembers. "This was unusual in those times, and people enjoyed trying it that night. The guests loved touring the studio and were excited to see Jimi up close." One of those guests, a fan/photographer known as "Clicker," said, "It was a good party, but not great." He recalled that Hendrix seemed to be avoiding Devon Wilson. "He acted like he was afraid of her."

Although Jimi could have stayed another hour as the center of attention, he chose to leave early. He had a limousine waiting outside on West Eighth Street to drive him out to JFK Airport to board the British Airways flight to Heathrow. Eric Barrett, his favorite roadie and guitar technician, felt honored to be asked to accompany Hendrix.

Almost four years had elapsed since Jimi, then a virtual

nobody, had flown to London for the first time. On this August morning in 1970, soon after he arrived at Heathrow, he declared, "No one can ever understand what England has meant to me. Everything has happened here. So many good things!"

§

NO SOONER had I arrived in London than I received a call from the Rolling Stones' office—could I drop in at Maddox Street and see Mick Jagger? I knew the Stones only casually, mainly from encounters in Los Angeles, where Les Perrin had asked me to be friendly and helpful to the clients he treasured. Les knew how much I loved their music. In an atmosphere of controlled chaos—deliverymen calling up the stairs, stage costumes being inspected, telephones ringing nonstop, and rock music blaring on the stereo—Jagger was as bright and amusing as ever. He bowled me over when he asked if I would consider joining the Stones on their imminent European tour; Les Perrin wasn't feeling well enough to accompany them, and Mick needed a combination trouble-shooter / press liaison on the road. These days Jagger was not only lead singer and cowriter for the band but now also manager and tour producer, clearly thriving on a range of responsibilities. To be lounging in a big upholstered chair in the actual office of my favorite band, listening to Jagger pour on the charm, felt amazing. The idea of seeing the band rehearse and do a series of warm-up shows in Denmark, Sweden, Finland, and Germany seemed too fabulous—or "fab" as we all liked to say about anything groovy or cool. I hesitated; this opportunity would leave me no time for the true vacation I desperately needed. Jagger continued to be ingratiating. "We're flying out from Heathrow in two days," he said. "Sharon, I need you. *We* need you. Please come with us."

"I'd love to do this but—"

"Eventually we'll move on to Paris, and you won't believe how amazing it will be," he added temptingly.

"No," I said. "I really have to return to my job on September twenty-first." It was killing me to turn him down. "Give me a couple of hours to think. I'll ring you."

I set off on a quick shopping spree, because shopping was very much one of the reasons I liked to vacation in London, hitting Foale & Tuffin, Liberty, and Mary Quant on the run. Back in my room, I phoned Hendrix at the Londonderry Hotel, where he was doing wall-to-wall press interviews. "I've talked and talked and talked and let them take a zillion pictures," Jimi said. "You were right—they still like me! It makes me feel better to know that. Quite naturally, I'm tired and concerned about the gig. No rehearsal and all. A lot of questions about Electric Lady, though. That's tricky. I wanted to be honest and say I don't have any money and it's really Mike's studio. I'm just paying for it." He rambled on in the way celebrities do when they've talked with too many press people in too short a time. Finally he took a breath and said, "You're here! I *just* realized that you're in London."

"Yes, I am, and I'm thrilled, as always, to be here." I plunged in. "Jimi, I've decided to take your advice and not go to the Isle of Wight. It sounds *huge*, and I don't want to be caught up in a wild crowd going and coming. Anyway . . . uh . . . you probably know that Les Perrin is having some health problems, so I'm going off with the Stones on their tour for a few days to help out."

This got his attention. "You don't need to do that," he said.

"Well, I've never been to Scandinavia, so this is a good opportunity for me."

"Oh," he said flatly. "You'd better be careful." He didn't like it, and I didn't care.

I hand-selected each stem of a bouquet of flowers that I knew he would appreciate, tucked in a card full of good wishes for the gig, and had them delivered to his hotel. Two days later I joined up with the Rolling Stones and their mountain of luggage at Heathrow. Carefully placed on the heap was a charming toy box

with "Marlon" inscribed on the front. Keith Richards and Anita Pallenberg's young blonde son was a much-loved member of the Rolling Stones Touring Party.

§

"HENDRIXMANIA" WAS at a fever pitch on the Isle of Wight, where an unprecedented half a million fans from throughout the United Kingdom and Europe had camped out waiting for "The Man." Jimi was definitely, as he'd said, "on the spot" to deliver a strong performance.

Jean-Pierre Leloir, Jimi's French photographer friend, was there that weekend. "Jimi looked weak to me," he recalled. "He was thin, almost losing his pants. The sound from the loudspeakers was bad. I could see his unhappiness. He was not the strong guy I had seen before. Jimi did not have the same presence."

As Jimi had told me, he, Mitch, and Billy had not rehearsed for the festival. They opened their set with "God Save The Queen" and, despite sound and other technical problems, managed to sail, sometimes sloppily and at other times brilliantly, through such classics as "Spanish Castle Magic," "All Along the Watchtower," "Foxy Lady," "Purple Haze," "Red House," and, for old times' sake, the Beatles' "Sgt. Pepper's Lonely Hearts Club Band." At one point, in complete frustration over the sound situation, Jimi stepped from the edge of the stage far back to the rear of Mitch's drum kit, with Billy following his lead. The trio was practically joined at the hip in an attempt to tighten up and make it work. Through it all, the crowd rooted for Jimi, and they *loved* him then as they would forever.

§

AFTER ALMOST a week of the driving beat of the Stones' music and the usual petty jealousies and minidramas of the road, I was awakened from a sound sleep in my room at the Hotel Foresta in Sweden when the Scandinavian concert promoter, who was work-

ing with the Stones, telephoned me in the middle of the night. "Your friend Hendrix really screwed up at my concert in Århus," he said, his voice booming irately over the receiver. "He stumbled all over the stage when he could move at all. He was incapable of playing a full show. Incapable! I had to refund the money. I'll lose my shirt if he doesn't show up in Copenhagen. And his career will be over!"

Incapable? Oh, God . . . this word frightened me. Early the next morning, I quietly, seriously, and embarrassedly filled Mick Jagger in on my concerns. I felt uncomfortable and somehow disloyal speaking—oh, so briefly and choosing my words carefully—of Hendrix's personal business to Jagger, even though I knew that no one could understand it all better than he could. Mick made it easy. "Fly there today. You need to see to him. Don't worry about us. But don't stay long, all right?"

§

THE STONES' wonderfully efficient and good-hearted travel agent booked my flight and made a reservation for me at the Copenhagen hotel where Jimi, Mitch, and Billy were staying. As soon as I checked in and changed clothes, I took a taxi to KB Hallen, the concert hall, where the crowd was exuberantly filing inside for the show. The promoter had left a pass and a ticket waiting for me.

The door was wide open to the long, narrow dressing room; it was filled with pretty girls surrounding Jimi, who was sitting in a chair holding court at the rear of the room. I took two steps inside. Jimi's eyes widened, and he immediately stood up, moved forward, and threw his arms around me. He hugged me close. He kissed me warmly and then stood back to admire the new dress and high heels I'd picked up on my shopping spree. We were usually casual when greeting each other, so I had to assume that all this attention meant Jimi was happy to see me; it was the first time we'd been in the same room since the upsetting argument in June. The attractive Danish damsels appeared startled and curious to discover a

203

new ingredient in the mix. Hendrix looked thinner but fit enough. He was himself. This was all I needed to know.

"This is Sharon," he announced to the room at large. "This is *my friend.*" He sounded proud and sentimental.

"I've been worrying about you," I told him quietly, so no one else would hear.

Jimi's face softened even more; he was as touched by these words as if he'd never heard them before. "That's sweet," he said. He must have realized that I'd been told about the previous evening's debacle, and he added, "I'll be good tonight!"

I left him to return to his "distractions" so I could find my seat in the medium-size hall, which held perhaps four thousand people, before the show started. I appreciated a good stage entrance. All those fair-skinned, blond, usually laid-back Danes cheered and clapped in delight the moment they saw Jimi. He seemed the picture of health as he energetically covered the stage. Jimi played well, although it was not the band's greatest performance. Still, the people in the audience seemed to feel that they had gotten far more than their money's worth. At the drum kit, Mitch was as precise as ever, his face wreathed in smiles; he had just returned from a quick trip to London to see his new daughter. Billy Cox, despite recent stories I'd heard that he was not up to par, seemed in good form as he laid down the solid bass rhythms that had impressed Hendrix from the beginning of their friendship. The audience sat on the edge of their seats for the *big* Hendrix songs like "Purple Haze," "Foxy Lady," and "All Along the Watchtower." As at the Isle of Wight, Copenhagen simply loved their Jimi, ultimately content to listen to anything he chose to play. When he tired of the flashy, exciting showmanship, Jimi changed the pace and simply stood in place, a quietly dynamic presence, gently blending with his instrument. The roller coaster was back on track.

The only damper on an exhilarating evening was Jimi's concern for Billy Cox, his soft-spoken, unworldly former army buddy.

"He can't handle all this," Hendrix whispered to me when we all returned to the hotel. "It's too different from what he's used to." The confusion, the nonstop attention that permeated the Hendrix orbit, and all that travel to unfamiliar places—plus a dose of "bad" LSD in Sweden—had Billy acting very strangely. "You talk to him, okay?" Jimi asked.

While Jimi partied with his Scandinavian admirers, Cox and I sat quietly at a table in the hotel mezzanine, talking of the new Electric Lady recording studio and of his respect for Jimi. "He's a huge star *everywhere*, and he deserves to be!" Billy said. "I'm afraid that I'm letting him down. You know, there are people connected with him who *hate* me. They *don't* want me playing with Jimi. I don't want to let him down; I have to get my act together. But I'm not used to this crazy kind of life. I don't know how he stands it." He talked and talked about life on the road, then barraged me with questions about what the Stones were really like and what they thought of Hendrix.

At three in the morning, I finally returned to my room; it had been another long day. Six hours later I rode in a car with Billy in a small caravan of vehicles that included Mitch, Jimi, and his entourage on their way to the airport for the German leg of their tour. They were headlining a concert in Berlin and a summer festival on the German island of Fehmarn. As baggage was being checked, Jimi motioned to me to split from the group, and we strolled what seemed like endless miles of corridor in the vast Copenhagen airport. I was still clutching my passport as we walked. Hendrix gazed at it with surprise. "How do you keep your passport so *clean*?" He showed me his own well-worn, dingy passport.

"Simple, very simple. Every night," I said, "I gently clean it with a washcloth and mild facial soap, and then I put the hair dryer on low to daintily dry it."

He looked at me out of the corner of his eye, reflecting on this while I tried not to laugh.

"I just renewed it. My passport's brand-new!" I explained, and he chuckled, giving me one of his best wide smiles.

Spotting the gate to the plane that would take me back to Sweden and the Stones, I stopped, smiled up at Jimi, and said, "Have a good time!" I kissed him on the cheek.

"What do you mean?" He grabbed my arm. "Aren't you coming with us?"

I explained my situation. "They've come to count on me."

"How many Stones shows do you have to see anyway?" His frown became a glare.

"Hey, man," I declared, "I'm a free spirit!" I kept it light, but a part of me was thinking, Maybe you'd better change your plans. Go to these German gigs—you don't owe the Stones anything. Still, I stood my ground because I knew that I couldn't run Jimi's life or change it.

Abruptly, he inquired, "How's Keith?"

"Wrecked," I said. "He's messing with heavy dope. It's sad and worrying. Mick is very concerned."

Jimi sighed. "How are their shows?"

"Great! Getting tighter every night. Despite everything, Keith gets through the gigs."

"You won't stay on with them, will you?" he asked. "Didn't you tell me you had to go back to work soon?"

"I'll be back in the L.A. office on September twenty-first. I want my paycheck!"

He laughed. "Good! *You* deserve better than the road. Don't get too involved with those Stones. I'll come and see you in Los Angeles, okay? We'll go to the movies!"

We just stood there. He kissed me. "A free spirit . . ." he said. "Shucks!"

Breezily, I told him, "See you when I see you." Then I hurried over to the check-in counter for the flight to Stockholm.

§

I LOVED LISTENING to the Rolling Stones tune up in the dressing room, loved standing in the wings or sitting out front at the shows. Their high-energy music was the reward for urging a hotel restaurant to stay open after midnight so Keith could tuck into crêpes suzette, "properly flamed," and for sorting out requests from the long list of self-important reporters and photographers who "must have" time with "the boys." It was difficult to leave, but real life beckoned. After a very late night, I yawned my way to the airport in Hamburg and flew to Paris for a four-hour whirl seeing art, friends, and shops. The traffic was treacherous on the way back to Orly Aiport. I flew over to London; it had been a busy day, and I had four more of them planned before I jetted home to Los Angeles.

It was impossible not to be in high spirits in London on this Tuesday summer night. I dropped my luggage at a friend's home, and we journeyed back down Highgate Hill to Ronnie Scott's, the renowned jazz club on Frith Street in the heart of Soho. It had been some time since Eric Burdon, former lead singer for the Animals and these days a resident of Los Angeles, had performed in London, and here he was with his hot new band, War, ready to show his old mates his "new thing." The first set was loud and exciting. After the show Eric introduced me to his parents; they'd come all the way down on the train from up north in Newcastle-upon-Tyne.

The Burdons were an unpretentious, exceedingly kind and down-to-earth couple who adored the rambunctious young man they constantly referred to as "our Eric." It was difficult to hear their soft, thick Geordie accents in the crowded, noisy bar area of the small club. A lovely camaraderie floated in the air, and since I'd seen Eric and War numerous times in Los Angeles, I was convinced that all of London would be impressed by their music and that Eric, with his powerful voice and stage presence, would be back on top once more. The large turnout proved how ready the music industry was to root for Eric, and I assured Mr. and Mrs. Burdon that this would be a memorable week for "our Eric."

A sudden elated buzz whipped through the club that "Hendrix

is here!" I knew this couldn't be true, since Jimi's band was still on tour. Everyone at our table turned around to see, and there, a few feet away, just inside the door, was the back of a tall figure wearing a distinctive cape over his shoulders. A heavily but perfectly made up, expensively dressed, foreign-looking woman was at his side, her face glowing with pride as she clutched at his arm. Jimi moved slowly, as if in a daze. I rose to speak to him, and it took him a long moment to realize who I was. I actually had to explain—"Jimi, it's Sharon." His face was ashen, and his brown eyes appeared exhausted and even frightened. Never had I seen him like *this*. "Sharon . . ." he said. "Oh, Sharon." He gazed at me, and he muttered, "*I'm almost gone.*"

This was beyond being merely high or out of it. Something very serious was going on inside Jimi. Something *terrible*. I didn't know what to say or what to do. The woman pulled on his arm, and I moved away.

Returning to my table in the bar, I grabbed my handbag and quickly said my good-byes. I wouldn't be staying for Eric's second set. I couldn't enjoy anything just now. I needed air. I needed to walk. I wanted to be alone. On the way out of the club, I ran into a reporter friend who worked for *New Musical Express*. Hendrix had canceled the rest of his European tour, he told me, because "there were problems with Billy Cox, and it freaked Jimi out. Jimi brought him back here to see a doctor, and now Billy's flown home." From my talk with Billy in Copenhagen, I felt that it all boiled down to the fact that he was a sensitive person who'd had enough of the constant circus around him.

I was amazed to receive a telephone call from Hendrix late the next morning, as I prepared to leave for an appointment. Neither of us brought up our encounter at Ronnie Scott's. Not that I didn't want to, but I couldn't get a word in edgewise. Jimi sounded jittery and angry. "I can't sleep. I can't focus to write any songs. This Chalpin thing is making me a wreck. I hear that he's coming to London any day."

"You've spoken to him?"

"Hell no. I'm sick of talking. What good has it ever done with him?"

Ed Chalpin was now suing Track Records and Polydor Records, who released Jimi's music in the UK. High Court proceedings were scheduled in a matter of days. Jimi expected that he would have to testify, and he feared that the legalities would drag out and likely get in the way of allowing any new music to be released until Chalpin had put all concerned through the wringer and fought for every possible financial advantage—once again. Artists—*great* artists, in whatever genre—need and feed on a creative climate. For me it always seemed to come back to Mike Jeffery's lack of genuine, day-to-day respect for his artist. Weren't *managers* supposed to nurture and protect their clients? But I did not want to mention Jeffery's name to Jimi now.

He brought it up as if reading my mind. "Michael Jeffery told me from the beginning he'd handle it, but he's selling me out. Five years later and that fucking Chalpin is still hounding me; I get sick every time I hear his name," Jimi said. "And Alan Douglas's flown in from New York; I don't need his hustle at all. Devon's here, too. I *told* her not to come. Everyone wants something, all of them cluckin' over me and at me. They think they own me!" I heard a crashing noise in the background as Jimi flung furniture around. I had seldom heard him curse, but now he was letting the four-letter words fly. He seemed completely undone. On overload.

"Stop it!" I said, abruptly reminded of those old childhood warnings he'd told me about: *"Don't make a fuss. . . . Don't get in the way. . . . No sassing from you."*

"I'm *so* sorry," he apologized. There was a long silence, and finally he said, "I just need to find some peace of mind."

"I pray that you do, Jimi." Fighting tears, I told him I needed to get off the phone.

"Call me later," he said, "at the Cumberland. Okay?"

"Count on it," I said.

209

"It seems that all hell is breaking loose for Jimi," Jack Meehan, my UPI colleague, said gravely as we lunched at Wheeler's two hours later. I recounted my eerie encounter with Jimi at Ronnie Scott's, as well as his words on the telephone. The normally cool, calm journalist looked disturbed as he lit a cigarette. He told me he felt that if there was ever a time for Michael Jeffery to act like a concerned manager, this was it. I knew that Hendrix had spoken to Jack on the phone several times since they'd met in Los Angeles last June; they'd also exchanged letters. Jack had phoned Les Perrin at home earlier that morning. Les said he'd been told that Mike Jeffery was taking a holiday in Majorca. "I asked Les to try to get hold of Hendrix's tour manager," Jack said. "Somebody needs to keep a protective eye on Jimi. He's walking around in the middle of a nervous breakdown."

I wholeheartedly agreed. I had come to believe that, in part, Hendrix saw his friendship with me and later also with Jack as a safeguard; we were two rational professionals who knew what was going on. He *needed* others to know, and it meant a great deal to him that Jack and I talked with him in terms of what his life could be as opposed to what it was. Pat Costello, Jimi's friend and PR person, told me shortly before I left for England, "Jimi is being terribly manipulated, but hardly anyone realizes."

That night my Chelsea cronies took me down to Ronnie Scott's again to hear Eric Burdon, who now happily seemed to have picked up the momentum he had long sought. Energetic music didn't do much for me this evening, though. I felt exhausted and worried; once again I left the club early. Ironically, Jimi arrived there to jam with Eric and War shortly after my departure.

The next day's reports from "Hendrix insiders" were positive— "He was fine. . . . He played great." Yet I still had the bad feeling I couldn't seem to shake. Early that evening I telephoned Jimi at the Cumberland Hotel. The switchboard operator was a kind-voiced, trustworthy-sounding Englishwoman, who seemed to realize I was worried. "I'm concerned about him, too," she said. "He is such a

polite person, and he sounded upset this afternoon. He asked me to place a call to New York but, when it came through, he didn't answer."

"Could you send someone to check his suite? And call me back. And please not tell anyone?" I couldn't keep my voice from quivering.

"Of course, I will." When she telephoned, she sounded relieved. "Everything looked fine. He must have just gone out, dear."

I reported this back to the small circle of friends who were able to see behind the rock-star image, who cared about Jimi Hendrix the person. That night we all shared a great uneasiness. For the past year or more, we had anxiously watched Jimi stumble, pick himself up, stumble again in despair over the obstacles in his path. For us he had become a kind of Shakespearean protagonist, railing at and challenging fate, while a growing brood of greedy villains circled like vultures.

Watching the clock, we checked in with each other every hour, nervously jumping as the phone rang. I tried the hotel again and waited for Jimi to make contact. *Meet you at the Speakeasy!* or *I'm gonna jam again with Eric at Ronnie Scott's. Will you come down?* These were the words I needed to hear.

But none of us heard from him. At this point I held the heartfelt hope that this grim foreboding was only a trick of the imagination.

The next day, on the bright, blue, beautiful Friday afternoon of September 18, I strolled up Bond Street. It was just after one o'clock. The shop windows on this fabled street were bursting with luxurious temptations. This day, however, it was the corner newsstand that caught my eye. The afternoon papers had just arrived. I took a casual glance at the front page. A photograph of Jimi Hendrix topped by a bold headline: ROCK STAR DIES.

I froze in place. The roller coaster had arrived at its inevitable destination.

Chapter Twelve

Inside the Danger Zone

I WAS DAZED, and my legs felt wobbly as I wandered across Bond Street to the Westbury Hotel. I found a telephone in the lobby, fumbled for a coin, and dialed UPI's London bureau on Fleet Street. I didn't recognize the voice of the desk assistant who answered, but from my shaky "Hello?" he knew immediately who was on the other end of the phone. He called out for Jack Meehan—"It's Sharon!"

Jack's voice was quiet. "We've been trying to locate you all over London."

"Is it *true*? I just saw the headline on a newspaper. They come out so fast here, don't they?"

"Yes, it's true. We'll send a taxi for you."

"No, no. I'm fine. I'm just fine. Where is Jimi now?"

"At St. Mary Abbott's. Don't go there."

"I have to. Maybe I can do something."

Like Jimi, I hated hospitals. As I rode along in the taxi, I asked the driver to stop and buy me a box of matches. This elderly, white-haired man was kind, sensing I had a problem. When he returned, he lit my cigarette, and when the taxi pulled up in front of the hospital, he said he would wait for me.

"No, no, I'm fine," I assured him.

§

THE VENERABLE St. Mary Abbott's Hospital, a sturdy nineteenth-century building in the Paddington area of London, was busy with

births, surgeries, and deaths this afternoon, according to the nurse whose words I overheard as I walked quickly to the desk in the entry hall. "I'm a friend of Jimi Hendrix. I wanted to ask—"

I heard a woman speak to me, comprehending only some of her words, especially the part where she said, "He was dead when he arrived." The shock came in waves now; I didn't know what else I should be saying or asking. In the spacious reception area, I noticed two other staff members; they were coolly efficient, having already fielded many inquiries about Jimi in the past hour since news of his death was announced on television and radio. Now this tall, blond American in her bright red coat and would-be "dollybird" minidress just didn't seem to get it. "He's not here anymore," the tired-looking receptionist repeated. "He's gone. He really is dead."

Fighting against the shock, I slowly made my way to a telephone booth across the room. I wasn't quite sure who I wanted to call or what to say. Eventually it came to me that I should get in touch with Eric Burdon at his hotel. Did he know? It would be excruciating to tell him. Eric loved Jimi very much and understood him better than most.

There in my ear was that husky voice. "God, yes, I know. I've hardly slept. Girl, you'd better come here. You shouldn't be alone."

"I don't know what to do. It's terrible, isn't it, Eric?"

"Terrible," he agreed in his Newcastle accent, his "r"'s rolling with emotion. "It didn't have to be this way. That chick . . . Monika . . . rang me in the middle of the night, scared because he didn't look right. I told her to call the ambulance immediately. But she didn't do it." Eric's voice continued to tremble. "She rang up again later. . . . She still hadn't done anything for him. . . . She said she'd gone out for a packet of cigarettes. I screamed at her, 'Call the ambulance *now*!'" He was almost choking as he tried to hold back his tears. "It was too late."

"She went out for a packet of cigarettes," he said again. "She waited too long. . . . Oh, God . . . oh, God!"

Eric began to sob. Our beautiful Jimi . . . *gone.*

Sunlight rippled through the hospital windows, shining through the glass in the telephone booth and creating a glowing aura that seemed incongruous on this now unexpectedly ugly afternoon.

Rushing outside, breathing in huge gulps of air, I felt that I absolutely could not allow myself to dissolve in emotion. I *must* pull myself together. One thought kept pounding in my brain: We *have* to find out exactly what happened to Jimi in the hours before he drew his last breath. We *must* know the truth.

§

LONDON WAS quiet this Saturday noon. Jimi had been dead for twenty-four hours. The taxi moved easily down the hill from Highgate to the center of the West End; many shop windows along the way displayed large photos of Jimi Hendrix in tribute to a gifted human being the entire city and country had come to love and now to mourn. A wonderful honor; he would have been pleased to know this. Jimi had often talked about wanting to feel that his music got through to the "real people." These photographs today were one more indication he'd accomplished that.

Ahead lay a mission I dreaded. I was about to discover what had happened in Jimi's last hours. An accident? An overdose? Foul play? Eric Burdon had arranged for me to meet Monika Dannemann at the modest old hotel where he and War were in residence. In this black London taxi, I steeled myself for anything I might learn from the woman who had watched Jimi Hendrix die. I thought about the telephone call I'd received at my friends' home just before the taxi had arrived. An associate of someone who'd been present thought I would like to know that Jimi had joined a small gathering of men and women at a private home in London well after midnight several hours before he died and that Dannemann had picked him up in her car at about 3:00 A.M. I remembered Jimi's angry comments earlier in the week about

the so-called friends, both American and English, who were pursuing him in London. These hangers-on liked to feel they were always in the loop on all things Hendrix; whether he liked it or not, their lives revolved around him.

Eric's musicians filled the hotel lobby, surrounded by photographers and a motley assortment of press. I heard a shrill, demanding question from a reporter: "Tell us every word you remember Hendrix saying at Ronnie Scott's club!" I knew the members of War from Los Angeles, where I'd seen them in the recording studio and onstage with Eric. Mostly young and unsophisticated, they were unused to playing abroad, much less being caught up in the spotlight attached to the death of a celebrity they barely knew. The guys were vibrating with excitement and in some cases tripping on LSD, which Eric's creepy Hollywood comanager, Steve Gold, was handing out with sly, gleeful abandon. A couple of the members of Eric's band greeted me a little too warmly, seemingly interested in providing me with "comfort" I wasn't interested in receiving. Stupid jerks, I thought, as I pulled away. Don't they know death is final? It's not just another *gig*. I hurried to the elevator.

Eric's tiny room resembled a cell with a single bed. It felt dim and dull, with the beat-up old window shades half drawn. As much as I really didn't want to face her, I had been insistent with Eric that I must see Monika Dannemann. Within fifteen minutes a waxen blonde, dressed in black from head to toe, knocked at his door, accompanied by Eric's girlfriend. I recognized the blonde as Jimi's companion at Ronnie Scott's that past Tuesday night.

It turned out that she wanted to meet me, too. "I've heard all about you," she said in her German-accented English, ready to kiss both my cheeks European-style as I pulled back.

Her remark startled me. "Oh . . ." I said doubtfully.

"You're the writer, and you live in Los Angeles. I want to be friends with you and visit you in California."

Her words made me want to scream . . . curse . . . run! Friends? Jimi mysteriously dies in *her* flat, and the woman thinks of this as

a basis for friendship? I controlled my anger, aware that I must keep my cool to find out anything I could. Eric left the room. I sat on the edge of the bed, and she sat there, too, offering another smile.

Her demeanor puzzled me. No tears, no sense of grief. That morning I'd seen photos of a wan-looking Monika leaving her flat, gently supported by one of Jimi's roadies, plastered across the front pages of the London newspapers. But now she seemed almost upbeat. In the back of my mind, it registered that this was someone who craved attention.

"Tell me what happened Thursday night." I made an effort to sound calm, but inside I felt awful; this was *so* weird.

"We were very happy in our flat," she said. "We had such a pleasant dinner. I cooked. We drank wine. Not a lot. He sat at the table writing and writing. Finally I went to bed." This intimate little evening home alone didn't quite ring true; she hadn't mentioned that Jimi had gone out later. Since Jimi no longer drank much wine, I decided to follow up on this.

"What kind of wine did you serve Jimi?"

Monika hesitated, and her eyes changed. "I don't remember," she said.

"Exactly where did he die?" I asked.

"In my basement flat."

"Have you lived in London long?" I was curious about this.

"No. Jimi wanted me to be here, so I rented our flat a few days ago at the Samarkand Hotel."

"I'm afraid I've never heard of this hotel. It's not where Jimi was staying."

"He wanted to be with me. So I rented it especially for us. It's in Notting Hill."

It sounded dubious to me. He'd made a point of asking me to call him at the Cumberland Hotel. "What happened to him, Monika?"

"I don't know," she whispered, looking straight into my eyes,

and it seemed to me that this was one of the truer statements I'd heard from her so far. "I found him in the morning."

"*Found him . . .*" I repeated. "Did you talk to him? Was he conscious?"

She hesitated.

"Well . . . ?" I said.

"Sick was coming out of his mouth," she said, "and he was lying in it."

I closed my eyes for a few seconds to try to blot out this image. "Could he talk? Did you talk to him?"

"He couldn't talk," she said.

"But he was breathing?" I asked.

She didn't answer this. She became flustered and upset, saying, "I was frightened about what the press would say."

This was an unexpected remark. "The press?" I repeated. "How would they know? You were there alone with him."

I closed my eyes again. I found it tragic to know that Jimi had been uncared for in his last choking breaths on earth, while this self-absorbed person debated about what the press might say and how she would be portrayed.

"I knew Jimi wouldn't want them to know. I didn't know what to do. So I telephoned Eric Burdon." I already knew from Eric that she'd contacted him twice, that hours had gone by before Monika finally called for an ambulance.

When I attempted to pin down a time frame, Dannemann turned nervous and evasive. She threw herself into a speed rap about how she would paint a dozen life-size pictures "for my Jimi."

"*What* did he take?" I asked her.

Monika reacted with surprise to my question. Her mind seemed now to be completely focused on herself, on her anticipated career as an artist. She talked on and on about what Jimi had said about her work. "I will paint everything for him and exhibit my work for him all over the world." She was becoming excited—as if she were thinking, Bye-bye, Jimi; hello, Monika, the great *artiste*! She spoke

217

of Jimi as if he weren't a real person. Underneath that mask of makeup, she was *scary*. I feared that in hiding out from his so-called friends, Jimi had found himself in the clutches of someone ultimately more dangerous.

I couldn't fathom her self-centered crap in this totally surreal encounter, and I kept hoping Eric would return to the room; I didn't like being alone with her. Who cared about the damn paintings? Jimi was dead, and I wanted to know how and why. Didn't she feel some responsibility, or at least some interest, for why he went from very alive to dead in four or five hours? What the hell had he taken? Did she poison him?

It took steady probing to get the basic facts, to *force* her to piece it all together. "I have been a skating champion in Germany," she said. "I had an accident, then an operation, with much pain."

"*What* did he take?" I asked again.

"My prescription pills were in the flat."

"What kind of pills?"

"They are called Vesperax."

"Did you give them to Jimi? Discuss them with him?"

"No. He must have found them in the bathroom cupboard."

I knew I was getting most of the truth but not quite all. However, I did believe that Hendrix had found the Vesperax for himself.

"How many did he take?"

"I don't know." Monika began to cry.

"Pull yourself together," I said as quietly as I could manage, because I wanted to start screaming. "This is *serious*. How many pills did he take?"

"They came in a packet of ten. I had four packets. I had not needed to open them."

"How many are left now?"

Miserably she admitted that three packets remained intact and that she'd found an open packet on the floor.

"And how many were left?" I repeated.

"One . . . just one."

She stopped another trickle of tears to add, in a practical tone, "They're very strong. My doctor told me never to take more than half of one."

Nine pills. *Nine*—Jimi's number, the number he'd said was "very good or very bad." So he had deliberately taken nine. "Nine," I said aloud, soon wishing I hadn't. From her initial blank expression, it was obvious that this had no significance to Dannemann. Still, there must have been something in my voice or on my face that propelled her to suddenly become amazingly alert.

"This means something to you?" she said, getting excited.

"It was Jimi's number," I said shortly. She seized on this and kept at me until I briefly explained. I sensed that she was *too* eager to absorb anything I might tell her about Hendrix; this bothered me. I wanted *answers*.

"Now, let's get back to the pills," I said. "Have you given the police all the details you've told me?"

She shook her head.

"You must tell them every single thing," I said. "If you don't, I will."

"If you think I should . . ." Dannemann sounded hesitant.

"You said Jimi had been writing at the table. What did he write? Where is it?"

Monika rose from the bed. Now there was a smile. "I will show you." She left the room briefly and returned clutching three pieces of paper, obviously from a writing pad, approximately letter size.

"You are my friend," she said, handing me the pages as though presenting me with a great treasure. "This was the final thing Jimi wrote," she said proudly. "I found it on the dining-room table."

I read a long, slightly weird but coherent poem in his fluid, artistic handwriting. It began with *"The story of Jesus so easy to explain . . ."* and ended *"The story of life is quicker than the wink of an eye. The story of love is hello and good-bye until we meet again."*

It was wrenching to see that familiar, graceful handwriting for the last time.

I had already heard of this from a sober Eric Burdon. He told me, "Jimi left a long poem. When I went to the Samarkand the morning he died, I found three pages by the *bed*, and I called them to Monika's attention." So much for her dining-room-table discovery. In the last year of his life, Jimi had made a point of placing completed work in a burgundy leather portfolio for safekeeping, "so it won't get ripped off," he'd said. He must have wanted these particular pages to be *seen*. *These* pages were not song lyrics. There was nothing that Hendrix would have put on a record. They were the words—the musings—of a tired and troubled man.

So this was Jimi's state of mind at the end in the gloomy early hours of September 18, 1970.

For me, there could be no doubt of Jimi's intention, the choice he'd made. I thought back to several conversations about "number-nine days" in the past year. It was absolutely meaningful to him. I was certain that he had *deliberately* confronted fate, made a conscious decision. If the Vesperax pills—*nine* of them—didn't do it, then he wasn't meant to die.

Finally Jimi Hendrix had found peace of mind.

CODA

Whatever Mozart and Tchaikovsky have come to mean to lovers of classical music, Hendrix meant the same if not more to a whole generation.
—*Tony Palmer*, Observer, *September 20, 1970*

IN NEW YORK, Bob Dylan burst into tears when he was told that Hendrix was dead. An anguished Eric Clapton cried out, "No! Not Jimi. I wish it could have been *me*. Not *him*." The London daily newspapers ran Mick Jagger's reaction as a front-page headline: **I Am Shattered!**

Chas Chandler had traveled up north to Newcastle the day of Jimi's death; his father met him at the train station to break the news. Chas, like Mitch and Noel, suffered immense shock and pain. Dick Katz, Jimi's London agent, who so deeply believed that Hendrix's talent put him in the category of genius, said to me, "This is the greatest tragedy I can think of."

For Jimi's admirers news of his death was a landmark moment of grief and shock. Hendrix? No, the news reports couldn't be true; there must be a mistake. It was as if the sun had been ripped from the sky. *Impossible.* For weeping young people around the world, the loss of twenty-seven-year-old Jimi Hendrix on September 18, 1970, represented a cruel, crushing end of innocence.

§

IT WAS just after four in the afternoon when I arrived at LAX from London; my mother was waiting there to take me to her house to recover from my "vacation" before I resumed my job at UPI the next morning. When I checked in with my answering service, a deluge of messages greeted me—expressions of sorrow and sympathy, endless questions. "What really happened?" "Call me as soon as you get this!" voices urged. I was aghast when I heard a message about drummer Buddy Miles leading a movement to put Jimi's body on display at Madison Square Garden, with an admission fee to go to charity.

I debated calling Jimi's father in Seattle. I didn't know him. He didn't know me. Jimi, strangely, had given me the phone number last year when he was en route to Seattle to play a concert. I had scribbled it down at the time, never imagining I would need or want to use it.

A woman answered; I assumed it was Al Hendrix's wife, June. Quietly I told her that I was a friend of Jimi's, that my name was possibly familiar to Mr. Hendrix, and that I needed to speak to him. I was surprised to get through to this man. I knew that the world press must be attempting to reach him at all hours of the day and night. And now he was on the phone, mumbling, "Hello . . . hello."

"Mr. Hendrix," I said, "I've just come back from London, and I'm hearing some terrible ideas about what may happen to Jimi's body. Please don't let it be a circus. He was happy in England. I hope he can just be buried quickly and quietly there." I felt shaky and presumptuous.

Jimi's father grunted. Was this yes or no?

Suddenly his voice took on clarity and strength. He sounded almost perky as he asked, "Would you be knowing how much money there is?"

Perhaps Jimi would not have been surprised by his father's words, but they sent me into a tailspin. I stood there in my mother's

kitchen, clutching the phone, unable to speak. While Al Hendrix waited for an answer, I had nothing to say. Finally, delicately, I hung up the phone.

§

ON MONDAY I spoke with a sad, somber Henry Steingarten. He was one of the few with whom I ever discussed Monika Dannemann's actions during Jimi's last hours. Steingarten and I talked at length about my assessment of what had happened in Dannemann's basement flat that night. The lawyer had been in communication with Jimi on numerous occasions in the days and weeks before his death; he was privy to many of Jimi's concerns and thoughts, as well as aware of his despairing moods. Steingarten agreed with me that Jimi had made his own decision with regard to the nine tablets. "He took his own life," I said. "I'm convinced of that."

"Yes," he said. I heard and *felt* growing sadness and emotion in his voice. His words echoed in my ears for days—"That boy deserved so much more from life."

Billy Cox, still in the middle of his own breakdown, was fragile when I called him. "I feel terrible guilt about what happened to Jimi," he said in broken tones. "Maybe having me in the band added to his problems."

"This wasn't your fault, Billy," I said. "It had been coming for a long time."

"He really talked to you, didn't he? Jimi told you things," Billy said. "I didn't understand that when I first met you." He wanted to hear any word I might say about his friend. I felt compassion and concern for Billy; he had looked up to Hendrix since the day they'd met at Fort Campbell, Kentucky. Billy knew firsthand the former "Jimmy" and comprehended his friend's struggle as he marveled at his magic. Billy's sense of loss was huge.

"Nothing ever will be the same," Billy Cox said sadly as we

grieved together over the phone lines. "You respected him, didn't you?" he asked.

"I still do."

§

THE AMERICAN weekly record trade magazines, *Billboard* and *Cash Box*, traditionally were jam-packed with colorful full-page ads heralding the latest hot single, the new big-deal album. So a few days after the death of Jimi Hendrix, readers immediately noticed two unusual pages in the trades.

One full white page, bordered in black, bore a few lines of copy:

> To a black gypsy cat
> who rocked the world
> when it needed to be
> rocked Sleep well.

It was signed by the Monterey International Pop Festival. The other page said simply:

> Good Night Sweet Black Prince

At the September 28 inquest in Westminster, a noted forensic expert, Professor Donald Teare, offered the results of the autopsy he'd conducted a week earlier. The cause of Jimi's death was given as "inhalation of vomit due to barbiturate intoxication." A minor amount of amphetamine and cannabis were the only other drug substances found in Hendrix's body.

Coroner Gavin Thurston had no reason to believe, he said, that Hendrix had deliberately killed himself or was a victim of foul play. He had listened attentively to the words of Gerry Stickells, Jimi's tour manager, who testified at the inquest, "He was a happy man."

Thurston returned an open verdict, meaning there was "insufficient evidence" to be more specific as to why the death occurred.

Jack Meehan spoke with Dr. Thurston the next day for close to an hour, after going to great lengths to quiz other professionals about the credentials of the coroner. He told me that the coroner was "straightforward and well respected." Meehan said, "Dr. Thurston went into detail about the condition of Jimi's body and the contents of his stomach. He did not find needle marks or indications of long-term use of hard drugs. He told me a fair amount of red wine had been 'imbibed.' I found that strange, since I remembered from our time in Los Angeles Jimi mentioning that he didn't care much for wine anymore. Especially red wine."

A reporter for *Variety* told me he believed that Warner Bros. and Michael Jeffery held life insurance policies on Hendrix. "This is not particularly unusual," he said, "when it comes to high-earning 'properties' in the entertainment business. So they lucked out; a suicide verdict would most likely have invalidated the policies. No one at Warner wants to comment on it."

The funeral for James Marshall Hendrix, born Johnny Allen Hendrix, took place on the chilly afternoon of October 1, 1970, at the Dunlop Baptist Church on Rainier Avenue South in the "old neighborhood." Al Hendrix made the decision that the casket should be open, in an effort to show Seattle and the world that the rock star seemingly had died of an "accidental overdose" and did not resemble a ravaged drug addict. Jimi, the person his friends and his fans thought of as the most alive human being in the world, lay there very still and on display. How he would have *hated* to be viewed by anyone in this state.

Although one of Mike Jeffery's staff had telephoned me about attending the funeral, rather jauntily collecting RSVPs, there was never a thought in my mind about being present. I had already paid my respects to Jimi when he was alive.

It was a terrible occasion for Noel and Mitch. They were young and brokenhearted, clutching each other's hand. Their unique bond with Jimi, their love and admiration for him, would last

forever. "I can always count on Mitch," Jimi had often said, and now here Mitch was while the real Jimi had flown away.

§

"WHAT A SHAME," Mo Ostin, the president of Reprise, Jimi's American record company, said to me in October during a talk in his Burbank office. "He was just getting started. Hendrix will sell a few more albums, but essentially it's all over." Ostin was a businessman, a realist, and I had no reason to doubt his assessment.

In London, Chris Stamp and Kit Lambert at Track Records, the label that had launched the Jimi Hendrix Experience, issued a very special maxi-single for Jimi's grief-stricken fans. The disk featured three of Jimi's finest performances—"All Along the Watchtower," "Voodoo Chile," and "Hey Joe,"—in a simple black-and-white sleeve. The cost to the fans was a mere six shillings.

That October I traveled to New York to write a story about a movie shooting on location in the Bowery, then an ugly and frightening area of the city. After I finished my interview, summoning up my courage, I took a taxi to the tree-lined historic street in Greenwich Village where Jimi had lived on and off for the last year of his life. Tears gleamed in the eyes of Phil, the deferential, middle-aged doorman, when he saw me. I'd met him just once before, but he remembered. "Mr. Hendrix was always so happy when you sent him those packages of records," he said. The tears now rolled down his face, but he was not embarrassed. "He was so good, and so many bad people came here," Phil declared. "As soon as those people from the office heard about his death, they came and took almost everything. You know, *that* office . . ." He was referring to members of Jeffery's staff. "Rummaging through his things. Terrible how people can be."

He asked me if I would like to visit Jimi's apartment one last time. I wasn't sure I could bear it. "We will both go," he said, escorting me to the elevator.

Now it was barren of the expensive stereo equipment, the colorful rugs, shawls, and Moroccan pillows. The array of electric and acoustic guitars had vanished, along with dozens of reels of tapes of his song ideas and jams. Sun poured into the empty space. I walked quickly through the simple, compact two-bedroom apartment and gazed out the windows at the quiet street. As I turned, something shiny caught my eye just inside the entrance to the small kitchen. In the last months of his life, one dream *did* come true: Jimi Hendrix had finally gotten that refrigerator.

Walking down Sixth Avenue, I had one more stop to make in order to put it all behind me. I stepped around the trash on the sidewalk of West Eighth Street, pausing in front of a sleek, newly bricked building. At the side of the steps leading to a sturdy door, a closed-circuit TV monitor guarded the premises. I identified myself into a speakerphone and looked up to see the door opening. In these moments I felt that to climb these stairs, to pass through that door, was like entering the gates of hell.

I stepped inside Electric Lady Studios and walked down a long, elaborate, muraled hallway. I had no idea exactly who was working at the studio and how I would be greeted, but someone obviously had recognized my name on the speakerphone. Suddenly the last person I would have expected to see appeared—Michael Jeffery.

He was pasty-faced, nervous, and subdued until, horrifyingly, I felt him embracing me closely. Jeffery became emotional. I stepped back. "*Why* did he do it?" Mike asked.

For once he sounded sincerely concerned about his late client. He tried to pull himself together and muttered away at me, not bothering to pretend that Jimi's death had been the result of an accidental overdose. It was a tacit acknowledgment of his suicide. I remained silent. Finally Jeffery rose fully to the occasion, returning back to his old self. "Jimi had so much to live for," he said.

§

IN FEBRUARY 1971, the sexy, treacherous, confused Devon Wilson, now deeper than ever into hard drugs, plunged to her death from a high floor of the Chelsea Hotel, located along a bleak stretch of West Twenty-third Street in New York City. The old redbrick hotel, with some four hundred rooms, has long been known for its bohemian atmosphere and arty clientele. Devastated by Jimi's death, Devon felt unshakable guilt about various ways she'd let him down, acknowledging to me in an unexpected telephone call in November 1970 that she had hurt Hendrix and taken advantage of him many times.

"Everyone knows the hotel had its share of druggies," a New York policeman said days after Devon's body had been taken to the morgue. "But this was a mysterious death. We could not pin down whether Devon Wilson had jumped or if she had been pushed."

§

WELL AFTER Hendrix's death, posters and black-and-white photographs of Jimi dotted towns and villages throughout Britain. I observed them in a variety of shop windows, in a tannery, in factories. These images stood as symbols of continued mourning, of "raising the freak flag high," of love and affection—poignant reminders that "our Jimi" was an honorary son of England where, as he'd often said, "so many good things happened for me."

In the late summer of 1971, I took a London train to the leafy pastoral area of Surrey, where Eric Clapton lived in a beautifully designed and decorated home, its graceful windows looking out on verdant views of handsome old trees and flower gardens. Hendrix would have admired this "dream house" and certainly would have been close to dumbstruck at Eric's collection of sleek Italian sports cars parked in the driveway.

Clapton's girlfriend, Alice Ormsby-Gore, slim, with long, wavy reddish brown hair and a pointed chin, greeted me warmly and, with great sensitivity, left Eric and me alone to reminisce about

228

Jimi. Clapton looked as handsome as ever, if one discounted his pale countenance and troubled eyes. He said softly, thinking over each word, "I can't believe that he's gone. When I heard the news, I begged God that it not be true. I wished that I could have died instead of him. I was heartbroken. Completely heartbroken." His gaze was so full of sadness that I couldn't speak. Grief was palpable in the room.

Eric sat on the edge of the sofa in the lounge, remembering the first times he'd seen Jimi and how he hadn't known what to think of him as a person at first. "His playing was so amazing that it scared me. I suppose there was some jealousy mixed up in it. We all felt threatened by him, and we were in bloody *awe*! I came to know him as clever and amusing, sweet and interesting, and above all totally caught up in playing music. I loved Jimi. I respected Jimi. It was always a thrill for me to hear him play. One could imagine knowing him for years and years and never being bored. Musically or personally." Eric was expressing his very soul, and I found this deeply admirable.

As dusk fell, I wanted to telephone for a taxi to take me to the train back to London, an hour away. Alice wouldn't hear of it, insisting that she would drive me through the twisting roads deep in the countryside and back through the traffic leading into the city. She grabbed a key ring from the kitchen counter and escorted me to the drive, where she helped me into a low-slung mauve Maserati. We roared off into the darkness in rock-star luxury and speed, pouring out our thoughts to each other—about music and men, love and fear.

Alice was no more than twenty, but she seemed wise beyond her years, and she was brimming over with love and concern for Eric, filled with compassion for his loss, *everyone's* loss. "One of my best memories of Jimi," she said suddenly, turning briefly from the wheel to smile at me, as though she were presenting a treasure, "was one December when we had the idea that he should dress up as Father Christmas, white beard and all, for a charity event for

children. He immediately agreed, and he was brilliant! Jimi was so sweet to the children, as intrigued by them as they were by him. I'll never forget that day ... never forget *him*. Jimi was a very lovely person."

Part Three

The Reinvention of
Jimi Hendrix

Someday you'll account for all the deeds that you done.
Well, there ain't no man righteous, no not one.
—*Bob Dylan*

Introduction

ALWAYS, JIMI HENDRIX'S priority had been his music. Now he was a dead rock star, and his sad December 1969 prophecy— "If anything happens to me, the lawyers will be fighting it out for the next twenty years"—was to take on an increasingly powerful and horrifying relevance.

Today, thirty-five years later, Jimi Hendrix's songs are still being played on the radio and eager customers continue to buy the records, now known as compact discs, from that fleeting and magical time of Jimi's almost four years of stardom. While today Jimi holds the title of "greatest guitar player in rock," he also stands as the greatest creative figure in contemporary music to be used as a battleground for greed—yes, the lawyers are *still* "fighting it out." His prediction turned out to be conservative.

This is how the aftermath of Hendrix's death has unfolded. . . .

Chapter Thirteen

1971–1989: The New Regime

IN TELEPHONE conversations Henry Steingarten found Al Hendrix to be quite unlike his son Jimi, and Al wasn't interested in hearing what Steingarten could tell him about Jimi's thoughts and decisions on a number of pressing issues. In the early seventies, neighbors on Seward Parkway South in Seattle volunteered information to me regarding Al and June Hendrix's very first trip together to New York City after Jimi's death. Each of them had donned—of all things—a cowboy hat. The couple was in a state of high excitement, clutching their free air tickets and declaring, "We're gonna come back rich!"

However, "rich" didn't happen fast enough for Al. He didn't like most of what Steingarten had to tell him, didn't want to hear about the claims against Jimi's estate, didn't want to hear that there was no will. Al Hendrix absolutely didn't want to hear about debts. He was not interested in whether Noel and Mitch were owed royalties for their musical performances with Jimi. Nor did he want to hear about a claim in the name of Tamika Laurice James, the young daughter Jimi had never met, or to be reminded that there was also the small son in Sweden to be considered. He was staggered to hear again that there was only a measly total of $21,000 in Jimi's bank accounts at the time he died. Al wanted "my way and my money," he told friends after his less-than-victorious return.

While Jimi Hendrix had strongly believed in and demonstrated

qualities such as justice and fairness, his father did not. Al's position was that since his son was famous, surely Jimi must have been a millionaire or close to it. It rankled him that despite all the pressure he put on Jimi in Seattle at the end of July 1970 about making and signing a will with Al as the major beneficiary, Jimi had not accommodated him. Al was terrified now that some other "claimant person" would walk away with *his* money.

It was Herbie Price, a well-meaning black man who briefly worked with Jimi as a self-styled valet during the filming of *Rainbow Bridge*, who told Al Hendrix about Leo Branton Jr., a Los Angeles attorney who had represented actress Dorothy Dandridge and silky-voiced singer Nat "King" Cole. Branton had also been an integral part of the successful legal defense of Angela Davis, the beautiful black woman who was involved in the late sixties and early seventies with the political group the Black Panthers, and who was once placed on the Federal Bureau of Investigation's Most-wanted list.

Branton was one of the first black attorneys to practice in Los Angeles and was well known within the judicial system of downtown L.A. A white colleague of Branton told me in 1971, "Leo's tall, terse, and he looks white, even though he's not. He could pass for white, but to his credit he hasn't done that. I seriously doubt that he knows or cares about rock and roll and today's music business."

I hoped that he did, because the late Jimi Hendrix via his father now appeared to be Branton's number-one client. The lawyer and Al Hendrix had quickly hooked up. Branton got rid of Henry Steingarten, threatening to have him disbarred. Al had told Branton, "Do what you want. Just be sure I see some money."

In the year before his death, two young black lawyers in New York City, Ed Howard and Kenneth Hagood, had made several overtures toward Jimi; they wanted to represent him. He mentioned this once to me in 1969 and twice in 1970. Jimi spoke with them at the persistent urging of a mutual friend "from uptown." "I told

JIMI HENDRIX

them a few things. I listened a lot. I didn't want them to think I was rude or uppity. Later I said to myself, 'Damn it all, you don't need to be getting hooked up with any more lawyers.'" He was talked into making a couple of appointments, which he later had canceled.

When it became known that Al Hendrix was now represented by Branton, Howard and Hagood contacted the lawyer to offer their services. Since, at the time of his death, Jimi was a legal resident of New York City, the Los Angeles–based Branton could use New York associates. Ed Howard became the estate's "attorney of record" in New York, and his partner, Kenneth Hagood, also received a title he had specifically requested.

On August 31, 1971, Kenneth D. Hagood, the "Administrator of the Estate of James M. Hendrix," filed a "Notice of Rejection" in the Surrogate's Court of the State of New York. Hagood took the position that the "claim or claims" of Noel Redding and John Graham Mitchell were "not valid debts of the Estate."

Al Hendrix and his new lawyers ignored the 1968 contract Mitch and Noel had signed with Jimi and dismissed them as "irrelevant." Jimi had discussed this with me in 1969, after Noel left the Experience, and he was fully aware that he was responsible for seeing that they were paid for each record they played on with him, including all agreed-upon royalties. "Noel, each of us, will always get our royalties as long as the records sell," Jimi said, and he added with regard to touring, "We agreed among the three of us when we put the Experience together that I would get fifty percent as leader of the group, and Mitch and Noel would get twenty-five percent each of all our earnings. We all paid toward road expenses, but I have paid most of that. Bonuses and stuff." It was not in Jimi Hendrix's nature to cheat and disrespect fellow musicians, much less his bandmates.

Further letters and pertinent documents from the Experience's London and New York accountants illuminating Jimi's words were also ignored.

The notice of rejection was devastating to Mitch and Noel personally and financially. "They are being treated as though they never existed," a New York concert promoter said at the time, "and neither of them has the money to sue." Nor did they have the heart to take on major litigation against the estate of their dead friend.

Al and June Hendrix expressed joy to their friends in 1971 when "two terrific things happened." His new lawyers arranged for him to begin receiving $600 per month on June 1, and a quarterly royalty statement from Reprise at the end of the year showed that a check would soon be issued in the amount of $323,622 to the "Estate of Jimi Hendrix." Although Al still clung to his million-dollar dreams, *this* royalty statement, he said, was the most exciting thing that had ever happened to him.

§

I'D BEEN in touch by phone and mail with Leon Hendrix after Jimi's death, sending him photographs and telling him how important he'd been to his big brother. In 1972, when I was on a business trip to Seattle, we met face-to-face. Leon, in his early twenties, had been discharged from the military and now was just one more young American man trying to figure out how to make a living and what to do with his future. He was eager to hear all I could tell him about his brother, and I searched my memory for every story, thought, and anecdote that Jimi had shared with me. I reminded Leon of a word game Jimi had invented for him, and he grinned happily as the recollection flooded back into his mind.

Leon continued to be impressed and proud that Jimi had "made it out," that he'd become a star. He spoke far more affectionately of his father than Jimi ever had to me, mentioning Al's failings, but in an accepting manner. Leon was polite and sweet, the sort of person you always wish well. He told me that Al's wife, June, didn't like him and that he felt she was fixated on Jimi's

money. Leon referred to her daughter, Janie, as "my younger sister," again with the boyish sweetness that seemed to be an integral part of his personality. From time to time after this meeting, Leon wrote and phoned me, sometimes collect, to ask for advice or feedback.

In London I had been shown a short and charming film showing Jimi sitting on a tall stool playing a bit and speaking in that natural one-on-one way of his. At Island Records I met with a young Englishman by the name of Austin John Marshall, who had shepherded this film into completion. He spoke warmly of Jimi and explained that several people had contributed or loaned small amounts of money for the project. In passing he mentioned that record producer Joe Boyd was one of them. I knew that Boyd, an American, had produced Nick Drake, the Incredible String Band, and Fairport Convention, among others, and that he had recently moved to California, where he had an executive position at Warner Bros. Records in Burbank. I set up a meeting with Boyd, suggesting that Marshall's film be distributed throughout America as a kind of gift from Warner Bros./Reprise to the fans who mourned and missed Hendrix. "What I like about this film," I told Boyd, "is it shows the real, down-to-earth Jimi, the guy his friends knew. It's *him*. Not the overblown image. Wouldn't it be great to release it in America, charge a minimal fee, and give it all to charity in Jimi's memory?"

Boyd asked me to attend a meeting at Leo Branton Jr.'s office on lower Wilshire Boulevard near the Ambassador Hotel. Noel Redding, who had arrived recently in Los Angeles, was supposed to accompany me to the meeting—which already had been changed three or four times—but he was feeling nervous and insecure, and he chickened out, saying, "Please do your best for us, love."

Branton's office was drab; he was wearing a brown suit that matched his brown furniture. His firm appeared to consist of just him and his secretary. We discussed the documentary. Branton seemed enthusiastic. I mentioned Noel and Mitch's royalties and

wondered when they would be paid. Branton humored me by listening, but he didn't comment. I told him something along the lines of, "If you want them to appear in the film, I'm assuming they'll need the money they're owed. It costs money to fly to Los Angeles and stay in a hotel, and they're not working. It's quite difficult when they've played with someone as special as Jimi to just go out and start over. Remember, the audience loves these guys and will want to see and hear them interviewed." This really was not my business, but no one had mentioned Mitch or Noel so far. Branton said of them, "They are completely irrelevant." I certainly didn't want to repeat that line to Noel. Meanwhile, Boyd, who'd spoken to Al Hendrix on the phone several times, made a couple of disparaging comments about him. Branton smilingly agreed. The last ten minutes of the meeting were focused on charming me. "The ball's in your court," Branton said. Boyd declared, "You'll be well paid." The only reply I made was to tell them that my parking meter would expire in two minutes and that I needed to leave.

One of the dictates Jimi had offered to me on one of his "self-improvement days" was *"Never* assume." It took me quite a few years to get it.

Joe Boyd had produced good records by "sensitive" artists, so I just *assumed* that he would see the common sense behind my idea and that of course he would wish to pay respect to Hendrix. It never occurred to me that my simple concept was soon to become a full-blown documentary, with Boyd now envisioning his future as a movie producer. The charitable aspect of the film was gone with the wind, and when Boyd invited me to see some sample footage, I was distressed to view on-screen a musician and good friend to Jimi breaking down with emotion as a couple of the bozos working on the documentary chortled at the screen—"We'll cut some of this shit!" one of them said. Forget about seeing the "real Jimi." The reality I needed to face was that this now was officially "let's all cash in on Hendrix" time. The cast of characters behind

the scenes of this documentary loved the idea of making money and making movies; Hendrix was just the hot dead guy to get them off the ground. I got snippy and complained to Warner Bros. moguls while Boyd poured on the charm, phoning to invite himself to my apartment—"I'll bring a good bottle of wine, and we'll sit back and listen to those cassettes you have of Jimi talking." I turned down that offer, as I did the one that involved a six-figure fee for me to act as "consultant." I wasn't noble, just disillusioned.

Boyd's *A Film About Jimi Hendrix* received mixed reviews when it was released in 1973. It had brief moments that were interesting, moving, amusing. The best thing for Jimi's fans, of course, was the short sequence showing him sitting quietly on the tall stool and then later exploding into JIMI! onstage.

§

TWO YEARS after Jimi's death, in October 1972, Britain's *New Musical Express* printed the results of a poll of the world's leading guitarists. Jimi Hendrix emerged as the "undisputed winner," his peers' pick as "Number One Guitarist in the World." While Jimi was no longer physically present, respect for his talent had not died. Reprise Records was proud to announce to the record industry and the media that the new Hendrix *War Heroes* LP had garnered the top FM-radio airplay in America in its first week in December 1972.

Ron Saul, who coincidentally attended Garfield High School in Seattle, though not at the same time as Hendrix, became the head of promotion at Reprise during the last few months of Jimi's life. "We loved him dearly," he says today. "Jimi was the most incredible talent. I've *never* seen anyone like him; he was so far ahead of everyone else. Completely original." Saul recalls that he met Jimi only once and saw him play twice.

"Like so many, I was deeply saddened and disappointed when he passed away. I remember how weird and miserable we felt in the promotion of *Cry of Love*, which was released not long after his

death." Considered tops in his area of expertise, Saul, now retired, explains, "I felt very frustrated. At the company we loved our artists and worked hard for them. We were perpetually psyched up! Those were great days in the record business, and many times I wished so much that I could have done for Jimi what I—what we—did for other artists, that we could have experienced a shared pleasure with him in seeing another Hendrix record climb the charts."

§

NOEL WAS young, strung out, and scared about his future. He eagerly accepted the offer of a record deal with Natural Resources, a new "white" division of Motown. His English pal Les Sampson, a likable, enthusiastic young drummer, and an American guitarist, Rod Richard, only briefly in the band, were the components of Noel's trio, bearing the uninspired name of Road. He moved into a humble little rental in Hollywood, and my mother supplied him with good china and miscellaneous household goods.

Meanwhile, Mitch flew back and forth from England to the United States. He'd done some drumming for Jack Bruce and had now been talked into being part of a new American group called Ramatam, spotlighting a girl guitarist, April Lawton. Loyal Hendrix fans rushed to see Mitch's club appearances, but the band didn't last long.

Noel and Mitch had little communication, and I kept reminding Noel that it was important for them to present a united front if they were to receive the funds owed to them. I contributed to the cause in a variety of ways, involving time, money, and anguish. The New York lawyers Noel and Mitch knew from the old days were expensive and getting nowhere in their dealings with the Hendrix estate. So Noel retained an ambitious, relatively young Beverly Hills attorney, who came recommended by a friend at *Billboard* magazine. Noel asked me to explain that he could not afford a hefty retainer. Instead he would pay the lawyer's expenses,

including travel, and a fair percentage of whatever monies he might receive from Warner Bros. as opposed to the Hendrix estate.

Eventually Noel, his attorney, and I flew to London to meet with accountants and other pertinent parties on the quest for the mysterious Yameta money. Noel hoped that this Bahamian tax shelter would turn out to be his pot of gold. The highlight of the trip, if it can be called that, came when the three of us entered the antiques-filled office of John A. Hillman in the heart of posh Mayfair in London's West End. Hillman, who appeared to be close to fifty, politely and confidently played it cool, acting as though he were essentially unaware of who Noel Redding was, while I averted my eyes from Noel's miserable face and grimly admired the exquisite wood-paneled walls of this inner sanctum. Hillman was dapper in an expensive tailored suit. We all quickly comprehended that underneath the good manners, Mr. Hillman was a tough man and that while appearing cooperative, he would tell us nothing. This was Michael Jeffery's guy—Mr. Yameta.

Noel breathed deeply when we left. He was shaking like a leaf and clutching my arm. He'd held on to such high hopes that Hillman would be helpful to him. Noel's lawyer later managed to persuade Hillman to put him in touch with Sir Guy Henderson, still one of Yameta's "directors," and flew to sunny Nassau, billing Noel for the expenses. Henderson was as adept as Hillman in the charm department. Little was accomplished.

§

IN NEW YORK, Michael Jeffery's Electric Lady Studios were busy around the clock. Every artist, it seemed, wanted to make an album in one or the other of the two studios in the West Eighth Street building—among them Kiss, Lou Reed, Carly Simon, Deep Purple, and Led Zeppelin. If it was good enough for Jimi Hendrix, then it must be great! After Jimi's death Mike entered a brief period of seeming introspection and spoke of his interest in "meditation."

When it came to the problems of Mitch and Noel, however, he had no time for deep thinking or offering a helping hand. Both musicians were owed money—by Jeffery himself as well as Yameta Company Limited and Reprise Records. As ever, what Mike thought about was . . . Mike. Within eighteen months of Jimi's death, Jeffery was hunting down deals. He didn't need the money, but he missed the power, the pleasure of being a player in the scene. Record executives at several companies, among them RCA Victor, telephoned me to discuss several artists and groups Jeffery was attempting to sign to record deals. "He's really pushing the Hendrix thing," I was told. "He says Jimi was crazy about some of these musicians or wanted to produce them, etcetera etcetera. Do you know if Hendrix met or heard any of them before he died?" Mike's lawyer Steve Weiss was mentioned, too, in the pursuit of these deals. It sounded to me like Jeffery was back to his old tricks, using the dead Jimi as he had the live one.

On March 5, 1973, reality caught up with Michael Jeffery in a big way. Sixty-eight people died when two Spanish planes collided in midair over Nantes, France. One, an Iberia DC-9, disintegrated in the sky, raining debris and bodies for a ten-mile radius. One of those mangled bodies was that of thirty-nine-year-old Jeffery, who could be identified only on the basis of the watch, rings, and chain he always wore. The other plane, a Spantax CV-990, managed to land with no loss of lives. It was well known that Mike had a fear of flying, often changing his reservation at the last minute, but the fact is that for years he'd flown back and forth to Majorca, the location of many of his assets and a place where he owned lucrative clubs. Mike and trusted members of his staff often transported large sums of money on these trips. A strike by French air controllers at the time, unfounded accusations of pilot error, and "unwatched" radar were all elements in the mix of where to place blame for the accident. As it concerns the late manager of the late Jimi Hendrix, there is no truth to a series of rumors that the crash

was caused by Jeffery's enemies. Mike simply lost the luck he'd carried for so long. Delighting for years in his own shrewdness, success, and wealth, now he was just yesterday's news.

§

THE LAWSUIT that Ed Chalpin had filed in London in 1970 before Jimi's death, against Track Records and Polydor, finally was on the court docket in March 1973 along with other pertinent suits against Track, Chas Chandler, Mike Jeffery, and Jimi's estate. A settlement was reached. While his one-time manager, the late Mike Jeffery, had garnered millions of dollars from the talent of Jimi Hendrix, Noel Redding did not fare so well when he pursued legal action in America. Worn down, he eventually signed a bizarrely drafted agreement with Warner Bros. and Reprise Records giving up numerous rights for the pathetic sum of $100,000. His career was not happening in America, as it had not in England after he left The Experience. He bought a house in Ireland, where he spent gloomy hours endlessly reviewing his road journals, accounts and financial records and his boxes and stacks of legal documents. He worked on and off on a book, and although Noel engaged in an ongoing battle with drugs, alcohol, and lack of money, he did not lose his charm, his humor, and his likability.

The seventies were a period of tremendous drug use in the rock music industry. Often, when I ran into friends and admirers of Hendrix in England and in America, I was stunned by the drug-crazy lifestyle of young men and women who had seemed so vibrant and golden; now they appeared aged and tarnished, out of control. It had been Hendrix who'd owned the big, bad drug-gobbling image, but *this* was so much worse. To have dinner with certain stars was to find oneself carefully, casually pointing out that the plate they were waiting for was sitting in front of them and that their food was growing cold. Others simply didn't bother with regular meals at all; they had a yen for sweets and seemed to

exist on candy bars. What had happened, I wondered, to that fleeting, joyful time when we all felt and acted *so* cool? Often the worst part after one of these agonizing dinners was seeing that drugged-out Mr. or Ms. Famous needed help in standing upright and had to be protectively helped to the limousine or across the street and told, "The light is green now. We can cross." At the peak of all this self-destructive behavior, I was invited to a party in a ridiculously expensive suite at the Plaza Hotel in New York. "Anyone who's *anyone* will be there," I was told. A renowned California band, in New York for a sloppy performance at Madison Square Garden, was holding court; they were purred over by major record executives, who laughed with and schmoozed these completely out-of-it rock stars. In each room of the seven-room suite, two or three large bowls were prominently placed on tables and decorative chests. The bowls contained mounds of cocaine.

I was no Goody Two-shoes, but this lunatic decadence was not a scene I cared to be associated with. I was making tracks toward the door when I heard two of the stars of the California band listening as a reporter from a music trade magazine was discussing how producer Alan Douglas had taken *unfinished* Hendrix song tracks and added side men on drums and bass—men who had never played with Jimi. "Man, *that* just sucks!" said one of the stars. "Hendrix would be completely pissed off about it." He wiped the residue cocaine from his nose. "This business is just so *brutal*. Everybody knows that Douglas pushed so hard to be Jimi's producer, and with Jimi out of the way, now he finally is. Can you believe that Warner Bros. goes along with this shit?"

"I'm hearing that the lawyer's son, Chip Branton, is making plenty off Hendrix, too," the reporter said. "He's got something or other to do with being a 'producer' on Jimi's music."

The two musicians seemed confused. "Who are these Brantons?"

The *Billboard* man explained, "The father's a lawyer. He works

for old man Hendrix. I guess he wants his kid on the payroll, too."

Lingering, I felt like butting in and asking more questions, but I didn't. I'd seen and heard enough.

Not everyone was unhappy with Alan Douglas's "reinvention" of Jimi Hendrix. The *Crash Landing* album he produced by the cut-and-paste and overdub method hit the American top-ten charts in 1975, and his second Hendrix "production," the song "Midnight Lightning," was a strong seller at the end of that year. Douglas told the press that he was working with some eight hundred hours of Hendrix tape and that there would be more records to come. Leo Branton Jr. and his client Al Hendrix were delighted to be associated with Alan Douglas.

§

LIFE WAS getting better and better for Al Hendrix. He'd received enough money from Jimi's estate to buy a comfortable but not lavish five-bedroom, five-bath home with dual living rooms, and his own basement "hideout" complete with billiard table and beer-stocked refrigerator. The home was situated on a large lot with a spacious garage in an upscale neighborhood in Seattle's Skyway suburb.

It was here that he met Jimi's Swedish son, James Henrik Daniel Sundquist, when the young child and his mother, Eva, flew in from Sweden for a brief visit. They'd been having a rough time, allegedly living on welfare. The boy had already been recognized as Jimi's son in a Swedish court. Branton had told Al that this was going to cost him, and Al was miserable about it. "Everyone wants money from me!" he said. "Even when they don't speak English!" It annoyed him that Eva and her son were more comfortable speaking Swedish. The boy's uncle Leon's voice softened in recalling his first glimpse of the child. "When I met little Jimi, I said, oooh! There he was, just like my brother—a little pigeon-toed. He walked with that special gait Jimi had." June Hendrix's daugh-

ter Linda remembers, "The little boy was *adorable*. He looked so much like his father."

After months of strategizing and haggling on the Branton-Hendrix side, Jimi's son and his mother were paid approximately a million dollars "for his support." They fared better than Jimi's daughter, Tamika. Legal suits filed soon after his death came to nothing, since her representatives were unable to provide proof of her relationship to Jimi in the New York courts. Much later she would receive the grand sum of a hundred dollars as a gift from her grandfather.

On the home front, Al and June Hendrix's marriage was said to be "a quirky situation," punctuated by arguments and alter-cations, sometimes alcohol-related. June's concerns regarding "other women" were involved. June wanted out, although neither she nor Al seemed to desire a divorce—too much Hendrix money was at stake. After he was fed up with "wrangling,"Al agreed to give his wife an allowance. She left their home in Skyway. Her daughter Janie chose to remain with Al. He bought June an inexpensive house, but she soon suffered a stroke and needed physical therapy. In time she moved into a Seattle condominium. Several serious illnesses plagued her, worrying her children. June was in and out of nursing homes.

§

ALAN DOUGLAS did make at least one move that benefited the music of Jimi Hendrix. The producer was instrumental in licensing a limited amount of Hendrix music to Rykodisc, a tiny Massachu-setts company specializing in laser technology as applied to sound in the brand-new format of the compact disc. In 1987, Rykodisc released *Jimi Hendrix Live at Winterland.* The high-quality sound wowed older music fans, who loved their vinyl and the accompanying large, colorful, informative album sleeves, as well as younger fans and new artists, who hurried out to buy CD players

and turn Hendrix up loud and long. The CD sold with a strength that amazed the record industry and definitely helped to lead the major labels to a stronger belief that vinyl would soon be obsolete. The next and final CD for Hendrix on Rykodisc, *Radio One*, also sold speedily. One could say that Rykodisc was a large factor in helping to revitalize the career of a dead but incandescent artist.

Chapter Fourteen

1990–1999:
A Series of Showdowns

ON JULY 24, 1990, I telephoned Leo Branton Jr. at his L.A. office. I had long been encouraged by numerous friends and fans of Jimi to write a lengthy piece about him, possibly for the *Sunday Times* of London, as a tribute tied into the twentieth anniversary of his death. For years music-business insiders had gossiped to me about the inner workings of the Leo Branton and Alan Douglas alliance with regard to Hendrix; it was time to ask a few questions.

Branton's pleasant-voiced secretary wasted no time in putting him on the line after I gave my name and mentioned that I was thinking about writing a tribute to Hendrix. It must have been a slow morning for the attorney, who had represented Al Hendrix for some nineteen years now. I had planned to remind Mr. Branton of our meetings and telephone conversations in the early seventies, but he didn't give me an opportunity. Today he was in a jovial mood and quite eager to talk about the little kingdom he ran. I could hear the squeak of his desk chair as he mentioned that the sun was pouring through his office windows on this leisurely summer day. Throughout our twenty-minute conversation, Branton came across as relaxed and very sure of himself; he was a lawyer who was sitting pretty. *Now* the sun shone for him in an environment I remembered as being drab and cold.

I asked him about Jimi's record sales since his death. "I receive

royalty statements from record companies around the world," Branton said proudly. Still, he hedged when I wondered how many hundreds of thousands of Hendrix albums had been sold in the past two decades. A kid with a calculator could have come up with an approximate figure based on all those royalty statements. While he chose to be less than forthcoming about record sales, Branton was quick to tell me that all of Jimi Hendrix's publishing, his song copyrights, were controlled by him, as opposed to licensing the Hendrix "catalog" with major international song publishers such as EMI or Sony. "His songs go through Bella Godiva, Incorporated," Branton said, adding, "I'm the president of the company." I remembered that "Bella Godiva" was the name Jimi had chosen in the late 1960s when New York publishing pro Aaron Schroeder had administered his songwriting. I wondered why Branton had selected himself to lead Bella Godiva, when he possessed little solid experience in the lucrative field of music publishing.

Branton talked casually of how he and Jimi's manager, Mike Jeffery, had developed a "friendly working relationship" and had come to terms on many issues. This alliance surprised me. Surely the lawyer would have been shocked, perhaps even contemptuous, if he had learned of Jeffery's manipulations of Jimi's earnings and of Hendrix himself. "So you're the boss," I remarked, "when it comes to Jimi Hendrix."

"*I'm* the boss," Branton agreed.

"Are you surprised by the growth of Hendrix's popularity?"

"It's phenomenal," he said. "Certainly not something we would have expected at the time of his death."

"How do you account for it, Mr. Branton?"

He chuckled and answered candidly, "Apparently Jimi Hendrix was a greater musician than I ever thought he was. Kids who weren't even born when Jimi died look on him as one of the greatest guitarists of all time. I never would have and never did. But I have to recognize the fact that the world recognizes him as such."

Yes, this stranger to the real Jimi Hendrix was definitely sitting pretty, I thought as I thanked the lawyer for his time.

§

EARLY IN 1991 I was surprised to receive a telephone call from Monika Dannemann, who I'd last heard from almost twenty years earlier, when she'd written me a series of letters seeking my friendship and inviting herself to stay with me at my home in Los Angeles. Then, tremendously upset by these letters, I had turned to Henry Steingarten, who advised me to ignore her completely. "She's trying to make herself more important than she is," he'd said. Now, after all this time, she was telephoning me from England, sweetly asking, "Do you remember me?" I didn't reply; how could I ever forget the woman who let Jimi die?

Three times in this conversation, during which I had to work at remaining calm, Dannemann urged me to come and stay with her at her "country house" on the south coast of England. "We can speak of Jimi," she said eagerly. "I know you must have many wonderful memories. And, of course, I do. We can share them. We'll have tea, and you can enjoy my garden." I sooner would have stuck my head in the oven than have accepted her invitation. I understood that she wanted and, presumably, *needed* information from me. Friends in English press circles had advised me from time to time over the years that Monika was always trying to secure a book deal to write about "my fiancé," as she generally referred to Hendrix. I remembered how she had become involved with Curtis Knight, the cocky little New York musician, who'd been the first to exploit "the Jimi I knew." She had contributed her version of Jimi's death to Knight for his jivey, error-filled memoir, published soon after that tragic event, including a garbled version of what I had briefly said to Monika about Jimi's interest in the number nine.

Listening to Monika now, I felt anger at her colossal nerve. "I'm quite busy," I told her. "I must hang up and go out to an

appointment." I felt quite proud that I had made it through this "blast from the past" moment. Thank God I'd gotten rid of her!

Of course, I was wrong about that. Several months later I received a registered letter from Monika Dannemann's English solicitors, strongly warning me that I must never write about Jimi Hendrix's death and implicate their client in any manner. I scanned the two-page letter in less than a minute and immediately tossed it in the post office's trash can. Go to hell, I thought, but it did bother me that Dannemann had managed to track my address as well as my unlisted phone number, which she would use yet again in the future.

§

IN THE spring of 1992, Al Hendrix flew to New York to attend a fancy dinner at the Waldorf-Astoria hotel on the occasion of the induction of the Jimi Hendrix Experience into the Rock and Roll Hall of Fame. The impressive crowd, more than a thousand men and women, was packed with musicians and record-industry moguls. They all rose to their feet to celebrate the late rock star, and they applauded and cheered for Mitch Mitchell and Noel Redding, who stood alongside Jimi's father. Al grinned from ear to ear, and as the cheers continued, he shed a few tears. Neil Young was the official "inductor," praising Jimi and then performing "All Along the Watchtower."

"All that applause, that were really somethin'," Al Hendrix declared to photographers as he obligingly posed once more after the ceremony. "He's a cute little guy," a promotion executive at Atlantic Records said at the time. "All spiffy in his tuxedo. Didn't look a thing like you'd expect Jimi's father to look."

While Al Hendrix seemed quite content sitting back and collecting $50,000 a year from his son's estate plus having Leo Branton Jr. take charge of his income taxes and all those other niggling little matters that made up the business of being the father of a dead rock star, his adopted daughter Janie wanted to

be *involved*. She was now the mother of four sons; her early career training as a hairdresser never had panned out, and although she had no business experience whatsoever, it was Leo Branton who unknowingly inspired Janie to greater heights.

Beyond the yearly $50,000 to Al, from time to time Branton also sent checks to Leon and Janie, at their father's request. In October 1992 both Janie and Leon received letters from Branton on behalf of Al asking to purchase their contingent reversionary copyrights in Jimi's music. He explained that under federal copyright law, copyrights revert to their original owners after twenty-eight years. According to a lengthy, fact-filled trial brief later prepared by Leon's Seattle lawyer, Robert Curran,

> Branton informed Leon and Janie that Al originally sold the Hendrix copyrights in exchange for an annuity which had provided him with a steady income. Now that the original copyright period was about to expire, Branton indicated that Al wished to sell the reversionary copyrights as well; however, in order to do so he needed to first acquire Leon's and Janie's contingent rights which would vest were Al to die before the copyrights reverted.

> Branton's letter requested that Leon and Janie sign an agreement wherein each would waive his or her contingent reversionary rights in Jimi's music copyrights in exchange for $300,000 cash and a $700,000 trust to be established by Al for the "education, health and welfare of your respective children." Because the trusts would be funded upon the sale by Al of the reversionary rights, the letter offered to make the funding of the trusts binding upon Al's estate in case funding did not take place before Al's death.

Al and his lawyer met in Seattle before the letters were sent to his two children. Branton explained "reversionary copyrights" to Al several times, but his client had a difficult time grasping all the details. According to Curran's subsequent trial brief, "Leon signed the Reversionary Rights Agreement at what he believed was the

request of his father. Until that point, Branton had handled all of the legal and business affairs relating to the Hendrix estate. Moreover, Al had always dismissed Leon's concerns about Branton, telling everyone that he was 'well taken care of.' Al also led Leon to believe he agreed with Branton's proposal by telling Leon several weeks earlier that 'Leo has something for you.'"

Janie didn't sign. She retained a leading Seattle attorney, O. Yale Lewis Jr. of Hendricks & Lewis, to advise her. Lewis investigated the worth of the contingent rights, and he came to the conclusion that Jimi's estate was "extremely valuable." Lewis then met with Al Hendrix and discussed a range of significant ideas. Janie's thinking was that there must be many more millions that Branton had not mentioned in his letters to her and Leon.

Al's niece Diane telephoned him from New York to say that she'd read in a newspaper article that Branton was making a new agreement to sell the Hendrix "rights" that might bring in as much as $40 million. He was flabbergasted—"Leo never mentioned anything like that," he told her and then Janie, he would later testify.

News soon spread swiftly around Seattle that Janie was urging her father to dump Branton and "sue to get our legacy back." At Janie's urging, Al retained Yale Lewis and his firm to "investigate the handling of the Hendrix estate by Branton." Paul Allen, the Microsoft billionaire, had let it be known to Al Hendrix that he was willing to loan him $5 million for legal expenses. If "the family" won, they could repay him. If they lost, Allen would forgive the debt.

§

IN EARLY 1993, Branton received numerous legal letters from Seattle. One of them was from Yale Lewis, saying, "Mr. Hendrix has asked me to convey to you his instructions that you take no further action on his behalf or any action that affects, in any way, any assets that are held in his name or in any other name for his benefit without my prior review. A Revocation of Any Power of

Attorney associated by Mr. Hendrix is enclosed." Another letter requested copious information and records on Al Hendrix's behalf. Immediately defensive, according to subsequent testimony, Branton took a "stonewall" posture, reminding Al directly how much he'd done for him and writing him to say it would take a long time to locate all the records of their twenty-year relationship. Al was understandably nervous and scared about what he had set in motion, fretting over how long all "this awfulness" would take. His lawyers had advised that he would have to give long and tedious depositions telling all that he knew and that he would be expected to testify in front of a judge and jury. He didn't feel good about this. Janie and her husband, Troy Wright, prodded Al, shored him up, speaking of "victory parties" and generally encouraging him that "this is the right thing to do!"

Almost twenty years prior, Branton had wrested the Hendrix estate from Jimi's personal lawyer, Henry W. Steingarten, and had been given carte blanche by Al Hendrix to "go make them deals." It was a humiliating day for Branton when his family, his neighbors, his legal colleagues, and Jimi Hendrix fans saw the April 20, 1993, edition of his hometown paper, the *Los Angeles Times.* A prominent headline read:

Jimi Hendrix's Father
Files Fraud Suit Against Lawyer

The story, written by journalist Chuck Phillips, said that "the suit accuses Los Angeles entertainment lawyer Leo Branton Jr. of selling the rights to the late rock star's catalogue without the knowledge or consent of the father, James (Al) Hendrix. Branton defended himself by stating, 'Mr. Hendrix signed away all of his rights to the so-called legacy 20 years ago for a very valuable consideration. He signed the papers himself, and he understood them. Now that these things have increased in value, he's just trying to blackmail the owners into giving him some money based upon the claim that he didn't know what he was doing.'"

News, facts, gossip, and rumors traveled like wildfire throughout the Los Angeles record industry and spread internationally. "Poor Jimi, in his grave and *still* getting screwed," commented a musician who had seen his riveting performance at the Monterey Pop Festival. What *everyone* wondered was, is Branton a rip-off artist? Record producer Alan Douglas received less sympathy; after all, he'd "messed" with the music of a genius. Al Hendrix was who most people felt sorry for—"He's Jimi's father, for God's sake. The man deserves all the respect in the world." Record executives viewed it differently. This was simply business. Jimi Hendrix was dead. If his father had made poor choices, so be it. One thing was certain, according to the pros: If MCA Records and its parent company, Universal, wanted rights to Jimi Hendrix's music, they'd find a way to get them—everyone had his price. Still, the story in the *Los Angeles Times* brought sadness to music biz veterans who'd always thought of Jimi Hendrix as synonymous with Reprise Records. As Reprise's Bob Merlis had enjoyed saying, "Jimi Hendrix is the cornerstone of our hipness." Apparently Reprise and its corporate chiefs had mixed feelings with regard to a new Hendrix deal and didn't care to match the MCA offer. There was, of course, the possibility that Branton had better reasons for not wanting the music of a dead rock star on Reprise anymore.

Assorted relatives on both sides of Jimi's family, acquaintances, and former neighbors in the Central District talked nonstop when they saw the headline in the *Seattle Post-Intelligencer*:

Hendrix Lawsuit
Father of Rock Star Sues for Copyright Ownership

"Imagine Al Hendrix, of all people, filing a big-deal lawsuit," was a typical comment in his old neighborhood. The news story reported, "The court battle is part of a dispute that earlier this month delayed a multimillion-dollar deal in which MCA Music Entertainment Group was to buy Jimi Hendrix's recording and publishing rights." This surprised and confused those in Seattle

who had assumed that Al himself was already a multimillionaire. After all, now he lived in a big house away from the Central District, and his son had been one of the most famous musicians in the world.

On June 14, 1993, the Hendrix attorneys stepped up the pressure by filing an amended complaint "for an accounting breach of fiduciary duty, fraud, negligent misrepresentation, legal malpractice, restitution based upon rescission of contract, securities law violations, violation of RICO, conspiracy to defraud, infringement of copyrights, unfair competition, conversion, infringement of rights of publicity and declaratory judgments." The first page of the complaint spelled out the who's who of the drama:

United States District Court
Western Washington District of Washington

At Seattle JAMES A. HENDRIX, an individual,
 Plaintiff v.
LEO BRANTON, JR., AND GERALDINE BRANTON,
 individually and the marital community thereof;
LEO BRANTON, JR., A LAW CORPORATION,
 a California corporation;
BELLA GODIVA MUSIC, INC., a New York corporation;
PRESENTACIONES MUSICALES, S.A., a Panamanian
 corporation;
INTERLIT B.V.I., LIMITED, a British Virgin Islands
 corporation;
AUTEURSRECHTENMAATSCHAPPIJ B.V., a Netherlands
 company;
BUREAU VOOR MUZIEKRECHTEN ELBER B.V., a Netherlands
 corporation;
ARE YOU EXPERIENCED? LTD., a California corporation;
ALAN D. RUBENSTEIN a/k/a ALAN DOUGLAS, and
 JANE DOE RUBENSTEIN, individually and the
 marital community thereof;
and LEO L. BRANTON III,
Defendants.

In reading the full seventy-five-page legal complaint plus numerous exhibit attachments, it was amazing to discover the number of offshore companies and tax shelters that Branton had dealings with or had personally formed. Michael Jeffery and John A. Hillman would have been impressed. With its shades of Yameta, it was "déjà vu all over again," as the hipsters on Sunset Boulevard used to say. The complaint stated that Jimi had died without a will, "leaving no spouse or child," although his father was certainly aware that two children did exist, whether he chose to acknowledge them publicly or not.

In March 1994 Al Hendrix, now in his midseventies, sat down for several days with a coterie of lawyers—his own and those representing Branton and his record-producer partner Alan Douglas et al.—and a court reporter to give a deposition in the lawsuit he had filed. Attorney Kirk Hallam, representing defendants including Bella Godiva Music, Interlit, Elber B.V., Are You Experienced?, and Alan Douglas, questioned Al Hendrix.

> *Mr. Hallam:* Were you aware in 1970 or '71 that the value of your son's estate would depend in large part upon how successful the sales of Jimi's music were?
> *Mr. Hendrix:* No, I didn't know anything about the business of the estate.
> *Mr. Hallam:* So in your understanding in that period of time, 1970–71, there was no connection between how much your son's estate would be worth and how many albums of Jimi Hendrix's music were sold in the future?
> *Mr. Hendrix:* I had no idea what was going on. All I know is I inherited it and that was that.

There were few questions asked regarding precisely how the estate had come to Al Hendrix—the definition of "inherit" was a tricky subject to be avoided, since Jimi Hendrix had not personally made and signed a will or any other similar written agreement that gave his father any bequest whatsoever in the event of his

death. However, a friend of Al's, to whom he'd loaned substantial money, significantly overelaborated in her deposition testimony in her praise of Al as well as her certainty of Jimi's intentions.

Several times on different days of the process, assorted lawyers mentioned that Al Hendrix seemed "sleepy" or "rambling" or "tired." A handful of relatives and friends felt that the coaching and rehearsing process had taken its toll on him. However, Janie was on hand each day as moral support.

A number of answers given by Al Hendrix in the deposition process conflicted with known facts and/or statements he had made in earlier years about both Jimi and Branton. His deposition testimony about his relationship and conversations with his son were dotted with inaccuracies and outright falsehoods as he was questioned about Jimi's childhood and his visits to Seattle as a star.

The depositions became a soap opera within a soap opera when Al Hendrix was asked about a telephone call from Leo Branton's wife, Gerry, pleading with him not to terminate her husband. "She also mentioned," Al Hendrix said, "that there has been some personal things in the files that were—that would hurt Leo as well as hurt myself if they were disclosed. . . ." Mrs. Branton, an attractive, personable woman, reminded Al that they had all been good friends and urged him to come down to Los Angeles and talk things over.

Al declared in his deposition, "She was pleading for me to come there. . . . She said, 'Well, I trust you so much.' She said 'in case anything ever happened to Leo, I would like to have you preside over our estate,' and I just chuckled about that because I told her, I said, 'I don't know nothing about this lawyering business. . . .'"

All manner of Hendrix family dirty laundry was aired through the course of the legal proceedings in Seattle. Eleven hundred miles down the West Coast in Los Angeles, another sad situation was unfolding that conceivably could derail Al Hendrix's suit.

The existence of Jimi's son had not been widely known in June 1994 when a young man from Sweden arrived in Los Angeles. He

had changed his name from James Sundquist to Jimi Hendrix Jr. Encouraged by supporters in Sweden and America, Jimi Jr., now age twenty-five, hired a lawyer and filed a lawsuit in California declaring that *he* was the rightful heir to the Hendrix legacy.

It was tragic that the quiet young man who looked so much like Jimi was spoken of by those with vested interests as mere dirt under their feet. The unexpected presence of Jimi Jr. on American soil struck fear into Al Hendrix, his daughter Janie, Leo Branton and Alan Douglas. He was gossiped about by people who didn't necessarily know the circumstances as if he were no more than a greedy, lying interloper, while others understood that Jimi Jr. had a legitimate claim to the estate and that, in human terms alone, he deserved to be recognized as his father's son and to build some self-esteem instead of wondering who and what he was, as Jimi had before him. An impeccable source recalled, "It was a nightmare for the boy. There had been the prior support-money settlement and some birthday and Christmas cards sent to him but Al would not publicly acknowlege that he was Jimi's son. There was his remarkable resemblance to Jimi. And now he was shunned. He felt humiliated."

Eventually a California judge threw out Jimi Jr.'s claim. "The kid never stood a chance," a New York lawyer familiar with the Seattle suit as well as with Jimi Jr.'s California suit told me. "He's been up against too much and too many."

However, the young man ultimately received approximately $1.5 million in a final settlement from the family corporation on the advice of lawyers. No one wanted this "inconvenient" son of Jimi's to get in the way of their good thing.

§

EVEN MUSICIANS used to audiences get shaky when they have to talk onstage to a huge crowd, but, like her father, Janie Hendrix-Wright appeared to enjoy every minute of the spotlight when she arrived in upstate New York at the Woodstock II festival, in August

1994. After asking Carlos Santana to introduce her, Janie boldly stepped forward to address a crowd of approximately three hundred thousand people. In everyday life Janie seemed to be just another small, nondescript brunette, but at Woodstock II she was positively glowing. The fans naturally applauded wildly at the mention of Jimi Hendrix, and Janie told them how hard she and her father were working to "get my brother's legacy back from those lawyers!"

What wasn't clear to most observers was that Janie was not related to Jimi. Throughout the legal process, she made a number of unlikely statements to lawyers about her relationship to and with Jimi Hendrix. Aside from asserting that Leon was not Al's true son and thus not really Jimi's little brother, she told lawyers that she was Al's natural daughter and thus Jimi's real sister, showing them a birth certificate as "proof." The state of Washington certificate had been given to her mother at the time of six-year-old Janie's 1968 adoption by Al and did not differentiate with regard to her being an adopted or a biological child.

Her statements began to seriously trouble the Seattle legal team representing Al Hendrix. Finally another lawyer was handpicked to sit down with Al Hendrix to ask several uncomfortable questions about Janie's claims. Al was forthright—"I adopted Janie in 1968." Genevieve Lisa Jinka Hendrix Wright, aka "Janie Hendrix," had met and observed Jimi Hendrix during four brief encounters when he visited Seattle on tour and performed concerts there twice in 1968, once in 1969, and once in 1970—when she was between the ages of six and nine. Just weeks after Janie and her older siblings and their mother, June, met Jimi the rock star for the first time, June urged Al to move ahead on the adoption of Janie.

Hendrix v. Branton would be a jury trial. The judge presiding over the suit was Thomas S. Zilly. For all the posturing by both sides, it was apparent that settlement would be highly preferable to the risks of a jury trial. Judge Zilly asked his respected colleague Judge Willliam L. Dwyer to mediate the settlement. A "settlement

judge" acts as an interpreter; he does not make rulings. It was up to Zilly to make certain rulings.

It was agreed that the terms of the settlement between Al Hendrix, Leo Branton, and Alan Douglas would be kept confidential. Ultimately, however, a number of professionals and friends in Seattle, Los Angeles, and New York were made aware by principals in the case that Branton and Douglas allegedly were allowed to keep the millions of dollars they'd each made through the music of Jimi Hendrix. Al Hendrix also had to pay them a considerable amount of money for the rights to Jimi's music that had been acquired by Alan Douglas through various means in the past twenty years. Douglas possessed boxes and boxes of Hendrix tapes, ranging from dazzling master recordings to unfinished songs and bootleg cassettes. He carved a lucrative career off Hendrix, whom he had never produced in Jimi's lifetime. Douglas overdubbed, remixed, and reinvented material, added new musicians, and even gave himself a writing credit on some of Hendrix's songs distributed by Reprise Records and assorted international companies.

The federal courthouse in Seattle had never experienced the likes of *Hendrix v. Branton*, with two tenacious teams of lawyers billing their clients millions of dollars over a period of almost two years and generating a staggering nineteen hundred documents, each ranging from one page to almost one hundred.

Now it was Al Hendrix's turn to be in the catbird seat. Al, usually with Janie alongside, posed for the cameras in the summer of 1995. Victory was sweet! "Jimi's music is back home where it belongs," Janie said. They both spoke of "winning" as though a judge and jury had made a momentous decision in which the bad guys had gone down in flames and Good had Triumphed. The essential fact that the lawsuit had resulted in a settlement and had never gone to trial was played down. There was much rhetoric about the "legacy" and how overjoyed Jimi would be about this "victory."

The legal wrangling did not stop there. After the settlements

Janie and her husband, Troy Wright, retained other lawyers to take action against Hendricks & Lewis, the firm that had provided more than two years of solid guidance in a difficult and unprecedented lawsuit. The Wrights, with Al Hendrix's blessing, took issue with the size of the legal fees.

Free to profit from the music rights they had acquired in the settlement, the Hendrixes made a better deal than the one Branton had originally agreed to. This time there would be no outright purchase of Jimi's music, but rather a licensing deal that was renewable once the advance was earned out. It was a *great* deal, allegedly worth some $40 million for starters. "Al Hendrix had virtually nothing to do with any of it," says a former MCA Records executive. "The old man could barely read. He was a figurehead. His daughter paid through the nose for heavy-hitter record-business attorneys to guide her through the deal. She'd also hired away a fellow named Reed Wasson from the legal firm that won the Seattle suit for her."

Janie named the Family's company Experience Hendrix. Al assumed the title of chairman of the board. In September 1995 Al Hendrix sat on a large throne wearing a "royal robe" and a replica of a gold crown on his head at a tribute concert to his son, held in the Memorial Stadium at the Seattle Center's Bumbershoot Festival. Some members of the audience found the robe, crown, and throne ensemble an embarrassment, but Al enjoyed it, and he felt good about playing the role of surrogate Jimi. As many others cheered, Al, savoring every moment of the spectacle, waved and smiled widely. In the years since his son's death, he had come to relish soaking up the limelight, receiving rounds of applause, and meeting Jimi's famous friends and admirers, who telephoned to pay their respects whenever they came through Seattle. Rather oddly, he seemed to invent new dialogue between Jimmy the young boy and himself—"I said to him, 'Jimmy if you're gonna play guitar, you'd better be an original.' I gave him a *lot* of suggestions." Those who had known Al for many years wondered

where these new memories were coming from. By now, Al seemed to believe in a past in which he had been a dedicated single father raising his boy and also providing a significant inspiration and influence in the development of Jimi's musical career.

The Family's good fortune continued with a renewed worldwide interest in Jimi and his music. Cable music channel VH1 began to focus on Jimi Hendrix in the mid- and late nineties. "He's the greatest musician that rock and roll ever produced," sums up Bill Flanagan, a former journalist with a thorough understanding of popular music. The senior vice president and editorial director of VH1, Flanagan was directly responsible for a Hendrix "Legend Special" that has been run and rerun many times, exciting new generations of music buffs and turning them on to Jimi. Flanagan brought airings of *Monterey Pop* and Jimi's 1969 appearance on *The Dick Cavett Show* to VH1.

"Music goes in cycles," he says. "In the nineties there were a lot of kids who fell in love with rock for the first time. There was a focus on Seattle and electric guitar. That meant bands like Nirvana and Pearl Jam and, of course, Jimi." Larry King, a veteran of more than seventeen years at the Tower Records Sunset Boulevard store in West Hollywood, California, is an expert on retail record, CD, video, and DVD sales. He says, "Two things were particularly helpful in establishing Hendrix's longevity as an artist. Generally speaking, the tragedy of his early death and all that promise being lost created a sense of someone very precious missing in music. Specifically, there have been two movies that opened many eyes, mine included, to Hendrix. What a showman he was! *Monterey Pop* made us all want more and more Jimi. In the gigantic lineup of the movie of *Woodstock*, Hendrix was a colossus—he just rode over that stage like he owned it. There have been countless showings of these films on television, and those images, along with the CD revolution, have made Jimi unforgettable. Even though he is gone, his talent continues to speak for itself."

At the Virgin Megastore on the Sunset Strip, a young woman

sales manager said admiringly of Janie Hendrix, "She's really something! Imagine getting to run Jimi's company and make all the decisions. She's showing that women can cut it in the record business. I see the sales figures, so I know how great she's doing. And the big plus she's got going for herself is all the television screenings of movies with Jimi Hendrix. They're like free commercials for Hendrix CDs."

§

IN 1996 Monika Dannemann telephoned me for the final time. I felt instantly furious when I picked up the telephone and heard her softly say, "It's Monika." How can anyone manage to put sadness behind when there's always some *creep* unexpectedly bringing it all back into focus? What could she possibly want now? Had she forgotten the legal warning she'd instructed her solicitors to issue? How could she possibly think I would consider her a *friend*? She started in, once more pushing her desire that I should "come and visit . . . I *really* need to talk to you. Can you come next week?"

I couldn't believe my ears. I'd had enough of her, and I let loose. "I don't want to ever see or speak to you again. You've told too many lies through too many years. How can you possibly believe I would want to be your friend?"

She began to stammer at the vehemence of my tone. "Oh, is this a b-b-bad time to t-t-talk?"

I felt somehow that things had gone terribly wrong for Monika and that she was in some kind of trouble. But I didn't care, and I didn't want details. "*You* helped to kill a friend of mine. You showed no respect to Jimi Hendrix. He lay there in layers of his own vomit for hours, and *you* let him die."

I could hear myself yelling into the telephone, and I felt shocked by my own anger. "*You* could have called a doctor. An ambulance. The police. The hotel manager. But *you* didn't. The very next morning, you told me what happened. But you *didn't* tell

me everything! When he was choking, gasping for breath, did you *pour* red wine down his throat?

There was a long pause. I took a stab at something I'd discussed with Jack Meehan after his conversation with the coroner and had subsequently puzzled over for years. "I *know* you did," I said.

"It was all untidy. He was messy. I thought it would help," Monika haltingly explained. I could just imagine her running off to wash her hands because the dying man was "untidy."

"*You* made it all worse."

She let out a series of hysterical shrieks, but she did not deny my words. I kept at her. "*You* could have gotten help that would have saved him. But *you* made a choice, and *you* have been lying about all of it ever since." Monika was sobbing now, but she managed to interrupt her sobs to say, "Stop! You're going to give me a heart attack."

"*That's* an impossibility!" I yelled. "You *have* no heart. No *conscience*. You barely knew Jimi Hendrix, and you let him die."

"*No!*"

"You and your sick charade," I said, quieting down. I had never spoken to another human being like that before.

She was quiet, too. The sobs had vanished.

"Don't you ever telephone me or contact me in any way ever again. You are a cruel and terrible person. And a goddamned liar!"

Monika Dannemann moaned into my ear on the telephone; it was terrible to hear. Finally she said, "I am *sorry*. Believe me, I am sorry." I couldn't listen to another word. I hung up, and two days later I took the advice of friends and changed my telephone number.

Through the years Kathy Etchingham, Jimi's first London girlfriend, had never bought into Monika's assorted concoctions of the "Jimi I knew" or her assorted tales of Jimi's death. In the nineties Etchingham conducted her own private investigation of the woman from Düsseldorf, Germany, and late in 1993 she asked

the authorities to reopen the investigation of Jimi's death. Scotland Yard's inquiry proved inconclusive.

Monika continued to make slanderous comments about others, including Noel Redding. Most unwisely, she made a series of false accusations to journalists about Kathy Etchingham, and Kathy took Monika to court in April 1996 over her allegations. The judge ruled in Kathy's favor, and Monika was also found guilty of contempt of court. The English press had covered the story, and Monika's house of cards had toppled down. She was distraught over this public humiliation.

Several days after the judge's ruling, Monika attached a hose to the exhaust pipe of her shiny Mercedes. She sealed the car windows tight and sat down at the wheel and turned on the engine. Apparently the last thing she did as she began to lose consciousness was to switch off the engine. She was found dead in her fume-filled car on April 5, 1996.

It took several years for me to bring myself to visit a public library and spend fifteen minutes looking through Monika's 1995 book containing forty-five full-color paintings of Jimi or allegedly "inspired" by Jimi, plus mind-boggling text. Then there were the photographs of Monika grieving at his Seattle grave, and with Al, June, and Janie Hendrix. Jimi's father even offered words of endorsement, including the "fiancé" riff that would certainly have startled numerous young ladies who knew Jimi in the last year of his life. On an early page of the book, a message from Al Hendrix declares: "*To whom it may concern . . . I would like to state that my son Jimi Hendrix was engaged to Monika Dannemann and that they planned to get married. All those slanderous stories written about Monika regarding my son are false. . . .*" Even though Al Hendrix never heard from his son again after Jimi's last performance in Seattle in late July 1970, he chose to agree to the above words written for him in Dannemann's book.

§

AL HENDRIX and Janie flew to London from Seattle in July 1996; it was the first trip to England for both of them. Each had bought a new wardrobe for the business trip. Al felt ill at ease in a strange country; some of the food mystified him, and Janie had a difficult time keeping him out of the hotel bar. They were in England on a *mission*: Janie had arranged for an appointment with Jimi's friend and onetime manager and producer Chas Chandler. She was determined to buy the early Experience tapes that Chas had in his possession. The meeting couldn't and didn't happen, because Chas died on July 17 at Newcastle General Hospital, where he was undergoing tests related to an aortic aneurysm. Bryan James "Chas" Chandler was a popular man in England, and his early death at the age of fifty-seven came as a great shock to his friends. The loss was devastating for his second wife, Madeleine, a former beauty queen, and their three young children and certainly for Steffan, the adored son from Chas's first marriage to Lotta, the young woman who had been so kind to Jimi, even down to helping him wash his clothes as he adjusted to living in London.

Chas's death put a damper on Janie's plan to return to Seattle with the tapes; she decided that she and her father must attend the funeral. Understandably, they were fish out of water, with Al complaining he could hardly catch a clear word in the northern accents of Newcastle. Janie networked, meeting several of Chas's friends who'd known Jimi, and she made it clear that she "definitely" expected to purchase "my brother's tapes as soon as possible."

After Chas had left the Experience, he'd managed several bands, but the next true success for him after Jimi had been Slade, a huge group in England in the seventies. He later talked about never having received much of anything to show for his youthful years as bass player for the Animals and it was a great triumph for him to become a wealthy man. Chas and I had always been very open with each other; there was a long period where we were out of contact, but in the early nineties we ran into each other in

London. We spent four hours one day talking nonstop over a lavish lunch in Mayfair. Chas told me about his plans to develop a major sports and entertainment complex in Newcastle. The enthusiasm in his voice and the confidence in his pale blue eyes told me that it was certain to be a success. From what Chas said, the timing was *just* right for the arena he was envisioning in partnership with an old friend. I was happy for him. Mainly, though, we spoke of Hendrix. Chas was so "over the moon" to have an opportunity to relive the days and nights when he first got to know Jimi that his Geordie accent kept getting thicker and thicker. I felt as I listened that his memories of bringing a guitar virtuoso to London and seeing all the musicians they both revered falling at Jimi's feet had given Chandler more happiness in retrospect than he felt about any other part of his career in music. He told me that he was miserable about all that he knew of how the estate was handling the songs that he and Jimi had worked on together. Softly, he thanked me, "for your loyalty," and hugged me. I wish I'd been able to see him again.

§

ON SEPTEMBER 14, 1997, after much campaigning by Kathy Etchingham, English Heritage unveiled one of its famous "blue plaques" outside the Brook Street flat where Jimi Hendrix had so briefly lived in 1968. These sought-after plaques have long marked historic sites in tribute to people who have made a significant contribution to the United Kingdom's cultural heritage through the centuries. Jimi was the first rock star ever to be memorialized in this way. His ardent admirer and friend Pete Townshend of the Who spoke warmly and at length of Hendrix, calling him "a transcendental artist because he seemed to create light on the stage and with the music." A great crowd of fans and musicians filled the street, cheering their late hero. A few feet away, watching the proceedings, were Al Hendrix and his daughter Janie. Al blatantly bad-mouthed the event and Kathy Etchingham to

attentive members of the press. It was quite a slap in the face to friends and admirers gathered to celebrate Jimi.

In 1998 Janie Hendrix was to be reminded that she wasn't the only one who had rights to Jimi Hendrix's music. The ever-vigilant Ed Chalpin of PPX Enterprises continued to have his own issues about *his* rights. He filed suit in New York against MCA, Leo Branton Jr., Alan Douglas, Are You Experienced? Ltd., Elber BV, and Experience Hendrix, L.L.C. Chalpin wanted his own piece of the pie, but he fared poorly in the outcome. However, he would return.

§

AFTER SEVERAL sieges of illness in assorted nursing homes, Ayako Fujita Jinka Hendrix, generally known as June, died on August 20, 1999, at the age of seventy-nine. Linda, her brother Willie, and her sisters Marsha and Donna were raised by their father, Satoshi Jinka, when June left the family. She had become involved with another man, of European descent, and, out of wedlock, gave birth to Janie. Her older children didn't see their mother or meet Janie for several years. June became Al Hendrix's wife in 1966, and although Janie's real father was alive, June encouraged Janie to think of Al as Dad, even though the marriage got off to a rocky start and was a union filled with arguments. The obituaries and news reports, focused, as one headline had it, on **"June" Hendrix, Jimi's Stepmom**.

The spin that had come into play since Jimi's death kept increasing in the years since Al Hendrix won his big settlement. The obituaries painted a portrait of a strong, close family, even though the facts had disputed it for some time. June and Al had long lived apart, and he had acquired at least one "special friend," but now, on this sad occasion, readers were able to picture a grieving widower. Leon Hendrix, who in his younger years had lived with his father and June and her daughter Janie, was not mentioned, but his brother Jimi was a focal point, taking pre-

cedence over June Fujita Jinka Hendrix's four older children. It was mentioned that June had loved Jimi's song "Purple Haze" and frequently dressed in purple head to toe. "Foxy Lady" was played at her funeral. The obituaries did not note how brief her acquaintanceship with Jimi actually had been.

§

AS THE century drew to an end, Janie Hendrix spent long hours on the telephone, in business meetings, and fleshing out an exotic range of ideas calculated to keep Jimi Hendrix's name in the marketplace. Janie also continued to work on "sanitizing" Jimi's sex, drugs and rock and roll image, going as far as buying up every possible photograph and negative of him and having cigarettes and any accompanying smoke airbrushed out.

She had encouraged her father to publish his own book, *My Son Jimi*. Jas Obrecht, a respected professional journalist, was hired as "cowriter." Al Hendrix's memory was often shaky and the book contained factual errors and misstatements, according to fans and some family members. The revisionist history apparently focuses more on Al and his family background than it does on Jimi.

The self-published book, however, did not bring in anything close to the substantial money that came from Reebok, to whom Janie licensed Jimi's classic song "Are You Experienced?" for a sneaker commercial. On the record front, Janie toiled tirelessly preparing and "producing" a four-CD *The Jimi Hendrix Experience* box set. Some of the recordings came from the tapes that the late Chas Chandler had protected for so long. Janie purchased the tapes from Chandler's second wife for $2 million, a larger sum than she wanted to pay. Still, she was ecstatic; it was as though she had claimed the crown jewels. Janie was convinced that the world would view her box set as a masterpiece and a triumph for Experience Hendrix.

Janie told the press that she was in the process of finding a more suitable place for Jimi's remains. She proposed to construct a

large purple edifice at the cemetery, which family and fans could enjoy visiting. Fans had no trouble finding Hendrix's grave. "All you have to do is follow a trail of beer cans and cigarette butts," writer Tony Paris said, "left by some of Jimi's sloppier admirers." His gravestone had been stolen several times, until Al Hendrix was fed up with spending the money to replace it. Janie urged the public to make financial donations for her purple mausoleum, but there was enough of an outcry throughout the city against her idea that soon enough her plan vanished into thin air.

Chapter Fifteen

2000-2004: Wealth, Power, and Reflected Glory

AS WE moved into the beginning of a new millennium, Jimi Hendrix's music continued to sell around the world, despite the fact that the guitarist had been dead for thirty years. As historians and critics assessed varied genres of music of the twentieth century, the words "legendary" and "immortal" were frequently attached to Jimi's name.

Janie often listed her name as producer of Jimi Hendrix "product," emanating from her Experience Hendrix company, for which she paid herself six-figure fees. After her divorce from Troy Wright, Janie made a legal adjustment to the surname of her four young sons. They were henceforth to be referred to as Hendrix-Wright.

President and CEO Janie operates from a spacious, expensively decorated suite on her executive floor in a fine office building adjacent to a major Seattle freeway. She supervises a staff of ten, plus right-hand man, vice president Bob Hendrix, who previously had worked in warehouse management at Costco. Bob is the son of the late Frank Hendrix, Al's brother and the only blood relative of Jimi's employed at Experience Hendrix. The other man who really counts for Janie is lawyer Reed Wasson, her personal and business counsel since the 1995 victory. Additionally, Janie has lawyers on retainer in New York, Los Angeles, and London. Many of Janie's meetings are held in a private room where participants

sit around a conference table with a top that features purple velvet under glass. An array of photographs of Jimi decorate the entire floor, along with carefully selected images of Al Hendrix. Autographed celebrity photos are also part of the executive atmosphere.

The "catalog headquarters" take up yet another entire floor of the building. The fulfillment department handles worldwide orders for some 650 items bearing the name or image of Jimi Hendrix, ranging from golf balls, boxer shorts, and "Road Rage" air freshener, to a book of Hendrix lyrics personally signed by Janie Hendrix. She has produced a limited edition of one of Jimi's childhood drawings and titled it *The Prayer*, though the colorful art doesn't appear to have any connection with praying or religion. A small print sells for $600. She also sells a T-shirt emblazoned with a replica of Jimi's handwriting displaying the last words he ever wrote in that troubled poem during the early hours of the day he died.

An Experience Hendrix bus dubbed "Red House" has toured the United States, seeming at first an inventive traveling "Jimi museum." Musician Dave Rabinowitz tells of seeing the big bus pull into Boston: "I couldn't wait to go inside and check it out. There were some photos of Jimi and a couple of gold records and then all this merchandise, pretty tacky stuff for the most part. In no way was it a museum; it was a *store*. It made me sad to see Hendrix exploited this way."

What would particularly horrify and anger Jimi Hendrix himself, some of his most sensitive fans believe, are CDs of the recordings he made with such great care and concern that now bear a gold seal on the cover that reads APPROVED BY THE HENDRIX FAMILY or AUTHORIZED HENDRIX FAMILY EDITION. Several of the recordings issued by the Hendrix Family contain "takes" Jimi never approved and in fact didn't consider up to his standards.

Janie's big music coup has been the release in 2000 of *The Jimi Hendrix Experience*, which has sold in a consistent pattern nationally and internationally since its unveiling. Critics and fans speak

enthusiastically of this classy CD package, with some referring to it—fulfilling Janie's hope—as a "masterpiece." Despite Jimi's own supervision on most of his tracks and his dedicated, evolving growth in the recording studio, Janie's usual producer credit is emblazoned on the box set. Another producer credit is given to one of her staff members, writer John McDermott, who never met Hendrix and was never in a recording studio with him. Eddie Kramer, who engineered numerous, but not all, Hendrix sessions and certainly knew more than most about the sound and approach Jimi was going for in the studio, rounds out the trio of producers.

Steve Rodham, editor and publisher of the England-based *Jimpress* fanzine, believes that the box set "has some stunning moments" but says, "For hard-core collectors the best thing Experience Hendrix has done is to introduce the Dagger label releases of official bootlegs."

§

IN JUNE 2000, at a cost of $250 million, Microsoft billionaire Paul Allen officially opened his pet project by smashing artist Dale Chihuly's glass replica of a Fender Stratocaster guitar and smilingly decreeing, "Let the Experience begin!" Seattle didn't know what to make of the Experience Music Project. Initially it had been inspired by Allen's admiration for Jimi Hendrix. He'd hired the world-renowned architect Frank O. Gehry to design the building that would sit at the foot of the Space Needle. As construction was winding up, Seattle residents wrote local newspapers to offer comments, most along the lines of, "This is a huge fiasco." VIP guests from Hollywood and New York attending Allen's fancy black-tie "pre-opening," many of whom knew their art and architecture, seemed to admire the building or so they said.

Al Hendrix and his daughter attended yet another opening. Their relationship with Allen appeared, as Janie said, "cordial." But the media, Janie's employees, and many of the Experience Music Project staff believed that she felt competitive with Allen

when it came to the late Jimi Hendrix. Despite the huge financial favor Allen had done Janie and Al in the lawsuit days of the midnineties, Janie refused to loan Allen any of the motley assortment of Jimi's childhood artifacts that Al had kept, stuffed in boxes and folders along with various other remainders and reminders of the numerous moves he'd made through the years. "My dad never gets rid of anything," Jimi's brother Leon had told me years back. "He's a pack rat. He keeps all kinds of junk. Luckily, he did keep Jimi's things from growing up. And mine, too." Al, however, did sell several items of clothing Jimi had worn during his fame to eager collectors.

When the public was finally allowed entrance, one fellow declared that the building's exterior "calls to mind a squashed soft drink can." Others echoed the sentiment. Still, you can't please everyone, and this "EMP," as it's known, has brought pleasure and entertainment to visitors from all over the world, especially those who love Jimi Hendrix specifically, or who are music lovers generally, or, in particular, to children who are fascinated by the interactive technology offered inside.

"*The* Man" is how many of the music lovers who tour EMP refer to Jimi. "Coolest of the cool" is a description often heard there, especially from other guitar players or women who think Hendrix is "totally sexy." Visitors gaze in awe at such items as Hendrix's black hat, his embroidered silk kimono, and several of the exotic bracelets he collected. Guitars are to be found in abundance, particularly in the lobby, where an eye-catching tower of five hundred guitars is a focal point.

Paul Allen even has his own "Sky Church," quite unlike Jimi's "Skychurch." While Jimi envisioned an outdoor environment for his musical friends only, Allen's concept, which works well for him, is an impressive *indoor* concert stage in a space with an extremely high ceiling, adjoining the lobby, that can accommodate hundreds of people. Just looking at it, you know that the sound and lighting must be world class. On the downside is the $19.95 ticket price for

entry to the many displays. Most Seattle residents, especially kids from the Central District, have never entered EMP. "Too rich for our blood," a group of fourteen-year-old African-American boys told me. "Twenty bucks is hard to come by." Perhaps eventually Paul Allen and his EMP executives will establish a "locals day" or two each year, following the lead of such popular destinations as the Monterey Bay Aquarium in California.

§

THE FALL and winter 2001 art calendar in Paris was rich and rewarding, full of myriad and diverse high-quality exhibitions. The Grand Palais featured a homage to Pablo Picasso and Henri Matisse, a veritable sensory explosion pinpointing the marvelous growth and range of these two brilliant artists. A few blocks away on the rue de Rivoli at the Musée de la Mode et du Textile of the Palais du Louvre, visitors stood in line to view a remembrance of Jacqueline Kennedy.

Across Paris on the avenue Jean Jaurès, Jimi Hendrix was being honored in a comprehensive exhibition. Jimi, I'm quite sure, would think of it as extraordinary that a presentation focused on *him* would take place in Paris, one of the great capitals of the world and the city that had so impressed him thirty-five years earlier. Not to mention being honored at a time when Pablo Picasso, Henri Matisse, and Jacqueline Kennedy—all people he admired—were being celebrated.

It was Emma LaVigne of La Cité de la Musique, the cultural complex that encompasses both classical music through the centuries as well as contemporary music, who came up with the idea to honor Hendrix. The French had not forgotten that Jimi and the Experience got their start in France. Ms. LaVigne queried the Experience Music Project in Seattle about lending Cité de la Musique a variety of Hendrix items. The curators at EMP felt huge excitement about making a connection with such a prestigious venue and were cooperative in numerous ways. The event also seemingly

enabled EMP and Janie Hendrix to mend a few fences. This included Janie's lending some of her father's "Jimi stuff" for exhibition in Paris; she later allowed these artifacts to finally be shown at EMP in Seattle. As president and CEO of Experience Hendrix, Janie jetted to Paris early in the planning stages to ensure, a Paris television journalist told me, "that this place and these people knew what they were doing." He added, "I wonder if Janie Hendrix has ever considered how very lucky she was to be associated with so many professionals of taste and knowledge in France who worked so tirelessly to honor Jimi."

EMP "big boss," Paul Allen, contributed a sizable sum of money toward the French exhibition, which included prominent billboards placed throughout Paris. Allen's immense wealth has transformed the shy Seattle native and self-proclaimed "computer nerd" into a jet-setter who owns fabulous villas, private jets, and a yacht and who enjoys mingling with film and music stars, often hosting lavish junkets and parties so that he can meet everyone from Mick Jagger to Clint Eastwood. However, at the gala October opening evening reception of the Hendrix exhibition in Paris, Allen was nowhere to be found. Janie Hendrix had the spotlight to herself.

I attended the Hendrix show weeks later on a cold December day, peering out of the taxi as it arrived at La Cité de la Musique to watch a gathering of Parisians admiring a poster of Jimi. Sentimentally, I wondered if any of them had seen the butterfly with a guitar in all his glory at the Olympia "back in the day."

It was the guest book in the foyer of the exhibition that got me. Scores of French admirers as well as visitors from other European countries and the United Kingdom had taken the time to write down cherished memories and loving tributes to Jimi. A group of schoolchildren and I walked through together, inspecting five or six small rooms of "Jimi memorabilia." A noisy room with the door closed featured a film and light show. I took a peek inside; the only thing missing from that sixties feel was the scent of marijuana! The kids chuckled as they looked at several boyhood

drawings, including one of a cool young Elvis Presley in a red jacket. Items of Jimi's clothing were displayed in special cases; the last time I'd seen one of the shirts, Jimi had been wearing it. It felt weird and unsettling to view his clothes. He'd once casually said to me, in one of our far-ranging conversations, "You know, the moon is a dead servant." I thought of that interesting phrase now, looking at these items of apparel. But I had to laugh when I came upon a pair of cheap striped pants he'd bought in London in 1967; Jimi had hated them and tossed them out as soon as he could afford better ones. Subsequently Paul Allen had purchased the pants at auction for many thousands of dollars. Projected black-and-white photos flashed on a wall—Jimi as a child, some showing him full of energy and one haunting shot where he was a picture of alienated unhappiness. Leon was shown once; his father, Al, many times. Janie as a child, of course. Then, by some miracle, an image of Jimi's mother, Lucille, appeared, a flower in her hair. I had never seen this photograph before, but Jimi had described it to me—"It's my favorite picture of my mother. I hope I can get a copy of it." The handwritten lyrics on hotel stationery gave me a jolt. The last time I'd seen those pages was when Jimi had handed them to me in Los Angeles and New York—"What do you think? Be honest! Is it good writing?"

In Paris I was shown a letter received by a devoted fan of Jimi's, a Frenchman who was too young to have seen Jimi play but who spoke of him as "the man who changed my life." He had written to Janie with an idea of what he would like to do to honor Jimi; it involved the participation of Paul McCartney. Her lengthy, negative reply deeply wounded the young man. I gazed at the "Experience Hendrix" logo at the top of the page, featuring Jimi's face. I thought about how Jimi and Paul had respected each other, about how kind in how many ways McCartney had been to Jimi and the Experience. I remembered the delight in Jimi's voice as he recounted how he'd admired a custom-made jacket McCartney was wearing and that the Beatle had insisted Jimi should have it. "It

even had his initials inside!" Jimi declared. I also thought of Jimi's appreciation of Paris and the warmth he had always shown his fans.

Three days later I attended "Jacqueline Kennedy: The White House Years," a touring exhibition assembled with grace and integrity by fine curators under the supervision and loving eye of Caroline Kennedy Schlossberg for the John F. Kennedy Library and Museum in Boston. This was a beautifully assembled display of fashion, charming art and sketches, handwritten letters and details of the White House restoration by America's beloved first lady; it showed her heart, her mind, her original style. The French, despite the rain that Sunday, turned out en masse, with visitors driving or taking the train to Paris just for this exhibition. It had two things in common with the Hendrix tribute: The visitors were quiet and respectful, and the guest-book messages here, too, were filled with love. For both Jimi and Jacqueline, hundreds of men and women had inscribed touching sentiments. The common theme was simply "We will never forget you."

§

JANIE HENDRIX fell in love with an attractive black vocalist and guitar player, Sheldon Reynolds, who became known for his work with the Commodores and later with Earth, Wind & Fire. The couple married in a relatively small but lavish marriage ceremony in Hawaii. Talk circulated around Seattle that Janie had presented her new husband with a large cash wedding gift. Even before Sheldon left Earth, Wind & Fire, the new Mrs. Reynolds had added her husband to the Experience Hendrix payroll.

Juggling the time-consuming business of Jimi Hendrix with her role as mother and new bride, Janie's schedule became increasingly hectic. She had less time to drop by and see her father, and when she did find time to be alone with him, the conversation tended to be about assorted legal situations. It was never a secret within the family or in his neighborhood that Al Hendrix had

problems with alcohol as well as with an ongoing heart condition. "Sometimes he'd feel depressed and even downright lonely," a former neighbor in the Skyway residential area, recalled. "Then there were days when fans would knock at the door and treat him really nice, very respectful and all. If he were in a good mood, Al would invite them in and show them what he liked to call 'Jimi's Bedroom,' a sort of a showcase of posters and pictures, a big bed, even a pack of cigarettes on the nightstand. A little strange really, because although it was Jimi Hendrix's money that paid for the house, he was already dead. From what June had told me, Jimi the rock star was only ever in their place in the Central District on Seward Parkway." She also mentioned Al's assorted girlfriends and the daughter born to one of them. "Al never denied being the father and put out quite a lot of money for the child and her mother."

Janie ensured that nurses and medical technicians gave her father all possible care during hospital stays and at home, according to a Seattle source who visited him in February 2002. He felt that while Al suffered from what he termed "borderline senility," he also enjoyed periods of great lucidity. "He still got revved up about money; he talked about how rich he was. But he also seemed to enjoy telling me about his old gardening days. He told me that he hadn't really worked in many years. I wondered if he missed the time when he was in control of his life. Many elderly people do. Mainly, though, I came away thinking of him as lonely."

It became apparent in March that Al Hendrix was fading. Vigils were held for several weeks, at Janie's direction, and according to testimony and court records she gave instructions that Leon was not to be advised of Al's condition or allowed contact with his father. It wasn't until the day before Al died that Leon was given permission to visit his father.

Father of Guitar Hero Dies at 82—this was a headline in the April 18, 2002, issue of the *Seattle Times*. As was the case in the death of his estranged wife, June, James Allen Ross Hendrix's

obituary contained the by-now-customary "spin": "It was Mr. Hendrix who introduced his son to music."

The news story said "poor health forced Mr. Hendrix to retire from his landscaping job in 1979," some twenty-three years before his death, and that he was "remembered as hard-working and religious." Janie was quoted as saying, "When people asked me what Jimi would be like today, I told them to look at my dad. Jimi was so sweet and softspoken and wise beyond his years—just like my dad."

The story explained that after the settlement of Al Hendrix's lawsuit against Leo Branton in 1995, he transferred control of Jimi's estate to Janie. Janie was further quoted regarding her adopted father: "Everybody who met him was touched by his kindness."

Surprisingly, although her grandfather refused to publicly acknowledge her as kin and didn't want to hear about the "new-fangled" DNA testing, Tamika, now a thirty-five-year-old woman, was allowed to attend the funeral. Days later Janie proclaimed to the press, "Everyone loved my father. Around the world! He's just a universal granddad!" Her deification of her adopted father, however natural, has been heartily debated by a range of Seattle residents, some who'd known the young Jimmy and others who think of the ongoing dramas of the Hendrix family and attached international press coverage as a tacky soap opera that is an embarrassment to Seattle.

Local papers handled news involving the Hendrix family after Jimi's death with kid gloves—although several honorable reporters were and continue to be made aware by a wide range of sources of the backstory. Their editors gracefully allowed a certain amount of spin. It is fair to say that the newspapers were generally more than honorable in not dishing the dirt and never stooping to tabloid levels regarding the reinvented Jimi Hendrix and the infighting over money. The policies of the major Seattle press did not signifi-

cantly change after Al Hendrix's death. They objectively published only the facts. And the latest facts were startling.

On August 16, 2002, Leon Hendrix filed a lawsuit in Seattle alleging that he had been denied his rightful inheritance by his father and that Janie Hendrix used "undue influence" in overseeing Al Hendrix's will and living trust, signed by Al while a videographer captured the event.

Lance Losey, one of several attorneys representing Leon, stated, "We believe that had Al been in full possession of his faculties and full possession of all the facts . . . he would not have disinherited Leon as he appeared to do. The bottom line is that we believe this will is more the will of Janie than it is the will of Al."

Leon's only bequest from Al Hendrix was a gold record to be selected by Janie.

In a rebuttal to Leon's suit, Experience Hendrix stated, "This is the latest attempt of Leon to capitalize on Jimi's fame and legacy." The principals, Janie Hendrix and Leon's cousin Bob Hendrix, further commented, "The pleadings reflect the sad story of a man who has made many bad choices in his life, is unhappy with the natural consequences of those choices and continues to lay the blame at the feet of others."

After Al Hendrix and Janie began rolling in dollars from licensing Jimi Hendrix to MCA in a deal worth many millions, Al was generous with "his family" while ignoring Jimi's mother's family, especially Dolores Jeter Hall Hamm. Lucille's sister had been considerate of Al in a variety of ways, both while he was in the army and afterward, when he returned and needed a place to stay. Often it was Dolores he turned to when he didn't have a job. She'd fed Al and looked after his two sons on many occasions. Several of Jimi's Jeter cousins and other relatives could have used a better living situation and had hopes of being offered a job at Experience Hendrix. No gracious gesture, no helping hand was extended. Each time Al showed a lack of respect for Jimi's mother's

family, he disrespected Jimi. His Jeter connections mattered to Jimi. Even at the ongoing Jimi Hendrix exhibition at EMP in Seattle, with many photos and artifacts loaned by Janie, the Jeter family is barely in evidence. In the matter of Al Hendrix's will and living trust, there was no bequest for Dolores Jeter Hall Hamm or for any other member of Jimi's mother's family.

Janie continued to snipe publicly at Leon and again claimed that Leon was not the "natural" son of Al Hendrix. She took shots at the troubled lifestyle of the late Lucille Jeter Hendrix. Whatever the truth may be, Al Hendrix often spoke of Leon as his own son, including in previous wills.

What Janie had no way to know was that in the last months of his life, Jimi Hendrix had spoken to me in detail of the life his mother had lived. In discussing his family relationships, he went as far as to say, "There's a good chance Al isn't really my dad." I understood that he felt hurt by his father's seeing him as what Jimi termed "a money machine." Still, I had also seen photographs of Al Hendrix, and I saw a certain resemblance between the two men.

Leon, as Jimi had feared, did not fare well under the shadow of a famous brother. Several years after Jimi's death, Leon became a druggie. His life went through a series of ups and downs. At one junction, Leon seemed to be following his father's early path, working at odd jobs. A sometime friend of Leon's told me that there used to be a joke that went, "Want to meet Jimi Hendrix's brother? All you have to do is call and order." This was when Leon was working as a pizza deliveryman. Leon married and eventually became the father of six children, but his family life was disrupted when his drug problems escalated to the point that he was sent to prison. In the late 1990s Leon pulled himself together, entered rehab and began to take guitar lessons and study music. He was realistic about not expecting to follow in Jimi's footsteps. "I love music, and I work at it every day, practicing and writing songs," he told me. "I've been clean and sober for more than six years.

I always had a strong creative force inside me, from the time I was a little kid, but it wasn't encouraged. But now, I swear, I am *focused*! I hope you'll listen to my tapes. And you can be honest with me. I know they're good, maybe not great, but good enough that I'm not ashamed to have you listen."

Many of Leon's musical and other expenses have been bankrolled by Craig Dieffenbach, who began working with him in the nineties as an adviser and business manager. Dieffenbach is a bright, amiable divorced man with an eight-year-old daughter he adores. Years back, he says he, too, had substance-abuse problems. He worked to turn his life around, eventually to make several million dollars selling his interests in SeattleOnline.com, which he founded, and through his savvy as a real estate developer in Washington state. Dieffenbach owns several large buildings, and his associates say he's an easy touch when he comes across someone with a problem, even going so far as to pay for serious, necessary, and expensive dental procedures for someone he barely knew. Certainly he's taken some huge financial risks in his relationship with Leon Hendrix.

§

I HAD SEEN Billy Cox only a couple of times after Jimi's death, once when he appeared at the Whisky A Go-Go in Hollywood, when he was playing bass with Charlie Daniels's country music band. In January 2003 I spoke again with Billy, who has lived for years in Nashville. "I don't really care about the music industry these days," he said, "and I'm not interested in being on the road. I *never* liked all that. I had a rough time after Jimi died." In the seventies Billy went back to college "so I could make a living. I turned my back on music."

I told Billy that I had never forgotten the look of pleasure on Hendrix's face when he told me about meeting Cox early in 1962 at Fort Campbell, Kentucky, and that Jimi had always remembered

Billy's first words to him: "You're very talented." I reminded Billy that he'd once declared with certainty that God had "sent Jimi as a special messenger."

"Do you still feel that way about Jimi?" I asked now.

Billy took his time; I understood that it was painful for him to speak of Hendrix, to go back and dredge up memories that perhaps he'd tried to put to rest for his own peace of mind. "Yes, I do," Billy said. We talked briefly of Billy's hurt that he had "not been wanted around Jimi by certain people." Finally Billy said, both sadly and bitterly, "Jimi was under the assumption that if you were a good player people would treat you good. He was taken advantage of over and over. He was naïve."

§

NOEL REDDING died alone at home in Clonakilty, Ireland, on May 11, 2003. His mother, Margaret, had passed away a few weeks before. Noel took the loss hard, for she'd always been his staunch supporter, in good times and bad.

Like Experience fans throughout the world, I was very sad when I was told the news. It seemed to me as though Noel had simply worn himself out. Noel's friend and close associate Ian Grant, who heads a new version of Track Records in England, has hopes that Noel's Irish home will one day be turned into a music museum.

Admirers around the world reacted with sadness and shared precious memories of the Jimi Hendrix Experience for weeks and months after Noel's death. I remembered that in one of the last conversations I ever had with Noel, he spoke of how he now wished he'd been more comforting to and supportive of Jimi when the subject of Ed Chalpin had come up. "You know, love, at first I thought it was just Jimi's problem. But now I see how that cheap little recording contract affected our band in so many ways for years. Now I know all about hurt and disillusion . . . disappoin-

ment. I wish I hadn't been so caught up in myself then. I should have given James a big hug more often."

We were both on the edge of tears as I told Noel how terribly upset Jimi was those last days about the English court proceedings Chalpin had instituted.

§

IMPULSIVELY, ON the morning of June 11, 2003, I spent an hour tracking down the current New York telephone number of Ed Chalpin, the somewhat elusive music producer and publisher, who has made it a practice to keep a low profile. The day unfolded with the slyness of a Molière play. I phoned Chalpin's office and spoke with a polite woman who declared that she was "only a temp" and didn't really know Mr. Chalpin, that he wasn't in, and she wasn't exactly sure when he would arrive. I gave her my name and number and told her that I was writing a book and wanted to speak to Chalpin.

I called back an hour later, and the same voice on the telephone gave me the "temp routine" again. I could hear a man's voice in the background, and suddenly I realized that this routine was undoubtedly standard procedure in Chalpinland. He must have many callers he wanted to avoid. As the woman went through her little "I know nothing" routine, I had to laugh. "You are a *wonderful* actress," I said. "You're *not* a temp. You sound far too savvy! I'll bet that you've worked for Mr. Chalpin for years." *She* had to laugh, too. "Well . . ." she said. She put me on hold and came back on the line to ask, "Are you with Warner Bros. Records?"

I was puzzled by this. "No, I'm not."

"You're *sure*?" she asked.

"As I told you, I'm a writer. The number I gave you is my phone at home, hundreds of miles from Warner Bros."

Apparently now curious, Chalpin actually got on the phone

for a few minutes. I volunteered to fax him my personal biography immediately so that he could see for himself I had no affiliation with Warner Bros. He seemed satisfied with this idea, but he did not phone me back, as he'd said he would. I wondered why, after all these years, Chalpin was that nervous about Warner Bros. Records, so I telephoned sources in Los Angeles and New York. They told me that although Chalpin had received "substantial money" from Warner Bros. since 1967, they had continued to war since Jimi's death.

By 3:40 P.M. on the West Coast, I was extremely annoyed that Chalpin had never called me back as promised. Suddenly I remembered that he and I had a mutual acquaintance, a tough and powerful man who used to tell me, while I tried not to giggle, "It's *so* lonely at the top. *You* can't imagine. When I sit in my office at the end of the day all alone, sometimes I could almost cry."

I dialed Chalpin's number—and bingo! No "temp," just Ed Chalpin himself answering his own telephone in New York at the end of the day. For two hours he talked, talked, talked while I listened, listened, listened. Chalpin was a spellbinding orator—and operator.

Chalpin told me that Warner Bros. "owes me money, and they're stonewalling." He told me that he hated Al Hendrix's former lawyer, Leo Branton Jr. "That guy built a smoke screen around what he was up to and had the nerve to paint *me* as a villain." He said even worse things about little Janie Hendrix, president and CEO of Experience Hendrix.

"It sounds as if you don't like her," I said facetiously.

"Well, you know we've been in court in England," Chalpin said, as if the entire world were keeping tabs on his years of litigation. I was aware that Experience Hendrix had sued Chalpin and his PPX Enterprises in England the previous year, claiming that he'd breached a 1973 agreement with Leo Branton concerning the release of recordings from Jimi's time in the studio with Curtis Knight in the midsixties. Experience Hendrix won a partial victory

in the English High Court proceedings, and Chalpin had been upset over the judge's decision that he pay a large portion of the court costs, although PPX was given the right of appeal.

"I'm calling you about music, not lawsuits," I told him, because I just didn't want to hear about one more damn lawsuit involving Jimi's creativity.

"One thing I'll give Janie," Chalpin said. "It was quick-witted of her to take on Branton. . . ." Though the remark seemed complimentary, his tone implied that Janie Hendrix had not heard the last of him. Everyone who'd had dealings with Ed Chalpin understood that he, too, was "quick-witted."

Then he launched a spiel about his "warm relationship" with Jimi, claiming that he was the one who'd introduced Jimi to his pioneering recording techniques. He told me, "I taught Hendrix about overdubbing. After he was famous, he came into my studio and did some work on the records he owed me. He couldn't have been sweeter. We had a good time; he was so enthusiastic. He even drew a cartoon for me." Poor Jimi, I thought as I listened, remembering how he'd tried so hard to keep it all cool so that the lawsuits would cease, so that his music wouldn't suffer. Chalpin went on and on about Jimi, and suddenly I heard myself interjecting, "But *that's* not what Jimi said."

Chalpin reacted instantly; his tone of voice was abruptly sharp and close to stunned. "Not what *Jimi* said! What are you telling me? Did you *know* Jimi Hendrix?"

"Yes," I said calmly. "Quite well."

He asked for details, and briefly I told him about Les Perrin's introducing us and telling me, "Jimi could use a friend." My impression was that Chalpin knew who Perrin was and that maybe he could now trust me after all his concerns that I was a Warner Bros. spy.

"So you were one of Jimi's girlfriends?"

"Girlfriends came and went," I said. "I was . . . uh . . . a real friend."

"A *friend*," he repeated. In a tone of genuine sensitivity, Chalpin said, "Yes, he would have *needed* a friend."

He told me about his wife and his two young children who lived in Switzerland, where the wife had other children by a former marriage. Ed Chalpin wanted to clear up that villain image Branton had given him, he said. "I want my kids to be proud of me." He asked me about my thoughts on whether he should hire a PR person.

He discussed his image as a "litigious character" and told me of the many people he'd had to sue through the years, "because that's the nature of the business." He moaned about how expensive lawyers were. He even mentioned that he had "eighty volumes of legal papers to do with Hendrix."

Chalpin told me that he and Jimi had planned to work out a settlement of their legal differences in September 1970. This is not how I remembered those difficult days. I well recalled that Chalpin had a hearing scheduled for the English High Court in September 1970. I asked him for more details of his conversation with Jimi about this alleged settlement. He hedged and finally admitted that he hadn't personally spoken to Hendrix on this subject and that he had in fact only arrived in London on Friday, September 18, the very day that Jimi died. "I saw the newspaper headlines," Chalpin commented, "and I said to myself, 'They've killed him!'"

I wondered as he spoke, Is this the original perpetrator of the "Jimi was murdered" conspiracy theory that has been bandied about for years, with no sound basis?

And here is Ed Chalpin some thirty years later. Like the Energizer Bunny, he kept going and going and *going*. He sounded relieved when I changed the subject, away from that miserable September.

I asked him about Curtis Knight, who had originally introduced Hendrix and Chalpin in 1965. "You know," Chalpin said, "when Curtis and Monika Dannemann became tight in the seventies, he brought her to my office and she asked me to become her manager."

Now, there was an offer that must have been easy to refuse, I thought. "Ah yes, Monika," I said. "The skating champion . . ."

He laughed and then surprised me once again. "*I* used to be a champion skater, and I learned from skating that it is not fun to cheat to win."

I asked him to clear up an amazing rumor I'd been hearing for some time. "It's the wildest thing," I declared, "but I've been told that *you* are now in charge of Mike Jeffery's estate."

He proudly assured me that this was true. "When Jeffery died in that airplane explosion in 1973, his estate went to his parents, Mr. and Mrs. Frank Jeffery. The mother died, and when Jeffery's father died, the estate was left to fourteen charities. I went to those charities and said that I could help them make a bigger profit on the assets of the estate. So yeah, I handle things."

Theoretically, Jeffery and Chalpin had been archenemies while Jimi was alive, and Mike had savvily used Jimi's fear of and disappointment in Chalpin to shore up his position as manager and "protector." Jeffery would be outraged that Chalpin had delivered the final coup de grâce.

§

THE SUMMER of 2003 saw the drama of the suits and countersuits between Leon Hendrix and his father's adopted daughter Janie continue. A story in the *New York Times* circulated across America and around the world. There had been a time when Jimi Hendrix's name was mentioned in the *Times* only for his talent. Now it was about the marketing of Jimi Hendrix air fresheners and Jimi Hendrix golf balls and how much his "sister" was worth and how his brother was cut out of his father's will. As the family fought in the glare of the spotlight, Janie Hendrix, who was so concerned about Jimi's image, now had her hands full regarding her own. The CNN appearance of Leon and his lawyer on one half of a split screen with Janie and her lawyer on the other half, being interviewed from separate places, shook up longtime fans. "I love Jimi

Hendrix for his music," a London taxi driver told me. "I used to queue outside the clubs when Hendrix lived here. I heard him play three times, and I'm glad he's somewhere that he doesn't have to see how his relatives are behaving."

New Hendrix Memorial Could Play to Big Crowds
Rock Icon's Remains Moved;
Lavish Renton Plot Nearly Finished

This was a headline in the *Seattle Post-Intelligencer* in early 2003. Janie had secretly moved Jimi's body, which came as a terrible shock to his brother Leon. "We have Indian blood," Leon said. "Indians do not like to be moved." Janie arranged for Al Hendrix and his mother, Nora, and her own mother, June, also to have resting places in the custom-designed burial vaults beneath a thirty-foot-high granite dome supported by three pearl gray granite columns trimmed in what she described as "rainbow marble." Janie, too, expects to reside near Jimi when the time comes.

On an October visit to Seattle, hurrying out the door of Nordstrom's Rack, a bargain hunter's paradise, I inadvertently bumped into an elderly woman with a cane. She was waving good-bye to another older woman just outside the store entrance. Apologizing, I took the opportunity to ask the lady with the cane if she could direct me to a bus that would stop in the Pioneer Square area. She gave me full instructions. Slowly, we walked down the street together in the afternoon sun, unusually hot for an October day in the Northwest. We introduced ourselves. "I'm Ruthie," she said. "I've lived here for a million years! Well, ninety-one, to be exact." She told me that she and her friend had spent late morning "at the cemetery out in Renton." As the sun beat down, I started to feel thirsty, and on impulse I asked Ruthie if she'd like a cold drink. Soon we were inside one of the dozens of downtown coffee shops. My new friend told me about growing up in Seattle and said that she still lived in the family home not far from Garfield High School.

We talked about Mount Rainier and the Cascade range and

local architecture, but I kept thinking how odd it was that this stranger, in the space of less than ten minutes, had mentioned subjects that resonated with regard to my friend Jimi. She was a white woman who probably didn't even know who he was, but I gave it a small try. "I wonder if you ever knew anyone named Jeter?"

She thought about it and said, "Of course. But you're too young to know of the lady I'm thinking of. She's been dead a long time. She helped a friend of hers from their church clean occasionally for my mother when she was getting along in years. Clarice was her name. Clarice Jeter."

I was more than a little surprised to hear this name. Clarice Jeter. Jimi's grandmother.

"As a matter of fact," Ruthie continued, "I thought about her when we were out at Greenwood this morning. Greenwood is the cemetery. *That's* changed, too," she said. "People keep dying, and Greenwood keeps expanding. We left flowers on a friend's grave not far from the biggest, showiest place you've ever seen. Could you possibly imagine that Clarice Jeter's grandbaby is at the bottom of this towering hunk of marble? There's even a sign, 'Hendrix Circle.' I never knew that little boy, but I do know he became a famous musician."

"He was very talented," was all I said.

"Clarice had a number of children, I believe. I lived at home because I never married; I worked as a secretary until I retired. The only reason I had any conversation with Clarice is because a couple of times I drove her home."

Ruthie and I sipped at our cool lattes. "You seem like a nice person," she said, "and this might make you feel funny to hear it, since you're not from around here. But my friend and I almost wished we hadn't seen that expensive monument." She paused and seemed to be feeling some emotion, but she continued, "My mother told me that Clarice's youngest daughter had problems, and that she died too young. Her name was Lucille, and I thought

about her today, too, even though I never knew her. The terrible thing about going out to Greenwood today is that I recollected my mother telling me that Clarice's girl Lucille had been buried in the dirt in the part of the cemetery where they put poor people, and that there wasn't even a proper gravestone for her. It's so far from the fancy monument we saw that I couldn't possibly have walked there. Very far from her boy. No room at Hendrix Circle, it seems. But next time my friend and I go out to Renton, we will have someone help us find Lucille's resting place, and we will take roses from my yard and pay our respects."

§

LEON HENDRIX and the board of directors of the James Marshall Hendrix Foundation had long planned and advertised the annual Jimi Awards ceremony and birthday celebration to be held on November 21, 2003. Just days before the event, Janie tried to stop it from happening. According to music critic Gene Stout, reporting for the *Seattle Post-Intelligencer*:

> Operated by Janie Hendrix, Experience Hendrix controls the Hendrix estate, worth about $150 million to $240 million. It owns the name, image and music of Jimi Hendrix.
>
> The company had sought to prevent the use of the name James Marshall (Jimi) Hendrix Foundation and to have all money received by the foundation placed in a trust. Experience Hendrix had also asked that the organizers of the Jimi Awards publicly state that the event was in no way affiliated with the Seattle company or with the late Al Hendrix.
>
> But Leon Hendrix, who is suing Experience Hendrix over a claim that he was denied a rightful inheritance from his father's estate, has said that Al Hendrix gave him permission in 1988 to use Jimi Hendrix's name for non-profit charitable causes.
>
> In addition to celebrating Jimi Hendrix's Nov. 27 birthday, the Jimi Awards will help the foundation raise money to

restore Jimi and Leon's childhood home, as well as improve the lives of needy children and their families . . .

U.S. District Court Judge Thomas S. Zilly denied the temporary restraining order and preliminary injunction that Janie had asked for in an attempt to see the event canceled. In his ruling he said, "The plaintiffs have not acted in all respects in a prudent way here in waiting so long, and then at the last moment attempting to derail a charitable event. . . . What I believe strongly on the facts I have seen is that what the plaintiffs have done here is done at the last moment for purposes of attempting to disrupt an otherwise planned, long planned event, to their benefit. And it's unfortunate, it's tragic really, that this family and its various parts could not and have not been able to live out the Jimi Hendrix legacy in a more positive way."

§

ON FEBRUARY 9, 2004, two more people joined Leon in one of several lawsuits he filed against Janie Hendrix. In the matter of the "Revocable Living Trust of James Allen Hendrix," a "joint joinder and cross petition" brought (Janie's sister) Linda Jinka and Diane Hendrix-Teitel (sister of Robert Hendrix and cousin of Leon and Jimi) into the fray. They had never received a penny from Al's trust, which during his lifetime he had spoken of as his "gift" to the beneficiaries.

The plaintiffs requested of the Superior Court of the State of Washington for King County the following:

— that the court remove Janie Hendrix as trustee of the revocable living trust of James Allen Hendrix and appoint a professional trustee in her stead

— that the court remove Janie Hendrix as personal representative of the estate of James Allen Hendrix, and appoint a substitute personal representative in her stead

— that the court remove Janie Hendrix and Robert Hendrix

from management positions within Experience Hendrix, Authentic Hendrix, Axis Inc., Bodacious Hendrix, or any other Hendrix-related business entity

— that the court order Janie Hendrix and Robert Hendrix to personally pay to petitioners and other beneficiaries of the James Allen Hendrix estate damages and restitution for their multiple breaches of fiduciary duty, and to reimburse the estate for the costs they have incurred in the furtherance of this litigation

Linda Jinka, a mother and grandmother, sadly told me about her "mixed-up" relationship with Janie, whom she met for the first time when Janie was three years old, after June, their mother, had left her husband and the older children. "Janie was my little sister. I loved her." Linda tried to be as positive as she could be about the president and CEO of Experience Hendrix, even after she was aware that Janie had "absolutely trashed" her in trial depositions in early 2004. "You see," Linda said, "Janie believes she's worked for all that she has. She *fought* for the Jimi Hendrix rights she controls. She did what she wanted to do, had to do, because Al couldn't do it. He didn't know how." Linda was about twenty years old when she met Jimi Hendrix in 1968, but unlike others her memories of Jimi have not expanded over the years. "We thought it was very exciting to meet him and to suddenly have a star in the family," Linda said. "Jimi seemed to be a nice person, but we really didn't know him."

What deeply bothers Linda is that now a wedge has been driven between her and her other siblings, who are also beneficiaries of trusts set up for them by Al Hendrix. Some Jinka family members are on Janie's "fulfillment department" payroll, and they need their salaries to survive.

Linda told me that she had no genuine "family feeling" toward Bob Hendrix. "He's never, ever given off much warmth," she said quietly. "It's difficult for me not to feel resentment toward Bob; he has not acted honorably as a trustee."

Linda Jinka is wrapped up in dismay over this unhappy situation; she's hurt, and it shows, but it's no pleasure for her to talk against Janie. However, if Linda is perhaps appealingly soft, Jimi's cousin Diane Hendrix is strong.

For a short time, Jimi lived with his younger cousins Diane and Bob in the home of their parents, Al's brother Frank, and Frank's wife, Pearl. I remember Jimi telling me briefly about "my little cuz Diane." Diane told me that the last time she had seen Jimi, all grown up and a rock star, was when he played Vancouver in 1968. A year or so later, Diane and Jimi spoke on the phone several times; one of those conversations was about Jimi's taking some time off and "hiding out" in Vancouver.

Diane, who worked for a number of years in New York City, has returned to Washington State, where both she and her husband are ministers. She is hopeful that when this unhappy situation is resolved, she will be able to work with her cousin Leon to accomplish charitable good works on behalf of the James Marshall Hendrix Foundation, where they are both on the board of directors. "My cousin Leon is a sweet, sweet guy," she said. "Only now does he seem to be coming to terms with his life. He's more than fifty, and he's still growing up, but I am counting on him."

David Osgood is the young Seattle lawyer who represents Linda Jinka and Diane Hendrix. His colleagues respect Osgood, and in my conversations with him, I understood why he was described to me as "an objective, capable, honest attorney."

"What I hope to accomplish," he said, "for Linda and Diane is to get Janie and Bob off those trusts and out of control of this company."

So if this were to happen, who would run Experience Hendrix?

"Ideally," Osgood said, "someone with business-management experience who will run it for the benefit of all the beneficiaries and family members." He seemed quite certain that justice will prevail. "Not only will the judge take all the facts and evidence into consideration," Osgood said, "but the legal standard has to be

taken into consideration. Trustees have an absolute duty, to take care of the beneficiaries. That is called a fiduciary duty, and it means you can't use your position of authority to enrich yourself. Your duty of loyalty is to the beneficiary above anyone else, including yourself. And if you put yourself in a position where you stand to gain and the beneficiary does not by virtue of your representation, it's your duty to resign. The duties are so clear as a matter of law."

This particular February was perhaps the most stressful one in Janie Hendrix's entire life. Her public image was increasingly shaky, and her lawyers were working overtime on legal strategies to fend off Leon, her sister Linda, and Bob Hendrix's sister Diane. Janie hit the spin button; she and her husband, Sheldon Reynolds, assembled a three-city concert tour, titled "Celebrating the Music and Legacy of Jimi Hendrix." Opening night was in Seattle, and then the tour moved to Portland, Oregon, and then on to San Francisco, where Jimi had been loved from the very beginning of his American breakthrough.

I flew into Seattle three days before opening night. The day before the show, I spoke with two middle-aged musicians who had once known and participated in some elementary jamming with the teenage Hendrix. They wouldn't be attending the event, they told me.

"It's not meant for people like us," one of them said forthrightly. "It's a Janie thing."

I debated these words throughout the concert, held at the Paramount, a beautifully restored Art Deco jewel box of a theater in downtown Seattle. The air was ripe with excitement this Sunday night, and the concert promoter, Janie herself in a new role, had stationed a large table in the lobby, manned by a friendly staff of young men who were selling a variety of Experience Hendrix items to eager customers. For those who had paid approximately fifty dollars a ticket and also wanted Hendrix merchandise, it was a pricey evening. One thing was free—the famous Experience Hen-

drix catalog chock-full of Jimi items for all ages. I struck up a conversation with a young woman who stood watching the sales staff arrange piles of merchandise. Her husband joined her. "I got a really good parking place, baby," he said. "A free spot!"

She grinned up at him and explained to me, "A hundred dollars for two tickets is a whole lot of money to us. But Jimi's worth it."

The audience of perhaps fifteen hundred people was treated to more than three hours of exceedingly loud music, minus intermission. The show kicked off with Sheldon Reynolds's rendition of "Foxy Lady." At the end of the song, her husband announced "this goes out to Janie." I found it surprising that there was not a wonderful photograph of Jimi to be seen on the stage, no flowers, no brief words as to what was rare and special about him. More Jimi songs followed. He'd told me so many times, "Now, remember, it's all about tones." Tonight it was more about *loud.* Then the lady herself, Genevieve Jinka Hendrix Wright Reynolds—Janie—walked onstage. Oddly, Janie, who had expounded at length about her childhood recollections of Jimi, hardly mentioned him this night. Now in her early forties, Janie preferred to offer a loving tribute to Al Hendrix. The short brunette president and CEO of Experience Hendrix, tonight turned concert promoter, was wearing dark pants that ended just below her knees and high wedge shoes with leather-look laces wound around her legs. She also sported a colorful, probably expensive hand-screened top emblazoned with Jimi's face. Bob Hendrix, her vice president, wore a somewhat similar shirt and periodically played the role of overly enthusiastic cheerleader and wannabe rock star as real musicians came and went, including Vernon Reid and Living Color, and Double Trouble. Kenny Wayne Shepherd, in a heavily Hendrix- and Stevie Ray Vaughn-influenced performance, played with a passion Jimi would have appreciated. The audience, approximately 80 percent male, ranged in age from ten to seventy. Veritable claques in the crowd screamed and applauded for several local Seattle bands included

in the lineup. Mercifully, midway through the concert, Billy Cox and Mitch Mitchell appeared. Billy grinned widely, enjoying his recognition from the fans. Mitch, still slim and blond, displayed concern about the drum kit, which didn't appear to be up to his meticulous standards. Embarrassed, he stepped out front for a moment to quickly explain to the audience that there'd been little time for rehearsal at the theater. The lack of the solid introduction he deserved had some in the audience wondering exactly who Mitch was. Others weren't familiar with Paul Rodgers, the fabulous lead singer for those great British bands Free and Bad Company, when he joined Mitch and Billy in a rendition of "Angel." He encouraged the audience to join him in the chorus.

Buddy Guy, in his sharp green threads complete with matching hat, expertly performed on acoustic guitar on a low-down, dirty Chicago blues song. I left a little early, missing Buddy's rendition of Jimi's "Red House Blues" backed up by Mitch and Billy. The finale, according to newspaper critics, featured nine different guitar players working out on "Voodoo Chile."

§

THE THREE-CITY celebration of Jimi's music was a great accomplishment for Janie but afterward she sat on a very hot seat. Weeks turned into months of depositions, with more than forty witnesses telling their stories. A gentleman walking through a corridor of the building told a reporter that Janie Hendrix had rushed out of a room sobbing, telling one of her lawyers, "I can't afford to go to trial!"

The closely guarded (until recently) financial records of Experience Hendrix were now made public, showing Janie's extravagant lifestyle. What Janie didn't spend money on was her fiduciary duties as the lead trustee of Al Hendrix's trust. Two years after his death, the beneficiaries of his living trust had received nothing at all.

Messy Trial Over Jimi Hendrix Legacy Begins was a June 29,

2004, headline in the *Seattle Post-Intelligencer* as it all got under way.

An early witness was Yale Lewis, the lawyer specializing in intellectual property and entertainment law who had guided Al and Janie to their "victory settlement," testifying of his dealings with Janie from 1993 to 1995. He told Judge Jeffrey Ramsdell that even before the settlement, Janie was concerned about Leon's inclusion in Al's will and made it clear that she did not want Jimi's brother to be involved in the business of the estate in any way. "She was quite concerned," Lewis said, "that it be handled in a way that the legacy would stay in *her* line for generations, as she said was true for people like the Rockefellers and the Fords." Janie wanted her four children, he told the court, "to have those same benefits and legacy." Spectators were startled to hear that even before the so-called legacy was taken over by Al and Janie, she had dreams of her sons' being spoken of in the same breath as America's old-line billionaire families.

Leon's forty-three-page trial brief, submitted to the court by his lawyers Robert J. Curran, Lance L. Losey, and John P. Mele, is a fact-filled document that succinctly details the composition of the Family and takes the court inside the financial maze that came into being after Al and Janie founded Experience Hendrix in 1995.

During a trial that spanned several months, Robert J. Curran, lead lawyer for Leon Hendrix, examined and cross-examined a parade of witnesses to back up a major statement in the trial brief: "Both before and after Al's death, Janie disregarded every fiduciary duty she had and every responsibility as a corporate officer in order to live the extravagant life of a rock star. Although Experience Hendrix earned more than $48.5 million from 1995 through 2002, it spent about $49.54 million, for a net loss of about $540,000, over those years. At least $19.2 million of that was lost through waste and mismanagement."

Supporting documents showed that Experience Hendrix lost money on every business venture it entered into on its own. The

trial brief states, "Notwithstanding the business losses which piled up year after year, Janie and her fellow board members paid themselves exorbitant salaries and even more obscene bonuses. For example, Janie paid herself $672,800 in salary and bonuses in 2003. She paid her husband Sheldon a $4,000 per month retainer as a consultant. Company expenses included $34,128 per year auto payments made for Janie's investment-grade Mercedes. In total, Janie received over $4.1 million in compensation and benefits through 2003, with her spouse receiving an additional $250,000."

Janie, Robert, and Janie's niece Amanda also benefited from more than $1 million they voted to loan to themselves to pay off their home mortgages. Curran suggested that such funds could have been used to pay down company debt—or to distribute money to the trust beneficiaries.

"Janie, since day one, has treated Experience Hendrix as an ATM," attorney David Osgood told the court. "They will tell you that the income over the past few years earned them $47 million, but what they won't tell you is that they spent $48 million, which is a huge net operating loss."

There was snickering in the court when it was mentioned that Janie had charged more than a hundred beauty appointments at $500 each to Experience Hendrix.

"Their complaints," said Janie's lead attorney, John Wilson, "are with Al. They may think there were bad decisions, but they were made by Al."

Wilson painted a sad relationship between Al and Leon. He told the court that Leon's demands for money from his father increased, that he had a drug problem, and that Leon had skipped out on a criminal bond posted by his father.

Her lawyers made a point of mentioning to the press that Janie Hendrix was a "committed Christian" who regularly attended church.

Leon, lithe and slim like his brother, arrived early at the

courtroom each day of the trial, attending both morning and afternoon sessions. Dressed appropriately, with his gray-streaked dark hair in a neat ponytail, he looked younger than his fifty-six years.

Judge Ramsdell's courtroom in the historic old King County Courthouse, undergoing a lengthy major retrofit, is a pleasant, sunny space with its white walls and large windows. Two long tables are parallel to each other in front of the judge's bench. Janie Hendrix and Cousin Bob sat with their legal team at one table a few short feet from Leon and his advisers at the second. A third table forms the base of this U-shaped arrangement. David Osgood, representing a majority of the beneficiaries of Al Hendrix's trust, and Karen Bertram, counsel for Leon's children, sat here, surrounded by a backdrop of heavy legal binders containing trial exhibits and documents. The courtroom holds no more than seventy-five spectators. One regular attendee was Janie's tall, attractive husband, Sheldon Reynolds, who throughout the day supplied her with paper cups of coffee and soda and periodically glared at Leon and his lawyers. Janie's brother Willie and her sisters Donna and Marsha attended the proceedings on occasion; they were the only three beneficiaries of Al Hendrix's trust who did not join the other beneficiaries in the suit against Janie and Bob.

Before the trial started, Jackie and Frank Hatcher joined Linda Jinka and Diane Hendrix-Teitel as clients of attorney David Osgood. The Hatchers are the grown children and heirs of Al's late niece Gracie, a beneficiary in Al's trust. On the witness stand, Jackie Hatcher identified family photographs and recalled the days when Jimi and Leon lived with their family. She spoke matter-of-factly of "haves and have-nots." With quiet dignity she made it clear that poverty had always been a way of life for her family. Her mother had been named a beneficiary of Al's trust, and she told the court that Al had been generous with Gracie, giving her a $500 monthly check to live on. When Gracie was struck down with cancer and unable to afford fine medical attention and necessary

prescription drugs, Al Hendrix told the Hatchers, "Talk to Bob." But no help was forthcoming from Experience Hendrix. In his heart-wrenching testimony, Gracie's son Frank, who dropped out of school to take care of the dying Gracie, talked about her last days. "Mama died in poverty in the projects. She didn't have the money for a real hospital." Nor could the Hatchers afford a proper burial for Al's trust beneficiary Gracie. They contacted Bob Hendrix again. He and Janie agreed to do a "loan note" for $10,000 to be repaid to Experience Hendrix at 6 percent interest.

On a July afternoon, Joe Alan, a longtime friend of Leon's, was called to the stand and thoroughly questioned by Janie Hendrix's lawyer John Wilson. Wilson wanted to know if there had been talk when they were young boys as to Leon's parentage. Hadn't there been rumors that his mother had "been with another man" before Leon's birth? Alan was uncomfortable, embarrassed. He conveyed that Leon's friends thought of Al simply as "Leon's dad."

As I sat in the courtroom that day, I saw Janie and Cousin Bob fix their eyes on Leon, sitting just four feet away, as he was cross-examined by their lawyer, John Wilson. Leon maintained his composure as Wilson briefly commented on his mother's personal life and as the lawyer smilingly, pleasantly attempted to make it clear that Leon was not really a Hendrix.

Each day of the trial, an assortment of Hendrix fans would drop by outside the courtroom, eager to hear what had been happening inside. I watched several men in their thirties and forties approach Leon as he stood by the elevators shortly after Joe Alan's appearance on the stand. "How's it going, Leon?" they asked with concern. He forced a smile. "Okay," he said. "Okay." He paused in reflection, then smiled pensively at me. "I've got Jimi, and I've got my mom." He spoke as though their memories were talismans that would get him through. No matter how hurtful Janie and her lawyers were, he was not alone.

I asked a lawyer who attended the trial but who did not

represent Leon Hendrix what he really thought of Jimi's brother. I was blunt. "Is he a disgrace? Is he bad news?"

I was surprised by the answer from this conservative-appearing attorney. "Frankly, I don't think he's led any different life than any other child thrown into the foster-child system," he said. "There are reasons for why he has had such a difficult life. I believe that any adult has to take responsibility for himself. That can take a long time for many of us. Leon Hendrix strikes me today as a very nice man."

Up the hill near the courthouse are the aging, somewhat depressing Yesler projects, one of the many places young Jimmy Hendrix had lived in the shabby neighborhoods of the Central District. In 1968 he had summed up his memories in these matter-of-fact words: "There was nothing there for me. . . ." No one in those neighborhoods could ever have guessed that Jimi would grow up to accomplish a great deal in a short time. Now, all these years later, his legacy had turned into a battle that would surely have caused him intense pain, anger and humiliation. There is an incredible irony in the fact that money *his* talent has generated was spent in 2004 to pay lawyers representing Janie Hendrix and Experience Hendrix to discredit and disrespect the little brother he loved.

In the fourth week of the trial, Jas Obrecht, a respected journalist who was the longtime editor of *Guitar Player* magazine and who currently is a professor at a Michigan community college, took the stand. Obrecht told how excited he was to receive a call from Janie Hendrix "on September 18, 1995, the twenty-fifth anniversary of Jimi's death." Janie said that she would like him to write an authorized family biography, working on it with Al Hendrix. Obrecht said, "Jimi was my boyhood hero, and I felt honored to have the opportunity to meet his father." He told her that he would prefer to do an "as told to" format book.

A few days later he flew to Seattle, where Janie personally

picked him up at SeaTac Airport. She also took him to lunch and made certain things clear to him during the meal, he testified. Janie wanted him to understand that Leon was not Al's son, not Jimi's brother, and that the two boys were not close as children. Janie told him that she was Al's daughter and Jimi's sister, and she told him not to ask Al if Jimi had any children.

Obrecht ultimately participated in seventeen meetings with Al Hendrix at his home and spoke frequently to him on the telephone for the book, which was titled *My Son Jimi*. He told the court that at an early meeting with Al, he was shown a box of Jimi's childhood drawings and was horrified to see Janie, who was eating a greasy snack, carelessly handle the aging paper so that grease spots were left on the edges of some of the artwork.

During the almost four years he was in contact with Al, Obrecht testified that he noticed a great change in Al's health and demeanor. "He slowed down as if he might have had a stroke." Obrecht sounded sad as he said quietly, "On the phone he seemed befuddled, as though he was not sure who I was. The book took so long because of Al's inability to read beyond a fifth- to seventh-grade level. Finally my wife read the manuscript onto a tape so Al could hear it."

Al told Obrecht that he went into the Experience Hendrix office on Mondays and signed whatever Janie and Bob wanted him to sign. "I'm just the figurehead," he told Obrecht.

Robert Hendrix appeared uncomfortable as he listened to Obrecht's words. The expression on Janie's face read *No big deal.*

Obrecht told the court of a conversation he and Al Hendrix had while driving in Al's Mercedes. "He said that sometimes he was frustrated with Leon when he didn't toe the line. But that Leon and Leon's children and grandchildren would never want for anything. He said, 'They are taken care of in my will. I'm certain that Jimi would want it that way.' Al was keenly aware that they were Jimi's blood relatives."

Soon after this testimony, "Rayrae" Goldman, a friend of

Leon's, told me that several years ago Leon had visited him at his home in Southern California. "Leon said, 'I know you've got the book my dad wrote. I want to see it,'" Goldman recalled, "I felt very uncomfortable. I said that I didn't have it. Leon insisted that I show *My Son Jimi* to him. Finally I got it out and told him a little bit about it. He looked through the book. 'A lot of this isn't true,' he said." Later that day Leon telephoned his father. Goldman heard Leon tell his father, "I don't care what you wrote in that book. I love you, Dad." Leon said after the call that his father replied, "I love you, too."

§

AL HENDRIX, who had earned little more than $5,000 yearly as a gardener, and who had been joyful in the 1970s when Leo Branton had eventually arranged for him to receive $50,000 annually from Jimi's estate, was gradually to execute a number of wills. Immediately after Janie retained Hendricks & Lewis in the 1990s, Lewis drafted a "Revocation of Prior Wills" that Al wanted to sign. In order to avoid a conflict-of-interest situation because of their representation of both Al and Jane, Hendricks & Lewis brought in attorney Jonathan Whetzel to draft a new will for Al. According to Robert J. Curran's trial brief, "the principal purpose of the new will was to replace a 1987 will, which left most of Al's estate to a trust controlled by Branton. Leon, Janie and June were the principal beneficiaries under the new will signed by Al on January 29, 1993.

"On September 24, 1994, Al executed a second will drafted for him by Whetzel," the brief continues. "The will left 38% of Al's estate to June in a marital trust. Janie also received 38%, 19% outright and the remainder in trust. Leon received 24% in trust. . . ." Upon June's death the remainder of the marital trust was to be distributed to Jane's children Linda, Donna, Marsha, and Willie, as well as to Al's niece Diane and nephew Robert and to Al's sister-in-law Pearl Brown and his niece Grace Hatcher.

Jonathan Whetzel had an amiable and professional lawyer–

client relationship with Al. They met alone, and he listened to Al's thoughts, answered his questions, and sent Al correspondence, summarizing the details of Al's decisions. Al was comfortable with Whetzel.

After Al won back "Jimi's legacy" from Leo Branton, Janie's lawyer Reed Wasson retained the law firm of Stoel Rives and estate planner George Steers to assist in the preparation of Al's estate plan. In November 1996, according to the trial brief,

> Al executed a third will drafted by Whetzel. This will was similar to Al's 1994 will except that it recognized the formation of Experience Hendrix and its related companies and the birth of a child, Corvina Pritchett, whom Al believed to be his daughter. Leon and his children were to receive 24% of Al's holdings in trust. Al's other beneficiaries were to receive their interests in the family companies outright. Under the 1996 will, no single heir would have had a controlling interest. For her part, Janie received 38% of Al's estate under the 1996 will.
>
> According to a brief filed by Leon's attorney, in late November of 1996, Janie and Robert met again with Al, Wasson and Steers to discuss Al's estate planning . . . Whetzel was not asked to attend this meeting, nor was he asked to do any additional estate planning for Al.
>
> The Stoel Rives estate plan differed greatly from the terms of Al's previous wills. It did away with the concept of a family owned and run company, and replaced it with a multilayered structure of entities to be controlled by a "successor." In essence, it gave complete control of the Hendrix companies to Janie and to a lesser extent Robert. None of Al's other heirs were allowed to have a meaningful say in the operations. In the early versions of this plan, including those explained to Janie in 1996, Leon and his children were to have a 24% interest held in trust.

George Steers of Stoel Rives took the stand on July 22, 2004. Judge Ramsdell listened attentively to the testimony of the estate

planner who'd drafted the documents constituting Al's last will. Steers appeared quietly evasive and defensive on the stand. In answer to questions, he acknowledged lawyer Reed Wasson's presence at the meetings and his role in negotiating Al Hendrix's estate plan. Leon's attorney argued that as Janie's employee, Wasson had involved himself in a conflict of interest. But now, sitting in the sunny Seattle courtroom, Janie Hendrix didn't appear worried as to what conclusions the judge might draw. She chewed gum, giggled, and whispered to big, bald Bob Hendrix, incessantly scribbling on tiny blue Post-its. It was like a movie playing out.

In 1968 little Janie and June, her mother, whom Jimi had recognized as "starstruck," had met him for the first time. He had come prepared with cash to please his father, he'd been generous to Al's new family, and then, following their final meeting in 1970, he had left his hometown hurt and disillusioned over the pressure put upon him to make a will. After Jimi's death Leon had become disillusioned, too, for many reasons, including, as he had told me in 1971, the fact that "June's being very ugly to me, about me. It's all about the money." Now, in 2004, it was still all about the money as Leon and June's daughter Janie battled in court.

Ultimately, as was his custom, Al had dutifully signed the papers put in front of him. On April 16, 1997, he signed the first codicil to the 1996 will. It bequeathed all of Al's stock in a subsidiary company, Axis Inc., to Janie. It increased Corvina Pritchett's share of the estate if she was proven to be his child. It increased the marital trust's share to 50 percent of the remaining estate. It bequeathed to Janie the contingent reversionary rights Al had purchased from Leon. It disinherited Jimi's brother Leon with the exception of a single gold record, and it disinherited Leon's children entirely.

On February 12, 1998, Al signed his living trust and the accompanying "pour-over" will was executed. Janie had arranged for a videographer to capture the signing.

Representing Leon's six children, Karen Bertram, the only lawyer involved in the court action who has an exclusive practice in estate planning and trust and estate litigation, listened intently to George Steers's July 22 testimony. On behalf of her clients, her hope, she said, was "to obtain a ruling that the 1996 will—should govern the estate."

Leon and his legal team asked the court to consider the following solutions and remedies:

— creation of a trust for Leon and his children, which holds 24 percent of the Hendrix Legacy, taken from the portion of the legacy currently held by Janie

— a damage award against Janie in favor of all estate beneficiaries other than her and Robert, in their proportionate shares, for the monies she wrongfully squandered while in control of the Hendrix legacy

— removal of Janie as personal representative of Al's estate

— removal of Janie and Robert as trustees of the various trusts created after 1996

— a permanent injunction preventing Janie and Robert from acting in any fiduciary capacity, participating in the management of Experience Hendrix, and receiving any compensation from Experience Hendrix other than their share of the net profits as owners of the company

— an award against Janie and Robert in favor of the estate, directing them to repay attorney fees and costs incurred by the estate at their requests

— an award against Janie and Robert in favor of Leon for the reasonable attorneys' fees, litigation expenses, and costs incurred by Leon in this action.

On Saturday, September 25, 2004, a long-awaited *Seattle Times* headline read: **Jimi Hendrix Brother Gets None of $80 Million Estate**. The story by Christine Clarridge, who regularly had covered the trial since June, read:

Jimi Hendrix's stepsister—a woman he met only a handful of times—will inherit the bulk of the late rock legend's estate, under a ruling yesterday by a King County Superior Court judge.

Jimi's brother, Leon Hendrix, lost his bid to get a share of the estimated $80 million, after a seven-week court battle that left both sides feeling bruised and looking less than saintly.

As part of yesterday's court ruling, which was read by Judge Jeffrey Ramsdell in a densely packed but muted courtroom, Janie Hendrix—who was adopted into the Hendrix family when her mother married Jimi's father, Al—was removed as trustee for some of the other beneficiaries because she violated her financial responsibility to them.

In other words, there was no clear-cut victory for anyone.

Observers in the courtroom said that Janie cried after the ruling was read; they mentioned that she was bolstered by members of her church who had told her all along, "God wants you to win!" Leon, hurt and disappointed on behalf of his family, remained composed.

Brian Alexander reported in the *New York Times*, "Friends and relatives of both Janie and Leon Hendrix overflowed into the hall outside the courtroom. Supporters of Leon Hendrix wore white shirts that read 'Jimi's blood runs through me' and 'His legacy lives through his family and friends.'"

Seattle legal sources found the judge's ruling to be conservative with room for further legal hearings as to how the beneficiaries will be treated in the future as well as other significant financial issues. "The judge didn't like Janie, and he didn't like Leon," declared an attorney uninvolved in the proceedings. "He went by the facts, and it was clear that Al had given Janie all the power that she wanted, whether it was being in charge of the money, the music or where she chose to rebury Jimi's remains."

Judge Ramsdell found that "Al trusted and relied upon Janie to provide him with advice and counsel," that "Janie was involved in

the preparation and procurement of Al's estate plan," and that "the bequest received by Janie was unnaturally large." While these facts were "sufficient to raise the presumption of undue influence," the court found that Leon had failed to prove undue influence. The court found that Leon's own behavior—including his failure to complete a drug rehab program as promised, and his "failures to manage monetary resources," which indicated that a bequest would be "squandered"—was sufficient reason for his father to disinherit him. But the court did find that Janie and Robert had breached their fiduciary duties to trust beneficiaries and should be removed as trustees.

Among the "Findings and Conclusions on Legal Issues Presented" in Judge Ramsdell's thirty-five-page ruling, he declared the following:

— "The court finds that plaintiff [Leon Hendrix] has failed
 to establish that Al Hendrix lacked testamentary capacity
 to enter into his post-1996 estate plan."

— "The assertion of conflict of interest boils down to a
 contention that the attorneys creating Al's estate plan
 were not acting in Al's best interest. Having painstakingly
 reviewed the evidence presented, I am unable to find that
 this assertion is supported by the evidence."

— "Leon Hendrix and his children have failed to prove the
 existence of undue influence by the high standard of
 clear, cogent and convincing evidence. Therefore, their
 request for relief is denied."

— "This court orders that Janie and Robert Hendrix be
 removed as trustees of the Diane Hendrix-Teitel, Linda
 Jinka and the Hatcher Family trusts. The court also orders
 that Janie and Robert are obligated to pay the attorney
 fees of the aforementioned beneficiaries, the costs
 associated with the investigation by special counsel, and
 the costs arising from Washington Trust Bank's role as
 co-trustee. These costs were necessitated by Janie and

Robert's breach of fiduciary duty and therefore should be borne by them."

— "The request to remove Janie as the personal representative of Al's will is denied without prejudice. This court is not satisfied that adequate justification exists at this time to remove her from that position. However, the court will retain jurisdiction to revisit that issue should future circumstances warrant reconsideration. Janie and Robert are also ordered to continue to cooperate in efforts to identify personal expenses and loans that should rightfully be repaid to Experience Hendrix."

It was revealed during the course of the trial that Sony/ATV, the worldwide company that administers Jimi's song copyrights, loaned Janie and Experience Hendrix $2.5 million towards legal expenses. This courtesy surprised some members of the record industry, who found it unseemly that Sony/ATV would take sides in what Court TV called "the rock trial of the century." In effect, this sizable sum to be paid back from funds earned by music written by Hendrix was spent in an attempt to punish and defeat the brother Jimi loved and to protect and defend Janie, whom he barely knew. "There's something very cruel about this fact," summed up a Seattle law student, "but then this trial has never been about Jimi or what he might have wanted. After all, he took himself out of the equation on September 18, 1970."

In the years since Jimi died, there have been constant disputes about ownership of rights to his songs and performances with various parties claiming to hold rights in different countries. Several of these disputes have resulted in litigation. Indeed, it is likely that Janie Hendrix has spent more money on lawyers than she ever has on paying *musicians*.

A Seattle lawyer who knows Leo Branton told me on the basis that he not be named: "I understand that despite that bitter lawsuit in the nineties Leo Branton has continued to assist the Al Hendrix

estate in assorted subsequent litigations and in trying to recover additional intellectual properties." When I expressed surprise at Branton aiding Janie, who had spoken publicly against him, the attorney chuckled. He added, "As a matter of fact, Janie even sent Branton a letter of apology."

I telephoned Leo Branton and he verified that on March 31, 2003, Janie Hendrix sent him a lengthy letter wherein she thanked him for his recent help to her in the PPX litigation in England and for his legal opinion on other contracts. She admitted his loyalty to her father and expressed regret that the 1993 lawsuit had made unfounded accusations of fraud against Branton. The retired lawyer acknowledged to me that he felt that Janie's number one lawyer, Reed Wasson, had likely suggested that fences be mended. Her letter made Branton feel at least slightly better about the entire situation, and he wrote one in return thanking her for her words.

He is convinced that Janie would never have encouraged her father to take legal action against him if she hadn't had the financial help and support of Paul Allen. "The lawsuit was completely unnecessary," Branton said.

"Do you believe you would still be handling the Hendrix estate today if it weren't for that lawsuit?"

"Yes I do!" Branton declared.

In two lengthy conversations, Branton spoke to me about several of the cast of characters in the ongoing saga of Jimi Hendrix, the rock star worth more dead than alive. Regarding how Leon Hendrix fared in the 2004 litigation against Janie, Branton said, "There was a will where Leon was left a certain percentage, and within a year the will was changed and he was cut out completely. I don't know what could have happened to change things within that time. I think it's a shame. And I am quite surprised that no one got in touch with me regarding being a witness in any way in connection with that case."

"I am amazed," I told him. "I would have thought you would have been a very important witness."

"I would have thought so, too," Branton said. "But nobody called me."

I asked him about his feelings regarding Ed Chalpin. "You were helpful to Janie Hendrix in 2002 regarding Mr. Chalpin. Did you meet with him a number of times over the years?"

"Oh yes indeed," Branton said. "I often say when I describe Chalpin that he gets a vicarious thrill out of litigating. I remember when I went to England to try the case in 1973—which he lost—he tried to settle the case with me, and I wasn't willing to give him fifty cents. Warner Bros. had already settled with him on the United States rights. They saw that Hendrix was a multi-million-dollar-product and they didn't want any possibility of losing him. They *rushed* into a settlement but at the same time Hendrix's lawyers didn't get Chalpin to waive any rights in connection with the foreign thing. The whole thing should have been settled at one time or it shouldn't have been settled. That Chalpin, him and his settlements. In my dealings with him, I finally told him, 'I wouldn't give you a dollar to buy a cup of coffee and a bagel.'"

"*Show* us your ownership. *Prove* it." These taunts have been coming Janie's way from the big world outside Seattle, where two elderly men have taken particular interest in the trial that pitted her against Leon Hendrix. In a coastal town in England, John Hillman, who drafted all the original Yameta agreements and served as a Yameta director, along with his close associate the late Sir Guy Henderson, frequently telephones Seattle sources who are monitoring the latest Experience Hendrix developments. Ed Chalpin, too, is always near the phone in the New York City apartment where he has lived for more than half his life. It's within blocks of the small onetime studio where he first met Jimi Hendrix in 1965. He is said "to e-mail the day away," as always full of suggestions for potential deals regarding Hendrix's music.

For a time Chalpin and Hillman seemed friendly, but they ultimately had a serious falling-out. Chalpin had encouraged Lawrence Miller, a former promotion man in the British record industry, to form an independent record label, Purple Haze Records. "Janie *doesn't* own the rights to all the Hendrix tapes," he declared. "Go ahead!" Chalpin and Miller then had their own falling-out.

Subsequently Hillman and Miller collaborated on four CDs of Hendrix material issued on the Purple Haze label, the latest release being a CD of Jimi performing in Stockholm in 1969. Miller claimed to the press that he had reported Janie and her lawyer Reed Wasson to the U.S. attorney general and the FBI and alleged that he was filing suit against her. Miller did not provide any details as to the nature of their alleged wrongdoing or his claims, and the government has taken no action against either of them.

According to documents from the Law Society in England, on November 2, 1989, John Arthur Hillman was "Struck Off" (disbarred) by the Solicitors Disciplinary Tribunal. Periodically for some fifteen years, commencing soon after the death of Michael Jeffery in 1973, Hillman had been accused of a series of grave improprieties, often to do with betraying his clients' trust. These included utilizing for his own purposes "money held and received by him on behalf of clients."

Hillman went through a serious heart operation and later suffered a major stroke. For a time he had a loss of memory yet today, in speaking to business associates and with the press, he sometimes offers memories of conversations with Jimi and even with Monika Dannemann. Hillman claims that it is *he* who owns the rights to the Experience's albums, *not* Janie.

In his twenty-plus years of serving as Al Hendrix's lawyer, Leo Branton is certainly as knowledgable a man as can be found about ownership of the various musical rights involving Jimi Hendrix, and he was mightily surprised to hear of Hillman's 2004 claims.

Branton says, "While it's true that John Hillman was one of the organizers and founders of Yameta in the sixties, in the 1970s *we* got control of Yameta and all of the product that came from Yameta."

He adds: "There are people coming out of the woodwork on Hendrix every day with claims, hoping for financial gain or 'settlements.' I don't think the saga will ever end."

A London solicitor familiar with many details of Hillman's past says, "He is a very smart man who believes he knows where the skeletons lie. Perhaps he wants to sell his knowledge. Or, like Ed Chalpin, he may just enjoy being in the game."

A retired record executive in New York who knew Jimi and helped promote the Experience's records, and who has had dealings with both John Hillman and Ed Chalpin, sees Chalpin as the biggest threat to the Hendrix empire. "Chalpin's always lurking in the background," he told me. "I expect he's got a few more fireworks planned. He's an amazing instigator when it comes to the music of poor Jimi."

The series of serious accusations against Janie Hendrix, "president and CEO of Experience Hendrix," also has concerned Vivendi/Universal, a publicly traded company, where Jimi Hendrix's music is a proud asset of the MCA Records division. Seattle sources say that the MCA agreement with Experience Hendrix will come up for renewal at the end of 2009, and that before the 2004 trial began, Janie mentioned a figure of $50 million as the amount of the next advance. However, according to reliable sources in New York, Los Angeles, and Seattle, Janie's various record "productions" through Experience Hendrix have yet to earn out the hefty advance she received in the late 1990s. And of course no one can say for certain who will be in charge of Experience Hendrix in 2009—or if there will even *be* an Experience Hendrix still in business.

Numerous fans and members of the media around the world find the manner in which Jimi Hendrix's music and memory have been abused deeply sad. In his lifetime Hendrix was both

worshipped and exploited; he could trust only a handful of people, and it seems that this has not changed a whit in all the years since his death.

Recently, I saw a full-page advertisement from the Television and Film Music Special issue of the *Hollywood Reporter*. It shows a large image of Jimi Hendrix playing his guitar at Monterey. The text above his head reads "The World's Greatest Guitarist." Below the photograph, this is what it says:

Experience Hendrix
Licensing the Name, Likeness, Image and Music of Jimi Hendrix

All details of how to contact Janie's Seattle headquarters are included.

John Fogerty, the major talent and songwriter behind Creedence Clearwater Revival, told a reporter: "When you use a song for a TV commercial, it trivializes the meaning of the song. It almost turns it into nothing." Jimi undoubtedly would have agreed. But there's nothing that a dead star can do when his songs are used to advertise Pop Tarts, automobiles, or Reebok sneakers—or when his likeness and his words are merchandised in the Family's catalog.

Jimi once spoke admiringly of Charles Dickens's *David Copperfield* and how the poignant story had brought tears to his eyes. However, he never read Dickens's *Bleak House*, one of whose themes detailed generations endlessly fighting as lawyers came and went, profiting through the decades as they bled the estate.

Although the creative assets and physical image of Jimi Hendrix have been turned into a multi-million-dollar "family" business, during the 2004 court battle it was easy to forget that Jimi himself had no credit cards. He was not a millionaire. He owned no home. He was a man with a deep sense of humility and humanity who lived by his talent, his desire to please and his own hard work.

In the summer of 1969, during a serious conversation about

the constant barrage of legal documents over the past almost three years of his success, Jimi sat in calm reflection. He said, "I can envision the day when all material things are pulled from me, and then the stronger my soul will be."

Part Four

The True Legacy

Chapter Sixteen

The True Legacy

Jimi was the very first, and perhaps the last, to be loved
so deeply, so purely.
—*Concert promoter Bill Graham*

GOOD GUITARISTS pay attention to horn players.

I learned this from Jimi, whose ears were ever open for tones, be they divine and golden, unexpected, or previously unknown.

In the years since his death, comparisons have often been made between Hendrix and John Coltrane, the stunning visionary of the tenor saxophone, and with revered alto sax player Charlie "Bird" Parker, another soul-thrilling improviser. But always Hendrix has reminded me of the impoverished black youth from New Orleans who grew up to be a trailblazing trumpeter, loved and respected around the world—Louis Armstrong. Long before songs like "Hello, Dolly" came along, Armstrong in his heyday made a huge musical impact that expanded the boundaries of jazz and American popular music.

Beyond their tough childhoods, Armstrong and Hendrix had much in common, including bigger-than-life personalities, eclectic vocabularies and a love of words, quick intelligences and impressive memories, as well as innate modesty. "Louis Armstrong said he believed he was born with the talent inside him," Jimi told me. "Struggle is one thing. Practice—always, always, always. But you

gotta have it in there to begin with. I guess you have to *need* it, too."

There was that brief period in Hendrix's early life when it seemed that everything was meant to turn out differently. In those all-too-short months in Berkeley, California, the hand of destiny had reached out to him, blessed him with the nurturing and stability he needed and then—without warning—rudely retrieved the gift. In the tremendous twist of fate that had transported a two-and-a-half-year-old child from Seattle, Washington, eight hundred miles down to Berkeley, one can only speculate on what and who he would have become if he had remained with the "secret family" that took him in. Young "Johnny" forever remembered that they'd wished he could stay with them, but what he didn't know, never knew, was that the family had asked to adopt him.

Just out of the army, Al Hendrix had little to offer the son he'd only then met for the first time, but he made up his mind that the child was returning to Seattle with him; these well-meaning people would not be allowed to adopt *his* boy.

"No one could ever know how I felt going off with this strange guy," Jimi Hendrix recalled twenty-three years later. "I cried and cried. It was the worst thing that ever happened."

"Jimi Hendrix was born Jimi Hendrix," said his friend Tony Palmer, today a world-renowned film director of important music documentaries and an authority on the lives of diverse musical gods through the centuries. "Great musicians are not created; they are *born*. Jimi was meant for music."

Los Angeles record producer Jack Joseph Puig put it this way: "What so many players today are missing is what Jimi had—*feeling*. A feeling is not transferable. It comes from the soul, which God makes innately unique to that one person. Without a doubt Hendrix is responsible for a *whole* approach to rock guitar and an attitude that, frankly, still really hasn't been touched."

The great miracle of Johnny/Jimmy was that he managed to transcend his shaky beginnings and create himself into someone

rare and special by engaging his deepest feelings and his virtually unparalleled sense of sound. He propelled himself through sheer will and concentration and, above all, by building a fortress of his imagination.

In the summer of 1967, a reporter for Keith Altham, *New Musical Express*, visited the flat that Jimi and Chas Chandler shared off the Edgware Road in London. In Hendrix's bedroom Altham noticed that, suspended from a lampshade in the middle of the ceiling, were two small gilt figures of cherubs that Jimi had recently bought in an antique shop. One of the little angels had a broken arm. "That's the groovy thing about him," Altham quoted Jimi as saying with a smile. "He can fly with a broken arm!"

Hendrix saved that press clipping in a box in my garage, and even now I still see that cherub as a metaphor for Jimi. Although he never did lose the scars of his broken boyhood, he could still fly.

His true legacy can never be summed up in the number of records and CDs sold or the dollar figures attached to his name. For Hendrix the great axis of the universe was music, and he reveled in its enlightenment, power, and pleasure, owning a gift that he was eager to share. That gift lives on.

Certainly there are Hendrix fans in America and around the world who exist in the poverty that Jimi knew. Other admirers possess riches but lack the talent that money can't buy. Many fans are fine musicians for whom he is an inspiration—for example, his friend from the early days in London, Pete Townshend of the Who. The September 18, 2003, issue of *Rolling Stone* focused on "The 100 Greatest Guitarists of All Time"—Jimi Hendrix topped the list. In tribute, Townshend wrote a full-page piece for the magazine. In it he said, "I feel sad for people who have to judge Jimi Hendrix on the basis of his recordings and film alone, because in the flesh he was so extraordinary. He had a kind of alchemist's ability; when he was on the stage, he changed. He physically changed. He became incredibly graceful and beautiful. It wasn't just people taking LSD though that was going on, there's no question. But he

had a power that almost sobered you up if you were on an acid trip. He was bigger than LSD."

Townshend said of Jimi, "He made the electric guitar beautiful."

In 1977 John Lennon, his voice crackling with emotion, told me, "I'll never stop missing that brilliant boy. How I would have loved to have played or sung on an album with Hendrix! He brought excitement into the room with him. Just his physical presence was amazing, much less his music! Ah, Jimi lad, we'll love you forever. . . ."

Singer/songwriter Chris Jagger spoke of his friend Hendrix with warm affection when he said, "Thanks, Jimi, for all the good times you gave us. Purple Haze . . . *that* was a revelation."

Glyn Thomas is a schoolteacher in southwest London. He was born and grew up in South Wales, where, he recalled, "In 1966 I was like most fourteen-year-old kids, very into the Beatles. But I had become more interested in R&B bands with a harder sound like the Yardbirds and the Rolling Stones; therefore I liked the sound of 'Hey Joe' when it first came out. However, for me, the turning point was the release of 'Purple Haze,' which was so different to anything else at the time. It summed up the sixties and that whole psychedelic phase, with the moody lyrics and heavy riff and lead guitar like it had never been heard before. There was a watershed for me in deciding to spend my hard-earned pocket money on *Are You Experienced?* rather than the Beatles' *Sgt. Pepper* album. I walked into the Sound Centre shop in Tredegar and paid my one pound plus several shillings. In all the years since that day, I have never regretted my decision."

Like so many others, Thomas was devastated to hear of Hendrix's death. "It finished me for guitar-hero bands, because I knew no one else would ever come close to Jimi."

He is proud that his daughter is a Hendrix fan, too. She started borrowing his records several years ago and now possesses her own Hendrix "main CDs." "Jimi's music will always live on," Thomas

said. "The memories and the legacy will be passed down from generation to generation." Parents, grandparents, aunts, and uncles all over the world who cherish Jimi Hendrix yearn for the next generations to appreciate him, too.

"Jimi today is a genuine folk hero," says David Wish, a musician and teacher who in 1996, out of frustration over the lack of funding of musical education for children, became an integral force in forming an organization known as Little Kids Rock. Thousands of elementary school children in California, New York, New Jersey, and Tennessee have received free musical education and musical instruments through the popular afterschool program. Students listen to and learn to play rock, funk, hip-hop and the blues. "The kids are exposed to a variety of artists and songs," Wish commented. "You might be surprised at how many children, even six- and seven-year-olds, are familiar with Jimi's style and some of his songs. They know Jimi equals guitar." Les Paul, B. B. King, Bonnie Raitt, Paul Simon, and Bob Weir are among the noted musicians who are supportive of the Little Kids Rock program.

Phil Lehman is the executive director of the Fender Museum of Music and the Arts in Corona, California, affiliated with the Fender Guitar corporation, and the Kids Rock Free program. A young girl who has been learning to play drums wrote him, "Thank you for giving me the opportunity to do what I love," and her parents added, "She looks forward to each lesson!" Similarly, a young guitar student reported, "I have learned more than I expected. The teacher teaches us anything we want," and one of his parents noted, "You have provided a positive outlet for my son's music, his emotions and energy." A number of students in the Fender program have learned to play several instruments. Inspiration derived from the creativity of Jimi Hendrix and his fellow musicians has been a key factor in the success of these thriving organizations.

§

AS A KID Jimi did a drawing of Elvis Presley. In the Hendrix exhibition at Cité de la Musique in Paris, I viewed this sweet portrait of Elvis, depicted as the prototype of the fair-skinned all-American boy in blue jeans, a red jacket, and—oh, yes—a blondish pompadour! Hendrix respected Elvis's impressive title as "King of Rock and Roll," aware that Elvis had risen from the bottom, with his own roots of poverty, to the top.

A friend of Presley's once said, "Elvis didn't really pay any attention to music unless it was gospel. I remember when he was introduced to some English musicians and afterward said to me, 'Who the hell are Led Zeppelin?'"

I wondered if Elvis had ever given a thought to Jimi Hendrix in the late sixties. I asked two of Presley's closest friends, Jerry Schilling and Joe Esposito, key members of what was affectionately referred to as the Memphis Mafia.

Schilling told me, "Tom Hulett, the concert promoter, talked about Jimi to us. Tom promoted some of Jimi's shows at the time he was also promoting Elvis. He was going to put together a meeting between Elvis and Jimi, but it never happened." Joe Esposito said, "Of course Elvis knew who Jimi was, and he appreciated what a great entertainer he was. We spoke about him a few times, because Elvis understood that he played with his heart and his soul. With Jimi the audience could *feel* it, and that always mattered to Elvis."

A child piano prodigy, Herbie Hancock today is one of the most renowned jazz pianists in the world. In the sixties, at the age of twenty-three, he joined the Miles Davis Quintet, which also featured Wayne Shorter, Ron Carter, and Tony Williams. "I was young," Hancock said, "but I didn't necessarily think like a kid. I was a 'serious musician,' and I never gave any thought to seeing Hendrix perform. I had tunnel vision about jazz and wasn't paying attention to rock and roll at all. You could say that I had a narrow viewpoint in the sixties. But I began to notice that Miles Davis did have records by Hendrix, Cream, James Brown, and others; he was interested in a lot of different music. Miles, to me, was the epitome

of coolness, and I said, 'Wait a minute!' I had thought it was cool to just be into jazz, but seeing that Miles was open, I decided that it must also be cool to be open. I started to investigate a little more and listen to rock and funk.

"Later," Hancock said, "there came a point when I regretted not recognizing Hendrix's talent when he was alive, and it was evolving. I was sorry I never got to hear him play. It was too late when I came to realize that there was *so* much music in him. A great improviser playing with such freedom. Oh, yeah, he was avant-garde!"

Like Hancock, the superb jazz guitarist Barney Kessel also had his doubts about Hendrix, and in the beginning he found rock music forgettable for the most part. His son Dan Kessel recalled, "From the time my brother David and I saw Hendrix at the Bag O'Nails in London, we were huge believers in Jimi." The boys were desperate to make the father they loved a Hendrix fan. "Dad recognized there was creativity there, of course, and we were relentless in urging him to play Jimi's records. He became aware of other musicians he respected talking about Hendrix. Eventually he sat down and listened to Jimi's music. 'Okay, okay," he said. 'He's probably the most advanced player I've heard. I love the fact that he's blues-based; it's rock-and-roll blues. Yeah, Jimi is the guy.' He understood that Jimi had dedicated himself to his art. When Dad came around, it made us very happy."

John Mayer, the musical hero of a new generation, was too young ever to have known Hendrix, but the tribute he penned in *Rolling Stone*'s "Immortals" issue of April 15, 2004, resonates with a marvelous understanding, a rare familiarity, of what Jimi was all about.

Mayer wrote,

> Jimi Hendrix is one of those extraordinary hubs of music where everybody lands at some point. Every musician passes through Hendrix International Airport eventually—whether you're a Black Sabbath fan or an Elmore James fan; whether

you like Hanson or the Grateful Dead. He is the common denominator of every style of music. There were so many sides to his playing. Was he a bluesman? Listen to "Voodoo Chile" and you'll hear some of the eeriest blues you can find. Was he a rock musician? He used volume as a device. That's rock. Was he a sensitive singer-songwriter? In "Bold as Love," he sings, "My yellow in this case is not so mellow / In fact I'm trying to say that it's frightened like me"—that is a man who knows the shape of his heart.

I think the reason musicians love Hendrix's playing so much is that the language of it was so native to his head and his heart. He had a secret relationship with playing the guitar and though it was incredibly technical and based in theory, it was *his* theory. And I think that was sacred to him.

These phrases—"Hendrix International Airport ... common denominator of every style of music . . ." my, my, my! Jimi Hendrix was the kind of guy who'd be truly amazed and touched that another musician and songwriter would concentrate this kind of deep thinking about him and even take the time to write it out—and so impressively remind the world, as Willie Dixon had put it, *"what this all about."*

§

"ONE OF the many things that impressed me about Jimi and the Experience," Los Angeles writer Kirk Silsbee recalled from his teen years, "was that the band would tune up between numbers. You didn't see *that* with most groups. They'd just keep going song to song, but Jimi stepped up to the microphone and said, 'We tune because we care.'"

Jimi generally felt relaxed and ready for his L.A. shows. Denny Bruce remembered another Hendrix moment at one of the Experience's Forum performances: "Hendrix started the intro to 'The Wind Cries Mary' with a great country-tinged flavor. Then he stepped up to the microphone and said jauntily, 'Nashville, U.S.A.!'"

It's likely that the audience might have wondered what the psychedelic Mr. Hendrix could possibly know about the country-music capital of America, but the fact is that Jimi always considered Nashville to be the town where he'd embarked on the road to worldwide recognition. During 1962 and 1963, he could frequently be seen walking the streets of Nashville "playing" an unplugged electric guitar. Thus he was given the nickname of "Marbles," as in, "The boy's lost his marbles." This tag didn't really bother him, since a guitar would always be his friend, his source of focus, his security blanket.

In March 2004 the Country Music Hall of Fame premiered a high-quality exhibition titled "Night Train to Nashville: Music City Rhythm & Blues 1945–1970." An introduction to the exhibition states, "'Nashville really jumps,' sang Cecil Gant in 1946. Gant would know, for he was one of many stars playing rhythm & blues in the emerging capital of country music. During the years when Nashville grew into its title of Music City U.S.A., African-American artists such as Little Richard and Jimi Hendrix spent hours of bandstand apprenticeship in Nashville's black nightclubs. At the same time, Nashville station WLAC blasted rhythm & blues across half the United States when most national radio considered the music taboo, and black and white musicians made hit records together in the Nashville studios in tacit disregard of segregation."

In this fascinating exhibition, young Jimmy is seen enthusiastically playing guitar in a clip from Nashville's *Night Train* television show, which predated Chicago's *Soul Train* by five years. The rare video was loaned by Hendrix's friend, singer Frank Howard. A small framed newspaper advertisement for the Jolly Roger, one of a row of nightspots in Nashville's Printers Alley, reads:

JOLLY ROGER
Featuring BILLY COX and the SANDPIPERS
Also JIMMY HENDRIX
AND HIS MAGIC GUITAR

Michael Gray, the dedicated and painstakingly attentive co-curator of the exhibition, told me that Billy Cox, a longtime Nashville resident, had been highly supportive of the museum show, loaning numerous artifacts, including the old Gibson amplifier he and Hendrix shared.

Outside, it was a steamy-hot southern Saturday in July, but it was cool and comfortable inside the Ford Theater of the beautifully designed, ultraclassy Country Music Hall of Fame and Museum. More than two hundred fans of all ages, Hendrix loyalists, waited eagerly to hear what a special panel could tell them about the young man who'd spent more than a year on and off, circa 1962 to 1963, in Nashville after his discharge from the 101st Airborne. The predominantly white audience did include a number of black musicians and older people who had encountered Hendrix in those early days and had come to pay their respects to the boy, the artist, they never saw again. It was a heartwarming occasion, a most perfect tribute to "Marbles," who none of his Nashville friends could have guessed in the early sixties was to become an unforgettable figure in the big world of music.

Moderated by radio authority Ed Salamon, who as a fourteen-year-old kid had seen Jimi with the Isley Brothers, the panel—Johnny Jones, Frank Howard, George Yates, Marion James, Billy Cox, and Teddy Acklen Jr.—were clearly proud of the exhbition; the recognition of their roots meant a great deal, and they made a point of sincerely thanking Michael Gray in front of the audience.

Johnny Jones, who got his start playing with Junior Wells and Freddy King in Chicago, was introduced as "the leading guitarist in Nashville's golden era of rhythm and blues." Assorted R&B musicians had previously told me that Johnny, playing lead in the Imperials, had been the veritable king of the clubs on Jefferson Street and that Hendrix had been no threat. Today, as a panelist, Jones took the lead once again to confidently assure the audience that that had been the case. Jones, like the others, recognized that

Hendrix was a different kind of person, and he reminded everyone that even his manner of speaking was different.

The audience applauded especially warmly when Billy Cox was introduced "as one of Jimi's oldest friends, who played with him at Woodstock and with the Band of Gypsies." Most of the panel members were wearing their "Sunday best," but motorcycle-crazy Billy was decked out in full biker regalia; he was, he explained, "heading out for a rally later."

"Harleys are Billy's number-one passion these days," I was told by one of his friends.

Singer Marion James, known as Nashville's "Queen of the Blues," was one of the rare women leading a band in the 1960s, and for a while she employed both Hendrix and Cox. She remembered driving to pick up Jimi for a gig out of town. She waited outside patiently, and when he didn't appear, she finally went inside—and there he was sitting on the bed, dreamily playing his guitar. He'd be "down in a minute," he said. She went back to the car and, now impatiently, waited some more. Eventually she reentered the house, and Jimi was "still sitting on that bed playing his guitar."

Teddy Acklen Jr. grew up around music as the son of the man who owned the Club Del Morocco, where his father was known to many musicians as "Uncle Teddy." "Young Teddy," now a middle-aged man, was engaging, amusing, and interesting. As the afternoon drew to a close, he turned serious, making a special point of addressing the audience to say, "Jimi Hendrix was a very good person."

Panel member George Yates had been described by Salamon as "a guy who played guitar left-handed, played it with his teeth . . . and no, I'm *not* talking about Jimi Hendrix." The two lefties first met when Hendrix and Billy Cox dropped by the New Era Club at Twelfth and Charlotte in 1963. Later Yates and I talked. He said:

What me and most of the musicians on the panel realized in the sixties was the fact that the people of Nashville know good music. You had to know what you were doing in order to play and make any money at all. One of the things I knew as a musician was that the people wanted to see a *show*. So me being crazy I played behind my ear, behind my legs, behind my back. It was part of what we did to make a dollar, you know. It didn't have anything to do with learning or playing that well. It was part of the act, and people seemed to take to it. The night I met Jimi, he was interested in what I was doing, especially on a song called "Lucky Lou." He seemed to have a certain admiration for my tones, the style and the craziness. My impression was that this was the first time he'd ever seen someone play behind their head. Where I came from, guitarists in Louisville were doing it, and I learned from the very, very best. The first guy I ever saw do that was Arthur Porter. We called him Agie. He used to play behind Hank Ballard and the Midnighters.

I had a left-handed guitar, and it was strung up like a right-handed man would play it with the small strings on the top. Jimi had the big strings on top. He could play my guitar, though; it was a brand-new Fender Stratocaster. He'd brought along his blondish-looking Fender Telecaster; Jimi was a Fender man!

Something else Yates fondly remembers about Hendrix, he told me, "Jimi always wanted to put on a good show. He'd be really mad at himself if it didn't turn out good. When he became famous, and I heard 'All Along the Watchtower,' I said to myself, This is the *real* Jimi. That melodic line at the top—those tones!"

Yates, a sensitive man, went on, "After I heard that Jimi was dead, I thought then, and many times since, that maybe he'd just accomplished all he'd set out to do."

§

IN THE area adjacent to Hollywood known as Universal City, the sprawling Vivendi/Universal complex, encompassing a long and

illustrious history, rules the land. Here stands the famous black executive tower, along with sleek contemporary buildings, Steven Spielberg's lavish headquarters, and the thirty-five huge movie sound stages where Oscar winners like Marlon Brando, Paul Newman, Robert Redford, Gregory Peck, and so many more greats have emoted in classic films. Four narrow roads, manned by guards, form main entrances into the studio. They are named for powerful men in the entertainment business—film director Alfred Hitchcock, actor James Stewart, and Lew Wasserman, for many years the big boss of Universal Studios and virtual king of Hollywood. The fourth street sign says JIMI HENDRIX DRIVE. This acknowledgment would have dazzled movie-loving Jimi. In 1967, when he sat down with Leslie Perrin in London to discuss his background and his goals for his first publicity bio, he was asked about his professional ambitions. Jimi grinned and declared, "To be a movie star and caress the screen with my shining light." Then he blushed.

With the naming of a street, Hendrix's present record company, allied with Universal movie studios, has done him proud.

There are days when his friends wish for the impossible—that *he* could see Jimi Hendrix Drive for himself, that he could enjoy "all those movies" he dreamed of having time to see, that he could know of the wit, the humor, and the talent of Eddie Murphy, Chris Rock, and Jim Carrey. Jimi, who always appreciated laughter, would have been the first to recognize their artistry.

When I think of what Jimi has missed out on, I remember, too, the special plaque that is placed in the heart of the French town of Evreux. It reads HERE THE EXPERIENCE OF JIMI HENDRIX, MITCH MITCHELL AND NOEL REDDING GAVE THEIR FIRST OFFICIAL CONCERT OCTOBER 13, 1966. Jimi would be thrilled to know that France has not forgotten the trio who barely knew each other on that nervous October night. In Paris at Cité de la Musique's "Jimi Hendrix Backstage 2002" exhibition, it would have astounded him to see on display his broken 1965 Stratocaster, partially repaired and still in existence. On June 4, 1967, at the Saville Theatre in London, as

he wound up "Are You Experienced?" Hendrix smashed the guitar and then tossed it into the audience. He'd drawn flowers on the front, and on the back he'd depicted a heart full of feelings, ending with the words "*My darling guitar. Rest in peace. Amen.*"

Americans who visited the Boston Museum of Fine Arts from November 5, 2000, through February 25, 2001, viewed another of Jimi's guitars in a memorable exhibition encompassing four hundred years of stringed instruments, entitled "Dangerous Curves . . . The Art of the Guitar." Curator Darcy Kuronen wrote, "The guitar has been a musical icon for more than four centuries from the courts of Europe to the fields of Woodstock. Over that time, its form and decoration have varied dramatically, more than those of any other musical instrument, changing with time and place. Whether embraced in the arms or worn like a talisman, the guitar is intimately bound to its player—not just an instrument but a partner." There in Boston, alongside exquisite baroque guitars, lyres, mandolins and guitar harps was a 1967 Gibson Flying V, once owned and played by Hendrix. In those exhibition rooms was *proof* of one of his most heartfelt beliefs—the continuity, the bond, between musicians through the centuries. All those "partners" on display, just meant for magic fingers . . . Jimi would have been ecstatic.

§

IN THE summer of 1969, I drove up a West Hollywood side street leading to the Sunset Strip on a balmy Friday night, the last rays of an actual sunset illuminating the sky. Ahead I could see the brightly colored Whisky A Go-Go on its prominent corner, as I waited at a red stoplight that took forever to turn to green.

On that corner outside the Whisky stood a tall slim figure in creamy off-white suede pants and jacket dripping with thick fringe, complete with matching shoulder bag, its own fringe catching the breeze—it was an arresting portrait of Jimi Hendrix in profile, a vision of absolute beauty in this expensive ensemble. As he turned

though, there was something in his face, in his body language, that spoke of loneliness, of being slightly out of place. As he stood there by himself, the sidewalk started to fill with young men and women on their way to an evening at the Whisky, perhaps hoping they'd be lucky enough to sit in the red booths against the wall as opposed to the tables and chairs upstairs. Once they recognized Hendrix, expressions of disbelief came over their faces. They were sweetly thrilled.

When the light finally changed, I drove across Sunset. I saw a teenage boy stop in his tracks. My car windows were rolled down. "Oh!" I faintly heard him say. "Oh . . . how *neat!*" I pulled into the parking lot of the gas station a few feet from the Whisky so I could continue to take in this charming scene of fans enthralled to be so very close to this great god of their world. Hendrix remained still, but now he was smiling as dozens of fans came closer, yet respectfully kept just a bit of distance. "How are you?" I heard him say, and he was as gracious and gentle with these young people as he had been to me the evening I'd first met him. The kids exchanged expressions of delight; how could you ever top *this*?

Sitting parked at the gas station for at least five minutes, I wondered, should I get out of the car and ask Jimi if he needed a ride? Why was he alone? Famous stars don't just stand by themselves on Los Angeles street corners. Still, I couldn't think of interrupting this joyful crowd. Jimi was a grown man; he could handle himself, and here he was surrounded by love and appreciation. I'm sure that no one who was there that summer night has ever forgotten this shining encounter.

All these years later, for me and for his other friends, from Nashville to London, Los Angeles to New York, our memories of Hendrix are as vivid today as they were in the sixties. He was like no other.

The odds were against him from his birth. Success, when it came, offered a life that proved equally precarious and undependable. He was betrayed over and over again.

Perhaps it no longer matters. For Jimi Hendrix's magnificent talent and incandescent spirit continue triumphant. An ever-growing audience of all ages in every country in the world reveres the music of the humble young man who played only, in his words, "truth and emotion."

Remember the "golden-winged ship" that made the crippled girl jump in one of his greatest songs, "Castles Made of Sand"? *"And it really didn't have to stop,"* Hendrix whispered. *"It just kept on going."*

The castle melted into the sea. But fame, that most capricious goddess, has stood by him.

ACKNOWLEDGMENTS

A bouquet to everyone at Pan Macmillan, and especially to my editor Ingrid Connell for her attention to detail and professionalism.

Thank you to Jimi's many English friends, fellow musicians and fans for their valuable insights, memories and unwavering respect for Hendrix the human being and wonderfully talented guitarist, songwriter and singer. Your kindness and generosity of spirit brought him great happiness.

Thank you to the more than 250 sources, named and unnamed, throughout the United States, England, Scotland, Ireland and France for meaningful conversations about Jimi Hendrix both before and during the years after his death. With regard to the sixty-eight American, English and European attorneys and numerous record industry executives, who spoke on condition of anonymity, thank you for trusting me.

Thank you to the Seattle neighbors, friends and admirers of the young Johnny/Jimmy Hendrix for sharing long-held concerns and memories through the years. I continue to keep my promise to each of you and respect your collective right to not be named.

Thank you to world-class photographers Jean-Pierre Leloir, Barrie Wentzell, and Henry Diltz. And a special thank you to Jimi's Aunt Dolores for photographs of Johnny/Jimmy/Jimi, his brother Leon and their mother Lucille.

Thank you to the all brave men and women around the world who have risked and who continue to risk their lives in the interests of

Acknowledgements

peace and freedom for all human beings. The music of Jimi Hendrix resonates for many of you, and this fact would be most meaningful to him.

Roses always to my mother Margaret Lennartz Lawrence, to Caroline Boucher, Vicki Wickham, Nancy Lewis Jones, Patricia Costello, and to the late, great and lovely Penny Valentine.

Index

Visit **www.panmacmillan.com** to read more about all our books and to buy them. You will also find features, author interviews and news of any author events, and you can sign up for e-newsletters so that you're always first to hear about our new releases.